HARLEY PARKER

HARLEY PARKER

THE MCLUHAN OF THE MUSEUM

GARY GENOSKO

UNIVERSITY of ALBERTA PRESS

Published by

University of Alberta Press
1-16 Rutherford Library South
11204 89 Avenue NW
Edmonton, Alberta, Canada T6G 2J4
amiskwaciwâskahikan | Treaty 6 |
Métis Territory
ualbertapress.ca | uapress@ualberta.ca

Copyright © 2025 Gary Genosko

LIBRARY AND ARCHIVES CANADA
CATALOGUING IN PUBLICATION

Title: Harley Parker : the McLuhan of the
 museum / Gary Genosko.
Other titles: McLuhan of the museum
Names: Genosko, Gary, author
Description: Includes bibliographical references and index.
Identifiers: Canadiana (print) 20240481062 |
 Canadiana (ebook) 20240480724 |
 ISBN 9781772127935 (softcover) |
 ISBN 9781772128062 (EPUB) |
 ISBN 9781772128079 (PDF)
Subjects: LCSH: Parker, Harley. | LCSH:
 Museum curators—Canada—Biography. |
 LCSH: Painters—Canada—Biography. |
 LCSH: Typographers—Canada—
 Biography. | LCGFT: Biographies.
Classification: LCC AM3.6.P37 G46 2025 |
 DDC 069.092—dc23

First edition, first printing, 2025.
First printed and bound in Canada by
Houghton Boston Printers, Saskatoon,
Saskatchewan.
Copyediting and proofreading by
Angela Pietrobon.
Indexing by Judy Dunlop.

All rights reserved. No part of this publication may be reproduced, stored in a retrieval system, or transmitted in any form or by any means (electronic, mechanical, photocopying, recording, generative artificial intelligence [AI] training, or otherwise) without prior written consent. Contact University of Alberta Press for further details.

University of Alberta Press supports copyright. Copyright fuels creativity, encourages diverse voices, promotes free speech, and creates a vibrant culture. Thank you for buying an authorized edition of this book and for complying with the copyright laws by not reproducing, scanning, or distributing any part of it in any form without permission. You are supporting writers and allowing University of Alberta Press to continue to publish books for every reader.

University of Alberta Press is committed to protecting our natural environment. As part of our efforts, this book is printed on Enviro Paper: it contains 100% post-consumer recycled fibres and is acid- and chlorine-free.

GPSR: Easy Access System Europe |
Mustamäe tee 50, 10621 Tallinn, Estonia |
gpsr.requests@easproject.com

This book has been published with the help of a grant from the Federation for the Humanities and Social Sciences, through the Awards to Scholarly Publications Program, using funds provided by the Social Sciences and Humanities Research Council of Canada.

University of Alberta Press gratefully acknowledges the support received for its publishing program from the Government of Canada, the Canada Council for the Arts, and the Government of Alberta through the Alberta Media Fund.

Contents

Acknowledgements VII

Introduction 1

1 | Typography and Beyond 23
Events of Connection Between Parker and McLuhan

2 | The Making of an Epigrammatic Man 63

3 | Uncanny Selves and Family Resemblances 87

4 | The Hall of Fossils at the Royal Ontario Museum 111

5 | Reordering the Dutch Gallery at the Museum of the
City of New York 165
An Experiment in Museum Communication

6 | Regaining the Multi-Sensorial Museum in Translation 185

Conclusion 203

Notes 215

References 217

Index 229

Acknowledgements

I BEGAN WORKING ON the life and work of Harley Parker in 2012. At that time, Adam Lauder and I hosted a seminar on Parker's legacy, "Harley Parker and the Challenge to Curatorial Authority," attended by artists and a small number of researchers. Also in attendance was Harley's son Eric, whose acquaintance I had made a few months earlier. Eric brought with him an original work by his father, the first of the self-portraits that Harley had periodically painted, and it sat on an easel at the head of the room for the day, a reminder of a youthful painter circa 1945, released from three years of wartime service and about to begin his career as a designer and artist-teacher at his alma mater, the Ontario College of Art in Toronto. I am grateful for Eric's generosity and insights along the way during the writing of this book. I also benefited greatly from the reflections of Harley's daughter Margaret and her vivid recollections of her father's stories and of events in the life of the family. There are a few sections of this book where biographical details are provided about the Parker family, and these are a direct result of exchanges with Eric and Margaret. I have received generous assistance from the Parker Estate, the McLuhan Estate, and the Estate of Yousuf Karsh.

Much of the research for this book was conducted at institutional archives, including those of the Royal Ontario Museum, Art Gallery of Ontario, Ontario College of Art and Design, University of Toronto Archives, Columbia University Archives, and the Library and Archives of Canada, and the discoveries I made were assisted by the staff librarians and archivists, who are mentioned by name in footnotes.

I would like to thank Sarah Sharma, past director of the McLuhan Centre for Culture and Technology at the University of Toronto, for several invitations to present the results of my research on Harley Parker at the centre's symposia. Between 2015 and 2018, I also presented early versions of papers at "This is Paradise: Art and Artists in Toronto," "Then/Now/Next: The Toronto School of Communication," "Media Ecology and Ethics," and the "Many McLuhans" conferences. I edited a special issue on Harley Parker of the online journal *Amodern* (https://amodern.net/issues/amodern-5-harley-parker/) in 2015, based largely on the seminar of 2012. I was delighted to contribute a short piece on Parker and his book and journal designs at the request of Jaqueline McLeod Rogers for her co-edited special issue on "McLuhan and the Arts," in *Imaginations: Journal of Cross-Cultural Images* (Genosko 2017).

The focus of this book is on museums and the reception of Parker's statements on museums throughout the 1960s, as well as how his work was situated in the critical literature. But this also involves how the art of translation eventually transformed the understanding of his work, especially since 2008, when a French version appeared of a transcript published originally by McLuhan and Parker in 1969, known by the unwieldy title *Exploration of the Ways, Means and Values of...Museum Communication with the Viewing Public: A Seminar*, of an event from 1967 that featured McLuhan and Parker. This work will soon be republished due to the efforts of Bill Buxton. The French translation, *Le musée non linéaire: Exploration des méthodes, moyens et valeurs de la communication avec le public par le musée* (McLuhan and Parker 2008), not only managed to capture the spirit of Parker's ideas, but also put his work back on the agenda for a new generation of scholars and practitioners in international museum studies circles fascinated with the idea of the multi-sensory museum.

VIII *Acknowledgements*

The finalization of the text of this volume was pleasantly disrupted by the discovery of Parker's book manuscript in typescript dating from 1973 that had been missing for 50 years. Titled *The Culture Box*, the manuscript consolidated many of his existing publications, but also offered a number of valuable reflections on his own lesser-known practices in museum display, as well as elaborations on key concepts. The editorial challenges presented by Parker's manuscript included reconstructing all of his in-text references in the form of footnotes, as well as integrating his handwritten corrections into a final version in anticipation of its publication for the first time. It was due to the diligence of Margaret Parker that the manuscript was finally found. The disruption caused by this discovery also provided an opportunity for a long-delayed, late COVID-19-period visit to the Parker holdings at the Burnaby Art Gallery. Subsequently, I was able to visit in person the Ruth Nanda Anshen archives at Columbia University—Anshen was McLuhan and Parker's editor for *Through the Vanishing Point*—and receive from the Rochester Institute of Technology, in Rochester, New York, the files relating to the year during which Parker held the Kern Chair in Communications (1973).

I published an opinion piece about the discovery of *The Culture Box*, "When a Lost Manuscript Turns Up" (Genosko 2023b), and delivered a paper on this matter at the Canadian Communication Association Annual Meeting at Congress 2023, which was later published as "When a Lost Book Manuscript Turns Up: The Discovery of Harley Parker 's *The Culture Box: Museums Are Today*" (2024).

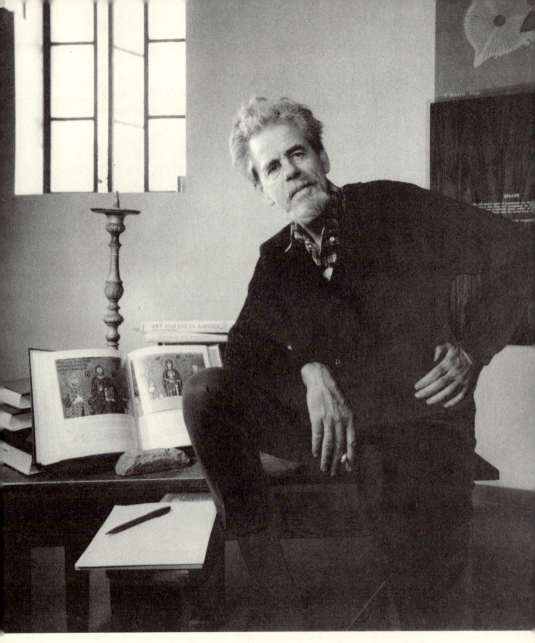

Portrait of Parker in his office at the Royal Ontario Museum, 1960.

(Courtesy of ROM [Royal Ontario Museum], Toronto, Canada. © ROM.)

Introduction

HARLEY WALTER BLAIT PARKER was a Canadian painter and designer who was born on April 30, 1915 in Fort William, Ontario (now Thunder Bay), and died on March 4, 1992 in Vancouver, British Columbia, aged 77. From Thunder Bay, he moved to Toronto and began his career after graduating from the Ontario College of Art (OCA) (*Fourth Year 1938–39 Honour Diploma: Commercial Art— Lettering, Commercial Art, Museum*).[1]

Parker's most celebrated career accomplishment was without a doubt being chief of display in the Division of Art and Archaeology at the Royal Ontario Museum (ROM) in Toronto, from 1957–1968. He was co-conspirator and collaborator (as designer and co-author) with Marshall McLuhan on a number of print projects: a journal (*Explorations*), books (*Through the Vanishing Point* and *Counterblast*), and a film (*Picnic in Space*). Parker was a visiting professor at Fordham University (1967–1968) and later served as the William A. Kern Institute Professor of Communications at the Rochester Institute of Technology (RIT), in 1973. Parker's criticisms of technology found local targets in Rochester's self-image as an original imaging tech hub, home of Bausch and Lomb, Kodak and Xerox (Barber 1973). From 1967 to 1975, Parker was a research associate at McLuhan's Centre

for Culture and Technology at University of Toronto (he first joined the centre in 1963). In 1976, Parker left the centre to pursue a life of painting.

Parker was active in arts administration for the Canadian Society of Painters in Watercolor (elected in 1961), and he served as president of the Canadian Society of Graphic Arts, in addition to acting as the society's representative at the Canadian National Exhibition in 1958. During this period, he attended Arts and Letters Club of Toronto meetings. He received a Canada Council Grant in 1958 to study European museum display and a further grant in 1964 to study methods of museum display in terms of new models of perception, a topic he never tired of discussing and upon which his legacy is based. His applications were supported by letters from McLuhan. This was not the only occasion on which Parker received such support. Parker published articles as a McLuhanite and, most importantly, as a theoretician of museum studies, with a focus on the role of the sensorium in exhibition display. He was a notable contributor to the Canadian mediascape in the late 1960s as a cultural commentator, book reviewer, and public provocateur. His interventions were themselves sometimes newsworthy, as he proved when he pronounced that "the middle class was dead" at the Couchiching Conference in 1967 ("Politicians Walking Backwards to Future" 1967), and he mocked the widely praised Ontario Science Centre (OSC) in 1970 as an "anti-people" place (Dempsey 1970) that had all the charm of a hotel chain. Parker was a controversialist at heart. He deployed an aphorism to describe the OSC's success at doing less with more: "'When all is said and done, more will be said than done'...there is a great deal of verbiage, but little inter-penetration of the skills of the community at large" (Parker 1970d, 7). Parker was recycling an aphorism he had used the previous year to decorate the four of clubs in McLuhan's *Dew-Line Newsletter* card deck (more on this below). Picking up on his aforementioned Couchiching bugaboo, Parker admitted: "I resent...the slickness of the presentations, obviously dedicated to reinforcing middle-class values of the utmost sterility and antisepsis." His conclusion could not have been more incisive: "a province which is capable of trying to ram through a Spadina Expressway is also capable of producing another piece of irremediable

irrelevancy." The Spadina Expressway would have run through more than one downtown residential neighbourhood in Toronto and, via a depressed trench, through the University of Toronto campus as well. The plan was defeated by a robust grassroots Stop Spadina movement, which enjoyed some high-profile intellectual support from urbanist Jane Jacobs, who had relocated to the city from New York a few years earlier, and from McLuhan himself. Parker had adopted the same Wyndham Lewisian tone of contempt for Toronto ("Momaco...a disgusting place") that McLuhan had effectively used for some time to express his exile there, and that appeared in his letters to Walter Ong, Lewis, and Ezra Pound during the 1950s.

Despite Parker's prickliness with respect to the shortcomings of over-hyped public institutions, he did accept an invitation in the spring of 1964 from T.C. Wood, Creative Director of Canadian Government Participation, 1967 Exhibition, to serve as a consultant in the area of communications for the Expo 67 project that celebrated Canada's centennial. To this end, he worked with industrial designers Frank Dudas, Julian Rowan and Jan Kuypers of Toronto, who founded the firm DRK in 1963 (letters concerning Parker's participation in Expo 67, and from McLuhan concerning his repeated desire for Parker to appear at events in his place, discussed in Chapter 4, were sourced from Fonds Marshall McLuhan 1964–1969). Parker continued to place opinion pieces on popular subjects (e.g., the birth control pill and its effects on family life; see Parker 1967c) in the Toronto daily newspapers.

Parker's devotion to McLuhan's thought, as well as their friendship, benefited him throughout his post-ROM career. In fact, much of his post-ROM career was bankrolled by it. He was part of the salaried entourage that accompanied McLuhan to Fordham University in 1967. Together with Edward Carpenter, Parker took over McLuhan's classes when he required surgery. Parker's unpaid leave from the ROM at the height of his career in 1967 was counterbalanced by a salary while at Fordham, but only for a short term. Parker's devotion made him an easy target, as he became known as a stand-in and right-hand man, and not as a creative conduit, but these circumstances warrant closer consideration, as the terms of the relationship between Parker and McLuhan were not always so obvious. Although Parker announced a

Introduction 3

number of times (first in the context of his 1964 Canada Council grant) that he was working on a book manuscript on museum design (tentatively titled *The Culture Box*), it did not appear as promised by the author in 1972, the year an excerpt appeared (see Parker 1972b). I was able to acquire a copy in the summer of 2022, as a result of sleuth work by Harley's daughter Margaret. References to that now published manuscript appear throughout this book cited as *The Culture Box* (2025).

The discovery of *The Culture Box: Museums Are Today* typescript solidifies the contribution that Parker sought to make to communication theory by applying McLuhan's medium theory to the museum environment in which he worked. To be precise, Parker (2025) interpreted museum exhibition display as a medium, but wrote, "if we accept [museum design] as a medium, however, we also have to accept the fact that it will govern *what* can be said because it will govern *how* it is said" (93). In short, a medium has inherently fixed characteristics that influence its impactfulness, and the changes it introduces—"the scale or pace or pattern" (McLuhan 1964, 8)—especially when McLuhan's extension thesis is also factored in: all media (and technologies) are extensions or "translations" of sensory and bodily capacities, and they focus and amplify these capacities to the extent that they succumb to specific autoamputations; this process rebounds on the body to such a degree that it tends not to be recognized. The challenge for Parker in analyzing museum exhibition design as a medium was that the museum, for him, "as an inclusive inventory of the extensions of humankind" (2025, 40), requires the designer to possess knowledge of many other media as well (86). This is the case given that the content of any medium is another medium or other media; these other media need to be accounted for, as they influence the arrangement of three-dimensional artifacts. As a communicator, the museum designer is a generalist with interdisciplinary aspirations, and this can put the designer at odds with specialist curators in each department of a large museum. This is why Parker recommended collaboration between designer and curator (2025, 118), and he certainly rejected curatorial authority as such. Further, the designer must be able to decode the "particular sensory mix" (2025, 26) of the culture or period that imprinted itself upon the artifacts with which the designer is working;

the designer must also account for the experiences of users, that is, visitors, through a process of acquiring feedback from them that then influences the presentation. This is the moment at which the designer must possess the capacity to recognize that recourse to a single presentational strategy based on the printed word, linear exposition, and visualization, is inadequate. "We need techniques for recalling the sensory components which figured largely in the life of the maker or user of the artifact," Parker wrote (2025, 34), underlining that his approach did not reproduce (match) the conditions of creation, but "shed light" (187) on and provided "insight" into the spatio-temporal assumptions of specific cultures of creation.

In keeping with the strategy of medium theory to eschew the traditional analysis of content—if this term is meant to refer to a social science method of extracting meaningful message components in a systematic manner (category construction, sampling, measurement, interpretation), often moving toward a quantitative assessment—yet not abandon it altogether, Parker picked up McLuhan's dual assertions about content: as noted above, other media are the content of any given medium, and users are also the content of the media they manipulate, consume, or visit. As Parker (2025) reminds us, "a gallery is finally designed only when the doors are open to the public, and this will only be true if the audience has been a part of the design thought from the beginning" (22). This principle of participation is not, unfortunately, usually or even commonly the case, Parker lamented, and he agitated for a greater role for feedback, suggesting that artifact labels could be records of audience reactions (2025, 142).

Assessments of medium theory point out that a typical weakness of this approach is the absence of any critique of the structural dimensions—institutional, economic, political—that influence media content and the direction of technological development (Meyrowitz 1994, 70–71). Yet, Parker's attempt to apply McLuhan's medium theory to the institution of the museum, largely assumed to be a publicly funded one, was approached from the perspective of a museum insider with a decade of experience. He was acutely sensitive to the damage that unsuccessful display practices can inflict on cultural communities through reductive, irrelevant, and ethnocentric approaches—yet there

Introduction 5

is, as I describe later, a limit on how robust an account that remains McLuhanite can achieve in this regard. Parker was certainly aware of the colonial legacies of collecting ("plunder"), the elitism of philanthropic culture, and the "preciosity" of museum culture.

The Culture Box manuscript belongs to Parker's early 1970s phase of publishing, extending from around 1970–1975, which was marked by a robust public contrarianism. After the publication of his books with McLuhan in the late 1960s, as well as his professorial museological journal articles, Parker broadened his interests to include new technologies, speculating on the effects of communications satellites—reinforcing all-at-once-ness and retraining perception (Parker 1970c)—and inserting this into the context of a "student-employer interface" where generations collide and fecund intervals can blossom (Parker 1970b). Parker fulminated against convention and hierarchy, making a reputation as a rebellious thinker who went on an international lecture circuit (making a visit to Melbourne, Australia; see Jenkins 1973) during his time at Rochester to criticize the state of public education systems, the hostility of many urban environments, the negative effects of the work ethic, and profit motive, all in the name of a broad humanism and a mission to reform learning by stimulating perception. This enabled him to articulate criticisms of public institutions, and as a book reviewer, to assay publications about the confluence of television and politics (Parker 1973a). He also praised Buckminster Fuller's paralogical invocations of a post-literate and post-logical feminine intuition: "intuition is an all-encompassing awareness of NOW" (Parker 1972a, 29).

During this period, Parker returned to his museum roots, advocating on behalf of a designer attuned to electronic orality (Parker, in a panel discussion with Shanks, Cantor, McCormick, and Williams; see Parker et al. 1975) and flirting with the museum as a work of art whose purpose is to retrain the perception of its visitors: "In museum presentation there are three factors: one is the artifact, two is the spectator and three is the interaction between spectator and artifact. This last is the area of action. So, the function of the designer of a museum installation is to decide on the effects desired and order these effects to achieve an empathetic understanding of a culture or discipline"

(Parker 1972b, 59). The work of design takes place at the interface between audience and artifact.

Parker (1963a) sought to consolidate his insights into the necessity of reorienting the senses of visitors "to the attitude required for an appreciation of a particular culture" (353). This was only possible by shedding any lingering privilege of cultural superiority and suspicions of difference and dispelling any further "unscrutinized assumptions" (Parker 2025, 192), by means of "shock," if required. He never sought an identity and sameness between the culture on display and the visitor standing before it, but rather sought to provoke a reflexive awareness of the differences in mental attitudes and sensory mixes between the culture on display and the cultures adopted, implicitly and explicitly, by those visiting. Although in his own estimation he never fully achieved this, even in his finest exhibition spaces, and only hinted here and there at what such a reorientation and re-education based on synesthetic awareness might look like, Parker's insistence on public involvement in gallery design looked forward to the era of participatory practices in more democratized museum environments. Parker would have recoiled, however, at community partnerships and the creative re-purposing of collections if they were undertaken without sound theoretical foundations based on research. His commitment was to creative questions that exposed natural attitudes and unseated dominant significations. Although he promoted discomfort and creative friction, Parker also had a liking for gentle, smooth transitions that might lead the public to the experience of more pronounced differences in due course.

The chapters in this volume bring Parker's contributions to Canadian cultural thought about the museum as a communication problem into focus, at once reviving his legacy as a medium theorist of the museum who translated McLuhan's ideas not only into the practical design of display and exhibit installation, but also into the theorization of this area of museum studies. Parker's experiments in multimedia museum design reached their apogee in October 1967, when he assembled a temporary "orientation" gallery within the Dutch Gallery of the Museum of the City of New York, a remediation of a traditional linear and sequential gallery space of labelled objects from a specific age, filtered by an effort to achieve a lack of specificity in the spirit of a

heightened qualitative awareness provoked by multiple screens, flashing lights, and facsimiles of artifacts. Parker's conception of a gallery without labels, with widespread use of reproductions that could be manipulated by visitors, shocked many of his museum colleagues in attendance at the event and was reproduced in the awkwardly titled volume *Exploration of the Ways, Means and Values of Museum Communication with the Viewing Public: A Seminar* (McLuhan and Parker 1969), or just plain *Museum Communication,* for short.

His most vanguard suggestion, which he developed at length in *The Culture Box,* was to build a "newseum." The idea is hinted at, however, in the *Museum Communication* seminar, with the following:

> which consists of a building outside the museum proper, but which draws on the artifacts and material of the museum for its shows. The idea of a newseum is that it is concerned with news, any news in the world which is of great moment, whether it occurs in science or archaeological discovery or what have you, or whether it occurs on the political scene. (McLuhan and Parker 1969, 33)

And something with the same name was eventually built —without his involvement, and without his goals—when the American foundation Freedom Forum, focused on First Amendment issues, joined forces with a number of journalism schools and media conglomerates to relocate its facility in Arlington, in operation from 1997–2002, to a permanent Newseum in Washington, DC that opened in 2008. Parker was no longer alive to defend his conception. His original conception remained largely unknown. Proposed in 1967, Parker's insights into media flows and information technologies in an emergent electronic world would not come to fruition until many years after his death, even if, already by 1970, the idea of information (encompassing some digital technology and non-technical referents such as the body and human sensorium) as a principle for organizing both artistic production and exhibitions had been widely adopted in the art world (Lauder 2022). Indeed, as Lauder (2015) argues: "the newseum emerges as an experimental satellite of the conventional museum space, which, like

the earth itself in McLuhan's gloss on Sputnik, is thereby transformed into an *art form*" (n.p.). The newseum is a Parker pun on the junking of the traditional museum, which, like the earth in McLuhan's estimation became a polluted midden after Sputnik, required a good deal of attention to amend and pick over. Throughout *The Culture Box*, Parker develops the equation of junkyard and museum, midden and collection. The small, satellite newseum that Parker imagined would lift off from the museum of disciplinary specialism and academic probity, riding the flows of media that have become central in the age of digital platforms. Such a building would be preferably built adjacent to any existing large prestige museum; it would be flexible, inside and out. This newseum would consist of a current public exhibition; an exhibition in process; and an area for gathering materials for a new exhibition. *The Culture Box* asks us to think about museums *beside* the box in terms of process over product. Despite Parker's efforts at experimenting with galleries that sought to reorient the perception of visitors, these were inside of existing museum spaces. Parker's newseum was never realized. It is, I will suggest, this factor that makes it still worthwhile exploring, because it releases the reader from the confinements of positioning Parker as a precursor to developments that have either already occurred in the field, and thus for a "past," or for events that at least are underway and thus datable. Care must be taken with the application of the label precursor.

The first chapter, "Typography and Beyond: Events of Connection Between Parker and McLuhan," revisits Parker's remarkable book and journal designs for McLuhan, beginning with the original series of the journal *Explorations* in the 1950s, as well as his contributions to McLuhan's *Dew-Line Newsletter*'s peripherals later in the 1960s. In particular, Parker had a hand in the collective design of the card deck ("Distant Early Warning Deck") for intellectuals that accompanied the September 1969 issue of the *Dew-Line Newsletter* (vol. 2, no. 1), titled "Inflation as New Rim Spin." Each card in the deck contained an aphorism, borrowed quote or McLuhanistic probe, that alone and in draws of multiples generated insights into either personal or professional challenges. Parker shared credit for the design with a few others, including Marshall's son Eric and George Thompson, a friend and assistant at

the Centre. Elsewhere I have taken up the kind of supplementarity featured in the *Dew-Line Newsletter*, a pseudo-journal with no editorial board, with a view to the emergence of the peripheral in a print context and as a strategy adopted in more serious contexts, such as Arthur and Marilouise Kroker's 1990s books that included audio CDs (Genosko, with Marcellus 2019, 149). The material mediatic field of the pre-peripheral device of today was limited to traditional arts production, using paper, including newsprint, but also photographic slides. These have been likened to "Flux kits," issued beginning in 1964 by the publishing wing of Fluxus that often worked with boxed cards, games, and puzzles, that also contained a film loop by Nam June Paik (see Cavell 2002, 193).

While McLuhan's journals reveal a range of contributions, a more concentrated example of Parker's work is found in McLuhan's book *Counterblast* (1969a), in which the design credit is included on the cover, rather than buried in the colophon in the back pages. From typography, this chapter moves into the making of the co-authored book with McLuhan, *Through the Vanishing Point* (1968). Using unpublished correspondence between Parker, McLuhan, and their publisher, Harper & Row, and with their editor, Ruth Nanda Anshen, the chapter's archival sources reveal the slow gestation and completion of the project, as well as the difficulties encountered along the way, suggesting that the tensions that arose over a number of issues may have affected Parker's own book project, which was also announced by Parker as forthcoming from Harper & Row in 1972 and 1973, but not by the press. The explication of this publishing process, largely hidden from view until now, acquires greater significance in light of the discovery of *The Culture Box* and its failure to find its way into print. It also exposes how the co-authors worked together, and how they engaged collaborators and attempted to bring them into the process. The following section of this chapter exposes how personal and professional relationships were mixed in Parker's role as stand-in for McLuhan, at the latter's insistence, for many invited talks following the publication of *Understanding Media* (1964). This substitution is one of several variations on the connections the two men enjoyed, and it had its own rhetoric. McLuhan was inundated with requests for articles and invited

lectures. For a period of more than five years, he managed his popularity by recommending that Parker take his place. In this sense, Parker was McLuhan's right-hand man. The key question is how McLuhan constructed and communicated his trust in Parker to those American institutions, mostly universities, that had extended invitations to him— in this study, all the surviving examples are from the United States—as a valued interpreter and sanctioned representative of the Centre for Technology & Culture. It cannot be ignored that in putting forth a right-hand man as a substitute for the southpaw, McLuhan took more than a little joy in this play with dominance and recalibration, without relinquishing any authority. Finally, in the third section, the transit is completed from typography and the graphic arts through substitution by cinematic collaboration in Bruce Bacon's art film *Picnic in Space* (1967). This film not only displays connectivity but makes connectivity a topic of discussion. What makes this variation on connection significant is that it attempts to cool down a hot medium by means of the putative setting, a picnic out of doors, without obvious boundaries, where sound and light fill space, for an "Argus-eared" audience (Carpenter and McLuhan 1960, 68).

The second chapter, "The Making of an Epigrammatic Man," revisits Parker's repeated use of a favourite epigram in a number of publications, exhibitions and media interviews, and casts him as an epigrammatic man, a typographically trained man drawn to aphorisms that were intended to dislocate and sharpen awareness, but who sometimes tended to resort to mockery in fanning the flames of controversy. If it may be said that the typographic man in medium theory was an individualist and print technologist, strong on point of view, visual acuity, and linear organization, and big on mechanization, the epigrammatic man I imagine Parker to have been was addicted to pithy, clever and sometimes satirical expressions that were beguiling up to a point, because of the way they eluded critical-analytical capture by means of a prodigious allusiveness. This tactical element worked well in interviews and in short journalistic writings, but it fared less favourably in long-form essays and explicatory writing. Epigrams are well-adapted to a hit and run style of criticism, strong on pronouncement, but relatively weak on contextualization and detailed explication. Yet the

repeated use of a few choice epigrams marked out a territory in which the author wanted to ensconce himself. It was almost as if Parker erected around himself for protection an array of affectively cruel barbs and flinty quips that were sometimes deployed aggressively. This was a tactic to avoid becoming a typographic man. The point of dropping the same epigram time and again would be to eschew an identifiable critical viewpoint, all the time sounding the same. Hopefully, by provocation, this would get readers and listeners involved in filling in an epigram's meagreness and following its rhetorical trajectory into some kind of reflective mode. In this chapter, I fill out the epigram's appeal for our epigrammatic man, where equivocation and mockery of convention are affectively enriched by a cynicism toward institutions and self-directed witticism, and I use McLuhan's *The Gutenberg Galaxy: The Making of Typographic Man* (1962) as a foil to contrast typographic with epigrammatic. Epigrammatic flourishes are escape routes from the destiny of a trained typographer to become another typographic man; they resist the "leveling function" (McLuhan 1962, 239) of print and attempt to break its hypnotic power.

Chapter 3, "Uncanny Selves and Family Resemblances," begins with Parker's painted self-portraits that he created over the entirety of his career. There are nine extant self-portraits stretching from the years 1945 to 1985. In the age of the ubiquitous selfie, these works may seem ponderous, even narcissistic, but they teach important lessons about the fluxes of identity over the life cycle, and subtle shifts of emphasis in the delineation of expressive characteristics, some of which reveal unsettling selves. My final emphasis is on the symbolic disappearance of the subject himself into the forest environment he spent so much of his time painting in his later years. The second section of the chapter revisits some commonalities shared by Parker in his design principles and by his son Blake, whose oral performances with the early electronic music group Intersystems, with its multimedia "synthedelic" performances built around the Moog Modular synthesizer, abstruse poetry, and architectural stage settings, were in close proximity to the creation of total environments popular in psychedelic art and certain entertainment venues at the time. Beginning with the release of *Peachy* (Intersystems 1967) and the landmark live performance by

Intersystems at the Art Gallery of Ontario (AGO) in 1968, the group moved firmly into the domain of psychedelic art. The focal point of the analysis is the *Mind Excursion* installation from *Perception '67*, staged at University College (UC) in the University of Toronto in the winter of 1967, a psychedelic event featuring visual art, music and poetry and a range of invited countercultural luminaries. Intersystems proper was formed, in fact, after and in light of *Mind Excursion*. Both Parker's invertebrate gallery at the ROM, the Hall of Fossils (opening in 1967), and *Mind Excursion* borrowed liberally from kinetic art, and the psychedelic scene in art specifically, from installations by American multimedia art group USCO (US Company)—"strongly influenced by McLuhan," as Chris Elcock (2023, 144) notes—to commercial ventures perfused with projective media, and including contemporary technologies like pressure sensors. The inclusion of these in a single gallery space assisted in the effort to shift museum culture into recognition of its uniqueness as a medium, and the important role it may play in retraining sensory perception. The "uncanniness" in the chapter title borrows from the psychoanalytic conception of a strange familiarity that provides insight into the expanded field of the self-portrait, the father-son relationship mediated by both the then *au courant* psychedelic reference and by the trajectory, and afterlife, of Intersystems.

The fourth chapter, "The Hall of Fossils at the Royal Ontario Museum," concerns this important gallery design and how it furthered Parker's theory of museum installation. Today, no trace of the Hall exists in the ROM. It is a largely forgotten episode in the museum's mid-20th-century history, featuring celebrity architectural makeovers and the occasional highly Parkerian installation, such as the immersive *Bat Cave*, which has itself undergone several incarnations. This chapter begins with a review of Parker's reflections on museum installation and display design published four years prior to the Hall's opening in the pages of *Curator* (Parker 1967b). Parker's two essays in this journal, from 1963 and 1967, as well as his other short essays in arts journals about his work in the museum and the tensions between curators and designers, constitute the professional foundation for his practice of museum exhibition design. Parker's articles are animated by his assimilation and application to the museum environment of McLuhan's

Introduction 13

critique of the primacy of visual bias within print culture, and how this is expressed in disciplinary knowledge. Parker (1964a) held the hopeful view that "the museum, as an inclusive inventory of the extensions of humankind, can perhaps lead the way in the contemporary attempt to reorganize the exposition of disciplines. It can only do this... in the light of the new assumptions of time and space being created by electric instantaneity" (112). He believed that the museum exhibition was a unique medium that required the critical study of presentation "syntax" and underlined the need for audience testing (1965b, 63–64). Parker disseminated these views through the ROM's in-house publication *Meeting Place*, as well as in McLuhan's new series *Explorations*, both of which were inserts in the University of Toronto's *Varsity Graduate* alumni magazine (as two magazines within a third magazine) (see Parker 1964a, 1964c). By 1967, with the opening in the ROM of his redesigned Hall of Fossil Invertebrates, Parker's views were again published in the respected museum journal *Curator*, with the lead sentence of his contribution setting the tone of triumph—"The Hall of Fossil Invertebrates which opened this year at the ROM is undoubtedly a break-through in museum design"—immediately followed by a characteristic qualification—"that it is a stumbling first step can be taken for granted, inasmuch as the field of communication in museums is relatively untrodden ground" (Parker 1967b, 284).

The dual track that Parker pursued crossed the built with the hypothetical. While this chapter deals with the built Hall, throughout *The Culture Box* (2025), Parker reflected on his thought experiments, his hypotheticals, being "dropped from the sky" at some future moment, no longer "museums" as such, but satellites, adjacent centres, local branches and imaginary exhibits focused on everyday objects like chairs and tin cans: "The focus in this book is not on providing absolute answers. At any rate, it cannot be done, for the exhibitions discussed here are largely hypothetical" (184). In *The Culture Box*, Parker provides only a few reflections on the exhibitions he actually mounted, but his comments are valuable, for some of these are from early in his tenure at the ROM and have not been discussed previously. Parker began using hypothetical galleries in his writings early in the 1960s, and this would inform his later work, despite the fact that

specific considerations of a cultural anthropological type regarding Indigenous artifacts and the role of the museum would, first, be displaced by his work on invertebrate fossils, and second, as the following chapter details, require an adaptation, in short measure and with a limited budget, of a permanent gallery at the Museum of the City of New York. In his experimental gallery—in the sense of hasty assemblage, on a shoestring, and more "explorimental" in the combination of experience and experiment, and thus not fully achieved— Parker tried to integrate a few of the elements he triumphed (from entertainment venues, world fairs, and industrial exhibits) and subtract a few he dismissed (labels, original artifacts, storylines). In short, following Derek Attridge (2018, 22), it was an installation that was inventive and "troubled the institution" in a constructive manner.

Chapter 5, "Reordering the Dutch Gallery at the Museum of the City of New York: An Experiment in Museum Communication," focuses on the immediate post-ROM Parker in full flight with his friend and colleague McLuhan in New York, through the transcript of the *Museum Communication* seminar (McLuhan and Parker 1969). This event gave Parker an opportunity to explore the museum as a medium through the use of a guest orientation facility with a few of the multimedia tools available at the time, with the assistance of media impresario Tony Schwartz, and a healthy philosophical disdain for visual Cartesianism, hence Parker's contempt for logic and rationality (see also Jay 1993, 66–70). The seminar began in advance of the event with a pre-recorded "pre-seminar" (taped by the aforementioned Schwartz, a sound engineer) contributed by McLuhan and Parker and sent to registered participants (either on audio tape or as a transcript). Taking the form of a dialogue, the "pre-seminar" ranged widely over topics such as the breakdown of pictorial space and lineality, and the implications of these shifts for the presentation of artifacts in museums, and Parker's specific interest in "orientation centres" that would help visitors adjust to the museum environment. The tension between the artifact and its original world(s) and those biases of the world(s) of the visitors (Parker does not delve into the history of the use of visitor surveys by museums) is precisely the point at which Parker set up his McLuhan-inspired research and experimentation. Over the course of two days, McLuhan

and Parker held forth among an audience of leading exhibit designers, museum directors, and assistants to directors from major New York cultural, historical, and scientific institutions, and including visitors from nearby states and a few from further afield. The morning of the second day was devoted to Parker's installation, *The Multi-Media Orientation Gallery*, beginning with managed small group visits, followed by a lengthy discussion. The significance of Parker's sense of "orientation" and visitor intake spaces are examined in the chapter, including his reflections on practical issues such as controlling the volume of visitors, but also by an array of examples he drew upon to situate his project beyond typical museums, which ranged from the Electric Circus nightclub in New York's East Village, to the IBM Pavilion at the 1964-1965 World's Fair in New York, and the National Film Board of Canada's *Labyrinth* at Expo 67 in Montreal. My approach in this chapter is to derive a set of four basic operating principles that define Parker's approach to exhibition design. Like the Hall of Fossils, the re-imagined Dutch Gallery only hinted at what an adjacent orientation centre might look like.

The final chapter, Chapter 6, "Regaining the Multi-Sensorial Museum in Translation," looks at how Parker's design contributions, as well as his more dialogical contributions to museum communication, fared in translation, primarily in French, with reference to McLuhan's *Counterblast* and the very late translation (almost 40 years after its publication) of *Museum Communication*, retitled *Le musée non linéaire* (McLuhan and Parker 2008). With a new title, *The Non-Linear Museum* foregrounds one of the core preoccupations of the *Explorations* journal group during the 1950s. One member, anthropologist Dorothy Lee (1957), explored through linguistic anthropology how contemporary English speakers draw lines of connection, following guidelines and lines of thought in a lineal fashion. Lineal process is a "cultural axiom," Lee argued (1957, 38), in which connection and continuity are sought, but this is not shared by all peoples. Lee's (1957) discussion of Trobriand Islanders exposed the degree to which they "did not act on an assumption of lineality at any level...because they find value in pattern [they] act according to nonlineal patterns; not because they do not perceive lineality" (38). What the French title suggests is that

a museum that organizes itself in the absence of a guiding line is not only possible, but may very well dispense with culmination, development, and even progress. Parker dreamed of mounting a museum display without a storyline, a plotless display, and while he made great strides toward this lofty goal, his career was defined by his struggles with institutions. Yet, in either language, *The Non-Linear Museum* volume of transcripts also stands as something of a second seminar, that is, second to the groundbreaking interdisciplinary Seminar in Culture and Communications that McLuhan and Edmund Carpenter directed in 1953–1955 at the University of Toronto, which had a similar spirit of "dialogue and playful experimentation" (Darroch 2017–2018, 18).

The analysis of *Le musée non linéaire* uses translation as a heuristic tool to pursue the French reception of Parker's work for a new generation of readers in both Franco- and Anglo-Canadian and European new museological thought and practice. The lead translators, philosopher Bernard Deloche and museologist and museum director François Mairesse, are both members of the International Council of Museums (ICOM), the international professional body behind redefining the museum in democratic and participatory terms, and active in publishing on new museological developments. Parker's writings have found a new place in the recent critical literature and this renewed interest is regained in translation. Although Parker's contributions to museology went quiet for several decades, the translation of *Museum Communication* changed the status of his work and how it was received. The *Seminar* was considered an important precursor to many of the concepts that animated the new museology, an influential international movement that first gained traction in the 1980s; and, in addition to its critique of the traditional museum's elitism—there was a need for a redistribution of power, including meaningful public involvement—new approaches to the relationship between the artifact and visitor would place an emphasis on museum sensoria. Some of Parker's application of medium theory with an emphasis on the role of the senses in the museum began to re-circulate in the museum literature beginning around 2010, and this recent development is bringing his work into focus for a new generation of scholars, such as David Howes (2022, 164), whose work in the area of sensory museology has

Introduction 17

drawn attention to the "rehabilitation of touch" beginning in the zero-zero decade and the possibilities this has created for "lower" senses such as taste and smell to assume greater importance. Howes' (2022, 165) genealogy of how touch was demoted in the late 19th-century museum, as vision came to dominate the aesthetic appreciation of artifacts, corresponds to Parker's (2025) understanding of how a 19th-century "assumption" that all sensory experience can be translated into the visual, and take its place in a lineal logical order, continues to dominate most museum presentation: "the museum as we know it... is largely a result of nineteenth-century assumptions" (29). Parker's (2025) efforts to make, in theory and practice, "the restimulation of the sensory life of audiences...central to museum interpretation" (34) can easily find a place in Howes' (2022) regaining of the formative work of McLuhan on sensory balances and of Walter J. Ong on the "senses-cape" for the links they provided between the sensorium and culture (6). If Howes (2022) can write that "McLuhan theorized the senses more capaciously than any other scholar" (16), the application of this theory to the practice of museum exhibition design expands the understanding of the reach of such a theory in Parker's able hands. The situating of Parker as a precursor to the sensory turn in general, and in museum studies in particular, was put into motion by the French translation noted above. Translation plays a vital role in the repositioning of Parker's work and the redefinition of its meaning and value, constituting a dynamic re-writing that finds an expanded audience. But references to Parker's very early articulation of principles that would animate the new museology of the 1980s are not limited to translation. Parker's prescient observations on the problem of creating exhibitions based on little knowledge about intended audiences, and of uncritically resorting to written and oral explanations within display spaces, remained key problems for new museology several decades later (Vergo 1989, 52).

The writing of this book is inextricably linked to the discovery, annotation and analysis of *The Culture Box* manuscript. The lengthy discovery phase began in earnest in 2012. I initially discovered that Harley's youngest son, Eric, a graphic designer and photographer, lived close to me in downtown Toronto. He graciously participated in a small

seminar on his father that my colleague, art historian Adam Lauder, and I held in Oshawa (entitled "Harley Parker and the Challenge to Curatorial Authority"), and he brought to our attention a Yousef Karsh portrait photograph of his father, the existence of which not even the Karsh Estate knew about, I later learned, a pleasant surprise wrapped in a larger mystery. There is a well-known Karsh portrait photograph of McLuhan taken in Parker's Hall of Fossils. Parker's portrait dates from about a year later. A comparison of the two portrait photographs is undertaken in Chapter 4.

I then learned that *The Culture Box* manuscript was not likely to be permanently lost. Monica Carpendale, based in Nelson, BC, the widow of Harley's late eldest son Blake, who passed away in Nelson, BC in 2007 at the age of 64, confirmed that she had seen it among Harley's belongings at some point after his passing in Vancouver in 1992. At that time, Monica and Blake had conducted a sale of Harley's paintings from their Vancouver home, before donating a significant collection to the Burnaby Art Gallery. The role of the Burnaby Art Gallery is discussed in chapters 2 and 3.

I was inspired by this confirmation and began to enlist more interlocutors, keeping in mind the twists and turns that the passage of time itself can bring into play. It was only once I had begun corresponding with Harley's youngest child, his daughter Margaret, that I began to piece together the story. Margaret eventually unearthed the manuscript among some of Harley's belongings. In early April 2022, she had the manuscript scanned and sent me a preliminary copy. Almost the entire 350-page typescript was intact, with the exception of a few stray pages that were quickly tracked down.

When a lost book manuscript turns up, the result of a combination of sleuth work and luck, the discovery phase ends and the annotation phase begins. The annotation of a manuscript that has been copy edited but provides none of the references for the myriad of citations that appear throughout it requires an immersion into period language and intellectual contexts of the time. The citational scaffolding of the manuscript has four layers: the first is to McLuhan, and is not as dense as Parker's intellectual debts suggest, but is augmented to expose the relevant textual sources; the second is to museum discourse, which is

Introduction 19

anchored by A.E. Parr, longstanding director of the American Museum of Natural History, and combines the aforementioned hypothetical galleries, accomplished installations, and some degree of experimentation (but without discussing the Dutch Gallery). The third concerns the status of communication within museum studies and the tendency during the period in question to adopt the transmission model and to dismiss, or marginalize, McLuhan's transformation model. Fourth, Parker draws upon the work of an international range of designers to contextualize his choices, and relies upon colour theory to work, by analogy, through his conception of the additional exhibition centre that would reorient the perception of museum visitors.

The interpretation of the manuscript begins with the reconstruction of its references and then turns toward the question of its place within Parker's oeuvre and its potential impact upon the field. Is the proper field media studies or museology or even sensory studies? *The Culture Box* is an advance on medium theory because it attempts to address the question of the institution, the public museum, and its politics, at least in a preliminary way. Parker saw his role as a designer-communicator with a community focus, a convenor of "deconcatenated" galleries, unchained from narration, linearity, and visuality, housing collections of people and artifacts in the "now," rather than in a solemn, timeless space-time. He points us toward discourses—experiential, participatory, sensory—about museums and practices that would not emerge until much later, and he opens up in a prescient way very contemporary issues around colonialist legacies, democratization, models of visitor experience, the development of display technologies, interdisciplinary research, and intercultural communication. Does Parker, in engaging in a critique of the institution of the museum, and its fraught legacies, ameliorate what Arthur Kroker (1984) insightfully called the "blindspot" of McLuhan's version of medium theory on the conjunction of capital and technology? Can he offer an escape from McLuhan's failure to expose the fact that he led his readers into the untenable condition of being servomechanisms of empire? The tension that exists in Parker's original contribution to medium theory and to museology arises and remains unresolved because of his debts to McLuhan's theories and their application to the museum in theory

and in practice, which opened up important vistas of critique, but did not provide him with an adequate way of surmounting the limits of the very terms of the analysis. This limitation of medium theory, despite Parker's advances by providing a specific institutional referent, and that of McLuhan's extension theory of the senses, of which Howes (2022, 52), for instance, is well aware, do not detract from the potential contributions that *The Culture Box* and all of Parker's prescient work can contribute to more recent sensory turns in museum and cultural studies.

1

Typography and Beyond

EVENTS OF CONNECTION BETWEEN PARKER AND MCLUHAN

THE COLLABORATIONS between Parker and McLuhan took many forms over the decades of their working relationship and friendship. In this chapter, the question of how they worked together is answered through the consideration of four different episodes. Their personal relationship dates back to 1950, when McLuhan first became familiar with Parker as a painter. As Parker related in his version of the encounter, "I was a member of a three-man exhibition of paintings and Marshall came in and began to look around. He immediately dismissed the other two and became interested in my work" ("A Citizen Profile" 1970, n.p.). A similar scenario would play out in 1963 at Rodman Hall Arts Centre in St. Catharines, Ontario, where a joint exhibit by Parker and two other artists was opened by a lecture from McLuhan about art's capacity to "make models of the future" ("From Ivory to Control Tower" 1963, n.p.).

After graduating from high school and then taking a technical certificate in Thunder Bay (then Fort William), Parker pursued training at the OCA in Toronto, graduating with an Honour's Diploma in commercial art in 1939 and taking up his first post as a typographic designer with Cooper & Beatty (C&B) and then at Eaton's department store in

Toronto during the period of 1939–1942. While Parker was working on camouflage projects for the military during his WWII service, he was also exhibiting paintings as early as 1943 and again in 1945 in Vancouver. "Newly discharged," he addressed industrial landscapes in particular, but also his situation in *The Camouflage School* (1943) and his assigned barracks in two early 1940s works, *Mountain Barracks in Chilliwack, BC* (c. 1940) and *Barracks at Chilliwack* (1942). From roughly 1943 to 1991, Parker actively exhibited his watercolours across Canada. In the 1950s, he participated in group shows (with Frederick Hagan and Eric Freifeld), in a well-received Pickering College of Newmarket, Ontario show (titled *30 Pictures* to which he contributed 10 of his own, including his 1949 study of urban despair *Slaughter of the Innocents*); he showed at Woodsworth House (the Ontario Woodsworth Memorial Foundation headquarters) on Jarvis Street in Toronto in 1951, and in Brantford the following year; and he lectured on colour theory at Carleton College, precursor to Carleton University, in Ottawa in 1954. From the haunts of CCFers to those of the business elite of Toronto's Wellington Street, Parker contributed two paintings in 1956 to a joint venture by *The Globe & Mail* and business supplies store Grand & Toy to bring art to the business district, in a generic *Exhibition of Canadian Art* that featured Harold Town, R. York Wilson, Charles F. Comfort and many others. During the 1970s, near the end of his tenure in Toronto, he regularly showed at Bau-Xi Gallery (1976, 1977, and 1980), Beckett Gallery in Hamilton (1977), Prince Arthur Gallery (1981) and Gallery Moos in Toronto (1986).[1]

Prior to joining the ROM in September of 1957, Parker was teaching at the OCA, and he enjoyed a long affiliation with the college. He specialized in watercolours and colour theory; his earlier attendance at the summer session in 1946 of colour theorist Josef Albers' seminar at Black Mountain College in Black Mountain, North Carolina, gave him the kind of direct knowledge of Bauhaus ideas that he would return to throughout his career. Parker became an Honorary Fellow of OCA (now Ontario College of Art and Design University) in 1984. He had worked out a cross-appointment with McLuhan's Centre for Culture and Technology at University of Toronto as early as 1963, with the

blessing of his head of division, A.D. Tushingham, an Old Testament scholar and archaeologist of the Middle East.

The first section of this chapter concerns Parker's occasional design collaborations with the communications journal *Explorations*, published between 1953 and 1959 under a Ford Foundation Grant (Buxton 2018) held by McLuhan and Edmund Carpenter (1953–1955), and subsequently supported by a local newspaper publisher. Parker was not a formal member of the *Explorations* group, but provided select advanced typography and cover design, as well as at least one article about colour. The second section groups together archival documents (primarily letters) from the editor, Columbia University philosopher Ruth Nanda Anshen, of the book series World Perspectives, in which Parker and McLuhan co-published *Through the Vanishing Point* (1968). This book project began around June 1965, when Anshen invited McLuhan to participate in the series, referring to him as a key feature of "maieutic force which this series increasingly symbolizes" (Anshen, 1938–1986, Anshen to McLuhan, June 28, 1965). This period, between 1965 and 1968, was also notable for two parallel developments in the careers of Parker and McLuhan: the publication by McLuhan of his landmark book *Understanding Media* in 1964, and its subsequent international influence, and for Parker, the completion and opening of the Hall of Fossils, which will be discussed in depth in Chapter 4. The third section moves to the post-*Understanding Media* period, in which Parker regularly served as a substitute for McLuhan on the invited lecture circuit. It is the rhetoric of the substitute to which this section of the chapter will attend. The final section deals with the film *Picnic in Space*, in which both men appeared in a bucolic woodland setting and ad-libbed a script about media hybridity. The four events discussed in this chapter will provide a foundation for the detailed examination, in Chapter 5, of the *Museum Communication (Exploration of the Ways, Means and Values of Museum Communication with the Viewing Public: A Seminar)* (1969) seminar, for which Parker was thrust into a leading role as McLuhan's health began to falter during the year they spent together at Fordham University in New York in 1967.

Typography and Beyond

The Colophon Caper

Parker was an enthusiastic host for meetings of the local members of the *Explorations* group at the ROM basement cafeteria, and he offered his services as an occasional typographic designer for the journal. He counted the eighth issue of the journal *Explorations*, "Verbi-Voco-Visual" (October 1957), in his portfolio of key design accomplishments, and his contribution has been noted in detail by keen observers such as journalist Robert Fulford (2005), who praised his "flamboyant and highly original typography" (314). Parker was specifically acknowledged on the first front page of the original issue, receiving credit for the cover and the interior, specifically his choice of colour inks and modified typefaces; the eight-page yellow section looked forward to the style of the "unknown" or "revived" *Explorations* once it moved to the University of Toronto alumni magazine in 1964. But issue number 8 was not his first involvement with *Explorations*. He not only designed the cover of *Explorations* 7 earlier the same year (March 1957), where it was briefly noted that the next issue would be "an experiment in photo-type designed by Harley Parker," but let's not forget that he received design credit for the "Anna Livia Plurabelle" pages in *Explorations* 5 (June 1955), along with colleagues Richard Grooms, Frank Smith, and C&B—the firm itself gets a small mention on one page of the spread itself: "Experimental typography by Cooper & Beatty, Ltd." Parker's typographic training served the *Explorations* group well during the original run of the journal in the 1950s, and beyond, during its later years. Parker contributed not only designs but articles to both (in the latter, the aforementioned reprint concerning "The Horse That Is Known by Touch Alone," and in the former, a "hidden" article on colour that didn't make it into the table of contents of *Explorations* 6, "Colour as Symbol"; see Parker 1956, 56–57) on the difficulties of using colours as symbols. Here, his brief training with Albers comes through as a proponent of colour experimentation, underlining the relativity of colours, the significance of their interactions, and the intricacies of the optic nerves.

What does the 1957 colophon of *Explorations* 8 tell us? A colophon appears at the end of a publication and makes note of the design, typesetting, and printing details. The typography was known as Flexitype,

expertise in which was provided by C & B of Toronto, where Parker had worked after graduation. This use of Flexitype had migrated from the world of commercial advertising and corporate design to the academic publication process at University of Toronto Press, and it marked an alleged first, at least in terms of the concentrated quantity of its use, but also in relation to the high quality of printing provided by another outfit, Bomac Ltd. of Toronto, not to neglect the type of paper, Paragon Offset Brilliant, and the company that sold it, Provincial Paper Ltd. Together with the sponsorship note from the front matter, it was added on the title page that the funder was the local daily newspaper, the *Toronto Telegram*; there is an unusually rich array of information about products and businesses but less about the people involved in this colophon. This would prove to be an issue for design historians.

The augmented reprint of *Explorations* 8 ten years later, in 1967, by Something Else Press, omitted the colophon of the original altogether. Such details and credits, once regained, are not completely transparent. The modification of the "original design" of Parker is acknowledged in the reprint, but no details are provided about which modifications were made and by whom.

The "colophon caper" begins with the study of one of the complications of crediting businesses rather than individuals with design kudos. The dominance of business printing and book and magazine design in the late 1950s and early 1960s certainly eclipsed small academic experiments at the time. Only later did small journals garner critical attention from researchers. Certainly, Toronto was a hotspot for designers, with Allan Fleming, Carl Dair, Parker, and others (like Victor Papanek) participating in exhibits, teaching at OCA, and producing highly visible commercial work (in the following section, Dair's role in conceiving a design for *Through the Vanishing Point* will be discussed). McLuhan's ideas about typographic culture were in circulation and well known within design circles, and Fleming had collaborated with McLuhan in the late 1950s. Specific new technologies were gaining ground and influencing the culture of design as it responded to social and cultural changes. Parker's use of an experimental process in both book and magazine design in his work with McLuhan will be critically reconstructed.

Upon Parker's return from his wartime service, he began teaching classes at OCA, where he continued until he joined the ROM on a part-time basis. Parker would have known designer Allan R. Fleming through OCA; Fleming became head of typography at the college in 1955, the same year Parker began working informally with C&B and using Flexitype for *Explorations*. Fleming was the typographic director in the creative department at C&B, and a few years later, in 1957, he also began his career at OCA, but later than Parker (Parker was 14 years older than Fleming). The fact that the colophons in *Explorations* do not mention Fleming led his daughter Martha Fleming (2011) to write about this oversight: "The company was forefront; its creative director unmentioned" (n.p.).

In addition to pointing out many of her father's accomplishments as a designer and researching his legacy and influence (his visible post-secondary institutional identities in Ontario during the 1960s and 1970s resulted from Fleming's work for Trent University and Massey College, not to mention his corporate logos for Toronto Hydro, Toronto Symphony Orchestra, Gray Coach, and CN Rail), Fleming also called into question Parker's role in *Explorations* 8. She claimed that:

> Nominally this issue of *Explorations* was designed by Harley Parker, who taught colour at the Ontario College of Art where Fleming taught typography. Parker, as display chief of the Royal Ontario Museum, would have also helped install the exhibition Fleming assisted in curating (by selecting books for display) there in 1956 to commemorate the 500th anniversary of Gutenberg's 42-line bible: "The Art of Fine Printing and its Influence upon the Bible in Print." (2011, n.p.)

Allan Fleming's catalogue essay for the exhibit, "The Development of Printing as an Art," ends on a rather sour note as he points out the paucity of fine Canadian books for display in a Canadian museum setting, remarking that "the production of printers and publishers here are still at the level of England in mid-nineteenth century, a period not of bad taste, but of no taste at all" (1956, 19). In the end, he found only one Canadian book to display. The cultural cringe of an accomplished

Torontonian does not amount to a critical insight, but rather a charge of underdevelopment.

In order to clarify the issue here, it is worth pointing out that Parker did not arrive at the ROM until September 1, 1957 (starting part-time for one year), while *The Art of Fine Printing and Its Influence Upon the Bible in Print* exhibition took place in September–October of 1956, a year earlier. These dates do not support Martha Fleming's claims. However, the product known as Flexitype was heavily promoted by C&B through a substantive brochure with abundant typeface samples and glowing self-promotional discourse grounded in the machinic modernization of tradition; Fulford (1959a) was an admirer of Fleming's brochures for C&B "type men" as they were then known. Flexitype was, in the mid-1950s, a new photography-based typesetting that directly generated negatives rather than relying on relief surfaces on metal plates, and C&B promoted their advantage in this way: "We're proud to be the first company to introduce photographic typography to the printing industry across Canada."

The distorted (bent) typefaces that were utilized in *Explorations* beginning in 1955 (and later in 1957) were generated by placing a prism before the camera's lens, which captured a photographic negative, and C&B did this in-house using a photo-mechanical process. It seems likely that the advertising copy for Flexitype was the work of Fleming, as his repeated point of reference was Gutenberg, a curatorial interest. For instance, a typical piece of hyperbole read: "Typesetting directly into film is the greatest advance in the development of graphic arts since Gutenberg first invented movable type" (C&B 1954).

As a graphic design professional in Toronto, Parker seized the opportunity to encourage experimentation by crossing over from commercial methods to academic publishing, a process of de-specialization that was at the heart of his critique of the position of the expert curator, and his public loathing for "POBS"—print-oriented bastards. Obviously, this put Parker at odds with Fleming, at least intellectually. After all, it should be kept in mind that Parker wanted to surmount the typographic tradition in which he was trained. Additionally, the yearly *Typography* exhibitions and lectures at the ROM, at least from 1958–1964, occasionally involved McLuhan, who guest lectured at the 1960 luncheon, but also

Parker, as these exhibitions would have been his responsibility to mount, as they occurred almost each year in the fall and ran for several weeks (i.e., staple yearly *Typography* shows ran in 1958, 1959, 1960, 1961, and 1964). Moreover, Fleming himself sometimes designed invitations to the exhibits and arranged for OCA students to show their work in them, as well as displaying his own graphic creations. McLuhan's work was certainly known among members of the Typographic Designers of Canada, especially Dair (see Dipede 2015).

Parker wrote to Dair, explaining to him the organizational principle of what would become *Through the Vanishing Point* (but began life as a Parker and McLuhan project known as *Time's Winged Chariot* in the 1950s; see Marchand 1989, 210):

> The idea is to take a double spread; on one side to reproduce a painting and on the other the commentary. The next double spread will be concerned with a poem which demonstrates to some extent the same qualities of space shown in the painting. One of the problems is that there is a constant necessity to refer back to paintings which have occurred earlier. I suggested to Marshall that a good solution might be to use thumbnail size reproductions of the paintings interspersed into the copy to serve as reminders of the original reproductions. (Carl Dair Fonds, Parker to Dair, December 20, 1964)[2]

Parker wrote that it would be "wonderful" if Dair would consider designing the book. In the end, the manuscript found its way into World Perspectives, the designers of which were the Etheredges (American Gilbert Etheredge was a noted jacket designer and illustrator), whose work is credited in many Harper & Row books of the period. Dair (1912–1967) did not live to see the publication of *Through the Vanishing Point* in 1969, although he was directly involved in the book's conception, as we will see in the following section. In the meantime, although the project Time's Winged Chariot, a line from the Andrew Marvell poem "To His Coy Mistress," was never realized, its use reveals that Parker attempted to bring McLuhan into the museum so that he could establish his bona fides as an external curator and

30 HARLEY PARKER

collaborate with an internal designer. Parker attempted in various ways to give McLuhan access to the museum world, beginning in the 1950s. Parker also brought an art historical perspective to McLuhan's literary training.

Martha Fleming (2011) rightly reminds us that it was her father who designed McLuhan's paper "Printing and Social Change" for the 1959 report published by the International Association of Printing House Craftsmen, in Cincinnati. This remarkable publication is clear about who did what, as *each* paper has a detailed colophon, an unheard of level of detail, including a personal reflection by the designer, who explains, in this instance, that he sought to "evoke a feeling of change in the reader" by means of a series of introductory pages consisting of wood cuts and a photograph and the title of the essay, a motif taken up in the page headers in the remainder, using red and black inks and two colours of paper stock. Still, Fleming attributes the design to the collective efforts of *all* 11 Canadian Craftsmen clubs! And, it is not C&B, but the Society of Typographic Designers with whom Fleming identifies himself; C&B provided the type for the body and display elements.

Although Fleming and Parker were 14 years apart in age, and Fleming died young at 48, they shared the C&B and Eaton's art department connections, where Fleming apprenticed, and both were OCA instructors. They both had, most importantly, McLuhan and the University of Toronto Press (UTP) in common, as Fleming joined UTP as chief designer in 1968, and later, even designed protest signs for the Stop Spadina campaign in which Marshall was active at the urging of Jane Jacobs. Both Parker and Fleming contributed design elements to Expo 67 in Montreal as design consultants and were active at the ROM, one as curator and artist and one as display chief, during the years when *Typography* took place there. *Typography '58* was, as Fulford described it (1959a), a "one-man show" by Fleming, who even designed the invitation card: "everywhere you turned in the small room in the Royal Ontario Museum in which the show was held, it was more than obvious that Canada's first attempt at an annual typographic exhibit was dominated by the work of one man" (268). Ironically, the focus of Martha Fleming's complaint is not so different from the absence of installation photographs in published records, such as

Typography and Beyond 31

catalogues undertaken by Parker for much of his recurring ROM duties on annual shows (e.g., Parker is credited as designer in *Canadian Ceramics*, 1959). However, her discussion of the use of the "bendy" film typography pioneered by C&B, and the credits to the firm and not the man, merely underline the kinds of oversights associated with the waning of a traditional practice in printing.

As far as archival sources permit, Parker's first impact on installation at the ROM can be seen in an exhibition of maps dating from the 16th century forward concerning the exploration of the Canadian Arctic and search for the northwest passage. Titled *Up North: The Discovery and Mapping of the Canadian Arctic*, this show opened on April 1, 1958, was extended to May 11, and was the third maps show hosted by the museum. This sort of exhibition was favoured by A.D. Tushingham, head of the Art & Archaeology division, and since 1958 was International Geophysical Year, an appropriate occasion for such a show. The language of the event was still mired in endo-colonial conquest, and Tushingham was aware that he was not exactly giving Parker the attention he needed for the project. In a letter from Walter Tovell, then the curator of geology, to Tushingham on February 7, 1958, it is observed that: "Harley is reporting to me generally on what progress he is making. I must confess that I am not helping him with budgets and other things in the air" (ROM Archives, 1957–1958). This map exhibit also didn't seem to inspire the editor of *Maclean's* magazine, Ralph Allen, who basically told Tushingham in a letter as early as July 10, 1957 that his publication could not give to it the attention it warranted (ROM Archives, 1957–1958). Parker's influence can be seen in the ambitious and interdisciplinary approach he took to mounting the show. He wanted to include alongside the maps contextual materials drawn from other ROM collections and from private holdings available to the museum from donors within the city of Toronto. Parker requested for loan six sketches and watercolours by Fred Varley that were executed on Baffin Island. The loans of artwork from Toronto families are documented by ROM paperwork, and were included alongside carvings and clothing, in addition to a model of the HMCS Labrador.[3] The following year, Edmund Carpenter used Varley sketches from 1938 to illustrate his study *Eskimo* (Carpenter,

Varley, and Flaherty 1959), including some from the same lenders. The multimedia augmentation of flat display combined with the interdisciplinary spirit of Parker's interpretation of curatorial intent are hallmarks of his style of display that would take shape in a remarkable number of ways over the following decade.

Not everyone would be generous toward the designer. Carpenter once cryptically remarked that he rarely had differences of opinion with McLuhan, but once in 1957, a "bungling designer who interfered with the printing of *Explorations 7*" had almost come between them: "I asked Marshall why he tolerated him. 'Every man', he said, 'needs a dog'. A harsh judgement, harshest on himself" (Carpenter, as quoted in Theall 1971, 242–43). If Parker was the object of this put down, it did not affect his ongoing contributions to *Explorations*, and did not make him less indispensable to McLuhan going forward. Although *Explorations* 8 sold poorly and *Explorations* 9 was just a label attached to Carpenter's collection of images, Parker would expand his page and cover design contributions to a book length work. His book cover designs alone would place among unsung designers like Hal Siegel, credited with the yellow/orange Cooper black type of *From Cliché to Archetype*, and Rudolf "Rudy" de Harak, whose abstract lightbulb graced later printings of *Understanding Media* in the mid-1960s; media and human ecologist and ethical designer Papanek (1967, 5) contributed an essay to the non-colour version of *Explorations* 8 (the so-called Fluxus version by Dick Higgins' Something Else Press), which restarts the issue on page one following the presentation of 24 "items" by McLuhan, and describes the difference between lineal noun-painters and simultaneous *when* painters of the haptic-acoustic world of the avant-garde. Papanek presents a valuable clue about the sensory dimension of the choice of Flexitype and its bendy letters. Parker's interest in Flexitype was not simply an exploratory technical operation in the service of illustration. In the colophon of *Explorations* 8, it is stated that "inherent in the visual distortion of the word is the possibility of its sounding. It was felt that the use of Flexitype in [this issue] (devoted to the oral) was particularly apt." This aptness is derived from 20th-century avant-garde traditions of experimental typography, and was regained by McLuhan and Parker in order to imbue the printed

word with a looseness and liveliness through a process of un-bricking. Crossing the avant-garde with James Joyce's coinage "verbivocovisual" (Theall 2001, 163–64), the modification of the typeface and letter arrangements present "possibilities of sounding," that is, an interplay of acoustic and tactile, arising not literally from being read aloud, but in the sound images themselves being animated by sensory forces.

Today, in the era in which sound is used to reform the characteristics of letters, such as Norwegian designer Hakon Meyer Stensholt's software "Sound Meets Type," in which sound is used to modify letterforms in three dimensions, or studies of the tastes associated with particular typefaces in sensory cross-modal "affective correspondences," revealing the relations between sweetness and roundness, as opposed to angularity and bitter, sour and salt (Velasco et al. 2015), Parker and McLuhan's invitations to overcome the overwhelmingly reductive visuality of the printed phonetic alphabet and enter a world of a more well-rounded and robust sensorium seem tentative. Nevertheless, as Janine Marchessault (2005) recognizes, McLuhan believed that artists, in particular designers like Parker, "would be the central artistic players of the twenty-first century...someone would have to design the new information environments that were coming into existence" (166). While Parker was a thinker of television's expanding role in general education and considered satellites to have the capacity to multiply television's powers, his attitude to computers was not well-developed. He held a luddite belief in the inhuman nature of computation and dismissed the rather arid power of compilation; his few references to "collation" (1970c, 11) suggest a radical instantaneity that might lead to political change in the forms of popular referenda. Overall, while Parker certainly saw the coming of the digital age through the lens of the extended human sensorium, or as he put it in his Greenbrier talk,[4] in the form of "a gigantic personal net," his passing remarks did not further coalesce.

The Making of *Through the Vanishing Point*

McLuhan was flattered by the highly solicitous invitation from Anshen to contribute a volume to the World Perspectives series with Harper & Row in New York, and mentioned in a letter that he had been finishing

a book with a "painter friend" about *Space in Poetry and in Painting*. Although he promised to "meditate on a suitable theme" for Anshen (Anshen, 1938–1986, McLuhan to Anshen, Oct 1, 1965), the work on *Space* attracted immediate interest, and by the end of October 1965, a contract was issued and signed, despite some of Parker's concerns about the delivery date. After all, as McLuhan explained in his letter, Parker had begun "building a large and complex gallery for Marine Archaeology" (the Invertebrate Hall of Fossils). Hearing this concern, Ashen moved the delivery date from November to February the following year (it had become obvious to the authors that despite progress on the manuscript, it would not be ready by February 1st). In the meantime, McLuhan had arranged a meeting between Parker and Anshen in New York, which had come off successfully, according to McLuhan: "So glad you enjoyed Harley Parker. He is really a most unusually kind and humane person, utterly lacking in any impulse to intrigue or advance himself. He derives his satisfaction in life from just learning and doing" (Anshen, 1938–1986, McLuhan to Anshen, Oct 1, 1965). McLuhan also wondered whether or not Parker and Anshen had discussed a new title, *The Culture Process*, and noted he would like to write a book tentatively titled *Young Peoples' Guide to the Media* (Anshen, 1938–1986, McLuhan to Anshen, Oct. 1, 1965). In a letter, Anshen expressed how eager she was to consider a children's book (Anshen, 1938–1986, Anshen to McLuhan, Oct. 2, 1965). These ideas were fielded by Anshen with aplomb, and she continued to strongly encourage the authors to deliver the manuscript on time, regardless of the final title (*Space in Poetry and Painting* became the subtitle), and to field requests by McLuhan about a number of projects, including his son Eric's book manuscript, and for contact details for the president of IBM (Anshen, 1938–1986, McLuhan to Anshen, Nov. 1, 1965).

The importance of these exchanges can be summarized in the following manner. They establish a first direct point of contact between Parker and a series editor working closely with Harper & Row, the putative publisher of his own book, *The Culture Box*. Although there is no explanation available answering why the book was not published, and no publishing contract has been located, Parker had opportunities to discuss plans for his own book directly with a Harper series

editor. As we will see below, relations between the press and Parker and McLuhan would become strained once the manuscript for *Through the Vanishing Point* was delivered—late, as it were, with the exception of a few sections that will be discussed below, sent in November 1966 (45 of 48 sections were posted by Parker in August 1966). This strain may have been enough to sideline Parker's own manuscript.

The first issue to arise in the production of *Through the Vanishing Point* was the project's design. As noted in the previous section, McLuhan and Parker were working with Dair in Toronto on a plan for the presentation of the poetry and painting examples discussed in the text. The issue of whether Dair's design was usable arose in late 1965 and again in July 1966, when McLuhan asked Anshen to confirm: "does it have to coincide in size with the World Perspectives Series format?" (Anshen, 1938–1986, McLuhan to Anshen, July 21, 1966). Anshen responded by underlining the need for "uniformity" (Anshen, 1938–1986, Anshen to McLuhan, July 25, 1966), and this was not the answer the authors had hoped for. On a parallel track, Parker had asked Dair in December 1965 to write directly to Harper editor Roger H. Klein about how to adapt his design to the specific series format (asking questions about the printing process, type of paper, size, and whether typographic heterogeneity within the text was possible), given that, as Dair wrote:

> My own feeling is that the typography should reflect some of the typographic form characteristic of the modern "kinkon" poetry, as exemplified in the recent exhibition "Between Poetry and Painting", in the Institute of Contemporary Art in London, since these poets, particularly Houédard, are much influenced by McLuhan. (Anshen, Box 21, Dair to Anshen, c/o Klein, December 11, 1965)

The *Between Poetry and Painting* exhibit at the ICA took place in the fall of 1965 and was curated by Jasia Reichardt. The exhibit highlighted the history of type as a medium of art in Dada and Futurism, through Lettrism, right up to the most recent visual and concrete poetry, including the groundbreaking work of "dsh"—Dom Sylvester

Houédard—who provided in his catalogue essay a reference to McLuhan picked up by Dair. Houédard worked only with a typewriter, an Olivetti, creating highly abstract typo-visuals or "typograms" that merged letter and image. He called these "typestracts," which sat "between" what he referred to as "ikon and logos." Houédard (1965) utilized McLuhan's distinction between cool (low in information and hence involving for users) and hot (high-definition) media, among other ideas: "Kinkon/spatial is cool: hot-media (like this note about things) leave nothing unsaid" (15).

Parker then weighed in on the matter during the summer of 1966, objecting, to Anshen, to the forced linearity of the presentation: "the structure of our book does not lend itself to page after page of unbroken type matter" (Anshen, Box 21, Parker to Anshen, July 29, 1966). Dair had conceived of the "double spread" (in the published book, paintings and poems on the left, "glosses" on the right; the proposal had the opposite arrangement). The low word count concerned the press (prompting a later demand for a hefty conclusion, in January 1967), even though Parker assured Anshen that the "glosses" were "not intended to be marginal," but to appear "iconic" (and with "something of the flavour of the headline" kind of typeface)—iconic here meaning a "succinct verbal commentary, or several"—and serving to break up the text. The press also erred in using the black and white thumbnail reproductions of paintings as final documents (they were originally used to remind readers of earlier examples and embedded in the glosses). Parker held out for a little while for some colour reproductions, but to no avail. Anshen agreed to the glosses, their appearance, and the double-spread format, and told McLuhan that the size of the volume was non-negotiable (Dair had envisaged a display in which both paintings and poems, and the glosses on each, would appear on the same page, requiring a much larger format than the series design permitted). Despite the use of the double spread, the fact that in a given numbered section the spread is repeated (poem-gloss followed by painting-gloss), without any thumbnail reminders, certainly flattens the effect that Dair had envisaged.

In November 1966, McLuhan initiated a process that would result in the inclusion of two further sections. Let's consider the first

Typography and Beyond

section and then return to the second in the next chapter. He wrote to Anshen, "I am enclosing another possible section for the book. The painting is by Harley Parker [*The Trip*, later called *Flying Children*] who has surely earned the right to appear in this volume!" (Anshen, 1938–1986, McLuhan to Anshen, November 8, 1966). As McLuhan went to bat for his friend, Anshen could barely hide her dislike for the painting, writing back diplomatically: "About Harley's painting I have mixed feelings, although I do indeed agree that it illustrates your point, especially in relation to the splendid poems [by Yeats and Auden] accompanying it" (Anshen, 1938–1986, Anshen to McLuhan, December 3, 1966). However, she also simultaneously wrote to her colleague Klein at Harper, to whom she explained: "McLuhan doesn't absolutely insist that the enclosed photograph of the painting by Harley Parker be included in the book. I myself have mixed feelings about it, but for the most part dislike it" (Anshen, Box 21, Anshen to Klein, December 3, 1966). In the end, both sections, proposed late by McLuhan, made it into the published book. McLuhan had insisted that "there are indeed very good reasons for including Harley Parker's painting," as it illustrated for him the "'outering' of the human sensorium" and the making of an "unconscious 'without walls'" (Anshen, 1938–1986, McLuhan to Anshen, December 9, 1966). This play on André Malraux's phrase "museum without walls," which Parker also utilized to express the implications of the speed of satellite communications in which space becomes time-like under the effects of implosion, appears to have moved Anshen to agreement.

As the book went into production, McLuhan was presented with a person he did not much like working with in the form of a former editor, David Segal, with whom, Anshen pointed out, he had worked at McGraw-Hill on *Understanding Media*. As general editor, Segal was now in charge of the production process for Harper, and the first order of business was to find a suitable title, not to mention an adequate conclusion (Anshen, Box 21, Segal to Anshen, July 5, 1967). McLuhan provided both in January 1967 (Anshen, 1938–1986, McLuhan to Anshen, January 26, 1967). Moreover, it was pointed out in February and March by Anshen that securing permissions fell on the shoulders of the two authors. Thus emerged the third issue, wrapped up in two

figures, a former editor, and a difficult task, given the sheer number of poems and paintings in the work. A compromise was worked out: Harper would handle the photographs, and the authors would deal with the quotations. This task fell to Parker.

Biographer Philip Marchand (1989, 215) used a sexist epithet to describe McLuhan's assistants, perhaps indicating a lack of respect for their accomplishments. In the Monday night seminar in the Coach House, Parker ran the slide projector, record player, and film projector; on publishing projects, he consulted with designers, as well as seeking permissions. Marchand believed that after a point, around 1968, Parker's relationship with McLuhan changed in tone, his status shifting from friend to lackey. By contrast, we see in the creation of *Through the Vanishing Point* how McLuhan was still only in the previous year supporting Parker's ideas and pushing forward his art and writing, against opposition from within the press.

As the page proofs arrived in March 1967, Segal was complaining to Anshen in a July 5, 1967 letter that "McLuhan's work is...uneditable." Segal appears to be referring to the so-called conclusion, "The Emperor's New Clothes," which Segal identifies as being about "art and environment" rather than "interrelationships between the arts" (Anshen, Box 21). Hence, for Segal, the "irrelevance" of the piece in the context of the book. Despite his familiarity with McLuhan's prose, or indeed, given his familiarity with it, fiction editor Segal may not have been able to judge the quality of more abstract forms of analysis of the relationship between an existing environment, the perception of which is accepted and unquestioned, and the artist's role in drawing attention to it, questioning it, and transforming certain elements, thus turning it into an anti-environment (McLuhan and Parker 1968, 247). McLuhan had made an effort to explain this to Anshen earlier. To the extent that he knew about Segal's remarks, McLuhan was unhappy about the situation, and insulted him and his colleague Wyeth (to whom he was writing) in his copied letter to Anshen on February 27, 1971. Moreover, McLuhan was further perturbed by the problem of the high-priced hardback edition of *Through the Vanishing Point*, which he thought, he wrote in a letter to Anshen on September 19, 1969, "would never sell a single copy in England." His later effort to buy up hundreds of copies of

Typography and Beyond 39

remaindered and reprinted copies (at remaindered prices!), circa 1971, even with a promised paperback release, put him into contact with the permissions team. Wyeth did help him with the educational film rights, as well as offering a press waiver over rights to rental incomes from cassette rentals. While the press complied with McLuhan's requests, the fact that Anshen was on a first name, even nickname, basis with her Harper colleagues ensured that McLuhan's insults were not well received. This haggling over contractual elements—which would continue when Corinne McLuhan asked Anshen in a letter on March 7, 1968 for a greater percentage of royalties and for the contract to be rewritten (Anshen, Box 21)—brought the question of the book's invisibility to a head. Marchand (1989), noting McLuhan's disappointment with the book's reception, claimed it "was...ignored by the press" and "received virtually no reviews" (210). This is not entirely accurate.

Perhaps the disappointment of both McLuhan and Parker about the reception of *Through the Vanishing Point* was partly based on what they perceived to be compromises with the press, beginning with the proposed design, which then, compounded by the exorbitant pricing, resulted in poor sales and hence low royalties, as well as—somehow—culminating in the hostility of its critical reception. This is no less fantastical thinking than Marchand's belief that the book was not reviewed. A few examples of reviews will suffice to show the book's poor reception. Soon after the book's release, Tom Wolfe (1968) accused McLuhan (and Parker) of trendy art talk with no effect:

> McLuhan unfortunately indulges in many of the most conventional assumptions, and much of the jargon, of fashionable art criticism. He depends upon one of the major nonsense words of current art chic, "space", stretching it, like most theorists who use it, until it means all or nothing. (4)

This approach would be rehearsed by British psychologist D.W. Harding (1969), who complained that the concept of space was "given the most elastic if not unlimited meaning" (n.p.). An even less generous assessment by Toronto philosopher Francis Sparshott (1969) described the book as "the worst thing McLuhan has yet done" (137), pointing out the

multiple blunders in the Greek etymologies presented on pages 226–29 as a "farrago of lexicographical accidents" (145). Ultimately, Sparshott simply recommends avoiding *Through the Vanishing Point* altogether.

McLuhan and Parker's book had an afterlife of sorts. They continued to promote it on campus at the University of Toronto, but through the student press. The authors originally had more lofty plans for the materials, hoping to provide educators in the high school and college systems, as well as the public, with media (slides, audio recordings, film, etc.) that would supplement lessons in poetry, painting, and perception. In 1978, the Innis College student newspaper, *The Innis Herald,* ran a lengthy transcript of a conversation between McLuhan and Parker about *Through the Vanishing Point* that had taken place five years earlier at McLuhan's Centre, in 1973. The authors discussed 20 examples from their book, adding a new factor to the studies of paired painting and poem, a musical example, selected by a colleague from St. Michael's College, Derrick De Kerckhove. The selections originally played in the background during the appropriate moments of discussion; however, they were neither period pieces nor topical matches, but rather suggested resonances among disparate non-connected components. The result was neither a rigorous structuration nor fine distillation, but simply a sense of appropriateness. Parker is presented as Doctor Watson to McLuhan's cultural Sherlock by student journalist Carl Scharfe, and Elma Miller is credited with graphically rendering the musical attributes of each study. In the discussion, Parker remarked that the Jackson Pollock painting *Full Fathom Five* suggested to him a computer wiring system, and that a few lines from the Lawrence Ferlinghetti poem *Coney Island of the Mind*—"labyrinth wires/of a telephone central/through which all calls/are infinitely untraceable"—confirmed it; augmented with an unidentified composition of electronic music by François Bayle was a series of squiggles and scratches (ringing and liquid sounds, and white noise). The uncontrolled expansion of this iconic-mosaic-assemblage added another facet to the book project, as a mixtape might complement and extend a novel, for instance, or for that matter, enhance the references of an undergraduate thesis. Taken together with the *Museum Communication* seminar, this transcript of a discussion provides another example of Parker's contributions to the

Typography and Beyond 41

McLuhan corpus, the informal scholarship of their interactions, and the kinds of investigations that were common at the Centre, but reproduced in places with limited exposure and scholarly pertinence.

The Rhetoric of the Substitute

In the third section of this chapter, another close working relationship between Parker and McLuhan is investigated. Moving from typographic work through joint book authorship, Parker regularly substituted for McLuhan in giving invited lectures. Reflecting on the extant correspondence and a single example of a lecture given by Parker, many familiar themes were rehearsed, but his comments on the failures of magazine design—the "obliteration of typesetting"—and the promise of innovation in phonetic writing, notably shifting phonetic to ideographic writing, highlight his independent contributions to the growing inventory of examples of contemporary iconization.

There is a well-defined collection of surviving correspondence between McLuhan, some of his many suitors, and Parker that addresses a set arrangement between the two thinkers and friends stretching over almost five years in the mid to late 1960s (unpublished correspondence referred to in this section dates from 1964–1969; see Fonds Marshall McLuhan 1964–1969).[5] The arrangement was that whenever McLuhan was unable or unwilling to accept invitations to speak, write, or otherwise make a personal contribution to one cause or another, he would nominate Parker in his place. This worked reasonably well from about 1964–1969 in the wake of the publication of *Understanding Media*, which brought McLuhan widespread recognition in the within academic circles, and beyond them as well. It was a set role that Parker played as a long-time associate of McLuhan's Centre for Culture & Technology. The surviving letters concern opportunities in the United States only. Although it is not always clear whether Parker was in all cases accepted as a substitute for his friend, the instances where he did step in do provide insight into how these occasions enabled him to expand his network of influence, especially in corporate quarters, and further his interpretation of the ideogrammatic icon. They also permit a more precise examination in one instance of the nature of his contributions, as a single unpublished script survives, dated June 18, 1964.

During the mid-1960s, Parker (1965a) elaborated upon the "icono-graphic mode" in a number of his single-authored publications, underlining the role of the total sensorium, the lack of specific space-time coordinates, and simplification. The icon results from the shift of sensory bias due to "electric immediacy" from visual-illustrative to iconic-tactile (Parker 1964c).

It is important to note that McLuhan's phraseology of nomination curled back on itself as it morphed over the years, especially during playfully rhetorical moments, and occasionally became rote like a form letter—not so much a boilerplate rejection letter, but a substitution letter, a new species to be sure. The question that McLuhan's practice raises concerns the rhetoric of substitution and not substitutionary logic. It would be a stretch to claim that it reproduced the atonement at the heart of Christian scripture since, after all, we are only concerning ourselves with a few speaking engagements, and not the theological necessity expressed through so many doctrinal hymns about the Saviour's blood. Instead, the vicariousness at issue involves a role aligned with Parker's place at the Centre, which acquired in the wake of *Understanding Media* a specific role definition beyond his regular duties during the seminar. It was not long before Parker became popularly known as the "McLuhan of the museum" (adopted as the subtitle for this book); less kindly, one Toronto wag referred to Parker's exhibition design as "McLuhan at the bottom of the sea"![6] As a participating member of McLuhan's Monday night seminar at the Coach House, Parker often worked the audio-visual equipment, spinning records and threading film. He often can be glimpsed on the edges of archival photographs, for example, those by Toronto press photographer Robert Lansdale, hovering over the equipment, and temporarily contained in that margin.[7]

The first example of substitution is from 1964 and the Greenbrier Management Conference in June of that year. This period corresponds to McLuhan's "TV Effects Research" of 1963–1964. McLuhan wrote to his contact there that he was sending Parker in his place, and this was acceptable to the organizers. Parker delivered a paper that made a strong impression on the corporate audience and engaged in follow-up correspondence with the director of advertising at Underwood Ltd.

Typography and Beyond　43

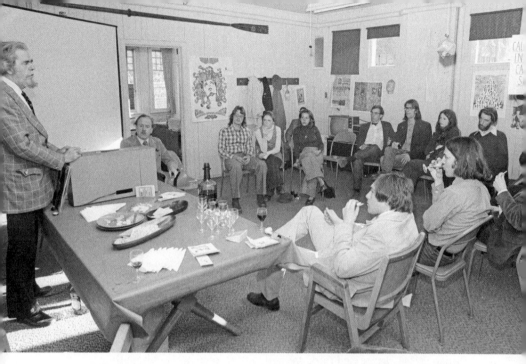

Seminar, Centre for Culture & Technology, Coach House. Parker stands and McLuhan is seated to his left. (Photograph by Robert Lansdale. Used with permission from the University of Toronto Archives [Item LAN731090b-026, dated 1973].)

of Toronto, explaining to him the basic theses of *Understanding Media*, but noting his interest in establishing sensory typology tests for populations experiencing television for the first time, specifically in Greece (television broadcasting would begin there in 1966). Ten years later, in 1976, McLuhan and Parker exchanged letters and clippings about the effects of the introduction of television in South Africa, and Parker remained interested in empirical studies of pre- and post-television sensory mixes within national viewing populations. McLuhan noted right away to Parker that the medium did not elicit very cool participation at all in South Africa in the months following its introduction.

In his Greenbrier presentation, Parker recounted his collaboration with McLuhan on an article about the effects of television on children, where they argued that the nowness and immediateness of the medium replaced a future orientation, and shrank near-point reading distances as children tried to replicate with print the involvement demanded by television (see Parker 1965a, 13). The initial effort of Parker when he

joined McLuhan's Centre in 1963 was with regard to television research into synesthetic perception, and the hypothesis that this was a factor in making children highly precocious (McLuhan 1963, 28). Specifically, the "Sensory Profile" study began in Toronto and was aimed at understanding the transformation effected at the population level by television. McLuhan thought he would then replicate the approach in a number of cities around the world. His ambition was to make the results available to the entertainment industry, advertisers, and manufacturers. McLuhan's (1967) approach was highly behaviouristic and reductionistic, since he thought: "once you know the sensory profile of a people, how much intensity they allow into their visual life or their auditory life, you can just read it off as a percentage of their whole sensorium...Then you can exactly program the environment...in that area" (102). His willingness to provide media corporations with recipes of how to manipulate and program audiences placed him at odds with critical television and cultural studies traditions, and gave rise to a highly acrimonious literature that allegedly exposed the dangerousness of his ideas, specifically with regard to the alleged "direct" effects of television on audiences.

Parker also addressed the transition from the illustration (visual, pictorial bias) to the icon (synesthetic sense) as a way of understanding the predicament of magazines in the post-literate age that typically include both elements. In an untitled typescript, mentioned briefly above, of his address at Greenbrier that he provided to Wm. S. Campbell, director of circulation for Hearst Magazines in New York, he predicted, despite his reluctance to engage in forecasting, that

> the magazine under the impact of electronic media will tend to become more iconic. There will be a tendency to break up large masses of grey type with more headlines. The type of writing will become increasingly non-sequential. Thoughts will be dealt with in clusters instead of sequentially. There will be an increasing use of phototype and other distorting devices to move the written word closer to its sound. In fact, I see the complete obliteration of the contemporary mode of typesetting. (Fonds Marshall McLuhan, 1964–1969, Parker to Campbell, June 18, 1964, p. 7)

Parker could have been describing the trajectory of his own work as a typographic designer throughout the 1950s and 1960s, and his decision to enlist photographic typography in *Explorations*, which was even more essential later on for the *Counterblast* design; this suggests that his interest was to put some distance between his own training and the typographic tradition within print culture. Parker was probably not directly anticipating such novel writing forms as the illustrated listicle, or the typeface designs of Barry Deck that appeared in *Semiotext(e) Architecture*, a special issue in 1992 where the pages were reframed using a central window like a television screen, with a large border of text as a frame. Forecasting made Parker feel "very strange," despite the fact that he was one of those blazing the post-typographic trail. Yet Parker would have been interested in Deck's "grunge fonts" (Cranny-Francis 2005, 35), like Template Gothic, which force imperfections and deviations into visual sequentiality, as they can be counted among the "distorting devices" with which he preferred to design.

In the aforementioned attachment to his letter to Wm. S. Campbell in 1964, Parker observed of the Pitman alphabet: "It seems to me that we have recently witnessed the birth of a new iconic mode, the new Pitman alphabet with its 42 characters. The attempt to wrap-up more and more in a single symbol is symptomatic. Isn't this getting closer and closer to the ideogram, that ultimate symbol?" (Fonds Marshall McLuhan, 1964–1969, Parker to Campbell, June 18, 1964, p. 7).

Parker had a limited understanding of the Pitman system, which is far from new, and he did not admit that the characters were not truly ideographic but phonographic, and joined together consonants and long vowels, all written in lower case. However, the construction of the characters would have interested him greatly. They were visual word sculptures, with many joined letters, often employing a modified typeface. Pitman's characters were undoubtedly one impetus for his innovations in *Counterblast*, such as tumbling and stacked letters and representational word-objects; Parker's (1964c) anticipated a style of print design oriented around headlines and glosses, and the "cluster-like use of the alphabetic symbols" (53). Still, Pitman's alphabet was, after all, predominantly phonetic and thus still exercised a hypnotic visual power. As McLuhan (1962) put it, "the dominance of one sense

[visual] is the formula for hypnosis. And a culture can be locked in the sleep of any one sense. The sleeper awakes when challenged in any other sense" (73). For Parker, even the stirring of the non-visual dimension in Pitman's alphabet could disturb the sleep of the typographic (wo)man, and embolden the epigrammatic (wo)man!

In the spring of 1964, Parker became involved in the planning of Expo 67 as a communications consultant. McLuhan's invitation to speak at the "automation conference" of the world's fair organizing team arrived in the fall, courtesy of Commissioner General Leslie Brown. McLuhan was asked to address the changing roles of technology in Canadian society, but wrote to Brown with an idea: since he worked closely with Parker and the latter possessed the requisite skills, Parker was "fully competent" to participate in the conference. It is not clear whether McLuhan's suggestion was taken up by Brown and other members of the Canadian Government Participation unit, but it did mark the third time in 1964 that he would promote Parker (the second was a State University of Iowa invitation). Once the ball began to roll, there was no stopping it. Parker did play a role as a design consultant in Expo 67. He eventually wrangled some funding to bring his entire design team from the ROM to Expo to study "new display techniques, many of which are far in advance of our own" (as quoted in Bissell 1968, 288).

In the fall of 1965, just as he and Parker were putting together the joint volume *Through the Vanishing Point*, McLuhan suggested Parker take up, in his place, invitations from the School of Library Science at Columbia University (Fonds Marshall McLuhan, 1964–1969, McLuhan to M.F. Tauber, September 1, 1965) and American University in Washington, DC (Fonds Marshall McLuhan, 1964–1969, McLuhan to L. Hoffman, September 1, 1965). McLuhan referred to Parker as his "right-hand man." To Earl Brill at American University, McLuhan even suggested of himself and Parker: "we are so entirely conversant with each other that we can give a joint lecture as if by one man" (Fonds Marshall McLuhan, 1964–1969, McLuhan to Brill, September 8, 1965). McLuhan, in full flight, explained to his courter at the Pratt Institute in New York that Parker was a "lively and witty man, though he insists 'he does not wear his *chez* in his tongue'. He abounds in

such phrases of original perception" (Fonds Marshall McLuhan, 1964–1969, McLuhan to J.S. Weber, September 13, 1965); indeed, this is an obscure expression to be sure. High praise for his friend, the epigrammatic man, who knew his way around a brief phrase. In 1966, McLuhan deferred to Parker ("a fine presence") to the American Association of Advertising Agencies in New York, University of California Santa Cruz, *Look Magazine*, University of British Columbia (UBC), and *Architectural Design* magazine. In 1966, to John McHale at Southern Illinois University, McLuhan quipped in good humour: "So far he [Parker] is not quite as busy as I am" (Fonds Marshall McLuhan, 1964–1969, January 5, 1966). McLuhan would provide many more opportunities for Parker, sending his way the chance to write on the art of Christmas cards for *The Canadian* (Fonds Marshall McLuhan, 1964–1969, McLuhan to A. Gorman, July 5, 1966); speak at the American Federation of Arts, Stanford University, Philadelphia College of Art, and Connecticut Arts Association (writing, "I strongly recommend Harley Parker as a stand-in"; Fonds Marshall McLuhan, 1964–1969, McLuhan to A. Thurm, August 17, 1966); and speak at Auburn University and the Eastern Arts Association in Philadelphia (writing he was "quite able to 'carry the torch'"; Fonds Marshall McLuhan, 1964–1969, McLuhan to D.J. Irving, September 29, 1966). In 1967, the pattern continued with the American Craftman's Council and Massachusetts College of Art. McLuhan also passed along to Parker the invitation to write a review of Buckminster Fuller's *Dymaxion World* for the journal *Technology and Culture*—Parker (1972a) would later publish a positive review of Fuller's book *Intuition* in the *Globe & Mail*. Occasionally, McLuhan would pass along matters he didn't care about or know how to deal with, especially requests for funding pet projects and idiosyncratic essays that arrived unsolicited in the post, and Parker would cordially but firmly offer critical advice (Fonds Marshall McLuhan, 1964–1969, Parker to J. Inglis, August 20, 1969). Finally, Parker was directly asked to provide an essay explaining the importance of McLuhan's work for education in a new journal at Ontario Institute for Studies in Education, which he happily accepted (Fonds Marshall McLuhan, 1964–1969, Parker to A. Effrat, August 11, 1969).

Intellectual fame requires screening mechanisms. Without them, it is impossible to parse the invitations that arrive from all quarters and threaten to overwhelm one. McLuhan promoted Parker as a substitute, and for some five years (but likely longer) tried to send him in his place to a wide variety of events. It is difficult to precisely determine how well this strategy worked, but McLuhan's sly observation about how busy Parker had become suggests it was a winning strategy over time. The substitute was also a skilled interpreter of McLuhan's ideas and beyond performing this service, his own intellectual interests and formulations could take shape. Substitution went beyond trust and entered the realm of endorsement of Parker's own abilities and insights. McLuhan settled into a standard promotional language regarding Parker, often stating he had a "clear head" (Fonds Marshall McLuhan, 1964–1969, McLuhan to Ewa Kujanski, August 5, 1966) and was an "able speaker" (Fonds Marshall McLuhan, 1964–1969, McLuhan to B. Hanson, August 5, 1966). The varied wordplay around Parker's role as "stand-in" allowed McLuhan to vary his phrasing and embellish his rhetorical statements such that, ultimately, any plan to engage Parker was a decision made by the *other* party. Ultimate responsibility for any event at which Parker appeared did not rest with McLuhan.

The role of the substitute is well known. As right-hand man, Parker was a trusted interpreter and representative. He was a Little John to McLuhan's Robin Hood. Is this much better than a dog to its owner's leash? The joking nature of the ironic qualifier—little and not as "busy"—was also obviously at work in the McLuhan-Parker pairing when it came to both the crowding of one's schedule and subtlety of word play, but also the reinforcement of the hierarchy. At play in the "instead of" relationship was that it was the same substitute every time, and not vice versa at any time. It was in this way deeply repetitive, but it would not have been experienced in this way by those issuing the invitations, unless they shared the outcomes of their efforts at the time or shortly thereafter. From McLuhan's perspective, this must have been beneficially predictable, and thus sameness provided both control and continuity. Yet every occasion would also have been different, and thus provide another test for the substitute, like a

one-liner repeatedly delivered to changing configurations of audiences in different venues. It cannot be claimed with certainty that Parker gave more or less the same talk—his Greenbrier talk—every time he appeared instead of McLuhan at an event. It is not hard, however, to imagine that this might have amused McLuhan.

Substitution can earn a bad name when someone like Andy Warhol engages in it. Warhol sent a look-alike, Allen Midgette, out on the lecture circuit, but without explaining this to his hosts. This shifted substitution into the realm of impersonation, and claims of "fraud" and "hoax" came back to Warhol and his retinue, but he was left nonplussed by them. He thought of it as an "experiment in mistaken identity" (Gopnik 2020, 579), and was surprised that his hosts were upset, since, after all, a film was screened at events in which the faux Warhol appeared alongside the real Warhol! McLuhan did not engage in any such subterfuge by promoting a "two McLuhans" solution.

Within the rhetoric of the substitute, there were affective contours at work within an intimate relationship that surmounted professional distance and the collaborative management of the Centre's profile and the two men's respective calendars. McLuhan almost always underlined that Parker was close to him, and that his many virtues would make any suitor's event a success. Ultimately, the diverse efforts by McLuhan to smoothen the choice of Parker reveal a familiarity that sometimes collapses substitution itself, shaking out possibility in all the carefully crafted modal phrases McLuhan used to get the job done—not by anyone, but by a special someone. Don't get me wrong, McLuhan was not always kind to Parker, and had a reputation for dealing with him impatiently, but within the familiarity of any relationship one expects that not all sailing will be smooth.

The type of connection under consideration here is the operation of substitution. It worked, as far as the evidence suggests, only unidirectionally, since McLuhan did not substitute for Parker. A bidirectional logic of substitution would at minimum have required an equivalent level of busyness between the two men, thus creating a need for reverse substitutions. Even without such conditions in place, it might be said that unidirectional substitution, if successful, should provide the substitute with useful evidence of his actions. Although John

Culkin once jokingly called Harley "Hardly," a good baseball name, as a *pinch hitter*, Parker would have evidence in abundance of his stand-ins. If we look at Parker's report of his activities for 1970 in the "President's Report" at University of Toronto (Bissell 1971), given that it falls at the edge of the period under consideration, and none of the material can be verified as substitutions, the list of 14 different talks—delivered throughout Canada and the United States, and including one in South Africa, at universities, colleges, and non-academic events—strongly indicates that the agreement had benefits at the level of popularity or status, and of course if stipends and honoraria are factored in.

Returning briefly to Parker's year at Rochester, this is perhaps the most significant substitutive role that he played, as it lasted one year. The inaugural Kern Chair hiring committee had originally targeted McLuhan, and then accepted Parker. Parker's application was fully supported by McLuhan. And, when Parker was planning the Sound of Vision conference, one of his keynote speakers was McLuhan. Some 50 years after the fact, Roger Remington, Professor of Design Emeritus at RIT, recalled his disappointment: "we were hoping for an in-depth dialogue with McLuhan about *Understanding Media*, but then nothing happened" (personal communication to Genosko regarding Parker's Kern Chair, February 3, 2023). What happened spoke directly to the power and persuasion of the rhetoric of the substitute.

Keeping It Cool (*Al Fresco*)

From the early days of the Centre, through the typographic design services, museum-focused discussions, collaboration on a book, and substitute lectures, we arrive in the final section of this chapter at the *Picnic in Space* film, to which filmmaker and critic Bruce Elder (2015) has drawn attention, arguing that these two "artists" practiced a "perlocutionary aesthetics" that sought to elicit immediate corporeal responses in their audiences. The use of literalized metaphors and montage sequences, not to mention extemporized dialogues, established a non-narrative style for a film that lacked a beginning and end. Elder leaves us with an engaging puzzle: what was that *picnic* between friends about, anyway?

As Canadian critics of *Picnic in Space* have pointed out, it rehearses McLuhan's distinction between film and television, and the implications of their integration or what might be called media nesting, an older medium as content for a newer one that he developed in *Understanding Media*. This documentary was made for television for a University-at-Large, Inc. series based in New York. As Bruce Elder (2015, n.p.) explains:

> In keeping with the idea that the content of a successor medium is its predecessor, this television program-to-be takes the nature of film as its content, and highlights the fact that advanced visual art and poetry of the three or four decades before the film was made were striving to become film. In keeping with that insight, the work emphasizes that its form, like that of the painting and poetry of the half-century that preceded its making, relies on the method of montage. In this sense, its formal construction resembles that of *Through the Vanishing Point*. The filmmakers make clear this television documentary is retrospective—that its content is the television's predecessor medium, the cinema (and the *mentalité* that brought forth the cinema)—by literalizing a metaphor that McLuhan frequently used to suggest the relation between successor and predecessor media: parts of the film show McLuhan and Parker riding in a car, and these sequences were made by shooting Parker's and McLuhan's reflections in the car's rear-view mirror. This film, the trope implies, reveals what the visual and literary arts of the previous five decades had longed to be (or, more exactly, reveal[s] the entelechy of the art of that period).

Elder astutely shows that filmic montage instantiates visual and poetic collage. This becoming cinematic of earlier media is demonstrated in a number of ways throughout *Picnic in Space* with reference to painting, music, and language, in particular through comments about the making of the film itself, the supply of film stock, and the film's meandering nature, evidently without beginning or end, not to mention the illustrative repetition of a sequence some four times, and the sideways movement of the camera, etc. As Richard Cavell (2002) explains, "ironic and

self-conscious references to the film's chaos" abound (27). What was in doubt, however, was whether this film would become televisual.

What the film rehearses, however, is a thesis that sprawled over two chapters of *Understanding Media*. McLuhan thought of film in terms of its bookishness, to be precise, in the ways it continues typographic principles while showing it is also possible to break from them. He gives the example of jarring "leaps of juxtaposition" (1964, 289), some with cinematic origins, that disrupt continuity and uniformity. These types of juxtaposition are deployed throughout *Picnic in Space*, and Elder (2015) proposes, beyond McLuhan, that film itself is composed of such discontinuities at the levels of the frame (positive and negative space) and in the action of the shutter. McLuhan (1964) thought rather grandly that film would be subsumed by television, stating without supporting evidence that "most of the film industry is now engaged in supplying TV programs" (293). Film kept adapting to television's threat, for instance, by going portable in 8mm format (McLuhan 1964, 291). As the realization of typographic culture's mechanical explosion, film had to adjust to the collision course it was on with television's electric implosion. The ways in which film was "disturbed" by television are discussed at length by McLuhan (1964), beginning with the psychic, social, sensory, informational density, and participatory temperature, ultimately rejecting the idea that an increase in definition would improve television (312–13). Various contrasts are developed between film shots and television images, the impact of television on film stars, and the icon, an inclusive television mosaic (320). And the analogical link between baseball and film—both are ill-adapted to television (326)—is briefly parsed in the manner of its appearance in *Museum Communication*, an analogy to which I will later return.

Picnic in Space does not so much answer the question about the impact of screening a documentary film on television as it explores it, both informally and formalistically. Elder (2015, n.p.) captures McLuhan's question: "'When that happens,' he asks, 'will it be film or television?'" McLuhan was, it is worth adding, a bit unsure, as he says the film *will probably* be shown on television. A preliminary answer was already given analogically in *Understanding Media*. For McLuhan (1964), "merely to put the present classroom on TV would

Typography and Beyond 53

be like putting movies on TV. The result would be a hybrid that is neither" (332). *Picnic in Space* understands itself to be just such a process of hybridization. However, hybridization is not an answer as such; it is a further hypothesis about the release of energy, McLuhan (1964, 55) maintained, that gives birth to new media forms. Is the impact of this hybridization greater on film or television? Or is the process of obscuration mutual (52)? Film may have been for McLuhan "hit hard" by television, but there is no reason to assume that every hit is of uniform hardness. Indeed, if mixing media is an art in its own right, and McLuhan wanted to have a hand in this, is there any evidence that a new form was born from it? Given the obscurity of the film, and in the absence of any evidence beyond aspirations about its broadcast on television, it would be prudent to leave the question unanswered. "Will probably" is still a kind of likelihood. Better still, when would this have probably happened? The 16mm colour and sound print, with a running time of only 28 minutes, dates from 1968, but did not appear to find a release until 1973, by Association-Sterling Films, also known as University-at-Large Productions (Ferguson 1991, 87, note 9). It may very well have gone straight to videocassette, a format in which it was also released, skipping theatres altogether.

Although this would appear to be a failing, McLuhan (1966) would not have thought so, for, on the contrary, he proposed that when videocassettes became available widely for private use, "there will be a revolution in education comparable with that which took place with the coming of the printed book" (38). The book, easel, and videocassette were in turn prime examples for McLuhan (1962, 206–209) of portable media's opening of access—not without barriers, of course, such as price—in the creation of new publics at the cost of a highly individualistic focus of private consumption. While he envisaged a complete revision of instruction as access to educational materials multiplied beyond the classroom and institution, his dream of the videocassette's ascendancy within the framework of an active audience was specific to an era of magnetic media during which tapes ran home computers, and came in cassettes, in 8-track and open reel formats, not to mention the VCR and Beta varieties.

Picnic in Space was shot without a script, but the repetition of one scene in which each man, in recline, repeatedly attempts to find the point of entry into the question of space signifies the attributes of the visual medium itself. The picnic basket is a through line that lends a degree of coherence as it is walked by Parker and McLuhan to the picnic spot, where the proverbial checkered blanket is spread, with a running commentary on the nature of the spot (scrub wood), free associations from their personal histories about such an environment (for Parker, his hometown of Fort William and the Qu'Appelle Valley, and for McLuhan, it could be anywhere in Winnipeg, near the Assiniboine and Red Rivers). The picnic basket contains objects from which one of two women (the aviatrix, an Amelia Earhart figure played by Jill Peterson Bacon, while the other is Sheila Mary Peace), who are never introduced, removes objects and hands them to McLuhan (a lightbulb, standing in for the new electric space, and a flashlight, a point of view device, as well as a balsa wood model airplane of the Spirit of St. Louis, Charles Lindberg's plane). This subtle distinction between light bulb and small flashlight has not always registered for viewers. For instance, Kerstin Schmidt (2014) describes the role of the flashlight in McLuhan's explanation of acoustic space: "At one point...McLuhan turns on a flashlight and points out that light radiates in all directions and does not have a point of view" (119). However, the beam of a flashlight has a centre and is focused and only spreads ("spills") out gradually. It has, therefore, a privileged point of view and its source can be readily located. In addition to these props, Parker smokes steadily, pensively, coughing, fiddling with a pen, bookending McLuhan's pronouncements. At one point McLuhan demands that Parker find a pen and make a note of something he just said about the relationship between the old hardware and the new software. Parker obliges his friend. McLuhan then asks the director: "Have you run out of film yet?" At the end of the picnic, the basket is walked out of the wood and the image of retreat is doubled and overlaid on itself.

The route of the picnic basket provides a small measure of continuity, but not sequentiality; it is, however, far from chaotic. Further, it is only the beginning of the film that is deferred. The ending is

punctuated by a sunset while heraldic fanfare plays, and so could not be more obvious. The soundtrack by noted electronic composer Morton Subotnik is used to augment the stream of sections from Piet Mondrian's *Broadway Boogie-Woogie*, by piano and by a Buchla synthesizer, and a steady flow of Warhol and Lichtenstein works, and flashing white blank frames juxtapose McLuhan's remarks that in film the main content is black (shades, perhaps, of Guy Debord's cinema without film, *Howls for Sade*, circa 1952). This is the only sequence where images of food appear. The picnic sequence is introduced by McLuhan as an interval, and by Parker as a rest. As an apparently resonant or, indeed, reclining space of tactility, with a discordant soundtrack, a picnic is not a model of unity and harmony, but one of separation with interfaces that bridge gaps. Parker's secretarial function helps to define his role; McLuhan's questioning of Parker's associative leap from scrub wood to Fort William, in terms of an immediate correction that the landscapes are totally different, further clarifies who owns the voice of authority. McLuhan is not the one who is interrupted. *Picnic in Space* is still, in the end, a buddy film of sorts, so any claims about its experimental nature must be taken with a grain of salt. Not everyone knew who McLuhan's buddy was. In an excoriating discussion of the film as a "self-advertisement," Marjorie Ferguson (1991, 79) characterizes McLuhan's "alter ego" as a "hapless interviewer/disciple who twitches visibly" without identifying Parker by name. The virtue of her approach is that she fully grasped the euphemistic meaning of made-for-TV film. In addition, she correctly parsed the distinction between the flashlight and lightbulb, even though the entire performance is just so much "gnomic devil's advocate" (79). As for the young women in the film who sit at the feet of McLuhan and Parker, these "handmaidens" could be "1960s groupies or a pastiche of women's role in McLuhan's world?" (79). Ferguson grasps the alter ego role as a trusted aid, and only hints at the master's becoming other through this second self.

If *Picnic in Space* is not, as I have argued, entirely successful in displacing through a series of disturbances the cinematic temporality that McLuhan learned to describe with heavy borrowings from Georges Poulet, perhaps it would be better titled *Picnic in Time*. After all, the struggle waged against sequentiality and segmentarity that, despite

much effort, survives in the film, and which informed philosophy unconsciously among the rationalists, with a hangover all the way to Bergson, underlines the lesson that cultural awareness cannot easily escape from the typographic sense of time and the line from beginning (even if deferred and multiplied), through a middle rural idyll, to an inglorious ending.

Parker (McLuhan and Parker 1969) invokes Poulet in order to state that "time wasn't on a line, time was a multi-layer thing. Many times existing coextensively...related to our sound appreciation" (42), and this follows McLuhan's (1962) recapture through Poulet of ranked *durations* in the plural during the Middle Ages (14), which are slowly reduced through the early modern and Renaissance periods to just one tense: the present. Philosophically, each moment gives way to the next in a sequence of "static shots" in which the self dissolves and reforms in each instant (McLuhan 1962, 241–43). Such instants must elude those who seek them, condemning them to chasing discontinuity between, in McLuhan's brilliant coinage, "typographic moments" (249). McLuhan never strayed far from Poulet when he wanted to detail this kind of temporality of the visible, and it is also from Poulet that he and Parker retrieved the idea of multiple, coexisting times, in "the architecture of medieval duration" (i.e., angelic time, human time, etc.) that Poulet (1955, 54) detailed. Poulet presented these times as supporting media with different attributes. Contrary to the bogeyman that McLuhan made of rationalism in his schema, Poulet (1955) distinguished between the human medium of continuous time as opposed to the angelic non-medium of discontinuous time, therein locating discontinuity in the medieval temporal architecture: "Only angelic thought could pass from idea to idea and from instant to instant without a temporal medium to support the passage and join them. To this discontinuous angelic time (strangely similar to that which was to be the time of Descartes) there was opposed the continuity of human time" (53). Although McLuhan agreed with Poulet that temporality changed fundamentally with the Renaissance, and after, the discontinuity of human instants in a human "existence without duration" (Poulet 1955, 58), or the non-identity of existence and duration, has an earlier source in the thinking of the latter. The movement of angels has been, since

Typography and Beyond 57

medieval philosophy, subject to various calculations regarding speed, finitude, and whether or not intervals are spatial or purely temporal. The discontinuity of angelic time, given certain provisos, is that of motion between instants without intervals. The development of discontinuity was found by Poulet (1955) in the conception of duration as "chaplets of instants" (59), an anguish-inducing feature of 17th-century thought.

If *Picnic in Space* is a hybrid form of film-television, it demands an interpretation that is as much about time as it is about space. Indeed, I would suggest that an overly spatial approach misconstrues the many *discontinuities* of the film as spatial rather than temporal (Cavell 2002, 3), therein concealing the importance of temporality. The perception of a film-television hybrid is a complicated matter, as one high-definition medium is filtered through another low-definition medium. How is the television viewer's construction of an image from among the few pixels that can be retained influenced by the film (Lazzarato 2019, 83)? Different respective frames-per-second and refresh rates would need to be synchronized and the effects of conversion noted—does the film appear sped up? Prior to the availability of built-in motion smoothing, such would be noticeable. As McLuhan (1964) stated, "the mode of the TV image has nothing in common with film or photo" (312–13). Thus, when brought into contact, there are artifact effects. In short, time relations are relevant to hybridization. These can be indexed to the different time-critical operations (how time is technically processed) of interacting media and how they are coordinated (i.e., how time delays and other chrono-technical specificities are managed; see Ernst 2016, 23). McLuhan (1962, 246; see also Ernst 2016, 48–49, 216) preferred the televisual temporality of the mosaic image (rendered by the scanning finger) to cinematographically linked images (rendered by the persistence of vision encountering projected frames), and this was supported by his hostility toward Bergson's integration of the technical apparatus of the cinema and conceptual human thought, as a symptom of his failure to critique cinema's mechanical segmental character. McLuhan's second departure from Bergson occurs in *Understanding Media*. He speculated that while language and consciousness are human extensions that Bergson identified as encouraging detachment and

diminishing involvement in the world of objects and in collective consciousness, in the computer age, electric technology promises, stated McLuhan (1964), to heal such "division and separation" by offering a "Pentecostal condition of universal understanding and unity" that would "by-pass languages in favour of a general cosmic consciousness which might be very like the collective unconscious dreamt of by Bergson" (80). McLuhan's thesis about electric technology "by-passing space and time" (105), indeed, about it creating "consciousness-without-walls" (130), with no need for translation, might mark an unresolved tension in his "Pentecostal celebration of the electrified body" (Peters 2011, 232). However, the irony in McLuhan's search for timelessness (Peters 2011, 235) was that he would not forgo a medium, even an a-semiotic one, and as a consequence, this made a purely discarnate condition for human being unacceptable. The very need for a medium may have caught McLuhan in the paradox of time noted above: conflicting temporalities exist in timelessness, in the crossing of temporal media of human temporal continuity and angelic discontinuity. McLuhan may not have been a thinker of time (Peters 2011, 35), but his reflections on time nevertheless reveal his sense of heterochronicity. Imagine a heterotopia in which time is transitory and flows freely, yet without forgetting that this precarity is captured on film, that is, in the language of Michel Foucault (1986), it is accumulated during the field shoot, then edited, processed, and maybe even screened on television, or perhaps in a classroom. Two competing ideas of time, time as flow and time as accumulation, are at work in this enjoyable picnic-time.

Rehabilitating Cronyism

Among the very few reviews published in the wake of the appearance of McLuhan and Parker's seminar on *Museum Communication*, Kenneth A. Marantz's (1970) short notice displays the struggle to be heard through the mediatic noise that McLuhan faced by the end of the 1960s. The post-*Understanding Media* period brought McLuhan both celebrity status and the demands associated with it from a fandom hungry for more and more of his aperçus, and a critical mob eager to mow him down while confirming his fading stardom amid a

burgeoning population of hangers-on and would-be hagiographers. Marantz aspires to join the so-called critical mob, but relies on too many analogical criticisms of a limited sort to really gain any purchase on the subject. Within less than a page, Marantz (1970) feebly deploys a local Chicago diecast metal toy diminution of McLuhan's status— "Although the McLuhan verbal steam roller now exists primarily in reproduced Tootsie Toy form, the widespread distribution of these miniature versions indicates a lingering love affair with his original utterances"—and an insult to Parker, "the Man and his traveling crony (Harley Parker)," not to mention the Man's clay feet: "this record helps confirm the very clay-like composition of his feet" (57). Marantz may have appreciated the questions raised about museum curation, but the answers were at best marked by avoidance, fuzziness, and naiveté.

I want to focus on only one out of this cultivated patchwork of insults, diminishments, and comeuppances, for it holds a key to understanding this important period of post-*Understanding Media,* for the intertwined fortunes of McLuhan and of Parker himself. The designation of Parker as McLuhan's "traveling crony" is of course a ridiculous and over-performed gesture. Yet the choice of "crony" contains in it a characterization of coziness between the two men, and alleges that McLuhan was the cause of this situation, because this was the kind of relationship he encouraged as alpha to beta, and the kind of behaviour he rewarded. McLuhan displayed favouritism to those who spread his word, and this, Marantz (1970) suggests, led to the kind of so-called failures that the *Museum Communication* dialogue represents.

Cronyism in this respect is no different to what supporters of a person or mode of thought typically engage in, and thus any disruption of the potential effects of cronyism is, for Marantz, positive. But the idea that Parker was purely a crony, that the only reason he appeared at the seminar was his connection *qua* connection with McLuhan, and that he lacked any qualifications, is patently ridiculous and a gross misrepresentation of his credentials in the arena of museology. It is as if Parker's history in the field did not matter; it is as if Parker's history at the ROM, his construction of an experimental gallery, and his theory of a newseum adjacent to the museum proper did not take place. A crony would have no means to carry the day. But this negative proof does

not yet explain the precise nature of the relationship in the late 1960s between two collaborators who had worked together since the mid-1950s, and who would, by the end of the decade, publish two books together and make a film. Beyond cronyism is, then, the challenge of characterizing how, during this period, McLuhan and Parker actually worked together.

While the complexity of the lengthy working relationship between McLuhan and Parker warrants further attention, the four events described in this chapter go some way in explaining how their relationship worked. It is also helpful to consider Parker's remarks in a profile published in what appears to be a neighbourhood newspaper in Toronto in 1970. In the profile titled "Fronting for McLuhan," Parker explains that fronting is what he does: "I front for Marshall." The unidentified interviewer interjects: "This seemed a shame, an indignity, for a 50-year-old man of many talents." To which Parker replies: "Oh no...I have my own dignity, and doing things for Marshall doesn't affect it. Because, you see, we also do things together." Since the two had a longstanding personal relationship and had settled into a steady working relationship from 1963 and into the mid-1970s, before Parker de-camped from Toronto to the Slocan Valley in British Columbia, it may be concluded that the displacements of secondariness are acceptable as long as they leave one's dignity intact. Both *cronyism* and *fronting* are hardly salutary when commonly deployed, but Parker seemed content to try to regain them for the sake of the many opportunities his relationship with McLuhan presented.

Typography and Beyond

The Making of an Epigrammatic Man

SOME ARTISTS leave a trail of crumbs to be followed posthumously, while others leave the same crumb all over the place. Parker did the latter with one notable epigram: "Good taste is the first refuge of the witless." Recyclable for many occasions, Parker's favourite epigram is closely associated with his many years of collaboration with McLuhan. I will consider its appearances in turn, beginning not with its first deployment, but with the pride of place it assumed in McLuhan's books. The philosophical value of the epigram may be, ultimately, grasped in its deviation from typographic culture, of which Parker was both a product and an enemy, largely at the same time during the height of his career. It might be claimed that I am casting Parker in a role, from McLuhan's perspective, once occupied by G.K. Chesterton. McLuhan's first literary love during his undergraduate years at the University of Manitoba in Winnipeg was for him a master of the epigram, stylistic condensation, an attempt at wisdom that could be brilliant in the form of a real zinger, or fall as flat as a one-liner devolved into a pun (Staines 2014, 76; Dotzler 2014, 87). Marchand (1989) captures Chesterton's influence on McLuhan, noting "Chesterton...frequently flashed out brilliant one-liners" (23), which McLuhan eventually specialized in delivering. Parker

undoubtedly modelled his penchant for the aphoristic on McLuhan's skillful construction of sententious phrases—not, then, from his study of Chesterton, but in his role as assistant and sidekick, although the demands of this role were often circumscribed while permitting a certain degree of freedom to innovate. However, Parker was, unlike McLuhan, not a specialist in one-liners, but a specialist in *one* one-liner. Following Marchand's evocative idea of McLuhan's "shower of percepts," Parker's single raindrop was a trickle extended by repetition. Yet, it cannot be accounted for simply by sameness.

Blindfolded or Blind

Parker's favourite epigram opens McLuhan's *Counterblast* (1969a), a book designed by Parker and inspired by the principles elaborated first by Wyndham Lewis in his art magazine *BLAST*. In addition to screaming headlines, Parker's typographic experimentation in *Counterblast* was augmented by colour inks and paper stocks, and even included a few standard pages of linear text, in which McLuhan explained his conception of acoustic space, the multi-sensorial, non-linear, and non-specialist world of flux and magical experience of pre- and post-literate persons. Parker (1970a, 104) used the term "iconic" for McLuhan's acoustic space— non-individuated images in a post-perspectival space, dis-embedded from specific space-time coordinates, and requiring "all-embracing participation," including religious devotion and how a blindfolded person experiences a horse through touch, inhabiting a tactile interval; a blind person lives in a world where "everything occurs suddenly" (Parker 1964b, 7). Some critics of Parker's typographic work in the iconic mode plead trendiness, making the author a "casualty of 'with it' layout and lettering" (Ferguson 1991, 78), but such criticism fails to investigate the contexts of design and collaboration.

The article in which Parker developed the iconic "truth of touch," titled "The Horse That Is Known by Touch Alone," has a curious pedigree. It is not only that Parker published it twice (six years apart, in 1964 and 1970), first in a magazine for advertisers called *Scope* and then in McLuhan's vanity version of *Explorations*, but that both he and McLuhan shared it in a way. Both McLuhan and Parker listed a version of it under the same title in their annual university reports for 1971;

McLuhan gave it at a Canadian National Institute for the Blind conference, and Parker presented it at an unlikely venue, the Ontario Mines Accident Prevention Association meeting (Bissell 1972, 51, 64).

Before proceeding further, a short reflection on McLuhan's and Parker's understanding of blindness is in order. Parker's and McLuhan's rhetoric of suddenness builds the characterization of the encounter of blind persons with objects in terms that align with the iconic mode and its refinements. Hence, suddenness builds the contrast with visual representation based on detachment, as opposed to tactual participation, which is non-representational. The tactual is a synecdoche for all of the senses, and is antithetical to the literacy, print, and letter that stand in contrast to the televisual mosaic image, a new kind of icon. However, McLuhan's route into blindness is rhetorically constructed in his explication of the televisual sensorium, as an extension of touch even stronger than other visual, historical icons, and in the process, he makes three moves to diminish vision through word choice. In *Understanding Media*, there is a "blurring" of attitudes and procedures; there is a "dimming" of basic pedagogy; and television "makes for myopia" (McLuhan 1964, 335), the latter implicitly linking viewing to claims about nearsightedness, without evidence. These terms align in a progressive diminishment of vision, not literally, of course, and therefore not due to aging. Rather, as the chapter on "Television: The Timid Giant" begins, the matter is explained by television's interference in children's reading habits; but print "rejects" their attempts at involvement in depth when trying to read as if they were watching television (308).

Whereas for Parker, his route branches off into an example of a blindfolded person physically encountering and then rendering a horse in a drawing. This translation of touch would neither involve perspective nor foreshortening, and would be childlike—both on the levels of individual development and on an evolutionary scale (Parker 1970a, 96). This rather broad claim is made in the service of exposing "the logic of the other senses," such that for Parker: "I can answer that by quoting Alex Leighton: 'to the blind all things are sudden'. In other words, the blind person walking through the world encounters things suddenly. Here is a chair. Here is a table. Lacking sight, one has

no ability to anticipate—everything occurs suddenly. This suggests that the opposite is also true: to the sighted nothing is sudden" (99–100). McLuhan and Parker use the Leighton epigram in section 47 of *Through the Vanishing Point* (1968, 221). The quote is from Leighton's book, *My Name is Legion: Foundations for a Theory of Man in Relation to Culture* (1959), a work in social psychiatry.

This indirect claim, while ignoring anticipatory sensory signalling that can take aural or olfactory forms, for instance, is notable for the deployment of one of McLuhan and Parker's most common borrowed epigrams: "to the blind all things are sudden." This is widely used by both thinkers and is variously attributed to Alex or sometimes Alec Leighton, and one does not have to search far and wide to find it. Indeed, the Jack of Diamonds in the *Dew-Line* card deck bears it (does the fact that the knave is often missing one eye in profile inform this placement?); McLuhan repeatedly dusted it off in articles, interviews, books, as well as letters to the editor. Most of the time it was used to underline the tactile world of denigrated or diminished vision, but there are a number of places where McLuhan pursued the idea and added to it a specific new dimension. Such nourishing usages began to appear in his writings around 1970. The Leighton quote is used twice in *Culture Is Our Business* (McLuhan 1970, 110, 162); on the latter occasion, it is *faith* that is the key to McLuhan's decoding of tactility. This idea is developed in his letter to the editor of *The Listener*, dated August 11, 1971 (McLuhan 1987, 435). While ostensibly a retort to Jonathan Miller's criticisms of his work, based on misidentifying percepts for concepts, McLuhan (1987) expands on the epigram by pursuing the "effects of the deprivation of sight on the other senses" (435). He does so with reference to the Jacques Lusseyran's autobiographical text *And There Was Light*, in which, McLuhan (1987) states, he "records the alteration of his *total* sensibility resulting from his sudden blindness" (435). The transformative effects of blindness and the overturning of objectivity and hierarchy that concomitantly arrived with the early onset blindness Lusseyran experienced as a boy are, after all, couched in multiple layers of historical and religious context. His struggle as a resistance fighter in France and the subsequent betrayal that resulted in his imprisonment in the Buchenwald camp, followed

by his remarkable survival, are creatively framed with an overt spiritual transformation along the lines of the creation story, with light playing the role of inner illumination and the felt force of reorientation—an "inner trip" has the power to change one's sensorium: "He [Lusseyran] is the pure case of Tiresias, the blind seer" (McLuhan 1987, 413). For McLuhan, blindness can be a breakthrough: a faith-buoyed voyage for the electric age. But in this archetype, a paradoxical reassertion of visionless vision is achieved, and prophecy is less bound to hearing than to faith. Is it to hearing or is it to touch that faith is bound? As Parker (1970a) put it, extending, in his estimation, Leonardo Da Vinci, (although, in the absence of a citation, it could be attributed to various others if taken as a closely related version), "seeing is believing but to touch is the word of God" (96).

The Leighton epigram, as noted above, begins the gloss in section 47 of *Through the Vanishing Point* (1968) on Jackson Pollock's painting *Full Fathom Five* (although the painting is never mentioned). Here, the epigram builds a set of distinctions between the "immediacy and unexpectedness" of the sensory life of the blind and the "habitual" experience of the sighted, made of "continuity, connectedness and perspective" (221). To summarize:

Sight	Unsight
continuous and rational	discontinuous and irrational
lineal connection and interrelation	intervals, no story of melodic lines
perspective (private POV, separateness)	integral, space between

McLuhan was fascinated by Linus Pauling's theoretical construct of resonance (resonant bond) that explains how chemical bonds are formed and maintained between molecular structures. At the outset of *Take Today: The Executive as Dropout*, he invokes a "resonant bond," stating "this is where the action is" (McLuhan and Nevitt 1972, 3). The interval or gap is the opposite of a connection; far from being simply "empty," it is dynamic and even "processual." In short, it is both "space between" and a "prime source of discovery" (McLuhan and Nevitt 1972, 3), characterized by touch. Touch forms a "bridge" across a "resonating vortex of power" (9). For authors McLuhan and Nevitt

The Making of an Epigrammatic Man 67

(1972), "since Heisenberg and Pauling, the only remaining material bond is resonance. The continuum of visual space of the Euclidean kind is not to be found in the material universe. There are no connections among 'particles of being' such as appear in mechanical models. Instead, there is a wide range of resonating intensities that constitute an equally wide variety of 'auditory' spaces" (10). Valence (combinatorial) potentiality and molecular vibrations populate the interval and make it a vibrant and dynamic between-space in which nothing can be taken in isolation and "mere" connection is a failure. All of these disparate disciplinary tools are brought to bear on the description of the sensory world of the blind or blindfolded. The breaking of sighted expectation that is suddenness looks "irrational."

Parker's source materials were quite different. He begins Chapter 2 of *The Culture Box* with a reflection on the acoustical properties of museum rooms—the sounds of heels across the floor, the echoes from hard surfaces, the muffling décor. He borrows from psychiatrist Warren Brodey's interrogation of a blind person's experience of architecture in order to learn something about the sighted person's "blindness to sound." The fecundity of the interval is aided in Parker's estimation by references to the potency of the "vacuum" in a Japanese tea ceremony; in the silence of a Cagean composition; in the observations about acoustical architecture as they apply to the museum. For Brodey (1964), a blind person's experience of the quality of a room's sound is nuanced and tonally subtle: "exciting and yet not sharp" or "soothing and yet not dull" (57). Affects accrue around certain sounds produced by materials in the walls, floors, and ceilings: "hard plaster...accentuates the high tones...and can increase fatigue." Using "earsight," thinks Brodey (1964, 58), a blind child can play with a given room's harmonics. Parker calls this the "pregnant interval" that requires rich sensory involvement of the kind that museums need to promote. Proceeding by sensory subtraction becomes, then, a design principle for Parker.

The repeated utilization of the Leighton epigram by both Parker and McLuhan, in the context of the development of the role of blindness in the perception of space, furthers in a coordinated manner both

thinkers' rejection of the lineal. The "interval," supported by multiple borrowings from across the sciences and arts, is aligned in Parker's estimation with suddenness and unexpectedness. This situation may be extended beyond the object focus into a non-object focus, suggested by Brodey (1964) in his description of how a "blind person will stop suddenly as he hits the wall of an acoustical room. To him it is as real as a sudden change in illumination to the sighted" (59). The "wall" in question is not a physical barrier but an acoustic demarcation that can break up continuity and connectedness in a sudden manner. Borrowing an observation made by Jacques Derrida in his *Memoirs of the Blind* (1993), a study of drawings of blind persons, there is an evident "apprehensiveness about space" (5) in many of the drawings examined, as the hands grope, calculate, and wander. They enter the "interval," if you will, with a combination of caution and boldness, Derrida suggests. Suddenness and apprehension belong together in this calculated advance of the blind, but so, too, belongs mockery of the sighted by the blind when scrabbling for a light switch, which is a put-on he enjoyed. A Parkerian repertoire of the denigration of vision would include pastiche, and discomfort, too, since he begins Chapter 1 of *The Culture Box* with a quote from Brodey (1964) to the effect that "humankind has become accommodated to sensory insults which bring more strain into life than necessary" (6). Regaining the interval against the bias of the visual is Parker's central goal in his book, bringing both sound and touch into design considerations—this is a retort to the indignities, the insults, of visual bias and dominance of one sense over others. It is not that Parker, following Brodey, cannot intentionally make use of the "perceptually uncomfortable" bias, with its cultural-literary conditioning, while at the same time rearranging and shifting elsewhere sensory focus in order to shift design into a more contemporary mixed sensory matrix in "the total sensorium in balanced interaction," which would include sight as well, while foregrounding touch and sound. Not at all, for the critique of visual bias is not a punishment of the sighted, not a metaphysical blinding by means of too much light, but a blindness that reveals design lessons for the other senses.

The Making of an Epigrammatic Man 69

The Sound of Vision Conference

The exploration of themes of the sensory world of the blind in *The Culture Box* pointed Parker in new directions that went well beyond those explored in his book and his enthusiasm for specific epigrams. As part of his duties in Rochester, Parker convened the "Interact" seminar,[1] a series of industry-academic "interfaces" about problems in communication. If his surviving presentation notes for his directed sessions are a fair indication of the themes he explored, it would be the emphasis he placed on what might be called inverse sensory biases, the "greater" sensory worlds resulting from blindness and deafness, that marked the development of his thought during this period. In deprivation Parker diagnosed potentiality for breakthroughs, while acknowledging the problems of education within the Deaf community in particular (lip reading, American Sign Language, or ASL, teletypewriters coupled to telephones, picture phones, etc.). He invited Robert Panara, founding faculty member of the National Technical Institute for the Deaf within RIT, and pioneer of "Deaf Studies," to contribute as a presenter to a number of the sessions.

Parker also chaired the 1973 "Sound of Vision" conference at RIT, and his earliest draft conceptions of the event were expressed in social justice terms, aligning the goal of inviting educators from hearing-impaired and unsighted communities with welcoming activists from socio-economically and psycho-physically "disadvantaged" groups, in order to ultimately synthesize their experiences of integration and exclusion. Parker (1973d) wrote: "The Conference will be concerned with communications problems of cultures separated from the mainstream." Shortly thereafter he clarified that: "It is our hope that a discussion of the changes in sensory orchestrations inherent in disadvantagement from the viewpoints of a variety of disciplines will result in fresh ways to mediate the problems" (n.p.). The language of "disadvantage" changed rather quickly to "deprivation," both sensory and social, and the focus on research became "sensory aids," as medical treatment grew in importance in the firmed-up roster of confirmed speakers (Dr. Eugene Mindel, Chicago-based psychiatric specialist in Deaf youth; Dr. Douglas Inkster, director of the New York Institute for Independent Living in support of geriatric blind persons;

the above-mentioned Panara; Robert Houde, specialist in technological aids for the Deaf). Although the event seems to have succumbed to the kind of "audism" that insists on medico-technological fixes, Parker also deviated brilliantly by inviting Mindel to read several scenes from a script: a "fictionalized biography for cinema," called *Two Blind Guys*, based on interviews conducted by Parker and Mindel with two blind university-age students. The dialogue between the two young men, one Black and one white, centred around erotic fantasies and social misrecognitions, as well as intergenerational family strife, scandalized at least one of the event's hosts, photography professor Richard Zakia, while exposing elements of the soundscape of the blind (including mouth clicking, cane tapping, Braille writing, etc.).

Parker told stories to his daughter Margaret about two blind friends, and these might be taken as parables of the resurgence of a new sensory configuration following the decentring of vision, or as based upon the two young men he interviewed with Mindel. Such stories might be appreciated in terms of their role in following up on the diverse kinds of engagements that Parker had with Mindel and his interlocutors and then adapted for his valorization of touch. Taken together with McLuhan's deployment of rhetorical and pastoral dimensions of blindness in *Understanding Media*, a loose assemblage of heterogenous materials is constituted in support of a renovated and expanded dimension of multi-sensory experience built around the revelatory characteristics of touch and the withdrawal, if not the denigration, of vision, and the elevation of the tactual as a synecdoche for all of the senses.

A more critical, interrogative turn toward Parker's (1973b) introductory remarks at the "Sound of Vision" conference in October 1973 brings forward his debt to McLuhan's retribalization trope, filtered through the galactic categories of *The Gutenberg Galaxy*, in lieu of any grounding ethnographic or empirical research. Parker's thesis was that sensory profiles of subordinate, marginalized, and disadvantaged groups make them well-adapted to technocultural change in the electronic world. In other words, such groups should not seek to acquire the benefits of modernization in a rapidly receding Western mechanical, visual, literate world, but to exercise their alleged sensory

(mal)adaptation to the present and future by magically jumping over a phase of socio-economic development enhanced by modern values. What Parker did at "Sound of Vision" was apply this thesis to the historically and socially disadvantaged groups vulnerable to systemic discrimination: blind, deaf, and economically-culturally marginalized or vulnerable (minorities, immigrant communities, disabled, elderly, unhoused, etc.) groups. Parker constructed, then, a McLuhanesque understanding of the states of being blind, deaf, and poor as *media* in the sense that they "mediate the sensory inputs and demand subjective sensory completions unique to each state." Yet Parker sought to find across them commonalities through "an appraisal of the sensory orchestration inherent in the various modalities [at stake]." In other words, for Parker, "sensory orchestrations" revealed "profiles" that overlap and that are sharable. Two large categories were relevant for Parker: visual bias and personal predilections for sense perception; and a return of the "ear's paralogic." This led him to construct "contrary stresses" in his presentation of blindness and deafness as moving toward a "kind of balance." Below, on the left, are Parker's points, moving in the opposite direction toward hearing from an existing expertise based in vision, while on the right they move toward the need for work on vision in a field with expertise on hearing. He then characterized each orientation by a dominant mode of logic:

Blindness	Deafness
existing expertise in vision	existing expertise in hearing
requires expertise in audition	requires expertise in vision
inductive reason	deductive reason

Parker then utilized these categories to construct the third grouping, the economic-cultural disadvantaged:

Economic-Cultural Disadvantaged	
inductive thinkers and ear-oriented	stuck in visually-biased schools based on deduction

The conclusion to be drawn is that the blind and the economically-culturally disadvantaged are in the best position to "cope" (his emphasis was not on thriving) in the current and likely future conditions of a retribalizing sensory orchestration around audile-tactility, as long as the latter can resist the confining sensory organization inherited from the education system. The deafness category drops out or remains implicitly aligned with blindness insofar as Parker's construction can be adopted, entailing a critique of vision, linearity, deduction, etc. This was Panara's role in his conference presentation, to reposition, à la McLuhan, the non-verbal communication of the Deaf through sign language as ideographic, via Ezra Pound's imagist writing, which shreds redundancy, serving as a conduit for diagnosing sensibilities: "In many ways our signs are an approximation of Chinese ideography... Pound...was studying Chinese poetry and he got the key imagism...[he] and others thought the time had come for a search for a hard, clear image" (Panara 1973, 24). The return of the embodied signer is a key moment in the interplay of sensory modalities, even when deprived of a hypervalorized audition. Embodied, yes, and moving in the opposite direction of the sense-reducing phonetic alphabet to be sure, in a semiotic struggle against the eye's powers of abstraction. As Marchessault (2005) explains: "the ideograph, like the hieroglyph, is a complex *gestalt* which involves all the senses at once...[and] ideograms require scholarly interpretation to be read" (127). Likewise, encoding and decoding a non-verbal sign in ASL is also dynamic, facial, gestural, highly interpersonal, and open to style, even if the visual persists, but as Panara (1973) says, literally, Deaf people may also use speech and fingerspelling if signs do not exist; in other words, the sign system is hybrid. Whether this hybridity diminishes the pertinence of Parker's (and McLuhan's) distinctions among the senses and the implications of the diminished faculties of sight or hearing, or simply enhances the complexity of the concepts, will not be explored here. Suffice it to say that the attempt to link logical modes of thought with disabilities seems arbitrary, and the integration of an economic-cultural dimension is trapped in the tribalism trope, in which disadvantaged and vulnerable groups are treated with the same inadequacy (crude, essentializing, politically naive) that Marchessault (2005, 129) and others

have identified as issuing from a position of assumed superiority (Towns 2019) that invites "others" into a techno-history in formation, but not one of their own making.

The Epigram's Effects

Parker's epigram mocks a retreat into conventional manners. It is pithy and witty, but at the expense of a witless conformist. It attracted the attention of Donald Theall, in his important study *Understanding McLuhan: The Medium Is the Rear View Mirror* (1971), as an example of McLuhan's snobbishness. Theall traced the epigram's theme to the collaborative volume that McLuhan and Parker published in the year before *Counterblast*, *Through the Vanishing Point*. Writing of McLuhan's adaptability to the times and underwritten with erudite reassurance, Theall (1971) did not want to condemn McLuhan on these grounds, but to point out that his position—his joy in puns, rhetorical hedges, and clownishness, and the conviction of his pronouncements—was "the antithesis of manners" (201). The problem here is that Parker has been conflated with McLuhan. Theall (1971) did not distinguish between them: "The epigraph of *Counterblast* reads that 'Good taste is the first refuge of the witless.' His [McLuhan's] works were to teach people that what they liked might well be what they should like, and what they had been told to or taught to like was 'witless'" (201). It may be unusual for a book designer to provide an author with an epigraph, but in this case Parker and McLuhan had already elaborated upon the folly of good taste in exhibit 45 of *Through the Vanishing Point* (1968, 212–13), and the version of the epigram in *Counterblast* is a variation, a different repetition, on this theme. It is presented in an almost cursive italic font, sitting between handwriting and typesetting, but with few of the personal quirks of handwriting, yet remaining delicate and serifed. It contributes to the discussion about the difference between handwriting and typing (McLuhan 1969a, 102–104). This typeface choice is not in good taste.

How did section 45 on "good taste" find its way into *Through the Vanishing Point*? It was proposed quite late in November and December of 1966. On November 8th, McLuhan wrote to his editor Anshen: "We have held back one section called 'Good Taste.'" In her response on

December 3rd, Anshen embraced the "Good Taste" section: "the question of 'taste' you raise is extremely important." Although she was resistant to the inclusion of Harley's painting, here she seemed not to know that this was Parker's gloss on his favourite epigram. It still came as some surprise to Anshen that the "Good Taste" section was illustrated not with a painting but with an advertisement for silverware (McLuhan and Parker 1968, 212). McLuhan forged ahead and sent the folder to Anshen on December 9th.

A few details are in order. Section 45 consists of two sets of opposing pages. The first set verso is a poem by Rupert Brooke, "The Great Lover," that catalogues domestic luxury items and the intimate pleasures of familiarity: "These I have loved/White plates and cups, clean-gleaming." The "spatial dialogue" that accompanies it on the opposite recto page pillories Brooke's good taste as lacking "any fresh awareness" (McLuhan and Parker 1968, 211), and contrasts him with G.M. Hopkins' ability to make the familiar unfamiliar. Citing the poem "Pied Beauty," which begins, "Glory be to God for dappled things/For skies as couple-colour as a brinded cow," McLuhan wrote: "Hopkins offers a new perception related to the new world that flowed across the old one" (211). McLuhan was revisiting here a much older passion for the poetry of Hopkins and his "analogical mirrors" of God's grandeur, and the very poem was cited by McLuhan (1945, 20) as an example of one of the simplest usages. "New perception" is not really adequate here, either biographically or interpretively, as analogously winning beauty from the everyday mirrors Christ in quite traditional ways and is not a reflection of the polisher's face or circumstances.

Nevertheless, the second set has on the verso an advertisement for silverware, with a maker's mark, and the tag line: "Be choosy." On the recto page are six epigrammatic phrases defining the failures of good taste. They are as follows:

i. a sin of omission;
ii. the refuge of the noncreative;
iii. the anesthetic of the public;
iv. the expression of a colossal incompetence;
v. the most obvious resource of the insecure;

vi. the highly effective strategy of the pretentious.
(McLuhan and Parker 1968, 213)

The old environment of good taste offers a refuge from a series of promised vital encounters: good taste is the place into which the uncreative retreat; where the unaware prefer to linger; where the numb tarry; where the incompetent feel comfortable, and the insecure find respite from a changing world. While highly effective for a pretentious person, good taste offers nothing new or perceptually challenging, as it is a ready excuse not to participate in new environments; so, one can fall back into being choosy about traditional silverware, instead. For Theall (1971), all of this was evidence, to employ an idiom in arguably bad taste, of the pot calling the kettle black—a new snob outing old snob appeal—a way for McLuhan to mask his own bourgeois shortcomings and failures to really engage with then contemporary developments in the human sciences. What about Parker?

The "good taste" section was certainly of Parker's making as his signature epigram sets up the discussion. The following, section 46, uses Parker's own painting, there called *The Trip* but elsewhere titled *Flying Children* (circa 1950), a nostalgic view of childhood play with/ as machines. Photographs of McLuhan and Parker seated before this painting circulated during the late 1960s. The painting is understood to provide an exemplary case of "sensorial reverberation" in acoustic space: "In Parker's painting emerges an environmental space that is not limited to visuality...the reverberation that shows the mutuality of relationships where space is only the space of the interaction of senses" (Machado 2011, 6). "Tactility as a matrix" (Machado 2011, 7) for sensorial interactions is the so-called "invisible environment" within *Flying Children*. Despite Anshen's protests, the painting was included in the book, and the glosses rely rather heavily on "nostalgic" themes around childhood play and imitation of flying machines.

The position that manners and taste had become irrelevant for McLuhan, as Theall (1971, 239) concluded, applies well to Parker. This did not absolve either of them of snobbism, whose theoretical expression is the necessity of the kind of discomfort provided by the artist. It is a position, however, that can exude mean spiritedness and contempt,

when left unchecked. Parker was a master of this mode of aphoristic dismissal. His short article "Notes on Perception" (1967a) contains two examples worth considering. In the first, he uses an anecdote to pillory a comfortable sensibility:

> Recently, I asked a gentleman why he had bought a particularly conventional picture in bad Renaissance style to hang over his mantle. His answer was: "Because I could live with it". My response was: "What you really mean is that you thought you could die with it, because that painting will fade into your wallpaper and be completely invisible within two weeks." Man reacts exactly as the cat who finds the most secure position for sleep in a box— surrounded on all sides. (26)

Here, the refuge is a safe and secure box that causes no discomfort; the dozing feline finds a warm, protected place to rest. The painting becomes meaningless, non-impactful, because it provides little infor- mation. The second example elaborates on this point:

> Most men prefer to walk rapidly backwards into the future. Only then can they manage to feed in sufficient non-information (pigeon-hole information) that they can feel secure. It has been said that a small child lives largely in a world of information— everything is new—the adult is a mixture of information and non-information. At the point of senile decay, the individual lives in a world of total non-information—and dies! (26)

Condescension gives way to cruelty, and the targeted complacent and under-stimulated person retreats into a hole, quite literally in a coffin! Casting himself in the role of the creative agitator, Parker is true to his position, inasmuch as he does cause discomfort in dismissing those non-contemporary persons who retreat into contained environments of good taste, comfort, and security, in calm feline repose. Information serves as a kind of stimulation, and its withdrawal appears to accel- erate entropic decline toward the absolute degree of simplicity in which there is no longer any information, all energy is dissipated, and there is

maximal entropy—in other words, death. To put it bluntly, this is what happens in traditional museum design: good taste removes artifacts from the vital "ground of life" (Parker 2025, 172). When museums become perceptual laboratories, they will have moved beyond the reach of good taste, except in ironic repose.

The first five variations on the epigram have descriptions attached to them:

 i. It leaves out direct awareness of forms and situations;
 ii. It is the last-ditch stand of the artist;
 iii. It is the critic's excuse for lack of perception;
 iv. It is the "putting on" of the genteel audience as a mask or net by which to capture ambient snob appeal;
 v. People of good taste eagerly buy the Emperor's old clothes. (McLuhan and Parker 1968, 213)

For Parker, direct awareness is the life lived by the average teenager who does not live separately, unless they are "bookish," from the electronic media and the rhythms of their generation. Artists, like anyone else, can yield to the seductions of ease and satisfaction and lapse into non-creativity, but it is a last-ditch rather than a first-ditch capitulation. Critics are no different. If they fail to undergo sensory retraining in the cultivation of media awareness, they will fail to pass through the vanishing point of the visual and into the audio-tactile. Like failed artists and lazy critics, connoisseurs put on a mask selected from their audience in order to capture snobbish attitudes that float in the air like kisses. And there is such a selection of old clothes from the Emperor's wardrobe in the beautiful junkyards of consumerism that people of good taste will likely never exhaust the supply.

While section 45 of *Through the Vanishing Point* contains the most concentrated reflection on Parker's epigram, he used it on a number of different occasions. At the opening of the Hall of Fossils at the ROM in late January 1967, his masterpiece of museum installation that was sometimes dubbed a "discotheque," Parker deployed his favourite epigram with evident delight. *Toronto Telegram* reporter Paul Gresco (1967) opened his article in these terms:

> When Harley Parker became chief designer of the Royal Ontario Museum 10 years ago, he listened to his new colleagues talk of museum design in their tepid, traditional terms. He listened a respectful amount of time then told them baldly: "Good taste is the first refuge of the witless." (5)

Not resting on shock value alone, Parker delivered a landmark anti-environmental poke and shook up the invisible and unquestioned environments of taste preferred by the museum's curator-scholars. Yet before making his bald, if not bold, statement that fed into his manufactured public persona, Parker was respectful. This phrasing adds an explosive, dramatic element to the epigram's appearance, which attempts to lift the entire museum out of its torpor of good taste. Parker explained: "The artist creates a taste, which eventually becomes a cliché; it becomes good taste and it becomes environmental and nobody sees it. The function of the artist is the creation of anti-environment" (as quoted in Grescoe 1967, 5). Although Parker's interactive museum display was not at the time of its inauguration in "good taste," even though it would soon enter an orbit of comfortable goodness in commodified form in his own reckoning by the late 1970s, by the 1980s, immersive environmental displays were a corporate norm in the rush to move from the display of expertise to the digital simulation of experience designed for a variety of learning styles from newly participating communities.

In a talk delivered at an undisclosed location to the Design Society of America at some point in the late 1960s, vintage epigrammatic Parker was on full display. The talk was titled "Good Taste Is the First Refuge of the Witless: A Refugee Camp for Philistines," with the derogatory term joining forces with the refuge of good taste as a retreat from living culture for those who insisted they could live without it. The title was in bad taste, but almost any traditional institutional environment could qualify as such a camp in Parker's estimation.

Toward the New Museology

It would not be jejune to suggest that Parker leaned toward the new museology of the 1980s and beyond, but decades before the fact, even

The Making of an Epigrammatic Man

though his conceptual touchstones were different, relying heavily on support and justification from McLuhan's writings. Since the key statements of the Declaration of Quebec (one of many declarations, all of which cannot be discussed here) and the Basic Principles of a New Museology from 1984 include the focus on broadening traditional functions by using "contemporary methods of communication common to cultural intervention as a whole," these would certainly include Parker's approach (ICOM and MINOM 2010). Parker used these "methods" (i.e., "light shows") as "probes into the environment" for "educational purposes" (McLuhan and Parker 1968, 253). Yet as I noted earlier, while he did explicitly advocate for a more advanced integration of users, he did not focus in depth on the development of communities through use of the tools of museology that could support local initiatives. While new museology was animated by humanitarian and ecological principles, with critical attention focused on cultivating mutually productive relationships between the institution and its communities, these were not Parker's main objectives; that is, he did not go so far as to try to integrate into the museum's organizational structure the bohemian youth he so actively sought to bring through the doors. The ROM was decidedly not a neighbourhood museum! Yet it could be! It should be! There are statements to this effect in *The Culture Box*, but they are not developed at length. At the same time, he loudly advocated for museums to rectify their isolation from contemporary life, to diversify audiences, and especially to adopt the latest technological tools and borrow from select entertainment venues. Granting access to decision-making to diverse groups and communities in meaningful ways was not part of his remit. Eschewing the cultural privileges of curators and academic specialists by cultivating interdisciplinary cooperation and levelling organizational hierarchies were part of his project. He was not a sociological critic and did not deploy the categories of race, class, and gender, despite his concern with tendencies to impose overbearing and misleading frameworks on Indigenous Peoples. Still, it is quite remarkable to read, in the context of an active museology that proposes organizational recalibration as a goal, the "curator-designer cooperation" by Parker and by palaeontologist R.R.H. Lemon, with both noting the role of over-stretched

craft persons. The level of cooperation was for Lemon "very close" and only "team-work" made it possible to successfully complete (as quoted in Bissell 1968, 283). This has an exception to the rule ring to it, not to mention that neither Parker nor Lemon stuck around the ROM, as both departed later in 1967, but it also speaks directly to the theoretical drive for a de-centring of curatorial authority and the recognition that in many cases multiple types of expertise exist in visitors, among others, and curatorial subjectivity needs to be contained, rendered plural if possible, and embedded in collaborative teams (Baker et al. 2019, 114ff). Parker had already arrived at this position by the mid-1960s. The fact that ROM Director Peter Swann (as quoted in Bissell 1968, 258) wrote in his annual overview that the results of Parker's research year at Fordham with McLuhan studying "the response of museum audiences" were "await[ed] with keen anticipation" hints at a possible rapprochement and unrealized future made equally of conciliation and experimentation. This did not pan out.

Designer-Curator Collaboration

In his own curatorial assessment of the Hall of Fossils published in the same issue of *Curator* as Parker's paper on its design, Lemon (1967) situated the accomplishment in a useful historical context with specific disciplinary points of reference. The move into non-linearity, he thought, is not at all abstract for an invertebrate palaeontologist. Rather, in the field there exist two typical and quite linear approaches to organizing an exhibit: first, a systematic arrangement of animals from the primitive to the most advanced, which is "the way most textbooks are arranged" (Lemon 1967, 279); second, by a chronological sequence that shows "the changing character of invertebrate faunas through geologic time" (279). Lemon understood one aspect of the non-linear approach, then, as temporal inversion, by beginning with living invertebrates in aquaria as well as recent fossils and moving to more alien, older fossils; put differently, start with the familiar/known and move to the unfamiliar/unknown. A further element was that instead of staple dioramas and models, Parker used 35mm transparencies, augmented with audio accessed through telephone handsets and cartoons explaining heredity and environment. Yet there was also

The Making of an Epigrammatic Man 81

a three-dimensional diorama in the Hall: "the primitive earth of some 5,000,000,000 years ago, before life appeared" (Lemon 1967, 280). The strangest, beyond alien, and most distant is left for last, so that time travel through the exhibit is complete, and the visitor, or rather time traveller, arrives at a display of the earth prior to the fossil record. The time traveller motif was embedded, Lemon (1967) noted, into the exhibit and used along the way. These non-linear breakouts complicate linearity, and for Lemon, the Hall "represent[ed] an interesting contrast to the gallery of invertebrate palaeontology which preceded it" (280). The previous gallery was purely curator driven, unlike the curator-designer cooperative effort of the Parker-Lemon version, and the former was also an exemplar of 19th-century museum presentation, even though the ROM opened at nearly the first third of the 20th century. This traditional gallery was a teaching facility for advanced classes in the field, and "the very sad part of all this was that the gallery was largely unintelligible to 99.9 per cent of visitors to the museum; few, in fact, ever ventured in" (Lemon 1967, 280). Lemon presented an anatomy of failure, but also a healthy prognosis in the guise of the necessity of curator-designer collaboration. He even insisted that designers have a role as lay interpreters in matters of science and technology decision making. In essence, Lemon (1967) praised "team-work" (281) because the ROM, like many other natural history museums, is riven by a schism between the sciences and arts, despite efforts to overcome it. The lay interpreter or designer can play a key role in conveying the excitement and vitality of research in the galleries themselves, so that it does not remain hidden behind the closed doors of the departments, and as Lemon (1967) put it in a borrowed McLuhanism, "the traditional museum must cease to be a rear-view mirror" (282). The rear-view mirror offers comfort and familiarity, similar to the cat's bed.

Parker's move away from tradition places him squarely between the poles of the traditional/new dichotomy. Granted, he does not easily fit into the reframing by Quebecker Pierre Mayrand (1985), founding member of the International Council of Museums/Mouvement international pour une nouvelle muséologie (ICOM/MINOM), into a post-museological vision of the curator as a kind of social progressivist-activist

mobilizing communities and building capacities. Yet, his role as a designer who sought to bring greater self-awareness to visitors and his commitment to the position that "the re-stimulation of the sense life of audiences must become central to museum interpretation" (Parker 1964a, 109), on a level of practice, led him to focus on experimenting with light (the use of fluctuating lighting) and electronic media (television, slide projectors). In this way, he recoded the traditional/new dichotomy into a sensory language that contrasted the visual/audio-tactile and the serial/iconic, as a general call to museum artists.

Again, his go-to epigram was put to work during the *Museum Communication* seminar. In an exchange with McLuhan, Parker opined:

> Mr. Parker. One thing I would like to stress about museum presentation: there seems to be a tendency to feel that if the presentation is in good taste, if the exposition lies within a surround of good taste, the museum is fulfilling its function. Not long after I was in my first museum job, about one month, I quipped that good taste is the first refuge of the witless.
> Dr. McLuhan: And the frightened.
> Mr. Parker: Don't move for good taste. Move to communicate. Let the aesthetic look after itself. You set out to communicate. If you communicate well, you can take it for granted that what you have done will gradually degenerate into good taste, ten years from now, and everybody will be doing it without any meaning.
> (McLuhan and Parker 1969, 52–53)

At no point did Parker allow good taste to meet with approbation and achieve the kind of stability that would recommend it to the aesthetically minded. It is the very unperceived thing toward which museum presentation, no matter how new and successful, tends to slide. Good taste is a kind of dangerous equilibrium that seeps into even the most surprising display. Mocking its compromised refinement—and really, good taste is always used pejoratively—was a kind of cruel pleasure for Parker and for McLuhan, but what was the critical context for these remarks? It appears that Clement Greenberg is a key reference.

Greenberg (1999) tackled the question of taste and how it congeals to such a degree that even surprise becomes safe: "The minute a far-out [media-scrambling contemporary creator like an earth] artist lets down his guard—and he always does—there comes good taste, good taste in the most conventional sense" (174). Good taste gets into aesthetic judgements; it seeps into them, as it were, and brings with it conventional ideas about prestige and refinement that satisfy expectations with ease. And in this way such art betrays itself. This is a peccadillo of Greenbergian art criticism to be sure, but it appears to apply to Parker's approach as well, which takes the givenness or hiddenness of the environment as the background and horizon for all anti-environmental artistic surprises—these "Early Distant Warning Systems" help to "create perception" and foster self-reflection about new opportunities and changing power relations (see McLuhan and Parker 1968, 244–45). For Parker, it is evident that good taste is a safe and comfortable environment that has "escaped observation" (see McLuhan and Parker 1968, 247), until it is stirred by the insertion of the epigram, which changes the temperature of the environment, so that it attracts attention, thus giving it anti-environmental or artistic attributes. In working at the interface between audience and artifact, the designer-communicator grapples directly with taste cultures, whereas the typical curator, Parker believed, avoids this knowledge. The epigram itself is not as intense as a new technology, of course, and thus the conversion of an existing environment into a new anti-environment is not accomplished. Instead, the epigram stirs by participating in the affective intensities of a situation—particularly, the effects of a museum presentation—that bring into focus forces that normally escape our notice (the feelings of satisfaction, safety, and acceptance that Parker rejects and wants to rearrange). The injection of the cruelty factor of the "witless" has a Nietzschean resonance that exposes the false comfort of those who refuse to think outside the box, or stray from the path. In his poem "Caution," Nietzsche, in "Joke, Cunning and Revenge: Prelude of German Rhymes," from *The Gay Science* (2001, 18) warns against the stewardship of the witless who urge caution even when caution is taken:

#37 Caution
Into that region trav'lers must not go:
And if you're smart, be cautious even so!
They lure and love you till you're torn apart:
They're halfwit zealots—witless from the heart!

Emblazoned across the top of the catalogue for his final exhibition of paintings at the Burnaby Art Gallery in 1991, Parker's epigram appears in type that regains Lewis' capitalized headlines: "GOOD TASTE IS THE FIRST REFUGE OF THE WITLESS." In bold, insistent capitals, the epigram declares its own finalities in the dramatic need for differing: the only things that count are the effects of disturbing the comfortable and deferring an inevitable degeneration into witless caution. Former gallery director and curator Todd A. Davis utilized the epigram as an inscription of sorts. This epigram would, ultimately, become an epitaph.

3

Uncanny Selves and Family Resemblances

AFTER EXITING FROM HIS SERVICE at the Centre for Culture & Technology, Parker retreated to rural Winlaw in British Columbia, where he had been offered a piece of land on which he planned to build a studio next to his son Blake's lot. He described his activities in this way: "These days I think of my paintings very much in musical terms. I create a broad sweep of melody, against which I juxtapose a series of staccato notes, which punctuate and provide for further melody. Paramount to all of this is my awareness of the value of silence. Mozart said at one point that he wasn't so much interested in notes as the space between them. He seemed to be intuitively aware of the Japanese belief that 'all action occurs in the space between events'" (Parker 1976, n.p.). The power of the "pregnant interval," as he put it in *The Culture Box* (2025, 100), whether it was derived from the potency of the vacuum, or the incisiveness of silence in music, and displayed non-connection, non-logic, and the aural-tactile, was what he called paralogic.

Once Parker moved west, he did not completely disconnect from McLuhan. The two friends wrote letters back and forth, sharing about news and projects. McLuhan was delighted to hear about Parker's

successes and renewed love of painting. A handful of letters survive from 1976, and they concern Parker's enthusiasm about an exhibit of his paintings in Vancouver. Both men faced health challenges during this period, and while geographically distant, still managed to send letters back and forth throughout the year. Prior to his departure, Parker had a delicate pension plan issue to deal with at the university, and this occupied a good deal of time in the early years of the decade—and may have hastened his departure.

Facing some health scares, and uncertainty about his university pension, Parker enjoyed the company of his grandchildren and began planning to show his work around Vancouver and across the country with the assistance of Paul Huang, founder of the Bau-Xi Gallery in Vancouver. He painted watercolours of forest scenes prolifically, and enthusiastically awaited an exhibition he had arranged at the Bau-Xi in Vancouver, which also went to the gallery's Toronto location later in 1977. Parker continued to produce works in watercolours, pastels, and oils, right up to his final exhibition at the Burnaby Art Gallery in 1991, only a year before his death. The catalogue statement (see Davis 1991, 3) for this solo show that included paintings spanning Parker's entire career framed him as a "cultural hero"; despite cycling in and out of the margins, he had made influential contributions to multiple artistic practices over the course of his lifetime that continue to resonate within multiple worlds. The exhibition included a cluster of three watercolour self-portraits on the title wall, with one *Self-Portrait* (circa 1950–1951), featuring his face in three-quarter view, vertically bisected by a shadow running from his forehead along his nose, down along the philtrum, across his lips, and spilling onto his chin and neck. This image became the public face of the exhibition on the front of the catalogue and in press reviews.

This first section of this chapter begins with a reflection on Parker's self-portraits. Nine of Parker's major self-portraits survive, and these stretch from the years 1945 to 1985, with a 32-year gap between the final two, from 1953 and 1985. Most are relatively small pieces on paper, predominantly in watercolour, but with a few in oil as well. Most were executed between 1945 and 1953, and all are in the possession of Parker's two children, Eric and Margaret, and their children. They

were last seen publicly as a group at the Burnaby exhibit. A broad range of self-representations is evident in the self-portraits, and the critical task is to understand how Parker, in quite different ways and in two periods, integrated environmental elements into his paintings, populating some works with contextual markers as well as blending the self with its environment in a progressive depersonalization. Parker's final self-portrait accomplishes his post-1976 withdrawal through a paradoxical diminishment of the person, or an erasure of the distinction between self and environment.

The second section of this chapter furthers the relationship of consequence already hinted at in the father-son pairing. The lines of the creative lives of father and son crossed at key junctures, and the familial relationship was always at play, with its obligations, tensions, and rewards. Shortly after his father's death, Blake Parker donated to the Burnaby Art Gallery some 30 sketches, woodcuts, and monoprints, most of which are early, pre-war works dating from Harley's final student year at OCA, and from his C&B apprenticeship and subsequent typography design position at Eaton's, all in Toronto. There are few exceptions in the monoprints dedicated to Black faces in frontal view, in one instance morphing into a triplex figuration with a third eye, which date from the mid-1950s. The collection of works in Burnaby is marked by a critical social eye on wartime production, struggles around conscription, and the dignity of labour under difficult conditions, especially in the undated *Design for a Mural*, a pencil drawing of a garment factory. Although Parker wanted his Burnaby show to travel, the best efforts of his curator, T.A. Davis, did not generate any interest. This perhaps explains why Blake and his partner Monica Carpendale showed for sale some of Harley's watercolours and prints at their home in Vancouver in the summer of 1994. However, the salient period of analysis was much earlier, in the late 1960s, when both men were at work in their respective creative communities in Toronto, Blake in experimental music, and Harley at the ROM. It has been suggested by Adam Lauder (2015) that "perhaps the most literal application of Parker's design theories was made by the Toronto art-and-music collective Intersystems, which included Parker's son, the poet Blake Parker" (n.p.). I would add here a mutual concern with both

Uncanny Selves and Family Resemblances 89

installation and performance-based arts seasoned with McLuhanisms: one derived from the senior Parker's non-proper, processual, newseum of the contemporary fine and commercial arts; and the other, Intersystems' *Mind Excursion* installation at the University of Toronto.

Fluxes of Self-Identity

Drawing upon some of the observations made by James Hall in his study *The Self-Portrait: A Cultural History* (2014), the nine self-portraits are read as registrations of the fluxes of identity, including spikes of caricatural exaggeration and uncertainty, as well as a number of typical efforts to contextually anchor the figure with the tools of the working painter, namely, brushes, canvases, and a notebook tucked into his shirt pocket. The final work brings to fruition earlier attention to the artist's hair, including moustaches and a heavy beard, in a more graphical, flowing style that allows him to blend into the background, setting the terms of his later years, as his final paintings featured dense foliage and trees from the Kootenays region of British Columbia with no human or animal figures.

Sinister

There are two works in particular that command focused attention: *Self-Portrait*, from 1947, in watercolour, which displays the artist in a sinister light, with an aggressively arched eyebrow and an insouciant flipped-up shirt collar; this is a feature that recurs, but more languidly, later in a *Self-Portrait* of the artist holding a paintbrush with a floppy yet still turned-up shirt collar from circa 1953. However, the second work at issue here is another *Self-Portrait* in watercolour, executed only three years later in 1950–1952, and it is marked by a facial expression of tentativeness and transitoriness, owing to the institutional interior background and the scarf tucked into his jacket, with a diminished detail of reddish hair. With eyes darting to the left and a moustache trimmed above the upper lip, the figure conveys surprise, even annoyance. All of the sharpness of the 1947 work is gone, and the artist's face is softer and rounder, certainly less threatening in its angularity. Although apparently from the same period, this is a man bearing experience, if not carrying longer years. Yet Parker did not abandon his earlier

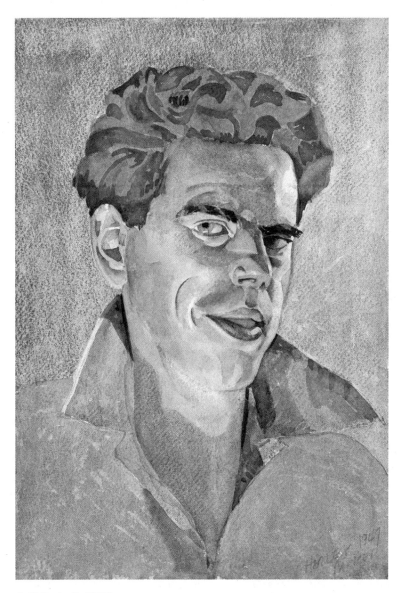

Self-Portrait, 1947. (Used with permission from the Parker Family Estate.)

Uncanny Selves and Family Resemblances

penchant for an elongated face dramatized by shadow and a look of confident certainty. Still, given that there are four self-portraits dated from around 1950, with disparate facial expressions and degrees of placidity, with yellow and reddish hair, with and without detailing, it is worth asking about the significance of this clustering.

Two further *Self-Portraits* from this period (1950–1953; 1950–1954) may be grouped together as yellow figures; both are frontal portraits and use white (1950–1953) and yellow colours. In both, the hair is light, even yellow, with a darker yet light brown moustache; this is in contrast with the redhead works, most pronounced in 1950–1951 and 1947. But the yellow head of 1950–1954 displays a shock of hair with few sculptural details, unlike the redheads.

The 1947 *Self-Portrait* is perhaps a study in facial expression, with a youthful brightness, sinister and devilish slightly arched eyebrow, atop a very wide almost vegetal collar in blue, lips parted, and hair pushed back with its contours marked by shading. The two characteristics, eyes and collar, are highly expressive. In discussing Rembrandt and Dürer, Hall (2014) observes the most highly expressive hair—sometimes "fantastical"—and the "sketchiness" of its rendering, in what is dubbed "a golden age for male hair" in self-portraiture in the early 17th century (152–53). I have noted Parker's yellow and redhead works, but there are controlled blocks and looser, dangling curls (1950–1951), as well. The levels of luxuriance peak with the sinister self-portrait, but it is not through the looseness of strands, but by an almost mineral shading that it is communicated.

Recalling the discussion of the afterlife of *Through the Vanishing Point* from Chapter 1, the *Herald* conversation (McLuhan and Parker 1978, 14) also included a Rembrandt whose play of light and shade evoke Shakespeare's "Sonnet 73" and Scarlatti's Toccata No. 7 in D Minor, with Igor Kipnis on a "busy" harpsichord. This later Rembrandt (with beret and gold chain) cited from the National Gallery of Canada is now thought to be a portrait by a pupil and not a self-portrait, although Rembrandt's penchant for self-portraiture was "taken to a new level," as Hall (2014, 150) observes, but agreement on this point is lacking. Nevertheless, Parker focused in on the "self-portrait idea...of perpetuating yourself in time," which he saw in the autumnal language

and time filters of Shakespeare's sonnet as well. The idea for McLuhan and Parker (1968) was that self-image was created by a public that served as a mirror: "The new public as mirror reveals the private dimension, spurring the new enterprise of self-expression" (105). It became more and more difficult for Rembrandt to find solitude and privacy in his busy studio, as his fame brought many visitors, but this situation heightened the need for it, and perhaps contributed to his penchant for self-portraits as a compromise strategy of self-protection against the glare of recognition: he would be his own public.

Hirsute

Parker's final *Self-Portrait* (1985) is focused on long grey hair and a full beard. Hints of colour persist in the hair and moustache, and the reddish glow lingers on the skin, but the deep, dark sockets around the eyes speak of age and fatigue. The elder Parker's ruddy skin reflects a flowing red force behind and beside his face, either of vegetal or atmospheric origin, but suggestive of the many snow-laden branches and grasses he painted out in the Kootenays during this period. The overwhelming effect is that the figure is intimately connected with his environment, and that he is in the process of joining it, disappearing into it, as it were. This is the force of mimesis, as social theorist Roger Caillois (1984) argued, disappearance through assimilation to one's surroundings. This late *Self-Portrait* is an exercise in subjective subsidence, accomplished by heightening the effects of flowing hair and red paint. The neatly mustachioed gentleman of the earlier self-portraits has given way to a wavy-headed elder. But this hairy self-portrait does not lend autonomy to the hair. On the contrary, it is a question of entanglement and of a luxury that is neither extravagant nor decorative but indicative of assimilation to one's surroundings. This hair piece differs from the remarkably expressive chin puff captured by photographer Yousuf Karsh in his polaroid portrait of *Harley Parker* (1968), the delicately lit strands of his chin hair reaching outward as the downward pointing eyelashes of the sitter diagram a reflective attitude. The artificiality of this pose contrasts with the organic and fluid final self-portrait.

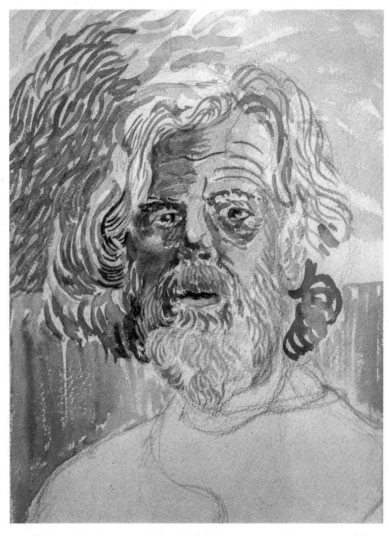

Self-Portrait, 1985 (unfinished). (Used with permission from the Parker Family Estate.)

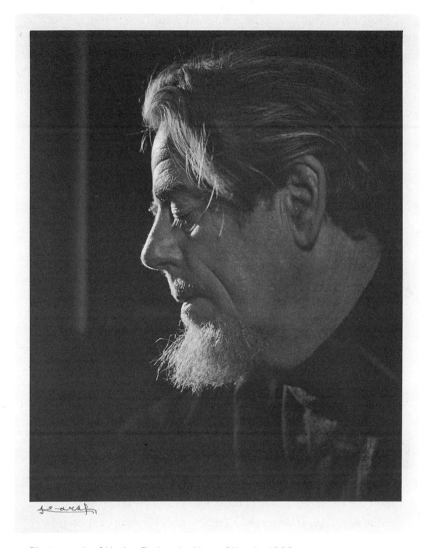

Photograph of Harley Parker, by Yousuf Karsh, 1968. (Used with permission from the Estate of Yousuf Karsh.)

Uncanny Selves and Family Resemblances

Self-Portrait (1985) remains unfinished. According to Harley's son Eric, the fact that his father retained the piece and didn't "cancel" it, a not uncommon practice in which the work is retained as a reference but crossed-out, is significant, given that formally "parts of this portrait are definitely 'not working', but I think the important parts are very powerful."[1] Margaret Parker confirmed that Harley considered painting in watercolours to be the "most difficult of mediums because you had to get it right the first time." However, she found the piece "disturbing" as it represented a time of difficulty for her father. The chilling, startled look in the eyes indicates some recognition of a fundamental slippage. To the degree that this slippage is incomplete at this juncture, or working slowly in the sense of a gradual entropic decline, the work is formally unfinished, somewhat experimental and biographically revealing. It is almost as if a warning has been sounded, and thus it brings the problematic of that recognition—by both the sitter himself and the viewers closest to him—to the fore.

Art College

Although Parker did not include any other figures in his self-portraits that would identify major influences, friendships, or even family members, there are a few interior details that mark his art school milieu while teaching at OCA in Toronto. Indeed, the bulk of his self-portraits were painted during his years teaching at the college. Hall (2014, 131) explains in detail how the process of painting and the artist's studio were mythologized in self-portraits throughout the 17th century, but Parker did not rehearse any of the obvious examples from the Dutch Golden Age, such as Vermeer, or French artist Poussin, or Spaniard Velàquez, all discussed by Hall in depth. The trappings of painting are visible in Parker's work, however, with the quintessential example of the *Self-Portrait* (1953, the year he taught watercolour painting and theory of colour courses) featuring the seated artist clutching a paintbrush vertically, and in his shirt pocket is found a notebook, with a painter's rag draped over his knee. The background contains elements of built forms, giving the impression of a studio space. A second example is found in *Self-Portrait* (1948), a watercolour of a young Parker executed with minimal colouration and delicate brushwork, in

which the artist grasps the top corner of a sketchpad or canvas and gazes intently toward his subject, which is presumed to be his own image in a mirror. The earliest painting is a *Self-Portrait* from 1945 (pre-OCA), in which a thin, red-mopped Parker with a smudgy moustache clutches a bundle of paint brushes and stares at the viewer, whose gaze is unerotically drawn into his deeply unbuttoned shirt.

No masks; no groups; no abstract assemblages; no self-referential relics; and Parker never presented his entire body. There are only head shots, and two self-portraits that reach down in any significant way toward the waist. The pathway I have marked through the nine paintings discussed here passes through a sinister persona that plays with malevolence through aggressive eyebrows and a darkened brow and exudes a hardness of character expressed in the sharpness of the lines and features of his face, not to mention the impressive block of hair on his head, a truly hirsute painter. This path cycles back and forward through self-portraits of the artist as painter at work and in place in a studio, where he is approachable, even chaste, and contained by his industry. Hair, though, is the most expressive characteristic of the painter's self-imaging, with loose insouciant curls and a hefty headdress with horn-like shading, sometimes yellow, sometimes red, until the final ultra-hirsute Parker, resembling the features of the landscape he detailed in his later years. The fluidity of self not only refers to trying on identities and playing with expressive features, but also culminates in a subjective detumescence: the slow draining of selfhood. If one can entertain the notion of a hairy and, indeed, bearded media, as an extension of one "man" it becomes entangled in the vegetal networks of life and death. These are less additions than a breakdown of self, and thus an environmental entanglement by decline.

The Winter of the Senses

Everyone's heard about the summer of '69, but I want to revisit the winter of '67. Not the summer of love, but January and February to be precise: the winter of the senses. However, it will be productive to isolate two events in the aforementioned months in order to solidify this observation in terms of the father-son relation announced prior: the first is the opening in the last week of January of the elder Parker's

masterwork, the Hall of Fossils at the ROM; and second is the building and opening of Michael Hayden's *Mind Excursion* installation for *Perception '67* at UC in February. During those two months, the dailies in Toronto and New York were chewing over the Hall of Fossils' opening, each trying to outdo in wit the McLuhan in/of the museum motif (Grescoe 1967). Then *Mind Excursion* burst onto the Canadian arts scene as a strange psychedelic, built environment that would catalyze the founding of Intersystems, help Blake find his voice, and put Intersystems on the international map of kinetic art. By the end of the year, the elder Parker was being referred to as "Marshall McLuhan's assistant oracle" (MacKenzie 1967, 20), as he would substitute for his much too busy colleague at UC's extravaganza Babel: Society as Madness and Myth in January 1968.

Sculptor Michael Hayden had exhibited successfully a number of kinetic pieces in Toronto and New York in 1966 at Gallery Moos and Martha Jackson Gallery, respectively, and had begun collaborating with Blake Parker, who contributed textual elements but had not yet begun to perform and record them himself. By 1967, *Head Machine*, featuring composer John Mills-Cockell's soundscape and Parker's recorded recitations, an "environmental container with its own sound and light systems and a timing device which programs the action of each piece in the whole," but within an 8' × 8' × 8' cube, was shown at the National Gallery of Canada (1967/1968).

Intersystems as a trio was born at the Hayden-coordinated *Perception '67* in February at UC in the University of Toronto, a psychedelic event featuring visual art, music, and poetry, and a range of countercultural luminaries, organized by the undergraduate University College Literary and Athletic Society, at that time under the direction of Jane Markowitz. *Mind Excursion* was a built structure located in the college's cafeteria, and was attributed to its designer, Hayden; it was a 10-room maze that heightened by parcelling sensory experience into rooms by means of modifying floor and wall and ceiling surfaces augmented with various substances including chocolate, cotton balls, and candy, as well as projections of images, strobe lights, soft and hard substances for shoeless visitors, live dancers, and low ceilings. Given its room-to-themed-room sequentiality, a given trip—the festival theme

was LSD, after all—would result in a series of experiential transitions rather than a true multi-sensual simultaneity. While Marshall and Corinne McLuhan attended the event, McLuhan was not on the bill; the following year, Harley Parker gave an invited talk at the annual UC arts festival alongside Vance Packard. *Mind Excursion* was later reconstructed in 1968 in Montreal (including a Mindex Department Store that sold packaged art objects, giving those in attendance the notion of "exiting through the gift shop," an early referent; Reid 2015, 98). *Mind Excursion* was, however, a three-part work consisting of the soundtrack, the third Intersystems album, *Free Psychedelic Poster Inside*, and Blake's narrative for *Mind Power*, a collectively produced bilingual graphic short story borrowing from group members' family photos (in addition to photos by Brian Thompson) to tell of the courtship and marriage of the fictional Gordie and Renée, an ordinary couple whose experiences are mapped onto the excursion thematics (e.g., the room of mirrors, confetti room, pastoral room).

Hayden, Parker, and Mills-Cockell first performed live together as Intersystems in Vancouver at the Vancouver Art Gallery's spring 1967 event *Direction '67*, an "electrosonic" installation and performance held in near darkness. When Mills-Cockell acquired a Moog Modular synthesizer in 1968, Intersystems' public presentations were enhanced, and the machine became a performer in its own right, especially at its first appearance at the AGO in March 1968 during the band's *Duplex* performance (later revisited at Carbondale courtesy of Buckminster Fuller). A new member was added, architect Dik Zander, who had been active already with Hayden during the construction of *Mind Excursion*. *Duplex* was again architectural in inspiration, with Mills-Cockell and Parker (voice and sound) on the ground floor and Zander and Hayden (lights and projections) upstairs, and Parker reciting a tale of an ordinary duplex, of laundry machines, and framed diplomas on the walls. This motif would become progressively darker as Parker troubled domesticity and suburban life (Storring 2015, 89). Parker was a poet of the everyday, of the foreboding ordinary. Intersystems would only survive until early 1969, after their performance of Network II at the Masonic Temple in Toronto.

The environmental impetus in kinetic art, which moves toward collapsing the space between work and spectator-participant, the latter being brought into close contact with movement, colour, and light, underlining psycho-physical experience in a defined and controlled space (Popper 1968, 204–207), was shared with Intersystems' built environments, especially *Mind Excursion*, and some of the tools that the elder Parker utilized for the Hall of Fossils, including a range of invisible triggers and pressure sensitive mats, a low cloth ceiling, round walls, sand and shells on uneven flooring, and a bank of wall-mounted dial-less telephones delivering recorded messages in lieu of typically printed didactics. Frank Popper gave a lecture at the AGO on kinetic art in February 1968, and Intersystems showed later that year, as part of the *Canadian Artists '68* exhibit, a series of acrylic tubes filled with fluorescent dye that glowed under black lights. Parker's (1967b) goal was to make the "changing sensory orientation of the public" a key factor in inventive exhibition design as, he cited, much can be learned from psychedelic events (296). Psychedelia refers to an era of pop and rock music normally encompassing the last three years of the 1960s, the youth culture associated with the use of mind-expanding drugs such as LSD, multimedia experiments with altered perception in sound, and the creation of new environments for performances encompassing music, theatre, dance, and projective media. Both Harley's and Blake's activities can fit into this general definition, and examples of psychedelia in art often include multimedia environmental elements and multidisciplinary activities that affect the perceptions and consciousness of participants, as in the work of Don Snyder, Jackie Cassen, Rudi Stern, and USCO. As Robert E.L. Masters and Jean Houston (1968) explain in *Psychedelic Art*, "environments most often fall within the definition of psychedelic art because those based on the experience of altered consciousness are the easiest kind to create, especially for an audience outside the psychedelic community" (140). The effects that environments have on perception, the artistic "forced imagination" of the participant, are best realized in a full-body immersive space, such as a small room, "cave," or other space of envelopment saturated with moving bodies, sounds, and lights, like a discotheque. Masters and Houston (1968) exposed a tendency to collapse two

different influences: "with inter-media, mixed-media, and multi-media [and Anthony Martin's Ultramedia used at the Electric Circus in New York that so impressed Parker] we get into an area that is psychedelic or McLuhanesque depending on whom you're talking to" (150). Certainly, McLuhan was ambivalent about LSD, and Parker was highly selective about championing countercultural event spaces, yet it is not difficult to grasp that in building galleries of experience, countercultural points of reference were invaluable. As Parker put it in *The Culture Box*: "museums properly used could present mind-blowing experiences" (2025, 116). "Experience" signified for Parker active sensory involvement, vivid immersion, and ongoing re-orchestration of sense ratios, as opposed to galleries of objects, which rely on "dispassionate perception," single-sensory stimulation, and sequential elaboration. In order to realize this ambitious idea, Parker (2025) wanted to "take museums out of museums" (124) as adjacent exhibition centres.

While a case can be made for broad overlapping extra-psychedelic (drugless trip) themes in Parker's late 1960s collaborations with McLuhan in print and film media (Storring 2015, 84), when Blake Parker found his voice and began performing live his poetry for Intersystems, as it had hitherto been rendered and recorded by others, a fact he allegedly disliked according to Hayden (2015, 26), then a controlled exploration of integrated multi-sensory elements emerged, and the possibility of taped performances within the plastic elements of specially built environments could take place: Blake Parker moved from published poet to spoken word performer, making kinetic art and records, and performing live, sometimes inside of the structures themselves (*Duplex*, performance, 1968). In its initial incarnation, *Mind Excursion* only stood for two days, a far cry from the long term of the Hall of Fossils, which captured the liveness of its many enthusiastic young visitors. While Hayden had insisted on exploring olfactory differences amongst the "programmed" rooms of *Mind Excursion*, Harley Parker once joked that it would have been appropriate to infuse the entire Hall with the smell of rotting fish to augment the bird, storm, and other sounds and pre-recorded voices, both thundering and quiet, not to mention the flashing lightning and film projection of a wave overhead: in the process, de-emphasizing the graphical, eschewing

naturalism for abstraction, in pursuit of a carefully deduced audience. The installation of elaborate smell-scapes—the failure, Parker noted (2025, 111), of "smell-o-rama" to catch on as a cinematic experience—was difficult if not impossible to realize, even as an affective trigger rather than a reproduction of odour. It was not until sensory designers turned their attention to "scentscaping" through the use of surface materials that exude gentle odours that olfaction came into its own as an option for interior design otherwise rendered antiseptic and sterile (Lupton and Lipps 2018, 113).

The Hall of Fossils was less boxy and more sensorily integrated than *Mind Excursion*, with its calculated sequential changes and hyper-concentrated atmospheres. Still, the Hall relied on fairly standard built motifs of museum design like dioramas, and borrowed the semi-circular ambulatory from church architecture (Nagel 2012, 164–65). *Mind Excursion*'s rhetoric of programming and its floor plan, viewed from above in standard architectural bias, may have forced an altered sensory experience into tight spaces and thus intensified it, without reflecting on the control elements of interplay imposed by structural factors. Indeed, Intersystems did not have an institutional critique (see Genosko 2023a). It fell back on parodic gestures, such as the non-CVs the band members submitted to the AGO as background for the three nights of *Duplex*. Using City of Toronto's Board of Education application forms for non-teaching staff, Blake Parker listed no formal post-secondary education, but noted his junior public and high schools, cited his production of tape poems with Hayden prior to the formation of Intersystems, as well as further tape pieces with Mills-Cockell, along with a handwritten list of performances in galleries and colleges. He was educated in the school of life, from the year of his birth to the year of this document. He did, however, receive a grant from the Canada Council in 1967, but no details were given (B. Parker 1968). Nevertheless, the late art historian Dennis Reid singled out Intersystems as a bright spot in an otherwise fragmented and ingrown Toronto that lacked a "supportive 'cultural matrix'" that would lift artists out of their isolation. For Reid (1970), *Duplex* was a prime example: "working with a barrage of sensual stimulants and communicating devices they bathe the audience in light and sound. Their projects

are most successful when most theatrical, and they now have performed on and off the stage in various communities in Canada and the States" (35). The AGO believed that the audience for *Duplex* would be drawn from the downtown Toronto colleges and universities, and it collected clippings from a sympathetic student press in its files. The performances followed closely on the heels of the John Cage-Marcel Duchamp chess match on the wired Reunion board, devised by David Tudor and Lowell Cross, staged at Ryerson Polytechnic on March 5th, with McLuhan in the audience (Cross 1999). Blake Parker was highly praised by the *Toronto Daily Star* journalist covering the event, who called his performance "remarkable." Paradoxically, it was when Parker read his poetry that the barrage of sound and light receded into the background, and his individuality was exposed, despite the reporter's nagging belief that the power of integration of all facets should have prevented this from occurring (Dexter 1968).

By the end of the 1960s, Harley Parker had returned to typographic experimentation and book design in the rollicking pages of McLuhan's *Counterblast* (1969a). *Counterblast* can barely contain the Lewisian eruptions of print, and the niceties of print craft are gone—no more colophons, no more nods to the ink and paper producers. Yet the designer's name is on the cover, in capital letters, fixing identity and authority, a hard-won acknowledgement that uses its power in the pages of the book to disorient and disrupt in grand gestures of de-signifying glitches and the construction of word-objects whose stability goes only as far as the foreign translations that of necessity remodel them. What Parker taught us about print culture is that a page is a process, speeded up by translation, slowed down by a redesigned reprint. And, as he wrote with McLuhan in the preface to *Through the Vanishing Point* (1968), "labels as classification are extreme forms of visual culture" (xxiv). He favoured a gallery that limited (or eliminated) their use and transformed them into recorded messages and projections that eroded stable visuality for the sake of new movements and relations. Opportunities for releasing new intensities were taken by Blake Parker when he decided to record his own poetry for art works and to perform it live, becoming a vocalist (a spoken word singer) in an experimental band. Harley Parker, in moving Flexitype from a commercial to an academic context, initiated novel intensities of aesthetic and conceptual relations.

Blake Parker was only 24 years old in 1967 when he joined forces with Intersystems. It would not be until 27 years later that he rejoined his former bandmates, Mills-Cockell and Hayden, to produce the lyrics for the performance piece *Stella! Black & White* (B. Parker 1994). Parker considered himself a multimedia artist, and in addition to his posthumously published poetry (2011), he wrote an extended narrative piece, an operatic text, that was self-released on cassette. The piece was written as a monologue that details in a series of scenarios the attempts of a character named Dr. Skinner and his associates to steal Stella's soul. The main subject of the piece is representation, and the nefarious doctor's attempts to insert himself in between an image and the body it represents in order to deprive the body of its capacity to be represented. The Faustian motif is augmented by the blue light of television in which Skinner likes to work, and the resistance is provided by Reverend Billy Flame's radio evangelism: he is a ladder to paradise, against Skinner's snakes in the children's game of Snakes and Ladders. He is the keeper of the blue-skinned and rainbow children and telepathic animals. Stella finds herself in a strange hotel lounge, bathed in the blue light of a projection, in which both men appear. Parker's Tom Waitsian voice is balanced by jazz vocalist Leora Cash's sung sections. The Beatnik lyricism that weaves technology in and out of metaphysical concerns about virtue and vice, and the sonic characterizations of the protagonists, trace the transitions undergone between colour and black and white. The huckster Skinner runs a Terminal City (the name of this Parker's final project) body emporium where new bodies can be purchased off the rack; and the reverend reminds everyone that a product is rarely what is advertised. Skinner runs a late-night television broadcast on Channel 13, a molecular television that seeps into consciousness: "to be is to be perceived." But this is a dangerous proposition. Skinner deploys one of his inventions: a blue light suction device that extracts Stella's reflection, draining her of subjectivity, siphoning off her dreams: "her solarized reflection comes off slick as a whistle." The lesson of representation is that "a photograph is a photograph but it ain't living like real people." In *Stella! Black & White*, Parker recoded the cool (television) hot (radio) distinction into that

between a high-tech devilry versus a telescoped sales pitch, and these struggle for dominance in what is essentially a morality play.

Harley and Blake stepped into the public light around the same time, but in quite different worlds, that of a university-based natural history museum as opposed to a countercultural electronic music group that gained more of a critical than popular following. Rather than look for direct lines of influence from Harley to Blake and Intersystems, it is rather that both borrowed from the prevailing psychedelic bohemian cultures in art, music, and performance, adapting the principles of kinetic art to their installations, with greater and lesser permanence. Indeed, Storring (2015, 80) used the idea of "cannibalizing" to describe the heady "anarchic polyglot" of Intersystems. Storring (2015), like Lauder quoted earlier, made a direct link between father and son, stating that Blake's "emergent creative work was no doubt coloured by the Beat poets—[William] Burroughs in particular—but also by his father Harley Parker's various artistic proclivities. The elder Parker was not only a painter, writer, and curator but also worked, parallel to the development of Intersystems, as a research associate at the Centre for Culture & Technology...His focus there was probing the relationships of contemporary artistic and scientific disciplines" (83). While much of Harley's research work with McLuhan involved sensory effects of new electronic communication, including television, to call it scientific would be to neglect the array of source materials assembled on the subject. There were, of course, key studies, such as the one by Dr. Arthur Hurst—optometrist and founding member of the Centre for Culture & Technology—on the causes of myopia in grade school children, a key text for both Parker and McLuhan on the waning of vision (psychological not physiological) and media demands for sensory adjustment from reading print to watching television (Parker 1964a, 111). It may be a surprise for some to appreciate just how far Blake's writing and spoken word performances strayed from McLuhan's ideas by the time of *Stella! Black & White*. The blue glow of television had acquired a rather diabolical edge. Yet, both Harley and Blake integrated contemporary artistic and cultural practices in order to highlight sensory reordering, envisaged by Harley in a redesigned gallery space, and by Blake in the

performances of Intersystems, combining architecture, multimedia light shows, and electronic music courtesy of Mills-Cockell's Moog Modular synthesizer, a rare instrument in live music performances in Toronto circa 1968. Blake's posthumous performance through his electronically simulated voice on *Intersystems #IV*, released in the spring of 2021, a long overdue follow-up from the band's heyday more than 50 years earlier (also minus Zander), is an eerie reminder of a slam poet before the letter, whose spoken words are not only bathed in pure electronic sounds, but are themselves just that.

Strangely Familiar and Yet Unknown

The psychoanalytic theory of the uncanny is built around the tension between the familiar and the strange, that is, the unhomely or *unheimlich*. Freud (2001) specified that it was the prefix "un" that served as a "token of repression" (245). What was once familiar becomes unfamiliar through repression, and the experience of alienation occurs when the repressed returns. Indeed, the conjunction of fear and recurrence enables Freud to define the affective contours of the uncanny. Parker's final self-portrait displays fear in the eyes of its subject, expressing the encounter with the uncanny. Through the kinds of relationships between self and others that sow seeds of doubt about identity, Freud's (2001) comments may be applied to the painting in question: "a regression to a time when the ego had not yet marked itself off sharply from the external world" (236). The subjective detumescence in this self-portrait is uncanny precisely in the sense that it vividly captures an infantile encounter with the blurry borders of the subject-in-formation, in the form of the landscape that Parker painted regularly.

The "secretly familiar" element of the uncanny can be applied to the poetry of Blake Parker and its electronic reanimation in the most recent music released by Intersystems. Although during the band's brief peak period, it was not uncommon for the producers to subject Blake's voice to microphone treatments in both recording and live performance, the computer voice created by William Blakeney for *Intersystems #IV*, which machinically enunciates Blake's words, displays some elements of Freud's discussion of the uncanny effects

within fiction and the arts. Especially significant here is that spoken words, rendered electronically, blur the lines between human and machine and exploit the fear associated with the "resuscitation of the dead," albeit in aesthetic terms. The synthesized voice strongly recalls Blake's performances, not only the improvisational, narrative, and Beatnik elements, but the fact that his voice was already on many occasions, during his lifetime, subject to electronic augmentation. The closing of this circle generates uncanny effects, especially anxiety around the man-machine assemblage across the divide between the living and dead.

In *Counterblast*, McLuhan (1969a) wrote in Parker's dancing, implosive text: "Blast LSD, forlorn strategy of chemical warfare against the bombardment of our sensibilities by the man-made environment" (6). McLuhan and Parker were not supporters of drug experimentation, and in calling LSD "sad" as far as a coping mechanism was concerned, they effectively distanced themselves from the use of their ideas within the countercultural community in support of psychedelic mind expansion: "If McLuhan is correct in viewing the artist as the radar warning system of society, then the psychedelic artist is the oscilloscope of the altered consciousness" (B.N. Schwartz 1968, 161). The cat, as they say, was already out of the bag. McLuhan and his collaborators had a good deal to say about the role of the *inner trip* in the electric-electronic age, calling it "the real space of our time" (McLuhan and Nevitt 1972, 259). His emphasis on the present, however, swallowed up all times and spaces, so that any trip could be anywhere. This approach calls into question the psychedelic bona fides of the *Mind Excursion* project, at least from McLuhan's perspective: *Perception '67* was conceived of as an LSD festival of art; the indirect promotion of illicit hallucinogens on campus frightened the student organization sponsoring the event, not to mention the college's principal. The *Mind Excursion* exhibit, which sought to simulate "some of the sensations produced by a psychedelic trip," was one of the least criticized events, perhaps because it sought to evoke rather than merely realize it chemically; in fact, it was praised in the press as a successful "experiment in disorientation" (Levi 2006, 180–82). The attempt to build an installation that simulated an inner trip, however, was of interest to both McLuhan and Parker, with the

qualification that inner trips were not drug-fueled but a product of the acoustic spaces, sensory mixes, and speeds of the electric environment. For them, drugs were simply secondary to the electric environment. Indeed, while psychedelic artists enjoyed invoking McLuhan's name as an influence or guide, his response, as W. Terrence Gordon (1977) explained, was often puzzlement: "Any multimedia artists who claimed to have drawn inspiration from McLuhan for existential commentary via strobe-lit exhibits of ball bearings cascading to the beat of heavy rock drove the inspirer away, asking 'What has this got to do with my work?'" (231).

Private Turmoil

Parker's public achievements during what may be called his golden year of 1967 were exceptional, yet his private life was in turmoil. He permanently separated from his spouse Mary (1913–2007) and moved into the Windsor Arms Hotel on St. Thomas Street near the University of Toronto, before decamping to New York. Parker's son Eric had earlier in the decade visited New York with his father and McLuhan, marveling at the then recently opened Guggenheim Museum, and Margaret had also visited her father there several times during his Fordham year. Parker's struggle with alcohol use disorder intensified through the mid-1960s. Upon his return from New York, he lived alone in a Bernard Avenue high-rise apartment. From 1972–1976, Margaret pursued an arts education at OCA (where both her parents had taught), with an additional year in silver casting in 1977, before subsequently moving to British Columbia and adopting a "hippie lifestyle."

Listed by her married name, Mary Parker taught for nearly 10 years at OCA, from 1954–1955 to 1962–1963.[2] She delivered the English and Literature course in the Foundation program, which was directed by Fred Hagan (who taught drawing). OCA was at that time split between the Grange Park and Glendon Hall campuses. While Harley was a general course instructor teaching watercolour painting and colour theory, Mary designed course content around writing exercises, modernist prose, and poetry (Eliot, Thomas, Miller), as well as selections from the journal *Explorations*—"ideas about the effect of the mass media on education" (OCA 1959, n.p.) and art theory from the 1950s (Herbert

Read's *The Meaning of Art*, Brewster Ghiselin's *The Creative Process: A Symposium*).

Harley's most extensive involvement in the college stretched from 1950–1951 to 1966–1967, with a few years of absence (1961–1962 and 1967–1968). Parker was primarily an instructor in the drawing and painting stream (alongside Carl Schaefer, painting techniques; J.W.G. MacDonald, drawing and painting; Eric Freifeld, life drawing and anatomy; Will Ogilvie, painting and murals; Aba Bayefsky, watercolours), but also took up the role of visiting lecturer (1960–1961) when he was not teaching, as he was then employed full-time at the ROM. In the early 1960s, some of the original *Explorations* group members served as visiting lecturers at the college: psychologist Carl Williams (1962–1963), political scientist Tom Easterbrook (1963–1964), and of course, McLuhan (1963–1964). It is not hard to see, then, an inter-institutional through line in the peregrinations of *Explorations* group members, with Mary and Harley making local arrangements for hosting visitors.

The Parkers were both teaching at OCA when the "new college" on McCaul Steet in downtown Toronto opened for the 1956–1957 academic year. Social designer Victor Papanek had arrived the previous year to teach design, and Allan Fleming began teaching typography the following year. Designer Carl Dair was a visiting lecturer in the 1958–1959 year and continued for several years in this capacity. Parker would eventually collaborate with Dair (on *Through the Vanishing Point*), and early in *The Culture Box* (2025), he picks up on Papanek's sense of the designer as "community problem-solver" (5) in order to enhance the status of, and create an opening for designing with social and moral responsibility. This entailed for Papanek taking part in international service abroad through agencies such as UNESCO to assist in designing locally manufactured sanitation infrastructure for the developing world, and versatile educational media hardware like televisions; pursuing ecological considerations (e.g., recyclable dishware); serving minorities and disadvantaged groups (e.g., enhancing assistive devices) by reversing "design discrimination" against large portions of the population (the young, elderly, physically challenged, left-handed, and poor); and elevating safety standards across industries. In short, as

Papanek (1972) put it in *Design for the Real World*, the designer's "only allegiance will be to the 'direct' clients, the actual users of the devices, tools, products that one designs" (97). Papanek's (1972) work on designing for the blind and pursuing the goal of bringing members of disadvantaged groups themselves into the design process (113) inspired Parker's research agenda in disability studies and sensory re-stimulation during his year at Rochester.

Eric visited his mother in India at a private ashram near Haridwar to which she belonged through her local yoga group, which also had two communal houses located near Toronto in Pickering. Eric acquired a lifelong interest in India, especially its musical traditions. In the 1960s, he was "fully engaged in the overall enterprise including building houses and digging wells but only after personally entreating Indira Gandhi to give us land to build the ashram. She didn't deliver but the ashram was built over the next several years." Margaret kept in contact with her mother over the years, and Mary remained part of the ashram up until her passing during the same year as Blake, in 2007. Eric had "left the yoga group in 1974 after a tumultuous break and sadly it was years before I fully reconnected with my mother."

The Hall of Fossils at the Royal Ontario Museum

HARLEY PARKER DEDUCED, in theory, ways to reach a specific audience with his museum exhibition designs, but struggled in practice. Conceptually, he deduced an audience of late 1960s teenage youth culture, especially counterculture, whose sense ratios had been shaped by television, rock music, and communalism—one that largely did not manifest itself physically in the museum space where he worked, that is, the ROM, then a university museum integrated into the University of Toronto and now an agency of the province of Ontario.

Instead, the audience he gained was much younger, namely children, whose openness and curiosity he valued, but as a means of reaching others over the long term. Even here the missing middle (teenagers and "hippies") remained a question mark. Indeed, Parker called for greater attention to museum audiences in general, at least as much as that given to collections of artifacts themselves. Reaching beyond attendance numbers, Parker devised thought experiments in exhibition design, as well as building experimental installations like a multimedia "orientation gallery" that would produce an "interim" period of adjustment for visitors, from their everyday sensory

environments to worlds other than their own: the encounter would be a sensory mix familiar from their own world, but about or upon which they may not have reflected. Parker described, "I'm bringing into their consciousness the fact that this is the way they think, because if you're totally unaware of the way you move through your world, it's going to be very difficult to come into a different world. I'm trying to bring into consciousness the way we orchestrate our sensibilities, and I'm also trying to reach a rapprochement with the audience of today" (McLuhan and Parker 1969, 68). In short, "by heightening consciousness, you heighten perception" (69), and this, Parker speculated, might be accomplished with an adjacent gallery of reception or preparation. A large part of the general audience needed a transition space, whereas those who had already transitioned to contemporary sensory mixes—children in part, and in a distracted way, and many teenagers in particular—could seamlessly, but in different ways, enter into an exhibition where total sensory involvement and immediacy would be familiar. This contemporary "training of perception" was contrasted with a more traditional visual "education by concept." The reflexive, critical alignment of sensory biases between exhibit and audience was the goal of Parker's design. The fact that Parker used the term "hippie," which some scholars reject (Elcock 2023, 12) as a word no countercultural person would apply to oneself, suggests his interest was in popular terminology and linguistic innovation, and not in sociological accuracy.

In revisiting a number of Parker's conceptual and practical formulations and expressions of his search for specific audiences, I will formulate and critically unpack a series of pseudo-equations inspired by the work of art historian Alexander Nagel (2012) on Parker's museological thought. I am primarily interested in how Parker sought to reach a cogently conceptualized audience that, while deducible from a variety of theoretical postulates, remained an elusive institutional target. This audience of the teenager and countercultural "hippie," exemplars of the contemporary world of communication "nowness," proved elusive—knowable but not easily organized—for an exhibition designer in a natural history museum in Toronto during the late 1950s, at least up until 1967, when Parker took a leave, never to return. After a leave of absence that began

on September 1, 1967, he resigned his post on June 30, 1968. His avant-garde masterwork was gutted in the 1978–1984 renovations of the ROM.

If the elusive spectator-quarry did not respond to the promises of Parker's gallery designs, which played along with the tune that youth culture was already generating, his efforts were not exactly in vain. Rather, they led to an intensification of his repeated calls for more audience research, to be undertaken in an interdisciplinary spirit.

Before examining the successes and failures of the Hall of Fossils, I will consider in some detail Parker's 1963 paper "The Museum as a Communication System," in order to excavate his conceptions of orienting and disorienting museum visitors. This early McLuhanesque reflection on his work at the ROM seems to have been forgotten among museum leaders in Canada.

Attributing his ongoing fascination with the museum as an electronic facilitator of the global village to his undergraduate work with *Explorations* group member Edmund Carpenter and to his exposure to McLuhan's ideas, George F. MacDonald—the anthropologist of West Coast First Nations influential in shaping the Canadian Museum of Civilization (CMC) in Hull, Quebec, serving as leader, from 1982, of the new accommodation task force of the old Museum of Man, and later as director and president of the CMC, as well as of the Bill Reid Foundation—overlooked the articles of Parker, whose practice-based applications and explorations of McLuhan's ideas from within the museum predated his own by several decades. When MacDonald (1987; 1991) did include mention of Parker while recalling his philosophical debts to McLuhan and Carpenter and the latter pair's unrealized projects at the fusty ROM, he seemed unaware of the Hall of Fossils. Indeed, when MacDonald wrote about the "museum as communicator…[where] the old artifact-centricity is abandoned in favor of the total experience" (MacDonald and Alsford 1989, 44), he would have profited from knowledge of Parker's available published works and, of course, *The Culture Box*. Just in case there is any doubt about the use of the term "total experience," already Tom Wolfe (1967) had reported on the design for the Hall of Fossils by "a McLuhanite named Harley Parker," for a gallery of "total sensory involvement," and "not just a gallery of data, but a total experience" (27). Parker's

coinage concerning the museum of total sensory experience is still in use today as a perspective on the "performative" museum's provision of multi-modal experience, often with no mention of the deep roots of the concept (Kjaer 2016), but with the same emphasis that Parker placed on smell, sound, and light for embodied experience.

MacDonald's colleague from UBC, Robert Kelly, established a plan for cultural tourism for the CMC and reinforced the idea of elevating user experience through the institution's mediation using new information technologies that would provide multimedia entertainment. But MacDonald remained silent on Parker's turn to the challenge of representing Indigenous Peoples in the museum, considered in his 1963 paper in the hypothetical galleries discussion (see Parker 1963a). I will offer, then, a close reading of Parker's article through his recourse to Indigenous examples in his hypothetical gallery construction exercises. Parker was not engaged in a decolonial critique, yet he did call into question the neutrality of the historical knowledge and memory generated by museums as agents of colonization. To be clear, Parker posed the question about who collects, but did not invite direct Indigenous participation in gallery design and artifact interpretation. He nonetheless managed, through his deployment of McLuhan's ideas about the role of perception and sensation, to trouble an existing paradigm of representation and to further a process of institutional change with regard to the roles of new information technologies, collaboration with Indigenous artists and Elders, and the audience edutainment still underway during MacDonald's tenure at the CMC in the late 1980s and early 1990s.

Before the Hall

In the article "The Museum as a Communication System" (1963a), Parker explained the need for non-sequential histories and non-linear narratives in exhibition design. He argued for the selection of architectural forms that would capture sensory simultaneity, like domes, as opposed to rectangular glass-shelved display cabinets, and explained how audience experiential feedback (and decision making on the spot) might be used to modify the kinds of information presented in

the gallery. Parker mastered a critical approach to habit, bias, and the uncreative side of technologies of display.

Picking up on the ideas of Dorothy Lee from *Explorations*, Parker maintained that museums lagged behind the waning of visually-biased lineality in 20th-century culture at large (his examples included Cubist painting and certain adaptations of German warfare in WWII; see Parker 1963a, 352–53). His argument hung on the idea that museums need to reflect, and he used the idea of "mirroring" to express what museums have thus far failed to do, broader trends in cultural and sensory reorganization in the displacement of the visual by the audio-tactile. In support of this claim was his supposition that museums approach presentation largely "implicitly," and without reflecting on lineality as a guiding, yet buried, principle. Continued adherence to an idea such as "a museum contains artifacts that should serve as illustrations to a story line" (Parker 1963a, 353) does not advance museum presentation in the present. It certainly does not acknowledge the "trauma and tension" of a coexisting waning older attitude with a waxing new one, as McLuhan (1962) insisted in the closing lines of *The Gutenberg Galaxy* (279), which Parker (1963a) took as a realized critique, quoting McLuhan in the process for a "complete explanation" (353). However, Parker (1963a) introduced in this early essay his idea of "reorientation": understanding the active sensory ratios of a variety of cultures "would provide the designer with insights which would permit him to organize artifacts and their methods of presentation so as to reorientate the spectator to the attitude required for an appreciation of a particular culture" (353).

Lauder (2011) has drawn attention to Parker's phrase designing "for a new ordering" or "a new montage" (53), which he utilized in this manner: "A really contemporary museum attempting to inject simultaneous insights of varied cultures into the complex *Gestalt* of contemporary life needs a new ordering" (Parker 1963a, 355). Designing for a "total sensory response" is adequate to a correctly deduced audience, the culture of which is embedded in electronic media, even if this audience is actually difficult to reach. Such "a new ordering" is supported by a series of contrasts between old (left) and new (right) modalities:

Data as Content (Structured Facts)	Data as Structure (Interplay of Facts)
visual	multi-sensory
passive receiver	active participant
single point of view	multiple points of view
packaged	unpacked process
segmented	interperceptual

A difficult-to-reach audience is one that is not fully available to realize the participatory requirement, that is, involvement, with the new ordering, leaving it unfulfilled (the audience part of the environment is missing). This forms part of what Lauder (2011, 56) has astutely called the "ambivalent legacy" of Parker's designs and of the concept of participation in general, tied to a specific generational vision and later co-opted as corporate programming by means of technologies of capture and control. In his 1963 paper, Parker does not have recourse to the kinds of conceptual artistic examples that interest Lauder in his emphasis on performance art and information-associated concepts (with only a few digital tech references) that would not blossom until the latter half of the 1960s (especially art collective N.E. Thing Co.). Instead, in addition to his eminently modernist examples from Cubist painters and James Joyce, Parker's examples from the museum are often Indigenous. This is a significant choice of focus that is not at all a conceptual turn, given that it is illustrative of how a designer works daily and "lives with the material" artifacts, the first example of which is an artifactual assemblage, a bow and arrow, which Parker used to introduce a further example of his approach to an entire gallery. Without identifying the provenance of this bow and arrow, Parker's (1963a) modernist discourse, spurred on by McLuhan's penchant for tribalist metaphors that today seem tired and strained, is used to ask a question about what it would take to "evoke a quality of mind conducive to appropriate perception" (356)—that is, evoke the "mental modes" of their original makers and users, and in the process adjust the "mental stance" of those who view them. It was "not just information" that Parker wanted to communicate, but rather, "the mental and

emotional formulations of a particular culture." It is important to be clear that Parker repeatedly argued against the strategy of verisimilitude in exhibition design. For instance, in discussing the use of lighting, he divided cool light (desk and office daytime brightness) from warm light (fluctuating, pooled, sparkling night light) in order to explain the many varieties of lighting available to and required by the contemporary designer (2025, 72). What he wanted to avoid, however, was the notion that one erects displays that are lit as closely as possible to the original situations; and, at the same time, he dismissed the imposition of a normative, constant, unfluctuating light in all galleries at all times as a "sensory inhibitor" (2025, 70). His approach was indirect: "rather than setting up displays lit as the originals would have been, we should use lighting which will be conducive to creating mental and emotional attitudes similar to those of the people who lived in the surroundings" (2025, 73). There is an inexactness at play here with regard to the range of similarity that Parker wanted to preserve as the proper concern of the exhibition designer, who leaned on evocative and assistive methods—allowing accessible dimmer switches that visitors could control to light a tableau—rather than verisimilitude based on literal and probabilistic measures—like utilizing a constant flickering flame LED bulb.

Imagining a Canadian Eastern Subarctic gallery, he began with two quick ideas: breaking up the sequence of historical periods (pre-contact, contact, tribal dissolution in a modern Canadian settler-welfare state) in a room built around a sociological fact, while emphasizing process over product, namely, a marriage custom, which was contrasted with typical practices of the museum goer; then another notion, namely, the tribal responses to a crisis such as the disappearance of the caribou, which would bring into focus the collective processes of thought and invite a museum visitor into the scene. He augmented these brainstorms with two principles: another room built around a religious object that would act as if it enfolded, like the fragment of hologram, all of a given nation's or community's "mental modes." Parker referred to the First People in question simply as Taiga (translated as "Boreal"), without acknowledging the many *Peoples* inhabiting the subarctic in Canada and around the globe. Taiga signifies a vast ecological zone, two parts of a shield, spreading east and west of Hudson's Bay. Nevertheless,

Parker's (2025) preferred usage in this regard was the artifact/custom/ event as a sensory index of the culture that manufactured/practiced/ experienced it in crisis; the artifact contained an index of its maker's response to formal elements such as colour, tone, texture, and space of creation (76); and strategies of *totalization*, akin to anthropologist Marcel Mauss' total social fact of gift exchange in *The Gift: The Form and Function of Exchange in Archaic Societies* (1966). "Total" signifies complexity and concreteness and the surmounting of any disciplinary restrictions that may prevent understanding of how all parts of a society interconnect through gift exchange or any other total phenomenon. Indeed, Parker (1963a) imagined an initial room built around one "possibility," namely marriage customs, which express much more than a simple choice of partners. Although he was not convinced of this selection and quickly abandoned it, his conception of an introductory space that would "communicate our structure, in which all the facts and artifacts would find their place" (357), was a totalizing gesture because it had to engage as many of the facets of the culture as possible through a single phenomenon. While this initial selection was robust to a degree because it threw into relief the cultural relationships experienced by museum visitors, and shifted them into another cultural universe where partner choice was replaced by economic necessity as an abiding concern—as "quite a shock will be required to shift from the world of the arterial highways to the world of the Taiga"—the "variance" expressed between the contemporary marriage customs of museum visitors and Indigenous practices, where "the smallness of the tribal unit necessitates marriage between relatives as close as cousins," needed to be delivered in a non-lineal manner, but one whose many threads could be pulled together (Parker 1963a, 357). Parker (1963a) suggested beginning with a field recording of an unidentified Indigenous dialect with an accompanying translation, where "on the wall in front, by serial projection, a chart is slowly forming which explains in a simple manner the economic necessity for this pattern" (357). The sound component, utilizing an Indigenous language, would be explicated by the unfolding chart. He then asked, what if a visitor arrived halfway through? A "lineal exposition" was thus excluded (although this seems more like a technological limitation of replay technology at the time). Marriage

customs were not, in the end, for Parker "sufficiently arresting." He then turned to a crisis example: the disappearance of caribou herds. Parker reflected on the degree to which the thoughts, feelings, and utterances of those experiencing such a crisis could be expressed in a single room. Parker (1963a) imagined the following display:

> Can we imagine a room in which, by various means, all these thoughts and feelings are expressed on the walls, in cases, via film, or label, and all going on simultaneously? What sort of room should this be? I would suggest some sort of dome in which all surfaces would be used. The dome suggests the actual physical fact of aural awareness—communication from all sides simultaneously. Deluge the audience, disorientate them in the downpour! Leave them standing in the shock of the discovery of a new identity—in a quiver of response. Use two, three, or even four projectors; use artifacts, but all in a non-sequential way. All the factors in this initial presentation must result in an inclusive awareness of the tribe in its birth, its life, and its death. (358)

Parker would then imagine an area devoted to quiet examination of an artifact, not alone, but through the interwovenness of ritual, technology, art, economy, etc. For Parker (1963a), "all these factors could be shown by proper juxtaposition of other artifacts around one central piece—a kind of atomic explication" (358). His meaning is somewhat obscure here, but "atomic" suggests an older model of an atom that features electrons circling around a nucleus like planets around the sun. This was then subject to a degree of clarification as a "paratactic" strategy, which, according to literary technique, places short sentences contiguously (side by side) without specifying how they relate to one another. However, Parker noted that he was considering Egyptian paratactic images here, in which a human figure's head would be in profile, its upper body would be rendered frontally, and its lower body would again be in profile. Consider this as a structure in which aspects of a human figure find their place. Even if a visitor successfully entered into this structure, cognitively and affectively, Parker (1963a) set limits on the degree of correlation between the mental modes of visitor and

Indigene: "we cannot make the mental attitudes of our audience identical with those of the native. We can, however, ensure that they get some insights into those mental modes by a stress upon the sensory attitudes typical of the native person and by treating each object as if it contained all the tribal attitudes within it" (359). Parker struggled to ensure that Indigenous artifacts would not be viewed "anachronistically" as remnants of historical societies, but his approach was limited by a number of critical factors, notably his inheritance of McLuhan's construction of First Peoples as chronically out of step with the dominant galaxy—tribal in a previously mechanical world, and demanding mechanization and modernization in a retribalizing contemporary period (see Genosko 1999, 106–109). Parker's displacement of museological attachments to visual, spatial, fragmented, homogenizing approaches in favour of the opposite values of acoustic space—an oral, multi-sensorial interplay, all-encompassing, heterogenous space of intense involvement—did not paradoxically permit him to advance far beyond the stereotypes that this approach imported. I will return to this shortly. The non-identity of the visitor and Indigenous maker was a given, but one that further must be called into question beyond the frame in which Parker worked, given that in this scenario a museum visitor was not a contemporary Indigenous person. This kind of exclusion is never really stated. Indeed, the designer-communicator was not Indigenous as well.

Parker's recourse to a hypothetical gallery was part of an experiment of thought that elucidated principles of design without solving in advance hard questions about how to actualize them (these would arrive in tentative efforts a few years later, to be sure), or indeed, how materials often dictate decisions. I will pick up this everyday material dimension of exhibition design momentarily. Parker was well versed in such "dangers," as he put it. However, Parker (1963a) continued thinking through how a mutual, restless modification of visitor and Indigenous cultures would animate the gallery, again turning to a counterfactual, as if, he wrote: "Ideally the result should be as if one looked at the tribal life through a transparency of our own culture, or [as if] by focusing one can see them separately" (359). Parker's reference is to an analog technology, an overhead projector, which utilizes

transparencies in sheets or rolls, placed upon an illuminated glass plate and projected by means of a mirror and lens. Parker's playful deployment of "broad concepts" was in the service of three principles that must be fulfilled: first, disruption of habit and givenness; second, analysis of the sense ratios of the culture at issue; third, appraisal of audience feedback. These principles would do much to ward against the treatment of "tribal" life as an anachronism, and the assimilation of such life into the contemporary visitor's lifeworld(s). Transparency was used in the sense of overlaid sheets that themselves became visible, and the effect was that of juxtaposition: "creativity occurs only at the point of abrasion" (McLuhan and Parker 1969, 49). In this abrasive space, Parker downplayed the role of "the book" and the linear world of print, and he valorized synesthetic awareness and the new orality/ tactility of electric/electronic communication. Recognition of this by the designer would enable "a new ordering" of artifacts that would "reorientate the spectator to the attitude required for an appreciation of a particular culture" (Parker 1963a, 353). The choice of Indigenous examples certainly echoed the thesis of McLuhan that the pre-literate and post-literate, the returning retribalizing world of simultaneity and tactility—"the mode of interplay and of being rather than of separation and of lineal sequence" (McLuhan 1962, 240)—could be materialized in gallery rooms. At his most philosophical, McLuhan (1962, 248) did not advocate for "naïve immersion" in the contemporary electronic world, because his point was to raise to consciousness and study the effects of the intrusion of electronic-information media into mechanical technologies. How, then, to break the hold of previous sense ratios on an institution like the museum? The effective utilization of contemporary electronic and organic means of interdependence and interconnection had the power to displace the lingering adherence to previous values by exposing their ugly faces. As McLuhan (1962) put it: "Our most ordinary and conventional attitudes seem suddenly twisted into gargoyles and grotesques" (279). But what did this mean for Indigenous Peoples?

Parker rejected the "three historical periods" approach to Indigenous history in Canada, that is, pre-contact, contact with white settlers, and post-contact disintegration of life (assimilation and the occlusion of self-determination) as a viable storyline ("sequential presentation") for

the presentation of artifacts. These broad categories did not interest him, but neither did they move him toward a robust critique of colonial legacies of ethnographic collection, despite working in a colonial museum with a "royal" imprimatur; he operated with a general critical approach to Western ethnocentrism, which he regularly expressed in *The Culture Box*'s (2025) calls to question the cultural assumptions of visitors. Still, he did consider it important for Indigenous languages (without selecting one or more) to be played back in the gallery, but his grasp of the implications of "aural awareness—communication from all sides simultaneously" (Parker 1963a, 358)—was limited to disturbing and reorienting visitors rather than positively initiating transformative institutional practices in which he would collaborate directly in his present with speakers of Indigenous languages and language knowledge keepers. What Parker was refusing in his hypothetical galleries was the "museum effect" that arises from presentation for viewing of an artifact in isolation from its cultural ground, a "way of seeing" imposed upon visitors (Alpers 1991, 27). Parker did not want to make it easier to see, as it were, but to make it easier to sense, to bring non-visual sensory evidence to the experience, and to make it possible to elude chronological capture by non-lineal exposition. He also wanted, at times, to "make it hard to see," not by erasing cultural foundations, but by intentionally troubling the museum effect, by applying McLuhan's ideas to the museum. According to the museum effect, when artifacts become artworks, they "register visual distinction, not necessarily cultural significance" (Alpers 1991, 30), and thus they constrain perception and distort it as a kind of representation to ourselves. Parker insisted that museums themselves were artworks, and that their purpose was to force a "re-appraisal" of ourselves, to make any visitor's encounter with artifacts the subject of reflection, and thus the aim was not to pull oneself up and out of the museum effect by denying that the exhibitor was engaged in a certain kind of sanctioned activity, but to explore it as a training ground for perception. Parker underemphasized the consequent actions of those visitors whose perceptions had been positively modified by the museum effect, and whose reflections resulted in a renewed wonder at their own worlds outside the walls. If it may be claimed that the museum effect "works in both ways"

(Kirshenblatt-Gimblett 1991, 410), must it lead to a super-charged viewership in which every thing and place becomes a museum?

Almost thirty years later, at the CMC, MacDonald (1992, 160) was pursuing, together with UBC colleague Kelly, what I would describe as a highly Parkerian agenda in terms of audience segmentation, the importance of multimedia displays, the role of simulations, including costumed interpreters and audio-visual effects, and the museum as facilitator and not "imposer of 'facts'" (Parker repeatedly rejected the unidirectional delivery of a facts model of communication), but also reflecting on the extent to which Indigenous nations are able to participate in such facilitation. MacDonald (1992) wrote:

> We have made efforts, although there is much more to do, in trying to get component communities involved. Native West Coast people have participated in creating the Grand Hall village scape... Native peoples are helping provide interpretive programming... As we develop the First People's Hall, I expect that such participation will increase in scale and quality, and that the end product will be not only a source of revitalizing pride for them, but also a forum through which they can communicate and converse with other communities. (177)

These sentiments echo the recommendations of the Task Force on Museums and First Peoples released in 1992 by the Assembly of First Nations and Canadian Museums Association, and they are far more progressive than Parker's approach. The specific recommendations include: for museums to engage with living culture, not simply collected objects; increased roles for Indigenous nations in all facets of museum activity relating to the interpretation of their cultures; greater access to collections, including research funding, employment, policy development, exhibition planning, etc.; return of certain objects and care for others remaining in the collection; active training programs in museological practice for Indigenous nations; support for the development of Indigenous-managed museums; and assistance in repatriating objects held in foreign collections. Stephanie Bolton's (2009) study of the McCord Museum in Montreal revealed that some twenty years

after the 1992 task force report "Dolorès Contré Migwans was the only permanent staff member of Aboriginal heritage" (159). Migwans elegantly and with great patience over the slow rate of change put it this way: "petit à petit; sans faire peur à personne (little by little, without frightening anybody)" (Bolton 2009, 160). Parker cannot be faulted for not advancing beyond the displacement he assisted in initiating. He passed away in 1992. But he did try to intuitively grasp Indigenous sensoria and adapt his designs accordingly. In an interview in the *Toronto Telegram*, Parker claimed that he wanted his "Eskimo" (an outdated, non-Indigenous, governmental term) room to be "cold...even if I have to move to refrigeration" (Grescoe 1967, 5). Like his intuition about the purpose served by the odour of rotting fish, his sensescape intuitions about gallery temperature would need fine-tuning. Although such a design might have overemphasized one dominant season, he also wanted visitors to be able to adjust the settings themselves.

The question of what set Parker on the road to hypothesizing about a Canadian Eastern Subarctic gallery, its potential architectural forms, and artifactual assemblages would have been what he found upon arriving at the ROM in 1958: a generic and outdated Eskimo Gallery that was a staple of the Ethnology Department, at least from the 1950s through the early 1980s. Indeed, it looked tidily rectilinear with glassed-in cases and a wall map, a purely, non-interactive, visual display, with anonymous mannikins dressed in sealskin. Thus, hypothetical gallery exploration was partly reactive, and also hopefully proactive, although Parker's hypotheticals were never constructed, despite the popularity of the Eskimo theme at the ROM. Parker sought, then, in probing possibilities in thought, to surmount the glass barriers, dry didactics, and overlit, sterile and fusty spaces of his workplace.

Two Torontos

Shifting back to the Hall of Fossils, the first Toronto I wish to invoke is an early Devonian fantasy of 400,000,000 years ago. This was one of Parker's reference points. Invertebrate is a catch-all category with a diverse taxonomical array, and although it is a staple of natural history museum programs, the fossil collection, as opposed to invertebrate zoology, was also especially conservative: original items completely

encased behind glass cabinets placed in neat rows. By contrast, visitors to Parker's Hall found sand underfoot, undulating walls, accessible facsimiles of fossils, photos of rolling waves, mobiles of sea birds, recorded sounds, and smells of the sea. This multi-sensory space utilized a diorama evoking a seabed of trilobites, anthropods, and fishes. The clean geometries of shell life were expressed by means of the placement of the display cases; Parker's love of pattern was evident. The *New York Times* reporter reviewing the Hall's opening seemed astounded that the fossils could be "felt" (Lee 1967, 32). This article put Parker firmly in his place as McLuhan's "disciple" and gave full popular rein to the imagined influence of McLuhan on the museum's future.

A second Toronto circa 1967 was captured in a photomural that Parker used of a local brickyard, in which excavated geologic strata exposed fossil invertebrates, with the goal of having samples of "local fossils" for sale in the museum. Perhaps this was the Don Valley Brickworks, which supplied the materials for the 1933 ROM expansion. Parker was not specific. This Toronto was a fossil bed; you could literally dig into it. Parker even wondered whether visitors should be able to smell the decomposition of organisms. This was the kind of joke he was fond of telling at the expense of his employer. That museums could offer selective reconnection with decay was, however, no joke in Parker's pursuit of a deeply embodied experience that would reposition olfaction as a vital way of knowing, but also as a sure means of overcoming intolerance toward strong odours, understood as an appropriately intimate reduction of distance produced by an incapacitating ocularcentrism. Mathilde Castel (2019) goes so far as to, in her doctoral thesis, directed by museologist Mairesse, rehabilitate olfaction for the museum in support of McLuhan's and Parker's turn to "primitive" affective capacities, even at the expense of exposing philosopher Deloche's over-reliance on visual perception in his museum aesthetics. Castel (2019) points out that the active visitor imagined by Deloche is foiled in any attempt to embed themselves in the space of objects by the antiseptic environment, guided by floor markings, ropes, and other signage: "I can neither smell nor touch them, at best, I turn around their display cases like a fish in its bowl" (45). Castel (2019) joins McLuhan and Parker by returning to the "existential sensoralities" that would

The Hall of Fossils at the Royal Ontario Museum 125

intensify the museum experience, and for Parker, signify intensely any visitor's connection to the seabed of a forgotten Toronto: following Castel, rotting fish and vegetation was Parker's Proustian madeleine (48) that would allow each person to connect with the origin of life in the sea. Parker did not ignore glass cases. In *The Culture Box* (2025), he reflected on the unique spaces that they present, and considered the issues of mixing figurines of disparate sizes together (abrasion) and the implications for the imaginative projection of visitors into displays (50).

These two Torontos were connected by Parker's goals as an exhibition designer struggling to achieve a "synthesis" of the 20th-century museum visitor with an aural-tactile-kinetic (while aspiring to an olfactory dimension) perceptual orientation in a curatorial space marked historically by linearity and visual perception of disciplined academic specialties. Experience or data; artist or scientist; non-visual or visual: these were the oppositions Parker (1967b) worked with, and his goal was to achieve a "sufficient rapport" (296) between designer and curator. This would mediate the experience for visitors in a highly engaging gallery that channelled McLuhan into the physical display space: curator's eye becoming designer's ear; definition reappearing as suggestion; visual connectivity in linear order becoming a resonant interval of haptic space; the book page turning into an abstract diorama beyond naturalist pretenses. Deeper in the Hall, there were buttons to push that illuminated fossils, inviting touch, and 16 wall-mounted, dial-less telephones delivering pre-recorded messages and activating slides.

Parker was well aware that dealing with invertebrate palaeontology would not be easy. This project was beyond the exhibition of culture, or to put it in different terms, the culture at issue was the museum's own history with these materials, the sensory profile of the discipline itself, the historical aesthetics of display. Rituals, social structures, and cultural artifacts played minor roles in this self-reflexive focus. Consequently, for Parker, there was a massive displacement onto the institutional culture of the academic discipline as a foil, and of the ROM itself as an organization within which institutional relations between its curators and designer (and construction staff) were paramount. The sensory mix of the subject area was hyper-generalized and abstracted to available sound samples of storms, waves, and birdlife, delivered by

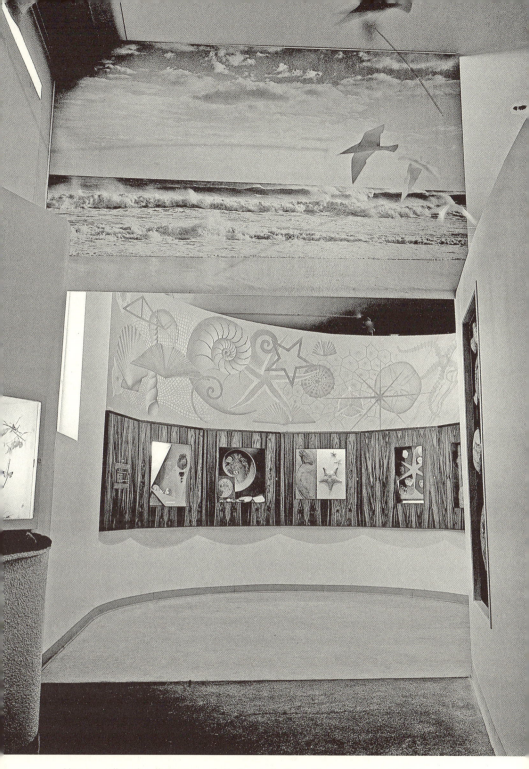

Upper wall and ceiling view of abstract shells, a film, and shore birds in the Palaeontology Gallery, Hall of Fossils, April 1967. (Courtesy of ROM [Royal Ontario Museum], Toronto, Canada. © ROM.)

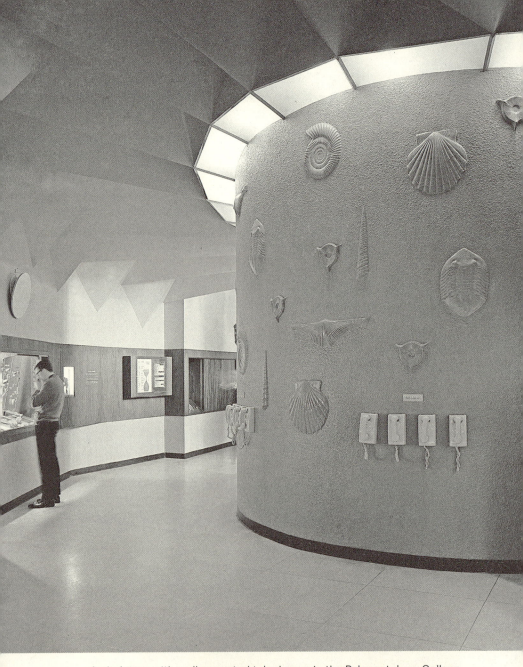

Ambulatory with wall-mounted telephones in the Palaeontology Gallery, Hall of Fossils, April 1967. (Courtesy of ROM [Royal Ontario Museum], Toronto, Canada. © ROM.)

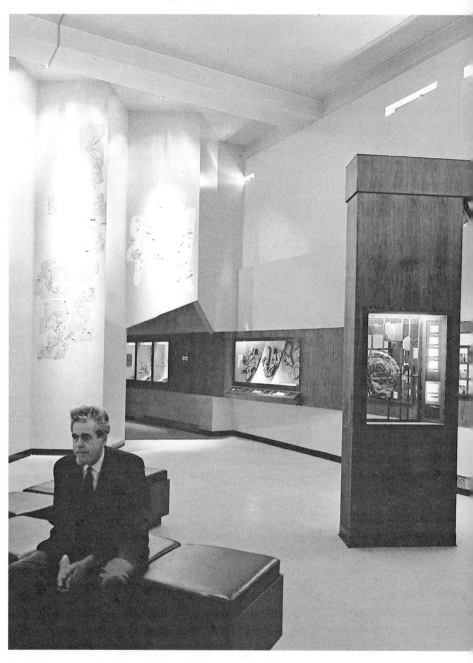

Parker seated in the Palaeontology Gallery, Hall of Fossils, April 1967.
(Courtesy of ROM [Royal Ontario Museum], Toronto, Canada. © ROM.)

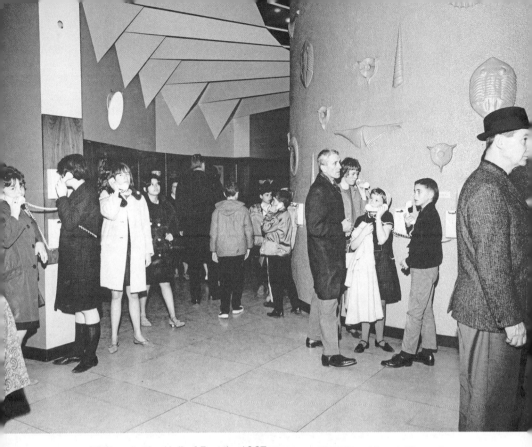

Visitors in the Hall of Fossils, 1967. (Courtesy of ROM [Royal Ontario Museum], Toronto, Canada. © ROM.)

technologies available at the time, some in modified forms. And the role of facsimiles increased as touch was emphasized, and a visual aesthetic of natural shapes dominated. The subject area was sometimes abandoned to outside references, as in his pre-Cambrian abstract diorama, which staged a period before the kinds of fossils of hard exoskeletons on display had even evolved. Parker had already resolved to step outside the lines, just as he would advise with his conception of an "other gallery" to think beside the box.

The Hall of Fossils utilized an exit strategy of directing the visitor prior (outside and beyond) to the trace evidence of life to a nebulous and sprawling time period on planetary evolutionary scales that linked the emergence of life with water. Parker's (1967b) recourse to this deep time of the planet stirred "initial controversy," he admitted,

but he explained that "the depiction of a period before life has tremendous dramatic impact and a seldom-forgotten experience is the result" (295). As Parker (1967b) explained, the first "experience" he sought to impart through the gallery was that "all life on this earth originated in water" (284). In this charged encounter, both of the orienting Torontos are erased in a stroke and sucked down a wormhole into geochronological vastness without even the benefit of the invertebrate fossil record for guidance. This intentional provocation must have been, for Parker, a shot of calculated insouciance against the traditional values of collection, analysis, and systematic display of specimens, but it was an escape hatch of his own design. At the same time, it was a gesture against the grain of his own commitment to audio-tactile sensory design, over-emphasizing abstract, visual, and hard-edged optics, while utilizing a storm soundtrack, simulated lightning, and a weight-sensitive floor mat that triggered sound and light. This hatch opening onto immensity was both anacademic and anti-institutional. It had an undisciplinary character that foregrounded pattern over the presentation of data and abandoned naturalism. Parker's intentional errancy, with its non-conformist elements, spurred on by a rich imagination and a commitment to non-linearity against disciplinary demands for chronology (inverted) and rigorous categorization was in the service of an audience reorienting to an aural-tactile-kinetic experience. Could it have been avoided? Not likely, for two reasons: it was, after all, the number one experience he wanted to design, and second, it actually "attracted" visitors. The museum was more than bit surprised that this gallery garnered so much attention. The Hall of Fossils bore many idiosyncrasies of its designer.

Rewritten Equations

In *Medieval Modern*, Nagel (2012, 163) formulated an equation that summarized the influences on Parker and his signature institutional accomplishment at the ROM:

> Parker (Albers plus McLuhan) equals Hall of the Invertebrate Fossils.

In conceptually unpacking a Yousuf Karsh photographic portrait of Marshall McLuhan, taken in the Hall of Fossils in the ROM (on January 21, 1967, according to Karsh's sitting diary), in front of the bank of wall-mounted telephones and scallop shells, Nagel brought forward the double de-centralization of vision that Parker learned from his summer session art teacher Josef Albers and that was reinforced by his colleague McLuhan, as well as decoding the importance of the iconography of the shell for McLuhan. Nagel did not mention that Karsh, neither at that very moment nor place, also asked Parker if he would like to pose for a portrait, but the following year, on June 28, 1968, to be precise. Karsh's photograph of Parker lacks an institutional context, and for good reason, since it was evident by that point that Parker would not return from his leave. Parker was not photographed in his Hall of Fossils. By any measure, this was not just. He would resign his post two days later, as his leave period ran out. The lack of an overt complementarity between the two portraits underlines the division of labour in the friendship, between the print productions of McLuhan and the installations and designs of Parker, with the latter directly addressing the hypothesized synesthetic awareness of an audience for which he went in search, an awareness that would make such a search a restless one.

For Nagel (2012), the McLuhan photograph was a "dense paradox," a frozen point of view and Gutenbergian bookishness, right down to the details of the page image of icons from the Hagia Sofia, but also a resonating field mosaic inspired by sifted layers of medievalism, emblematically signified by the scallop shell. The portrait is a "mosaic despite its supposedly photographic status" (168). Parker's Polaroid portrait taken by Karsh is an illumined face in profile with a single vertical shaft of light in the background. The harsh focus of the lighting accentuates skin detail and hairs to produce drawing-like lines and folds, with pronounced facial hair in an exaggerated, probing, chin puff. Bearded media in the form of a Van Dyke. The extraction of Parker from his gallery space, and the insertion of McLuhan into it, is perhaps too literal an understanding of McLuhan and the museum motif, but the media of separation, namely books, were no match for the gallery's powerful embrace. McLuhan and Parker were famously

Marshall McLuhan in the Hall of Fossils, by Yousuf Karsh, 1967. (Used with permission from the Estate of Yousuf Karsh.)

photographed before Harley's painting *Flying Children* from 1950, and they appeared together in the rambling film *Picnic in Space*, but ironically it is the Karsh photo of McLuhan that still garners abundant critical attention for Parker, as it displays key elements of his Hall of Fossils design, but unfortunately those are in the background.

The questions raised by the photo do not end with Nagel's acute observations. McLuhan's seated placement in the ambulatory of the gallery space arrests its flow as a place for walking; indeed, the table at which he sits is positioned before the central columnar structure with

low relief facsimiles of shells and trilobites, where the telephones hang. It does not belong there. And the telephones have little agency in McLuhan's sense of providing a technological exemplar for discarnate users "on" the telephone because they do not permit any calls to be made and only provide information in lieu of labels bearing Latin names of specimens (McLuhan 1978, 24). For Parker, the Latin names of specimens were banished, or buried. The gallery provided the device but not the full experience of a disembodied sender—only a receiver of information that arrested one's capacity to participate, except in triggering an action, which ultimately reinforces Nagel's sense of paradox. There were telephones but no calls. Here, the figure of the telephone itself incompletely realized the ground of a disembodied user. Given that cephalopods, especially nautiluses, are fossilized, the tensile coil of their spiral shell is arrested. The telephone cord had more elasticity. This was after all a hall devoted to invertebrate palaeontology. Still, Nagel (2012) pointed out that "these phones were an innovative precursor to the now familiar acoustiguide" (161). This is a bold claim that sends one back to the pre-digital and pre-mobile technological era, before the standard handheld equipment of audio tours became ubiquitous in prestige museums, especially for blockbuster shows with celebrity narration. Nagel's observation does not correspond to the history of audio technology in museums, whether in terms of early 20th-century experiments with gramophones (at the 1908 *Tuberculosis* exhibit at the American Museum of Natural History, in New York), Roto-Radio broadcast lectures in the 1920s that could be listened to while considering images printed in the newspaper, or mid-century prototypes like Acoustiguide, established in the late 1950s, which all pre-date Parker's exhibit (see Griffiths 2008, 236–37).

One might say that appearing amongst fossils and telephones without dials, and simulated television screens (rear projection screens) showing cartoon didactics about evolution, was a gamble in the first place for McLuhan, and sparked a question, in the second place, about Parker's capacity to translate ideas about non-visual orientation into exhibition design that still included recessed "windows" and an overall didactic recapitulation, like a conclusion of sorts.

In his published *Letters of Marshall McLuhan*, McLuhan was always circumspect in referring to his friend and colleague Parker as "the painter." What went unmentioned by Nagel in his analysis of the Hall of Fossils was its painterliness, the semi-abstract diorama of rocks with simulated rain in translucent threads, enhanced with the orchestrated sounds of a storm triggered by stepping on the mat before it, which had a marginal connection to invertebrate palaeontology, but highlighted Parker's Cubist tendencies, a movement he considered as seeking a cool and multi-sensory style still within the visual (Parker 2025, 164). In another diorama, the painted models of marine life, especially squids, staples of natural history displays, and the murals of shell forms in outline, were not of any obvious scale and not referenced to specific marine locations or dates. Parker's (1965a, 15) term for this was *icon*, namely the timeless image or object that does not represent, but results, he claimed, from "total sensory awareness," dominated by sound and touch. This notion of the icon was Parker's connection with medieval culture, and he worked on the concept throughout his published writings and presentations in his seminar at Rochester. The point of contrast between the icon and illustration that animated Parker's design work is perhaps best appreciated in terms of the subtractions that he introduced into the descriptions: for the icon, the absence of chiaroscuro in favour of a "stress on patterning," in other words, the use of strong outlines, highly tactile, with no connections, as previously noted. Whereas the illustration had a stress on the visual and chiaroscuro effects, with outlines "lost and found" (Parker 1973c). Eschewing visual realism and seeking simultaneity of sensory experiences, Parker sought to overcome objectivist detachment and highly constrained, stamped and dated, representations, for the sake of a reinvigoration of the icon for the age of electricity and the diffuse "total sensorium."

While he had a captive audience of children, on sanctioned school visits, who welcomed opportunities for unhindered connectivity and responded to choreographed stimulation, so he could claim somewhat defensively that he was using "pattern recognition" to initiate the next generation of invertebrate palaeontologists, the audience he

desperately sought, and which in theory would have been most sympathetic to his approach, remained elsewhere. After all, Parker thought that the kinds of hallucinogens youth were experimenting with circa 1967 made those who used them see in iconic rather than illustrative terms. Evidently, they could achieve this sort of awareness quite handily without the assistance of the Hall of Fossils.

In describing his goals with regard to the Hall, Parker (1967b) underlined that he sought to "synthesize" two spaces: that of the specialist discipline of invertebrate palaeontology (two-dimensional, linear, and visual), and the largely non-visually organized space (kinetic-aural-tactile) concerned with reaching an audience characterized as young, whose "sensory orientation" could be "deduced from advertising, clothing, transportation, even Go-Go girls and the psychedelic event" (296). For Parker, a key institutional point to this synthesis was "mutual belief and understanding" between academic curator and artist-designer. Without this mutuality, such a synthesis was impossible. The Hall of Fossils was proof of concept, if you will, when it came to designer-curatorial communication. While deducing the sensory orientations of a youthful public might be indirect, he would not uncritically valorize the "misdirected enthusiasm of hippies." Nevertheless, Parker (1968) thought: "there can be little question that the new corporate stance as manifested by the tribal 'hippie', in fact by a large number of our teenagers, more or less eliminates those factors of intense individualism which have been observed for the last five hundred years" (29). This contentious dimension made the hippie a highly sought-after yet uncomfortable target.

The audience he knew existed in places like Yorkville in Toronto— where he had moved his family around 1960–1961 to a rented house on nearby Tranby Avenue from suburban Willowdale a few years after starting at the ROM—did not fit the profile of a typical ROM visitor. Where were those with the right "receiving sets" (Parker 1963a, 360), the right wetware, who were ready for the messages of his exhibition designs? Parker circled around the mediatic conjuration of the hippie as a leader in the erasure of individualism by the youth culture in general, and drug culture specifically, as an enhancement of sensory post-perspectivalism and non-detachment. This romantic notion did

not match the experience of the Parker family. Suddenly finding themselves at the epicentre of countercultural Toronto, the Parker children, Margaret aged 10, Eric aged 14, and Blake aged 17, figuratively went "off the rails," as Eric put it.[1] Into a year and a half Eric squeezed five years of intense living, enthralled by "coffee, cigarettes and chess at The Bohemian Embassy" on St. Nicholas Street, and "jasmine tea at Wu's." Compared with the quiet suburbs, the "village" offered an abundance of information and rich stimulation, not always of the most propitious kind. Margaret was pulled out of a local public school and sent to a denominational private school. Eric had to repeat a year of high school. Blake may have found his calling as a poet in the Beatnik coffee houses, but two years later he went to London, UK, and Almuñecar, Spain, for a year with his new partner Penny Knapp, whom he married at age 19. By the end of 1962, the family had relocated to a house, now demolished, on Cumberland Drive in Port Credit, at the time a "strangely dead and culturally empty place," as Margaret referred to it. Despite the lakeside setting of this town on the southwestern edge of Toronto, the remaining two Parker children were deprived of their friends, and older brother, with access to few cultural resources. They had been banished from the centre to the margin. At the same time, the move to Yorkville had made sense and augured well. Harley was closer to work at the ROM; Margaret could visit her father after hours and have free rein of the great museum spaces, a "fantastic playground" for a tween-aged child; and Eric would eventually find summer employment there painting Ordovician Period invertebrate panels.

A more institutionally embedded equation would involve these relations:

> Parker (with a collaborative curator plus correctly deduced audience sensorium) equals Hall of Fossils.

If the "experiences" offered by the Hall of Fossils represented the most fully realized synthesis—although it qualified as not "totally achieved," as he tried to convince the press and public—of the above factors, how did Parker arrive at this point?

Parker's public remarks about the Hall diminished his accomplishment as "baby talk," although it created an audience that didn't exist: "It's a first step, at least it's kinetic, a walk-through, and it stimulates interest. There've been more people in that gallery in the past week than in the whole time since it opened, maybe 20 years ago" (as quoted in Lee 1967, 32).

The necessary condition of a collaborative curator was met in the person of Dr. Lemon, described by Parker as a "young paleontologist… [who] started with the attitude of 'Let's see'. Then he certainly began to dig the idea and began to come up with some of his own when he got the slant" (as quoted in Grescoe 1967, 5). An earlier Lemon article appearing in the ROM's series on fossils in Ontario in 1965, characterized by a highly linear and academic essay style, serves as a reminder of the line drawings and grids and glass cases that Parker wanted to challenge. Parker (2025) also wanted to grasp the dynamics of the relationships between different kinds of spaces: the stationary artifacts assembled in such cases, which may not have been originally in motion, and the kinetic space of the visitors moving around the cases (50). But already in 1965 it was reported by Parker that Lemon was having "far-out dreams," and had the ear of ROM Director William Swinton,[2] and a viable budget. According to journalist Shirley Mair (1965): "Visitors will walk into a darkened gallery with aquatic lights and sounds. As they walk along the bottom of the sea, they'll first see lighted aquaria of the fish they recognize, then modern fossils of crabs and corals and snails. Some of them will have signs bearing the un-museum like notation, 'Touch me'" (21). It is certainly important to note that, today, "touch" in multi-sensory museological contexts may not involve physical contact with objects in any way or require the wearing of special devices. Experiments in "touchless tech" that delivers "mid-air" haptic stimuli patterns were deployed by the *Tate Sensorium* in 2015 in a room of paintings (Vi et al. 2017, 2).

Parker deduced the audience's sensorium using tools borrowed from McLuhan, and in practice he gained an audience not all that distant from the one he sought: "I aimed this gallery at children…if I can get children, I can get adults. Children are very much orientated

to tactile-kinetic-oral forms of communication. The adults are still largely print-orientated" (as quoted in Grescoe 1967, 5). This tactical approach was wildly successful, even though the parents and guardians of the child visitors were harder to reach. But this still did not bring the deduced audience into the gallery, that is, the post-literate youth culture committed to immediacy-nowness and with the greatest potential affinity with the project. The children were delivered to the ROM by the busload, courtesy of school board programming; this is no exaggeration, to be sure, as "school classes" constituted by far the largest attendance numbers broken down by category throughout the late 1960s. Parker (1965a, 15) further specified, however, that he did not solely design his galleries for children. Children were great when it came to pushing buttons in a display, but they didn't care much about the "specific information" that appeared in doing so. The deduced audience of the tribal teenager and the child overlapped to the extent that the effects of television on media habits could be studied. But it was the teenager in particular, by virtue of television immersion and investment in icons such as rock groups, who would be receptive to the organizing principles of the Hall of Fossils and able to recognize the gallery as a site for intergenerational "interaction." Parker (1970b, 6) insisted on this point: repairing the relations between generations required interfaces that could address the breakages and thus help repair the community.

Responding to a question about audiences during the museum seminar in New York, Parker explained: "I'm primarily interested in the young, and within two blocks of the ROM, which is, after all, a pretty great museum, there is Yorkville Village, which has perhaps 3,000 hippies and their friends. I have never seen a hippie go inside the ROM." When challenged with the argument that a few hippies did attend special exhibitions that touched upon youth fashions, for instance, a point he conceded, Parker continued: "But I'm particularly interested in getting them in. I'm quite sure I can get them into a sound and light show. It doesn't have to be an electric circus. I wouldn't even mind putting on a discotheque" (McLuhan and Parker 1969, 39). Perhaps, then, my equation should be modified:

Parker (with a collaborative curator plus actually reached audience [x]) equals Hall of Fossils minus correctly deduced audience.

Thus, in order to account for the trickle of hippies into the museum from a nearby youth mecca, not to mention from the university campus next door, we should add a variable (x) to the term "actually reached audience" under the special circumstances of pop culture exhibitions that overtly address youth topics in some small measure (like the faddish mid-1960s "paper dresses" noted by Parker in the *From Modesty to Mod* textile exhibit, which ran at the ROM from May to September in 1967; see Brett 1967). More on this shortly.

A strong interpretation of the mid-1960s study of the "Sensory Profile" of Torontonians undertaken at McLuhan's Centre, based on the influence of television, would lead to more precise and accurate programming for specific audiences (McLuhan 1967, 102). Transposing television programming to museum programming, then, proved to be a challenge, given the content of a newly built semi-permanent display such as the Hall of Fossils. While the designer addresses the audience, the curator orients toward a certain subject specialization. While this meant for Parker that the designer must be aware of the changing sensory orientation of the public, the young people he sought to engage were best reached by an aspirational analogy with the televisual medium that apparently already completely involved them.

A Trickle of Hippies

Julia Petrov (2019) illustrates one of the key reasons for the marginalization of fashion curation in museology with reference to the ROM's *From Modesty to Mod* exhibit. This was due to its prejudicial treatment: "less like a profession and more like a set of informal skills to be learned through practice" (26). She points out that curator Katharine B. "Betty" Brett (Department of Textiles) was working on an "unpaid leave" at the time due to budget constraints, and relied on an external grant from the Centennial Commission to undertake research on a number of key costume collections in the UK. Petrov (2019) quotes Swann's "Director's Report," written for the *President's Report* at the University of Toronto, which ends on this note: "displays of costumes...were

studied with a fresh eye and particularly for hints on how not to display costume!" (26). Praising Brett's final design, Petrov draws attention to the collaborative nature of the exhibit, which interests us here as Parker had a hand in consulting on wall coverings: "the colours in the end section were chosen in consultation with Mr. Parker who happily suggested drapery as a background for the 1839–59 section" (Bissell 1968, 271). Petrov is aware of the team effort involving curatorial assistants, technicians, designers, and an associate curator. She draws our attention to Swann's style of moderating praise with humour, tempering his enthusiasm, when costumes were at issue. Another example is available from his report, in which Swann wrote earlier:

> The most notable exhibit of the year was organized by the Textile Department under the enthusiastic direction of Mrs. K.B. Brett... It comprised a collection of Canadian costumes...most imaginatively shown...the exhibit demonstrated the wealth and scope of the collection which the Department has assembled over the years, ranging from the most modest home-spun to recent haute-couture and uncompromising abbreviation. It is a consolation to a curator of textiles that the miniskirt and bikini of 1967 will, at least, create fewer problems of storage than the bustle and the crinoline! (as quoted in Bissell 1968, 267)

That this exhibit could be the subject of tendential humour speaks directly to the ongoing marginalization of dress in museology, and the fact that the director does not seem to acknowledge the many loans that made the exhibit possible. Indeed, the catalogue includes in an envelope Brett's own diagram pattern drafts, drawn to scale, of many of the 19th-century pieces included in the exhibit, both women's and a smaller sample of men's fashions, revealing a high degree of technical expertise impossible to relegate to informally acquired knowledge. Moreover, as an interpreter, Brett knew her audience, and the pull-out patterns would be familiar to home sewers and readers of pattern magazines. The draperies that Parker recommended were also donated by a local Toronto firm and appeared in a few of the colour plates (none from the "Mod" section).

Swann mentioned a bikini; Parker noted paper dresses. But the only curatorially significant item to make it into the catalogue from the women's fashion section of the exhibit focusing on the years circa 1966–1967 was a black vinyl miniskirt with a wide fitted hip-belt, kitted out with an Orlon "poor boy" pullover and stockings, both in orange, and low-heeled, French-made, black vinyl boots. Nevertheless, Parker's efforts to attract his correctly deduced audience of nearby hippies—who, as he put it in the museum seminar, didn't visit the ROM—were challenged by an unidentified questioner from the seminar audience in New York. The dialogue unfolded in this way:

> Question: I was there [at the ROM] for three days and I saw a number of hippies go in.
>
> Mr. Parker: Maybe I stay too much in my office, but I really haven't seen them going in. There may have been something special going on which appealed to them, for example, the period costume show. We had a show called [From] Modesty to Mod. We had paper dresses and all kinds of things. So it may have been that this particular exhibition would draw a few of that crowd. (McLuhan and Parker 1969, 39)

In the museum seminar, the gender of the audience did not become a matter of interest, although it is certain that it would have been. But the sequential-historical display of garments, culminating in contemporary fashions, did not answer to Parker's idea of the sensorium of his deduced audience; instead, it suggested interest in the content of the period display, with its relevance acknowledged by the institution and in which these few visitors could see something of themselves. This was not an auspicious reception: "If objects are presented and sufficient information given on labels visitors will be able to place information about the object in a mental pigeonhole" (Parker 1972b, 56). This would be the end of the matter only if the "appealing" part of the exhibit remained in isolation—from the total exhibit and from the museum as a set of disconnected rooms. In considering Parker's remarks on the orientation of visitors five years after the opening of the Hall of Fossils and the museum seminar experimental gallery, his

conception takes on a more general appeal, while still operating within the sensory training paradigm.

In "The Museum as a Perception Kit" (corresponding to Chapter 8 of *The Culture Box*), Parker (1972b) adapted principles from colour theory to the reception of museum visitors; he introduced this analogy based on the important role that sensory deprivation or "sensory blackout" could play in increasing the awareness of perception and bringing about "further action and thought" (56). Go to the unsurprising suburbs if you want to learn how to see, smell, or hear, Parker advised. In order to raise awareness of and transform vision into touch, to turn the seeing eye into a touching finger, he said, go to a traditional gallery in which all artifacts are behind glass. This frictional approach then incorporates colour theory. But it is a particular brand of theory, one that is richly analogical and sensation based (Lowengard 2015, 36 and 39), precisely those two features of Albers' legacy that Parker absorbed. The first part of a two-part statement by Parker (1972b) reads:

> The law is that any colour when placed on a background different from itself will appear as unlike the background as possible. To extrapolate this into terms of people one wonders whether or not an initial encounter with an alien culture immediately results in a stance which makes the observer as culturally different as possible from the culture he is observing. It is very likely true and if so it should be of much concern to design-communicators. (57)

The so-called "law" cited is that of high contrasting colours. Parker's (1972b) statement continues with an application of low contrasting colours:

> In colour terms we realize the least change in a colour when we place it on a background similar to, but not identical to, itself. This reinforces the idea stated earlier that the introduction to a museum should consist of first dealing with artifacts of our own culture. We could then gradually introduce our audiences to cultures a little different until they can finally stand before an alien culture and express themselves in terms of awareness of their

> own culture. This is not an easily attained objective but it is very
> necessary that we make moves in this direction. (57)

Low contrasting colours are close together or adjacent on a colour scale or wheel. They generate the least amount of vividness and agitation. Parker's shift from the sensory bombardment principle of concentrated multimedia saturation that animated his museum seminar work and the gradualism that marked his later version of orientation shows us how a "low" or "analogous" contrast of contemporary cultural artifacts, like the final section of the *From Modesty to Mod* exhibit featuring styles from 1966–1967, could be seen as a way to gently acclimatize visitors, by making them aware of their own perceptual methods, some of which would otherwise remain hidden; thus, the contemporary items would serve well as initial orientation devices. Further, Parker noted the role of gentleness in his gradualist approach to exposing visitors to cultural difference and generating reflexive responses to it. Following Parker for the sake of illustration, imagine if *From Modesty to Mod* was in a backwards chronology, from 1967 to 1780, from lower to higher contrast, perhaps leading into a gallery that featured the dress of early peoples, the processing of skin by Indigenous Peoples, etc. In this way, then, the exhibit would have demonstrated some affinity with Parker's ideas.

That Parker was unable or unwilling to seize upon the sighting of a few of his highly sought-after and correctly deduced audience members when it was revealed by someone other than himself suggests the rigidity of his earlier position on orientation. The gradualist shift in his thinking did not diminish in any way his belief in the importance of "first contact" for visitors, as he still insisted in his later work on its role as an indicator that could "provide an insight into the pattern of the total exhibition" (Parker 1972b, 56). But the low-to-high contrast approach, as difficult as he recognized such a transition would be, remained a goal within his understanding of museum communication and the sensory framework in which he worked.

Parker's thinking about creating empathic museum visitors who would be prepared upon arrival to find their way—and not in the vulgar sense of wearing a pair of headphones and listening to a pre-formed

narrative and following arrows on the floor—through carefully designed exhibitions, exhibits in process, and exhibits in early formation, remains untried. Attention to the embodied experience and self-aware perception of an active museum visitor was a hallmark of Parker's very contemporary approach, including consideration of the placement of orientation galleries, hence the preoccupation with both spatial-architectural and ordering concerns. Recent literature on the active visitor, defined as one who "enables museum space" (De Caro 2015, 58) and contributes to the activity of making meaning, has had occasion to reach back to the valuable lessons of *Museum Communication*. We will look at this example more closely in Chapter 6 as it refers to the reception of the French translation of the seminar.

The Emergence of the Designer

Long before the high-profile period from the opening of the Hall in February and the *Museum Communication* seminar in October, Parker worked on a myriad of projects and slowly built up a repertoire of experiments with materials and spaces while cultivating a friendly relationship with the local press. He had advertised himself as a troublemaker with a populist touch, maybe even a studied amateurism (Mair 1965, 35). Exhibition designers and installers know the constraints of budgets, staff, space, and materials, especially if the exhibit is arriving from elsewhere.

Whether in whole or part, this was the situation Parker found himself in during 1958, as *Masks: The Many Faces of Man*—the ROM's major show of February–April 1959, curated by Walter Kenyon and designed by Parker—was in production. Reading through the memos about the managing of this show provides a textbook lesson in anticipation and adaptation, but also in hierarchy and authority. As late as October 1958, requests for loans from other institutions were being denied. In November, the total number of masks was finalized, but how many would be behind glass was yet to be determined.

Indeed, that same month an emergency meeting was convened because of limits to the capacity of the Ming Tomb and Armor Court, recently redesigned by Parker, to hold more than 175 masks, thus necessitating cuts of some 50–77 masks. Which ones should be cut?

The Hall of Fossils at the Royal Ontario Museum

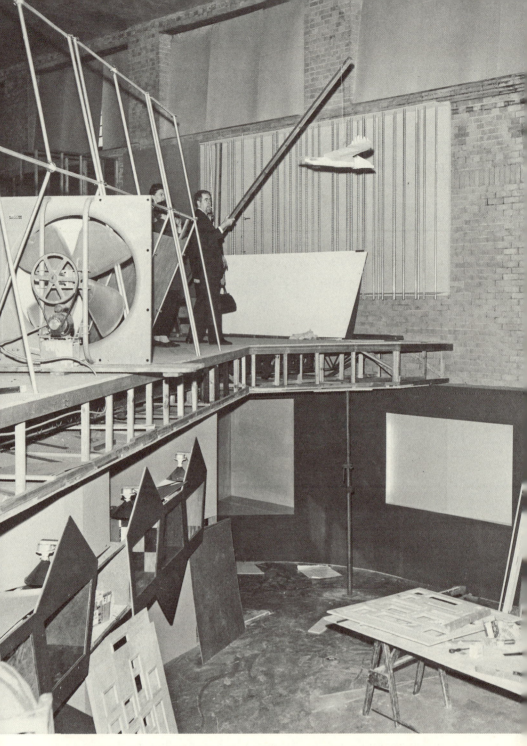

Parker checks on construction, 1967. (Courtesy of ROM [Royal Ontario Museum], Toronto, Canada. © ROM.)

Parker views a mock-up with assistant John Newman, n.d.
(Courtesy of ROM [Royal Ontario Museum], Toronto, Canada. © ROM.)

Where else could they go? Move some of the cut masks to the recent acquisitions cases, as Kenyon suggested to Parker? The correspondence between the curator (Kenyon) and the director (Theodore A. Heinrich),[3] with appropriate copies to Parker, and from curator to designer, meant that the designer did not always speak in his own voice. Not everything the mask show committee did would have concerned Parker, but practical matters abounded, and as chief of display, and a committee member, he had to solve the problems of mounting the masks in spaces he had already worked on, but for different purposes.

The year 1959 was a breakthrough for Parker in terms of his public profile in Toronto, as the well-oiled ROM press machine and local arts

reporters like Robert Fulford (1959b) provided the back story of Parker's Canada Council-funded European study of the "latest" museum display techniques, along with notes of qualified triumph: "The designer… has achieved an exhibition arrangement as good as any I can remember seeing" (n.p.). The important point here is that the designer forged a transversal line from the axis of the curator and director to the public, through the promotional technologies of the press release, exhibition review, on-site live radio interview, and press review, making the point that the commonplace experience of seeing masks in museum spaces had become "thrilling": "The name to be singled out here is Harley Parker" (McCarthy 1959, n.p.). Parker became a mask himself. This trend continued into the early 1960s with the *Search and Research* show for the ROM's 50th anniversary in 1962, which featured large hand-painted panels along the airy staircases with playful meta-historical references embedded therein, courtesy of Parker and his assistants.

The packaging of exhibition construction shots of Parker and gallery installation staff (carpenters, artists, preparators) was a new development for the ROM in the early 1960s; it was certainly newsworthy for arts reporters (Duval 1962). The focus on isolated artifacts and objects blurred when Parker's displays themselves moved from background to foreground through a shift in the promotional culture of the ROM and the arts reportage of Toronto and New York dailies that covered museum events regularly and reproduced these kinds of images, for instance, *The Globe and Mail Magazine*'s arts cover story of the *Search and Research* show (McCarthy 1962). Process and preparation stages of exhibits could happily exist, not in developmental order, but alongside each other in any well-designed gallery.

As the size of budgets for special exhibitions (*Search and Research*, $15,000) increased significantly over the decade, and investments in gallery renovation were made (Hall of Fossils, $30,000; but this was listed as much higher elsewhere), attendance at these events/openings swelled, and Parker emerged as an exemplar of successful institutional change from the perspective of the external arts media. The arts press was in fact tutored by the ROM and by Parker's repeated media statements in how to talk about presentation and display as much as about the content of exhibitions—raising process to the level of product. The

overall tone of press coverage welcomed the dissipation of a drab and overly-academic institutional discourse, reflecting the ROM's position within the University of Toronto before its separation in 1968, and the emergence of colour, drama, and excitement—even humour. The growing enunciative force of McLuhan's ideas within Parker's public pronouncements and professional and popular publications generated a potent mix of the sagacious insights of the museum designer about communication effects. If McLuhan helped Parker articulate his deduction of an audience whose sensory world could be "re-stimulated" in an empathetic way—and this would be achieved once the burdens of the glass display case and blanket ceiling lighting were thrust off and tossed on the junk heap of technologies of fragmentation—then Parker could successfully reframe his design work as concern about media. Further, he could pursue an audience primed by the changing sensory remixes, through intelligent and innovative displays and by challenging the authority of curators to control the exposition of their specialist scholarly disciplines, through the application of the principles of print culture. Parker (1964a) wrote:

> The museum designer today is faced with a complex problem. The earlier developers of museums (and many curators today) took it for granted that the order to be imposed was that of the separate disciplines. The ability to abstract and formulate ideas led to a concern with the output of the communication system with little regard for the ability of the audience to receive the communication. In fact, it led to the situation where, if the receptivity of an individual did not match the visual bias of the scholarly discipline, learning was practically impossible. So long as the book existed as the principal method, or even the sole method of scholarly expression, only the visually inclined could expect to gain intellectually. Today, however, intellectual possibilities are increasing for people primarily oriented to senses other than the visual. (112)

In this statement, Parker hints at both an audience educated on alternative principles and an abstract "layperson" for whom the

serial-visual principle of organization, perhaps culminating in illustration and high-definition lights and sounds, might one day seem arbitrary. Importantly, Parker (1965b, 57) could also foil the rather low expectations of the institutional bureaucracy, that any designer would add merely welcoming and tasteful decor to curatorial prerogatives, and go on to forge a new approach to exhibition design, right down to the detail of the label—whose very syntax must become an issue for post-linear exhibition design in the unique medium of the museum. Indeed, under Parker's watch, the very survival of the wall label was at stake. In *The Culture Box*, Parker (2025, 29) linked the use of the epigrammatic with typographic distortion, not a specific type of distortion, but as many distortions as there are designers. In other words, he sought a poetics of labels, full of wit and graphical play, not a more "explanatory" label (one that identifies and describes). But also, he wanted labels adapted to the diversity of audiences themselves. "Talk-back" methods use the audience as a resource, and labels based on different tones—confident, chatty, co-conspirator—bring into play different learning styles and learning challenges (Gurian 1991, 185). Parker (2025) concerned himself with how labels were lit, and where they were typically placed, and how audiences reacted to them: "*Apropos* of written labels, would it not be possible to tape-record visitors' verbal wonderings in order that labels could more adequately respond to the needs of the public?" (142). Parker even considered swearing to be fair game for label text.

The value of McLuhan's analysis of changing patterns of sensory awareness for Parker was that it allowed him to deduce an audience that could be approached indirectly, as it were, through children and their guardians as well as up-to-date, unbiased laypersons. As I have been arguing, his ideal audience, which he came to identify with youth counterculture and to whose attributes he repeatedly returned, remained conceptually and even geographically close, but practically elusive.

Parker's (1965b) thought experiments and occasional experiments were partial realizations of his belief in the value of a critical and reflexive design practice that seeks multiple kinds of evidence about the effects of exhibition materials and environments on audiences:

"there is an increasing need in our society to provide designers with an opportunity to test designs in their full social effects" (60–61). Knowledge of contemporary audiences could neither, he believed, be derived from one field (e.g., advertising) nor take a single form (e.g., empirical data). Such an audience was not monolithic, he thought; its members were subject to constant "re-structuring" by interacting with cultural and technological environments in their everyday lives. Yet Parker thought that in deducing an audience he could state something definitely about it, namely, that it "does not separate content from form" (60–61). The effects of form on content were a given, and the failure to accept this was to fall back into typical falsehoods, for example, "the fact that so many exhibitions are organized around the labels" (Parker 1965b, 63). Parker's ideal audience was already conceptually constructed as non-passive, participatory, and self-aware. He believed in the need for audience testing, and agitated for space for interdisciplinary research into the effects of experimental exhibition design:

> In order to arrive at any complete program for testing audience reaction in museums it is necessary that we bring together teams of widely divergent disciplines. It would certainly...require psychologists, social workers, designers, architects, medical doctors, psychiatrists, specialists in linguistics, as well as many specialists on various cultures and sciences who already work in museums. (64)

This interdisciplinary research paradigm was directed at the silo disciplines of the academy, yet did not project the result that specialist curators, once challenged, would simply drop out of the equation. The museum could play a leading role in this paradigm shift: "the museum, as an inclusive inventory of the extensions of humankind, can perhaps lead the way in the contemporary attempt to reorganize the exposition of disciplines" (Parker 1964a, 112).

Parker's decision not to return to the ROM after his leave was a clear response to the issue just posed: that the museum would not take the lead in reorganizing the disciplines; it would not step outside itself

The Hall of Fossils at the Royal Ontario Museum 151

in an act of decentralization and in so doing realize its "function...to coalesce the experiences gained from daily experience—to substantiate findings made in living context" (Parker 2025, 124). Within a few years, Parker's public pronouncements about the ROM and its director at the time, Peter C. Swann, became bolder, more definitive, and widely known—"the museum was a nightmare...an inhuman place," he once said ("A Citizen Profile" 1970). Still, Parker remained active in the first months of 1967 in the ROM's ongoing lecture series on "Arts as Communication," which had been running since 1963. He gave two lectures, the first in January on "Education as an Art Form" and a second in March on "Exhibitions as an Art Form." McLuhan curated the 10-lecture series in 1967 as part of the ROM's role in public liberal arts extension education for the University of Toronto (C. McEwen, personal communication, May 6, 2018).

Some qualification is in order with regard to Parker's attitude toward the ROM, an institution he sometimes praised. The ROM's annual reports contain a yearly record of each director's observations. In 1966, the remarks of Director W.E. Swinton on the Hall of Fossils project were sour:

> Once again, the anticipated date of opening for the new Gallery of Invertebrate Palaeontology has had to be pushed back. The task of selecting the fossils for the various cases was completed on schedule in June, 1965 and the very considerable labour involved in making the models for the dioramas was also finished by the summer of last year. On the other hand, the work on the case interiors has lagged considerably and, although a turnover of art staff has been a serious factor, by far the greatest ingredient has been caused by the fact that personnel have been constantly diverted to other tasks, many of which have been trivial. (30)

It was difficult to retain personnel within the department. The work environment hinted at above may be characterized by staff shortages and misrecognition of the sophistication of the models under construction as well as the demands on craft persons made by the case

interiors, not to mention problems with work assignments and work-flows. By the following year's annual report, new director Swann (1967) commented, a few months after the opening, on lessons learned about the Hall's fragile media technologies: "Since the opening much experience has been gained in the working of the electronic equipment which plays such a large role in the gallery, and many of the early teething troubles have now been eliminated" (34). The Hall was initially plagued by equipment breakdowns, long repair times, and the need for more protected installations. The culprit appears to have been the enthusiasm—perhaps the young ages—of the many visitors. By the following year, however, Swann (1968) was telling a different story:

> The Hall of Invertebrate Fossils appears to have stimulated a renewed interest in Palaeontology, judging from the number of people visiting it daily and the numerous enquiries on fossils handled by the Department. However, vandalism, including the loss of some equipment, has temporarily reduced the new gallery's attractiveness. Steps are now being taken to remedy this situation. (36)

The electrically powered models, invisible triggers (electric eyes), and other multimedia features were in some ways too fragile (invitations to touch exhibits may have opened a flood gate of overhandling), and too attractive to the wrong people, who knew the value of what they were visiting. Perhaps a lack of security exacerbated the problem. Whatever the case may have been, the director used his annual report to air these issues that were largely outside the control of the department itself, rather than emphasize more positive outcomes, or at least acknowledge the high costs of success. Year after year in these reports the Hall appeared as if it were under attack, and the museum was clearly playing a reactive role. The unit became a revolving door as personnel at all ranks began to leave.

The Hall of Fossils at the Royal Ontario Museum

Museum Communication from System Through Transmission to Making

By the 1960s, the term "communication" had entered the lexicon of museum studies. It was met with a debate limited by the continuing influence of the transportation/transmission model and the acceptance or exclusion of McLuhan's medium theory. Parker's effort to disseminate McLuhan's position introduced the idea of the museum as a "communication system." This sense of system, however, was specific to the extension of the human nervous system into electric/electronic circuity, and hence a human-artificial commingling in which, henceforth, neither would remain closed. Awareness of this, Parker thought, would lead to an eventual projection of consciousness as information into some network form that entailed a fundamentally "social consciousness" (McLuhan 1964, 56) of intersecting senses. One system would be translated into another: central nervous into information. This was the concept of system that Parker (1963a) attempted to explain, along with the implications for museum design, "when all the senses are turned outward in world-embracing extension" (353) and new ratios emerge. As McLuhan (1964) wrote, it is the "entire system [sensory] that is changed" (70). For Parker, this required a new kind of approach to design and display, one in which older values, use of language, and conventions of representation must be called into question. Instead, Parker (1963a) stated, all designers must face the challenge of "designing for total sensory response" (354).

This conception of system was based in a theory of sensory outering (extension and translation) and its implications. For those who rejected it, two steps were required: an initial diminishment of McLuhan (and either explicitly or implicitly of Parker) for a return to another "system," a communication model based on transmission. This is what Donald F. Cameron did (1968, 35–38). He dismissed McLuhan as fashionable and jargony, and did not mention Parker by name, but incorporated the title of Parker's article from five years earlier into his own title: "A Viewpoint: The Museum as a Communication System and Implications for Museum Education." A similar recuperative move was made a few years later by Eugene Knez and Gilbert Wright (1970) in their assessment of Cameron, who returned to a "primary communication system"

based on a transmitter/exhibitor (curator plus designer); media ("real artifacts" and subsidiary aids such as words and sounds); receivers (visitors); and message (storyline encoded into the artifacts and their supports). Cameron (1968) then added feedback: "The addition of feedback to the museum communications system is the basis of exhibit effectiveness research, when the function of feedback is to enable the exhibitor to modify and improve the effectiveness of his communication. Feedback can also serve when its function is to enable the visitor to verify one's understanding by comparison with the intended message" (37). Feedback here was merely used to match any individual interpretation to the institutional intention.

Thus, while some scholars added feedback, others emphasized visual communication in the exhibition medium (De Borhegyi 1963), defining its purpose as programmed effects impacting upon visitors, and holding their interest, motivating them, and engaging them in abstract thinking. Parker was included in this exercise and positioned as a medium designer of exhibits who was less concerned with wider museum messaging beyond McLuhan's medium theory. Notably, Christopher Whittle (1997) created a diagram of Parker's approach, in which knowledge about the "cognitive structures" and orienting the sense ratios of visitors played a decisive role in exhibition design (9). Whittle introduced the Parkerian anti-novel approach, referring to it as a *non-linear communication model* that was designed to bring the public into exhibit creation. From a one-directional exhibit-visitor model, through the bi-directional exhibit-visitor model of Parker, Whittle moved to the feedback model of Cameron, reversing the flow from visitor (creator of meaning and purveyor of feedback) to exhibit through the means of evaluation. Later transactional models cited by Whittle (1997) picked up Parker's "character of the visitor" (17) concerns and advanced a more empirically rigorous study of visitor behaviour. However, Whittle did not account for Parker's later papers in which he discussed in depth his exhibition design experiments and actual installations. Cameron and Whittle both used Parker's formulation from the early 1960s of the "museum as a communication system"; this has become a standard phrase in the critical literature, with and without any acknowledgment of Parker (for an example of

the latter, see Yudhawasthi et al. 2018). Mary Jane Calderon's (1990, 138–39) article on museum communication does not include Parker, but focuses on the ROM's mid-1970s efforts at formulating basic guidelines for museum communication. One of these added to the visitor's participatory role that of museum staff, a guideline as obvious as it was ironic (indeed, Parker begins Chapter 1 of *The Culture Box* with the observation that for many visitors, working at the museum meant guarding it, since this was the only conspicuous activity; see Parker 2025, 13). Parker's contributions were situated by Whittle (1997, 9–10) without reference to McLuhan's sensory configurations, underlining the interaction and overlap between exhibit and visitor; this overlap between institution and person was the site "where communication takes place."

Over the following decades, the conception of the museum as a unique medium became well-established in the secondary literature in museum studies. Roger Miles' (1989) work at the British Museum (Natural History) in London on planning, designing, and analyzing visitor feedback for educational exhibits kept the problem of media in circulation, but rejected McLuhan's approach, pursuing an empirical perspective based on "effective" delivery of content ("intended messages") (78). Miles (1986) sought to derive lessons about the operating assumptions that went into the large and long-planned *Human Biology* exhibit that opened in 1977. He considered exhibition design to be not indexable to any theory; rather, he considered that the "teaching point defined the medium," a reasonable assumption based on delivering messages about science to the public, which turned out to be of "limited heuristic value," he admitted, because media were selected depending on cost (process is more expensive than product). Electromechanical devices were replaced by microcomputers when they became available during a period of upgrades; thus, "the problem of selecting the right medium still remains" (Miles 1986, 237).

However, eventually, a kind of scholarly consensus emerged that information transmission was out of date, a relic of the "modernist museum," and thus it was "extremely limited," lacking in complexity, reductive, overly "technical," "unreflective," etc. (Hooper-Greenhill 2000, 134–35). Parker had pointed out these and other limitations

decades earlier, but in the conceptual language of McLuhan, which regained *making* from the limitations of *matching* messages using the destination or audience. The making/matching distinction served McLuhan throughout his career, at least from *Understanding Media* (1964) to *Laws of Media* (M. McLuhan and E. McLuhan 1988). Parker's *The Culture Box* (2025) is peppered with deployments of the distinction between matching and making, rejecting imitation-replication based on correspondence in favour of an engaged making or transformative approach, one more processual and creative, and carrying forward non-visual emphasis. Parker and McLuhan agreed that the transmission model had to give way to a transformation model. As McLuhan (1964) put it in kernel form in *Understanding Media*: "Each form of transport not only carries, but translates and transforms, the sender, the receiver and the message" (90).

Museum Communication at the ROM After Parker

While previous directors characterized the Hall of Fossils as a site of breakage and vandalism, as well as overenthusiastic uptake by the public, under Director J.E. Cruise (who had a 10-year-long tenure from 1975–1985), the ROM established a communication design team (CDT) chaired by David H. Scott that began a comprehensive process to develop guidelines for museum communication. Two years later, the following report appeared: *Communicating with the Museum Visitor: Guidelines and Planning* (CDT 1976). This comprehensive effort also included site visits with some familiar places and persons from the earlier *Museum Communication* seminar; both the Museum of the City of New York and Stuart Silver (then the assistant manager, but later the director of exhibits at the Metropolitan Museum of Art in New York) were consulted. Published almost ten years after *Museum Communication* (McLuhan and Parker 1969), the *Communicating with the Museum Visitor* report was intellectually worlds apart. Nevertheless, on the face of it, wasn't this the kind of study that Parker would have welcomed, and had been demanding all along? And after all, Swann had believed that Parker would return from New York bearing insights into museum audiences. In Part A—Museum-Wide Considerations of the 1976 report, the supposition is that "it is taken for granted that museums

The Hall of Fossils at the Royal Ontario Museum 157

wish to attract and communicate with visitors by making the museum experience both pleasant and interesting" (5), an attitude that Parker had dismissed as merely comfortable, and forgettable, alongside a focus on "good taste" in interior design. The "pleasant reception" of arriving visitors is a further consideration (CDT 1976, 27). The ROM appears in the report as a data-poor institution; for instance, when comparing characteristics of visitors with those of the Metropolitan Museum, a home study from 1959 is cited against the more current New York study from 1973 (9). That the ROM sought ground that was antithetical to Parker is evident early in the study with the questioning of the museum's overriding and unifying theme as well as linked sub-themes for the purpose of public communication beyond individual exhibits. Eschewing visitor discovery of patterns within galleries that provide "insufficient information" for the sake of the mission of educational support, and the systems that such a strategy would require, the discussion quickly circles around the necessities of language skills, directive didactics, and the contents of labels. Already in the first section it is evident that the enduring values of literacy, effectiveness at the gallery-level of storylines, and necessity of didactics are positively marshalled. Indeed, the understanding of orientation is halted at maps, directories, graphics, and information desks. The team believed that liminoid spaces for orientation, a matter for "debate," may be counterproductive, taking time away from visits or becoming in themselves a destination exhibit (34–35). Certainly, Parker's ideas about the value of an orientation gallery would have been anathema to Scott and his colleagues. All of these themes are fundamentally anti-Parkerian. While diversity in gallery design is praised in the report, lurking in this praise is belief in the danger of a "carnival atmosphere and visual chaos" (40). Security is notably mentioned as a function of orientation in some museums (48), especially in lessons about not touching—except for a targeted "sacrificial object" that invites handling (51). No mention is made of open cases of fossils and animal models with "Please touch" signage. The opportunity to address the evident security concerns underlined by previous directors, caused specifically by the Hall of Fossils, is missed.

Individual gallery design should be framed, then, the report reads, through "telling the story," beginning with the collection of artifacts held by the institution. The centrality of storyline should wind its way around two obstacles to avoid: the perpetuation of stereotypes, especially regarding Indigenous nations (CDT 1976, 86); and the professional biases of both designer and curator. It is suggested that attention to the needs of visitors will mitigate any such biases, yet the hypothesis is that bias arises from "authority" supported by the setting itself. Challenges to authority by visitors will depend entirely, the report says, on the type of visitor in question. The question of the influence of the designer remains a consideration within the report, as an attempt is made to maintain a clean separation between the role of the designer and the task of critical questioning (91). In short, it is not the role of the designer to critically question the museum! It seems that the designer must not act too strongly in any capacity, given the propensity identified in *Communicating with the Museum Visitor* for design to overwhelm the objects on display. Indeed, some display techniques may distort, it is claimed, the meaning of installations, just as much as overly simplistic labels may starve visitors of information. It seems that more is more—as long as it is not monotonous.

The use of media systems is assigned to those issues subject to "debate" in the literature, and Parker's 1963 *Curator* paper is cited, although he is not named in the body of the text, in support of one position in this debate: his position is characterized as "subjective" and linked to "intensity of arousal" (CDT 1976, 92–93) in the service of learning; this summation misses Parker's gradualist colour theory analogy. Conversely, appeals to non-visual multi-sensory stimuli in museums are "not well understood" and require study (93), it is noted, in a way forestalling progress toward the blossoming of the multi-sensory museum. Recourse to this category of the "little understood" invites further study, suspending the need to take a direct position. However, there is a further example invoked, that of the blind, which is highly suggestive of Parker's own experiences and interests. It appears that designing for vision-impaired visitors is directly linked to the integral use and development of audile-tactile-olfactory sensory media (93).

Thus, "it would appear that exhibit communication can be enhanced by creative exploration of means of simultaneously stimulating different senses, rather than by abiding by the usual constraints of visual presentation" (93). Considerations of access are linked, as they were for Parker, to sensory detailing of acoustics, surfaces, and spaces (see Lupton and Lipps 2018, 124ff). The conclusion is linked directly to the discussion of only one impairment, and does not invoke a theory of the senses, or pursue a museum of the sensorium. It is simply an admission that is narrowly pursued.

Yet surely the report's final statement that "it would appear that exhibit communication can be enhanced by creative exploration of means of simultaneously stimulating different senses, rather than by abiding by the usual constraints of visual presentation" (93) is something of a vindication of Parker's entire approach, and a gesture to the future. By linking design for visual impairment and analog technological developments through the work of George Moore (1968), decades prior to tactile digital screen display, an interest in blindness of the sort shared by McLuhan and Parker is rehearsed. The expansion of accessibility into a critical approach to the museum, grappling with residues of ocularcentrism—for instance, under the appendix "Tactile Samples," the supposition is that "the viewer can touch [and thus] discover things about an object" (CDT 1976, 419)—and the inclusion of work by blind artists, would result by the end of the 1970s in the formation of the ROM's working group concerning facilities for visually impaired visitors. Less of a critical and radical resituating of vision and more of a recognition of a "new" public, activated institutionally by the ROM Community Access Network (a social inclusion measure founded only in 2008), the provision of descriptive audio and tactile models and exhibits designed to be touched eventually became firmly embedded in museum communication. Parker's approach to sensory "disadvantagement," outlined in the thematic of the *Sound of Vision* conference he organized at RIT, called into question, then, the typical technologies of museum experience (e.g., recordings, slides, projections, screens) where visitors who were blind or hard of hearing were concerned. Although this limited approach to accessibility can also obscure more expanded fields of display, including marginalized

modalities of experience in general, designing haptic interfaces that involve touching objects and architectural features can expose a range of stratifications within touch, between the privilege of connoisseurs with regard to originals and non-expert contact with objects in lowly "handling collections" (Candlin 2008, 18), and limited numbers of tactile maps and fonts.

Public Highs

In his search for an audience for his exhibition designs, Parker recognized that children would be receptive to a number of innovations, and that "at the age of twelve you can condition them, you can make them aware of their environment" (McLuhan and Parker 1969, 72), and then continue to reach them when they are adults. This long view did not necessarily exclude the literate adults who accompanied them, but it held out no great hope in this regard.

Another side to this approach was not to design the gallery for palaeontologists, but instead to hypothesize a gallery without labels (or labels clustered at the end like footnotes, perhaps, but in which style?), or at least labels designed to be "crunchy," like boxes of corn breakfast cereal with multiple, distorted typefaces and inviting sugar coating (Lee 1967, 32). Parker was not content "letting children push buttons," as he soundly criticized the OSC for failing to provide any idea of the larger issues such as the impact of technology on people's lives beyond this meager opportunity. To publicly criticize the OSC was a daring act at the time, as it was considered to be at the cutting edge of participatory innovation in the science and technology museum sector, circa 1969, yet this brashness and mass access it gave to high-tech tools was shallow for Parker. Yet, he certainly did not eschew the use of buttons, switches, and telephone handsets.

Within a long, developmental view of his audience, Parker did not maintain that he would eventually attract his teenagers. It was surely a cruelty of geography that the youth enclave of Yorkville would be so close to the ROM by any objective measure, yet so distant in mental terms. In Parker's casting of the occasional flow of youth into the ROM as a variable with a fluctuating value alongside a more constant flow of children and their guardians, his ability to reach his quarry remained

largely a matter of theoretical deduction. After all, just a few blocks away, things only started to heat up as night fell and the ROM closed its doors for the day. The "night at the museum" sleepover had not yet been invented. Not only, then, did the museum not lead the changing relations between the disciplines, but it also could not deliver the audience whose sense ratios were best attuned to Parker's exhibition designs. And it was this latter predicament, as much as any other, that perhaps explains why Parker left the ROM's employment so soon after his greatest triumph as a designer: the museum was a medium through which his ambitions could not be fully realized. It would not become, as Parker (1972b) had hoped, "a perception kit." Instead, it was "a collection of oddments put together to provide sensory awareness. Museums also could fit that definition. It is unlikely that many people who work in museums have ever thought of them in that way. Museums by their very nature tend toward massive immobility" (54).

The Culture Box was written in the voice of a museum insider and seasoned exhibition designer. But the manuscript is not an anti-museum screed, despite section titles like "Museums—Close 'Em Down?" It becomes apparent that, for Parker, this was a question to which the answer hinged upon whether the assumptions museums worked with really did "strangle" culture and creativity by closing off access to their holdings to the broadest possible community. Museums, in Parker's estimation, needed to become less self-satisfied specialist enclaves, full of out-of-date conceptions and overcommitted to literacy and linearity. Parker (2025) certainly had some sharp words for museums: they were perfect places for "filing-cabinet minds" (9), and perpetuated unawareness by ignoring the restructured sensorium. In working by means of hypothetical examples, and by deducing audiences and proposing "new centres," Parker risked—and he was certainly aware of this—leaving out one of the main ingredients: the actual audience he sought empirically, not satisfied, it seems, to deduce it theoretically. For the public, Parker (2025) believed, should play a part in "the design thought from the beginning" (22), although he did not lay out a plan for access to collections. Without the public, he wrote, one risked "impos[ing] an overall design format upon content which should remain relatively malleable...one must almost live with the material, learn as much

about it as possible, and watch it until it finally dictates what one should do" (2025, 22). Hence, his repeated statements about the need for flexibility in the buildings themselves, in a responsiveness of form to shifting interests in subject matter. The role of visitor feedback is notable because it would in principle register the impactfulness of the "re-stimulated sense lives" of visitors on the modes of display themselves, and this element of involvement and of exhibition as a process was for Parker vitally important. He did not consider any exhibit in terms of a closed, "final" match between the "sensory state of the creator" (indeed, where creators existed) of the artifacts in question and the habits of the visitors, but rather attempted to use ideas such as *déjà vu* experiences as exploratory means toward a greater understanding of the encounter between two sense ratios: "it is not content which is being remembered but a particular interrelationship of the senses" (2025, 31), perhaps derived from a dream. For Parker (2025), the power of an exhibit may have been appreciated in the "subtlety of conveying a sensory ambience" (35) in a display, which worked by conscious use of similarity (affinity) or difference (abrasion): "The designer must learn to rearrange sensory input as a focal point from which the audience can encounter empathically the assumptions of other cultures" (37). This appeal to ambience suggests the creation of sharable atmospheric affects of attraction and repulsion.

The task of loosening encoded percepts is not semiological; it does not require language, and this makes it agree with the rejection of storyline and marginalization of printed didactics and explanatory labels. Rather, Parker's appeal was to catalytic patterns and intersecting non-discursive intensities, deliverable by immersive multimedia displays employing multi-sensory stimulation. Parker's sense of memory was linked to regaining not a specific content, but an attunement to "a certain ratio of the senses" (2025, 31) that may not have been consciously lived, but that perhaps formed part of a dreamscape or imaginary scenario. Parker sought to tune in visitors by means of multimedia display environments, and he likened this to *déjà vu* experiences as a kind of meta-memory.

The Hall of Fossils at the Royal Ontario Museum

Reordering the Dutch Gallery at the Museum of the City of New York

AN EXPERIMENT IN MUSEUM COMMUNICATION

||

THE *MUSEUM COMMUNICATION* SEMINAR convened for its second day on Tuesday morning, October 10, 1967. Parker had spent the previous week rearranging the New Amsterdam Gallery for multimedia, installing six projectors (five for slides, one for 16mm film), tape recordings, a loosely draped curtain, a few artifacts, and two manikins in period dress (male and female children) illuminated by strobe lights. The proliferation of projectors occurred because of the inability to use odours, for instance, and to create manipulable models due to time constraints. A visit to the space took place followed by a discussion. Parker relied on Fordham University colleague tape documentarian Tony Schwartz for his sound samples and films, although the film that is mentioned, *My Own Yard to Play In*, was not by Schwartz. Rather, it was Phil Lerner's 1959 record in black and white of children playing creatively with abandoned cardboard cartons of various shapes and sizes, used car tires, sticks, sand, building materials, and chalk on the sidewalks of New York (McLuhan and Parker 1969, 38). Parker also made a somewhat vague statement about the use of unidentified

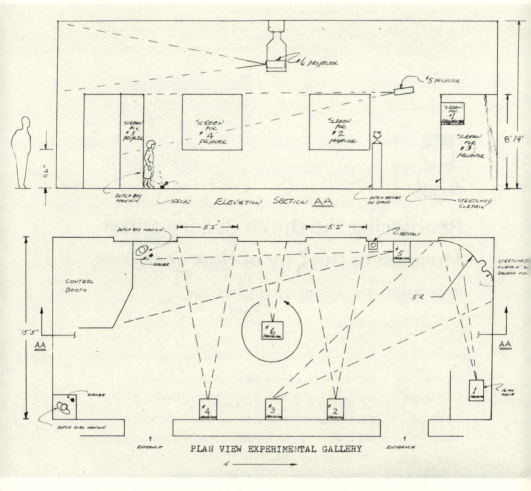

Diagram of an Experimental Gallery, Museum of the City of New York, 1967. (Used with permission from the Parker Family Estate.)

"Dutch music" and a soundtrack of "sounds of contemporary New York," the title of which he "forgot"; no assurances can be provided about its origin. He apologized not for his forgetfulness, but for the surplus of contemporary New York sounds in the exhibit (McLuhan and Parker 1969, 38). Imagine what this did to the listener: did one listen for Parker's intent as a designer, or for the force of his forgetfulness? Or did they overlap? Parker's realized sound and light sequence

of programmed images and recordings lasted only 16 minutes and 30 seconds (McLuhan and Parker 1969, 37). Attendance was proposed at an ideal number of 12 at a time, which was difficult to realize as it created a pool of unoccupied participants waiting in line; presumably, the directors and designers and museum insiders in attendance were not accustomed to standing in line-ups. When Parker began the seminar on Tuesday morning by addressing this exhibit, not everyone participating in the discussion had yet managed to visit it.

Despite the constraints under which he laboured, Parker was successful in mounting a kind of orientation gallery that he had been speculating about since the early 1960s, despite the fact that it was not purpose-built but a redesigned existing gallery. While working with historical and contemporary reference points that involved the use of Dutch music, slides of artworks, together with sound and film recordings of recent New York streets and children's games, about which Parker advised viewers to "extrapolate" from New York to New Amsterdam, his goal was not unity but pattern recognition. One seminar participant, Mary Black, the director of the Museum of Early American Folk Art, praised Parker for his bravery, but felt the exhibit was "awful." For her, the positive point surely was the purpose to "jog us [participants from the museum sector] into saying more"—moving beyond recourse to labels, classifications, and categories—and to restart perception (McLuhan and Parker 1969, 61). This observation correctly placed restarting perception at the heart of the reinvention of museum communication. For Parker, "I believe simply that if you take a person of the 20th century, living in New York, one has certain attitudes towards space, and certain other attitudes towards time. One has a general orientation to the world in which one lives which can act as a barrier to an understanding of an alien culture. The purpose of an orientation gallery is to provide an interim period in order to let one adopt a stance which is a little more congenial to appreciation of the gallery" (McLuhan and Parker 1969, 68).

Parker shared with Schwartz, and with McLuhan, the idea that multimedia technology could be used to massage the sensorium, bringing to consciousness existing habits and tendencies as well as reorienting them. In his book *The Responsive Chord* (1973), Schwartz developed an

Reordering the Dutch Gallery at the Museum of the City of New York 167

effects theory of communication built around the concept of resonance, similar to the idea that McLuhan had borrowed from organic chemistry to apply to tactile contact, but focused on sound metaphors. Schwartz understood "resonance" as a non-symbolically encoded experience stored in memory that has not undergone transformation. Hence, a percept that has not been semio-linguistically encoded is thus not retrievable by means of a further linguistic prompt. Rather, such encodings may be evoked by packaged stimuli that "resonates with information already stored within an individual and thereby induces the desired learning or behavioural effect. Resonance takes place when the stimuli put into our communication evokes meaning in a listener or viewer" (Schwartz 1973, 24–25). Hence, the need for understanding the stored information of receivers of messages in order to evoke it, but in a "patterned way." The pattern in this respect would be observable by examining the contours of the communication environment (displaying regularities, repetitions, and convergences/divergences); in this case, Schwartz claimed, the electronic media of the early 1970s shaped information storage. By "striking a responsive chord" through evocation, Schwartz displaced the message, as the content of the communication process did not come into play until the end of the process, as meaning arises late. The formal patterns of encoded information may be evoked through breaking anticipated patterns, for instance, especially in the case of manipulating the intervals between sounds and adjusting the speed and volumes of repetitive sounds. Parker shared the same view, since for him making visitors aware of their sensory organization by bringing perception to consciousness was the first step in adjusting it, breaking habits of linearity, and preparing visitors for new sensory mixes that gallery design could then deliver and reinforce, in some cases with the active participation of visitors if they were given some control over lighting, temperature, placement of objects, etc. In invoking ambience and making over matching, Parker sought in acoustic spaces a resonance that Carpenter found in Inuit dwellings, igloos, and sealskin tents. These displayed an acoustic openness based on an auditory and tactile understanding of space, as visibility was often at a premium in the harsh winter environment of the Arctic, but gave rise to an acute sensitivity to environmental perturbations of wind and

fog, water swells, mist, and animal sounds, perceived and decoded through different parts of the body (Carpenter 2011, 14).

For Schwartz in *Media: The Second God* (1981, 50), tape allowed for reality to be constructed, and this led to the reversal of the idea that a recording is not an original, which he believed was encouraged by electronic media. Tape gains a certain kind of cultural authority under this condition of reversal. Parker appreciated Schwartz's insights into how to deploy media in order to construct a reality that would have the power to modify everyday life so that it would fall into line with the construct. Perhaps Schwartz warranted use of the phrase an *edited* sensorium, consonant with Parker's desires to reorient audiences and recalibrate their sense ratios. A danger is that when the means are elliptical, they might be mistaken as cacophonous.

The task of this chapter is to extract from Parker's presentation and responses to questions about the elementary principles of exhibition design as far as an orientation gallery is concerned. Building upon both his hypothetical and built galleries, the temporary gallery he mounted in the Museum of the City of New York was an experiment (perhaps "exploriment") in the sense that it tested a hypothesis, even if the test was held together, as he put it, with "beeswax and chewing-gum" (McLuhan and Parker 1969, 38).

Basic Principles

> 1. An orientation gallery is a liminoid space within or attached to existing or potential museums.

During the previous afternoon, Parker had lectured solo on overcoming visual bias and underlined his belief in the uniqueness of the museum as a communication medium. Among directors of American museums present at the seminar, the role of special programming was a generally accepted strategy for building attendance. Parker raised in this context his idea for a newseum, as topics drawn from world events, augmented by existing collections, would satisfy the requirement for "special" programming that was responsive to contemporary world developments (one idea concerned the Vietnam War as a potential

exhibit). The newseum, as Parker imagined it, would sit "outside the museum proper" (McLuhan and Parker 1969, 33), yet utilize its resources; thus, special programs would not be driven by a given museum's collections, but by news stories (without obvious criteria of selection). Parker's fascination with liminal spaces emphasizes the transformational processes that visitors undergo in crossing a border of sorts, whether it is within the museum, when entering into the museum from outside, or even when coming from an adjacent space (he conceived of spaces in the museum being used for rest, movement, and display in terms of the attitudes they conveyed to visitors; see Parker 2025, 77). He thought of liminal spaces in physical terms, but also in terms of tools that would assist in such transformative experiences, the most significant of which for Parker was overcoming "pervasive lineality" (McLuhan and Parker 1969, 31) through the use of technologies that would play with sound and light. Parker seemed bewitched by the possibilities opened up by superposition (film running over slide projections; multi-screen projection; overlaid recorded voices), as these were evidently involvement enhancers: "as long as there was a single voice, you could just sit back and listen, but as soon as these two voices began to come out at you simultaneously, a tremendous sense of involvement was felt" (McLuhan and Parker 1969, 34). Intensification of sensory involvement through technology prepares visitors for a passage that begins with separation from the outside world, transits through this space that acts like a "liminal rite" (Sfintes 2012, 3) of sensory reflexivity, and, following reorientation, becomes a transformative experience in the museum or gallery itself (only if it has been redesigned with the reorientation in mind and thus is coordinated, and cleansed of any lingering prejudices). The concept of "liminoid" (Sfintes 2019, 8) was derived from liminal, at the border between anthropology and architecture, to describe not so much a mandatory rite of passage, and its code of assimilation, but one that is chosen and is playful and creative (in Parker's sense of making patterns).

The second principle concerns Parker's models of reference:

> 2. Selection of models of reference borrowed from commercial entertainment venues such as nightclubs, with transposed highly

focused sound and light shows of limited duration at appropriate
scales and in multiples, if required.

Parker's examples were borrowed invariably from the non-museum
world. His two leading examples were *Labyrinth* at Expo 67, and the
short-lived (1967–1971) nightclub in New York's East Village, Electric
Circus, created by rock promoters Jerry Brandt and Stanton Freeman;
the latter was an early adopter of multimedia, with immersive, perfor-
mance-oriented events, roving regular performers, house bands, and
guests, as well as a tent-like interior with projections on walls and ceil-
ings, speakers built into the floor, tunnels, a foam rubber room, and
limited seating.

Labyrinth was The National Film Board of Canada's Expo 67 exper-
iment that used, in the second of the building's two viewing chambers,
an innovative five film projectors and five screens in a cruciform shape
(the other chamber had two massive vertical and horizontal screens
viewed from balconies four levels high). In between was a zigzag-
ging maze with prisms and flashing lights. Janine Marchessault (2007)
underlined the power of the multi-screen experience not only for the
visitors but for the designers, and for McLuhan himself, to "end the
story-line" and for this "synaesthetic cinema" to "transform memory
and imagination" (42–46). For Marchessault (2007), "the *Labyrinth*
Project can be read as the sensory training ground for the new global
citizen" (47). This is precisely how Parker approached it, and his pro-
grammed slide and film projectors were deployed to disrupt lineal
narrative for the sake of a simultaneous, post-sequential, syntax
(combinatorial coherence). It should not be forgotten that two years
later in *Counterblast*, Parker was charged with graphically designing
McLuhan's (1969a) statement: "Words are multi-screened/faceted but
simultaneous myths" (24). Unfortunately, engagement with Parker's
ideas during the seminar did not get much beyond agreement about
the quality of *Labyrinth* and the expense of running a multi-screen
pavilion outside of a world exposition. The potential of syntactic orga-
nization to permit simultaneity effects is fairly limited in spoken
language and sign language, but more open when images and sounds
are concerned, with superposition, overdubbing, overlapping, edge

blending, and multiples at play. Parker also utilized "grammar of presentation" in *The Culture Box* to articulate how meaning is formed within constraints. Parker (2025) stated that "we simply lack grammars of presentation" (81) in the museum, by which he suggested that there was an absence of rules for packaging exhibits, beyond any designer's artistic intuition and appeals to decoration. Parker (2025) focused on the rules of media themselves in the museum context and how they configure meaning, that is, *how* shapes *what* is meant, or "the forms of presentation modify content" (94).

Parker referred to the circus and to discotheques in general as means to reach his select audiences of youth, and remarked on how much he enjoyed his visit there on Monday night after a day at the seminar (McLuhan and Parker 1969, 39–40). Parker's daytime interlocutors at the seminar suggested he was instilling fear in his audiences, but his approach was to curtail and concentrate continuous performance, too much of which seemed to exhaust certain attendees, who sought forms of relief from sensory saturation. The 16.5 minutes of concentrated multi-mediatic immersion was Parker's solution (ideally reducible to a mere 10 minutes, he thought, a short "prelude") in his design of a reception gallery. Hence, Parker claimed, "I would suggest that museums are in show business" (McLuhan and Parker 1969, 43). A single show was not an automatic solution to high-volume visitor flows, Parker readily admitted, since resources were limited in terms of multiplying preludes: "I wouldn't suggest one orientation center for the entire Museum of Natural History [New York]. I would suggest multi-orientation centers for the various kinds of disciplines involved" (McLuhan and Parker 1969, 45). Parker was not done with disciplines, as they were indexed to physical spaces such as halls and theatres. Even "orientation halls" were not unknown, although not in the Parkerian sense, such as the Wallach Orientation Center at the above-mentioned museum, but this was defined as introductory (presenting an arboreal evolutionary tree) to the linked Fossil Halls of dinosaurs and then mammals, and one was to literally follow a line through that was painted on the ground.

In *The Culture Box*, Parker sought inspiration from Italian designer Erberto Carboni, whose mid-century exhibitions for Italian industries

(chemicals, distilling, textiles, automobiles) included abstract forms, colours, and shapes in the spirt of sculptors like Alexander Calder. Carboni's highly influential architectural forms in the shape of television screens executed for the 1954 Milan Fair, on behalf of the Italian Broadcasting and Television Corporation, invited the visitor into the presentation itself as if they were passing through a television screen during the pre-flat era of the cathode ray tube.

Parker also sought advice from Bauhausian Herbert Bayer in two respects: he rejected the 19th-century Beaux Arts style of "beautiful displays" that ignored the objects in them, which Bayer considered to be a "misconception"; and, like Bayer, he rejected the distinction between graphic arts like typography (including advertising) and fine arts, arguing for a "new kind" of design in which "many mediums" (and dimensions) would be engaged and integrated. Parker utilized Bayer's "Preface" to Carboni's *Exhibitions and Displays* (Carboni 1957, 9). This volume is held in the ROM Library and Archives and would have been available to Parker. Although Bayer fixated on certain elements of "logical sequence" and the "reading habits" of visitors in executing floor plans, a very un-Parkerian approach, his Bauhaus bona fides were not in question, as he found exhibition design to be a kind of "intensified and new modern language." As previously noted, a "new grammar of presentation" to capture what Parker (2025) thought was lacking in exhibit design (83) required a medium theory. An "integral design" approach, to use Parker's concept (2025, 85), would require an interdisciplinary perspective that overcame dichotomies and broke up siloed knowledge production, so that the multifarious content of museum presentation could be critically apprehended.

In Carboni's aforementioned exhibit, as Bayer noted in his preface, the "evocative shape [television screen] is...a powerful symbol for the entire exhibition. Then he enforces the idea T.V. with additional visual elements which... [provide] an enriched picture of the complex, technical, imaginative world of T.V." The visitor, Bayer observed, "bodily floats in T.V.'s atmosphere...in the relativity of a curved universe" (Carboni 1957, 11). The museum designer must, Parker thought, work with embodied perception.

Bringing together some of the diverse themes in this section, design is susceptible to the compromise of falling back on "good taste," which was one of Parker's major targets over the course of his career (see Parker 2025, 82, on "the mind-anaesthetizing burden"), and something that any creative designer wants to avoid. Parker's interest was in overcoming any reduction to a purely decorative function, pushed through the example of what can be learned from collaborations with scientists, that is, taking into account the importance of basing design decisions on some sort of data. Parker's experience during his most active years was that good data on audiences was hard to generate, and he admitted that while "intuition" must often guide the designer, it must not be an unexamined intuition based on "cultural appliqués"— "habitual" assumptions about communication (i.e., the priority of the printed word and linear exposition that produces passivity). In other words, Parker conceived of an "integral design" in which both linear and non-linear approaches mutually influenced one another, as long as visual bias was rooted out. He called for the creation of opportunities to test designs on audiences and to learn from the migration of techniques from poetry and painting into advertising, and advertising's influence on exhibition design. At all costs he wanted to avoid "embalming" artifacts, rendering them bloodless. His embrace of persuasion was certainly not uniformly shared by directors of public museums, and he challenged the assumption that advertising techniques have no place within a public educational mission, where this duty mistakenly overrides opportunities for such borrowing. Parker predicated his approach on "intelligent use of techniques of advertising," not on moral grounds but on those of existing and unavoidable restructurings of sensory orientation by the world of media, regardless of the intentions of individuals who may wish to opt out or to claim some degree of immunity from them. "Grammar," then, was a term Parker (2025) used to push past intuition, to seek multidisciplinary input for design, and to seek acknowledgment that exhibition design always engaged many mediums, each with its own sensory limitations: "museum design is a medium that demands a knowledge of the assumptions of many other media" (87).

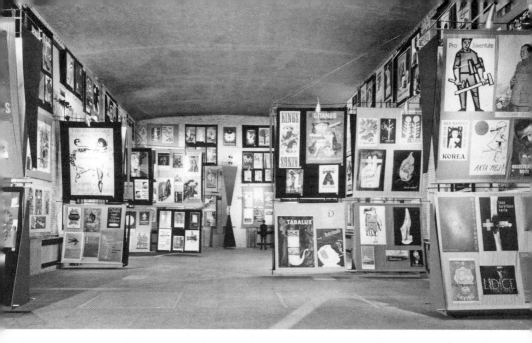

Impact: Poster Art of the World, 1960. (Courtesy of ROM [Royal Ontario Museum], Toronto, Canada. © ROM.)

Picking up on Bayer's importance for Parker, it is instructive to return to an installation from early on in his employment at the ROM. Faced with the arrival of the travelling *Impact: Poster Art of the World* show in 1960 at the ROM, Parker discovered damaged paper and adhesive marks among the 400 items. Moreover, his design strategy changed when wall-mounting was complemented by upright hangars consisting of cloth stretched over large sections of steel tubes. The densely packed exhibit of posters utilized wall spaces, open passageways, and pillars under the vaulted ceilings of Samuel Hall, and were easily demountable.

Impact: Poster Art of the World (1960) was utilized by Parker as an example of how he used simple techniques of mounting and reverse perspective to shift the viewer from familiar to unfamiliar spaces, preventing any retreat from immersion into a "dispassionate survey." This opens the discussion on Parker's sense of how he could "disorient" and "dislocate" museum visitors, that is, shift them from their everyday perceptions, by removing what he called "the cap of invisibility" of everyday spaces, and into more imaginative spaces—but this kind of

practice operated on a wide continuum between shock and accommodation. Parker's examples were used to develop the distinction between iconographic and pictorial spaces, and to translate this into a practice that would initiate critical reflection on the part of the visitor. The orchestration of "spaces" was key to Parker's (2025) practice:

> At the entrance, posters were pasted on a kiosk. This was an obvious attempt to place the posters where they would customarily be encountered. Half surrounding this kiosk and extending to the entrance was a wall covered with posters, again, a likely place to find them. This wall, however, sloped upward toward the entrance in a kind of reverse perspective, so that by its dislocation of the mechanics of three-dimensional illusion it served to act as a transition to the imaginative type of space to be encountered in the display. As the doors of the exhibition were entered one was met with such an overwhelming array of posters that it could only be described by the word "impact." (52–53)

Parker explained that he sought to create two different kinds of spaces, real and imaginative, immerse the visitor in the latter, and provide a transition between the two. This transition was an early, perhaps the earliest, example of an "orientation" space—not a gallery in its own right, but a way of "sliding easily, in an emotional sense, into it" (2025, 53), especially for those over 30 years of age. Parker did not think that children of the television age would have any difficulty with such a transition.

It is evident in this and the following example that Parker was indebted to Bayer's Bauhaus conception of the encounter of a museum visitor with "planes of content at diverse angles" (Lupton 2020, 114). Although Bayer's famous drawing of a figure with an eyeball for a head was a standard feature of his sketches, and thus visually biased in an overdetermined way, it informed Parker's shift from artifact to idea in his conception of design as a mode of communication that reduced the distance between the visitor and exhibition, opening up the field of vision to a surround that emphasized multiple planes beyond the horizontal (Lupton 2020, 97).

Consider in this regard Parker's explanation of his modification of the Ontario Regency Room in the Canadiana Gallery at the ROM. He approached this typical period furniture room by creating a wall-floor at a thirty-degree angle from the horizontal plane, at the back of which were placed two doors at right angles to the viewer with a single balustrade running from the back. This approach "forces people to look at objects which, if they were placed in a conventional background, might receive no more than a cursory glance. We have become, in our society, too used to pictorial space...It is the placing of an object in an unusual space which forcibly calls it to our attention thereby facilitating the possibility of perception" (Parker 2025, 55). Instead of looking at objects, the fallback position is simply to read the labels, except when, as Parker (2025) maintained, "the visitor cannot accept the object as a part of one's usual visual spatial orientation" (56). Among Parker's examples of pictorial-based exhibition design is the diorama, which would be inadequate for an audience with an audile-tactile orientation; further, he criticized reproductions of cave art as "totally violat[ing] the spatial conditions under which these paintings came into existence" (2025, 61), that is, on curved walls.

The third principle describes the orientation space:

> 3. Orientation gallery design is based on the same characteristics of receptivity that the correctly deduced youth audience experiences in the world of electronic media, even the least receptive among them.

For Parker, an orientation gallery consisting of an adapted sound and light show remained liminoid in relation to the gallery into which it discharged visitors, but to which it might be connected by a pre-recorded soundtrack delivered through an integrated speaker system. In this space, Parker emphasized the communication of "flavour" rather than a strict focus on artifacts, labels, and lineal narratives (storylines, chronologies, official histories). Sounds still signified in this scenario: quiet (New Amsterdam) contrasted with the cacophony (noise) of contemporary New York City. In this way, then, Parker retained his pursuit of youthful visitors, the correctly deduced audience: "let's start looking

after our youngsters who don't think in that way [linearly]" (McLuhan and Parker 1969, 42). His desire was to make them welcome and comfortable. This audience lived in a world of simultaneity, a new electronic world of the ear, a world of inclusive, dynamical, acoustic space that *lacked* fixed boundaries and precision with respect to sound sources, and that was vague on point-to-point connections. Parker outlined these goals and inserted into them brief observations about his own children, who had, with the exception of his youngest, already passed through their teens. He included his belief in the ideas of McLuhan as well. The alleged failure of the education system due to the fact that it was producing more and more intelligent dropouts who were alienated by the visual bias of pedagogy. These diverse observations supported an imperative of sorts to address youth issues, a theme of Parker's later work. By 1970, he had turned to statements about intergenerational relations and the fear of "losing our younger generation," especially in terms of his support for draft dodgers, better youth employee-employer interfaces, and the necessity of passing the mantle, as it were, to a new generation of so-called "entrepreneurial buccaneers" (Parker 1970b, 7).

Parker had begun to talk publicly about hypothetical galleries and orientation galleries as early as 1963, and he was quoted in 1965 by Mair about a plan to realize his ideas (discussed previously) at the ROM with regard to displays of Indigenous materials: "two 'orientation galleries' to front the ethnology displays...for the public to shed its Cadillac complex. I've got to make people understand...that the North American Indigene didn't even have a horse until the fifteenth century" (35). Buried among questions and answers about the role of films (to mistakenly perpetuate storylines) and film loops in gallery spaces, Parker and McLuhan turned to the signification of the artifact. Only one artifact, on a high plinth, is indicated in Parker's plan for his orientation gallery. The "Dutch artifact" (17th century) simply stands in for the Dutch Gallery proper (by indexically connecting to its holdings), the gallery for which Parker's room would be a prelude (if it was located adjacent to the museum instead of inside it), and it sits alongside the two "Dutch" manikins, dressed in national folkloric, gendered costumes (iconically simulating Dutch children). Although it has

been argued that McLuhan's clearest statement about the artifact as a medium was not fully articulated until the posthumous publication of the four-part model of the tetrad (Theall 2001, 71), the brief reflection on the artifact as a translator of experience indicates the conception was already at play. McLuhan said:

> Every culture has a sensory bias. Every artifact is an instant indication of the sensory bias of the culture. You can read it like a book or a language. But we haven't spent much time teaching people how to read the sensory languages of cultures. In any museum you have an incredible richness of artifacts that are clues to the sensory bias and preferences of a whole people. (McLuhan and Parker 1969, 44)

McLuhan's recourse to "book or language" suggests a kind of evocative rather than structural linguistic construction of signification in which the sensory bias embodied by an artifact is available for interpretation, for a trained decoder, that is, for whom presumably sufficient sensory training has occurred or sufficient knowledge of the sensory code exists. This reading is "instant," and the signification thus brings preference to mind by an immediate "indication." There is nothing ambiguous about this, apparently, likely because the range of signifieds are limited to two pairings: lineality or non-lineality (with variations on formal elements regarding materials), and visuality or non-visuality. These are not contents, that is, psychical entities, not "mental biases" but "sensory" preferences or exacerbations. McLuhan and Parker insisted that storyline (lineal) and simultaneity (non-lineal) could coexist, and hence the disjunction above should allow for some degree of inclusivity (so, too, could vision and olfaction coexist, alongside the other senses). Their interlocutors at the seminar were reluctant to abandon storylines, and a return to *Labyrinth* was made as it suggests, despite its technological sophistication, the storyline of the classical Greek myth of Theseus and the Minotaur. McLuhan insisted that the presentations in *Labyrinth* had "no literary meaning whatever" (McLuhan and Parker 1969, 46), since they lacked continuity ("the ear does not permit a line"). Objections were raised to McLuhan's interpretation that

Labyrinth was a "dramatization of the act of cognition," given that this, too, is a storyline, supported by myth. McLuhan made the point that training perception has nothing to do with "ideas," as the latter are simply adjuncts to visual bias (logical, rational, sequential, detached).

The valorization of simultaneity and nowness reinforces the elusiveness of storyline, while permitting the signification of sensory bias. Notwithstanding McLuhan's recourse to language to support a point about non-lineality (sometimes understood as abrasion and juxtaposition, but also emotional involvement), Parker's recipe for richness and pattern creation remained purposive, right down, he admitted, to the selection of the slides and sounds. Everett Ellin, assistant to the director of the Guggenheim, came to the rescue of McLuhan and Parker in clarifying that purpose and selection were not to be confused with storylines (McLuhan and Parker 1969, 48). Ellin was one of the few members of the seminar audience who had constructively absorbed the approach of McLuhan and Parker. The prickly reception of Parker's experimental gallery and McLuhan's explanations among museologists and gallerists at this event was not isolated and did not fade away. The extraordinary hostility toward the use of multimedia at the expense of traditional approaches to artifacts and the delivery of information about them and their contexts was still much in public view in the 2000s, especially in Toronto, where the legacy of Parker's design innovations and McLuhan's ideas were then considered to have had a "pernicious effect" on the ROM (Dewdney 2008, n.p.), due to the "tremendous loss of information" for the sake of "a few buttons and tape loops" (this was Barzun's opinion, too). Only if the theoretical justification for the use of multimedia in terms of generating an active "simultaneity of perception" (Parker 2025, 99) is subtracted, and Parker's denigration of button pushing is also studiously avoided, does this kind of critique make some sense. In targeting Taizo Miyake's use of buttons for the OSC, Parker (2025, xxiv) did not categorize the modalities of experience beyond dismissing the purely manual, being not yet able to qualify the differences between hands-on and hands-off participation and the new opportunities of the burgeoning immersion experience industry that would arise in the 1980s. It is worth noting that Miyake would much later pioneer the object theatre approach

at Science North in Sudbury, Ontario, using digital technologies and video to enhance *storytelling* (storyline), augmented with various types of participatory opportunities.

In summary, at this point, an orientation gallery was a sensory training facility that not only assisted visitors in the directed decoding of artifacts (toward the sensory biases of their creators and users), but its concentrated use of sound and light also transformed artifacts into art by changing their definitions. Change came about, Parker said, by inserting an artifact into a new environment, an "unusual circumstance" (McLuhan and Parker 1969, 49). "Blast those art galleries and museums which imprison and classify human spirit," McLuhan wrote in *Counterblast* (1969a, 65). Museums did not yet know that they were involved in the training of perception, with the power to dislocate and advantageously stimulate visitors. This largely worked not by using shock tactics, Parker thought, but by challenging assumptions (i.e., cultural superiority) and provoking a "sentient stance": "A museum presentation which makes available to the senses another sensory orientation is effectively raising into consciousness a rich and strange modality of being. The effect of raising new modes into perception will be a necessity of re-evaluating our own" (Parker 1972b, 59). This making strange of the familiar and given, coupled with the need to adapt, involved a deep sentience about self and other.

The fourth principle answers the question about changing habits:

> 4. An orientation gallery is about bringing perception to consciousness, dislodging assumptions and exposing biases where necessary by using multi-media design to produce an interface between visitor and artifact that builds empathic understanding and contributes to highly refined awareness.

McLuhan called what Parker's orientation gallery attempted to release in visitors "a sense of discovery" (McLuhan and Parker 1969, 52). Discovery is one thing, but issuing a challenge is another. As Parker noted, likening himself to an artist who exposes a hitherto unseen environment, the "designer in a museum is sort of a *persona non grata*" (McLuhan and Parker 1969, 52). Choreographing visitors is easier

under experimental conditions than it is on an everyday basis. Parker insisted on small groups, and briefed his adult visitors, at least, about where to stand, given the narrowness of the gallery space (McLuhan and Parker 1969, 53). With children and university student groups, he modified his instructions. The visits were also timed at 10–15 minutes. However, neither Parker nor McLuhan had a plan to analyze responses. Instead, they used anecdotes about classroom experiments and utilized a familiar tool to distinguish between responses based on lines—story- or party- or otherwise.

An orientation gallery was always a "prelude" and never a "postface." It was Parker's way of responding to the perceived need for understanding audiences. Much of the Tuesday afternoon session of the seminar was devoted to audiences, beyond box office numbers, through the use of surveys and other related tools of social scientific inquiry. The generally accepted view among participants was that not enough was known about audiences, who Parker thought of as key components of any museum environment. His approach was guided by the need for feedback; this was unspecified to be sure, but a measure that would result in gallery refinement. His "gallery without labels" idea was proposed as a way to get feedback that would provide guidance on writing labels, and then give more feedback along the way (McLuhan and Parker 1969, 61). The task of bringing to consciousness unexamined assumptions and given stances figured the audience as potentially receptive but essentially unprepared. In the case of his already attuned potential audience of countercultural youth, the task of orientation would be that of reinforcement and heightened reflexivity, although he did not assume in advance that this group, too, which lived in depth in a highly mediated world, was fully cognizant of the implications. Parker's general belief was that "by heightening consciousness you heighten perception" (McLuhan and Parker 1969, 69). For Parker, it was in a state of heightened perception and reflexive sensibility that audiences should be moved through orientation galleries into the exhibits proper, and thus into different worlds that would become progressively "alien" or distant. Ultimately, the orientation gallery's approaches to the processes of exhibit display would influence the design of the galleries within the museum proper. This

horizon would remain imaginary, as it was never built according to Parker's purest conception of it.

The use of multimedia technologies within an orientation gallery reflected Parker's belief that while his missing youth already understood this to some degree, many other groups remained unaware. This opened for Parker a pathway toward "rapprochement with the audience of today." He wrote: "I would regard multi-media shows as being very highly realistic in a sense that they tend to correspond to the general orchestration of sensibilities" (McLuhan and Parker 1969, 68). He was providing what he obscurely called a "method of insight"—not a method of inquiry for an investigation, but of insight gleaned through orientation and applicable to the museum experience for visitors. He re-embedded his missing youth into an intergenerational matrix, as he did with the Hall of Fossils, in order to ensure the longevity of successfully conditioned and receptive audiences over the life cycle.

The seminar was closed by invited guest Jacques Barzun. The Columbia College historian of ideas included in his highly anecdotal reflection on communication much of what Parker and McLuhan had just presented as a remedy, only to abandon it: do not meet bombardment with bombardment; do not abandon the linear for the non-linear and simultaneous. Barzun was not, as he put it, a "cyclical historian," and hence did not believe in the "endless duel" between the book and multimedia cathedral, now electric circus, but instead poignantly asked: "how soon will we get sick and tired of the 'interesting experiment' which hinges on some little play of sensation?" (McLuhan and Parker 1969, 80). Since Barzun was given the last word, Parker had no comeback. McLuhan (1962) had no way to extend his characterization of Barzun in *The Gutenberg Galaxy* as an alphabetic man without a clue (32). After presenting his storyline, Barzun, the transcript noted, received a "standing ovation" from the attendees.

Near the end of the final chapter in *The Culture Box*, Parker returns to Barzun in the context of a discussion of the museum as a storehouse of history. He cites Barzun's comment in his audio recording of *The Care and Feeding of the Mind*—to the effect that preservation of artifacts may be an obstacle to creativity ("hampered by the weight of accumulated masterpieces"; see Parker 2025, 189), and hence the burning

of the great library at Alexandria can be positively assessed—where Barzun pleads that this passing remark should not be conflated with his overall attitude toward museum (and other) collections. But Parker (2025) is poised to strike: "There can be no danger to the really creative mind...If there is 'an excess of the museum habit' it is because material is being presented in such a manner as to overawe the audience. Art is presented as a concept instead of as a percept. No artist can come to harm by being aware of the diversity of perceptions possible" (189). Therefore, Parker states: "No, Mr. Barzun, the library at Alexandria should not have been burned" (190).

Regaining the Multi-Sensorial Museum in Translation

||

Le bon goût est le refuge des imbéciles.
—French epigraph from *Counterblast*, translated by Jean Paré

El buen gusto es el primer refugio de los imbéciles.
—Spanish epigraph from *Contraexplosión*, translated by Isidoro Gelstein

IN THE LATTER HALF OF THE 1990S, I developed an approach to McLuhan's legacy by analyzing the patterns of his French reception in Europe and Canada. Key to this endeavour was close attention to the page designs of Parker. At that time *Museum Communication: A Seminar* (*Le musée non linéaire: Exploration des méthodes, moyens et valeurs de la communication avec le public par le musée*) remained untranslated in French and would not appear for another nine years, after my book *McLuhan and Baudrillard: The Masters of Implosion* (1999) was published. My point of access to the eventual publication of *Le musée non linéaire* in 2008, and its reception in largely French museology in terms of the diverse concerns of the new museological

thought, begins with a brief transit through the kinds of questions I posed in my earlier work, in addition to a few comments about the Spanish translation, and design decisions, of *Counterblast*. This chapter then settles into a more detailed look at how the translators of *Le musée non linéaire* understood the originality of McLuhan's and Parker's ideas, and how this translation was received in the critical museological literature. It was Parker's focus not only on the museum as a communication system, but also on his efforts to make the design interface between exhibits and visitors a subject of research that made his work relevant to the new museology, especially to its French adherents.

Translation and Reinvention

There were two approaches to translating McLuhan into French. The first was that of a hard-won fidelity to the text, executed brilliantly by Jean Paré on the foundational books, especially *The Gutenberg Galaxy: The Making of Typographic Man*, which was debated in the arts pages of the Quebec dailies *La Presse* and *Le Devoir* after its controversial launch at the Pavilion du Québec at Expo 67. This was not without its challenges, to say the least, as McLuhan's penchant for identifying Quebeckers in a salutary way, with countercultural "hippies" locked into the 17th century ("tribal and feudal") trying to communicate with English Canadians and others committed to a 19th-century viewpoint ("urban individualists and industrial"), was flagged immediately as anti-Gaullist (suppressing the import of language and the independence of culture). This blithe primitivism advanced by McLuhan claimed that the province's very backwardness was perfect for Expo 67 because of its unburdened adaptation to 20th-century technologies, having skipped several print-dominated centuries in between.

The first approach to translating McLuhan into French yielded a good deal of reflection about the difficulty of rendering stylistic elements, as it was believed that *The Gutenberg Galaxy* was strongly resistant to French cognitive styles, if these were considered to be Cartesian and neo-classical in construction (Garric 1967); similar acrobatics were applied to the (mis)fit between McLuhan and structuralism

(Paré 1968), and the political consequence (conservatism) of opposing him was to fall back into specialization, rationalism, and to choose explication over exploration (Dommergues 1967). Yet, rejecting his empty discourse and near-but-never-achieved-prophecies was to, as a consequence, embrace the importance of post-structuralist French thinkers like Derrida, Serres, and Barthes (Texier 1968).

The second approach was to largely rewrite the text for a new readership. The co-authored 1970 volume *From Cliché to Archetype* (McLuhan and Wilfred Watson), translated by Derrick de Kerkhove as *Du cliché à l'archétype: La foire du sens, Accompagné du dictionnaire des idées reçues* (1973), is a Flaubert/McLuhan reconfiguration, backgrounding co-author Watson and widely substituting French for English literary quotations, not always to the best effect (Marcotte 1974). McLuhan spent several years defending this approach to naysayers. There was no randomness in De Kerckhove's choices, and the backfilling of underdeveloped features in the original, all the while using Flaubert's definitions as a satire of platitudes, produced a superior version. Thus, a cliché deployed in McLuhanesque fashion may give rise to a breakthrough, shaking off the perceptual numbness that normally accompanies it. And this was precisely the spirit of De Kerckhove's brilliant translation experiment: foiling the expectation of remaining close to the original text, and instead collaborating with McLuhan on new examples to better orient French readers. A key question remains and is perhaps unanswerable: why wasn't this revised *Du cliché à l'archétype* translated *back* into English? In lieu of an answer, what is presupposed in this question is that the book was not first rewritten in English before being translated. Thus, a new, collaborative McLuhan book is still waiting to appear in English translation, perhaps with three authors listed on its cover.

However, besides readers who were bewildered about losing the thread in the French translations as much as in the original English, and complaints about a method lacking in the methodical, a notable issue would emerge in the case of such books as *Counterblast* when Parker's design had to be adapted to the visual qualities of the French language. Among McLuhan's books, those with Parker (especially

Through the Vanishing Point) were thought to be highly resistant to translation. I will begin with a few remarks about *Counterblast*, before considering the very late translation of *Museum Communication*.

One of the fathers of modern graphic design in Quebec, Gilles Robert (1929–2013), tackled Parker's word-objects and adapted them to the demands of new letter combinations (see Genosko 1999, 118–19, for consideration of a postural reterritorialization of bum / *cul*). Much of the work by Robert and his team focused on reproducing Parker's typography and fitting the French terms into strong iconic templates; for example, "bless The Beatles" / "*béni soient* The Beatles" (McLuhan 1969a, 29; 1972, 29), with a black mop atop the page with just a hint of sideburn, centred blue disk evoking vinyl records, and curved line evoking a cradle, not to mention the adage about those who rock the cradle. However, working with the translator Paré, Robert built upon Parker's typography and extended it, building new words like ice / *frais* in a hollow lettering suggesting skate markings. Likewise, he squeezed new letters into old shapes as in the capsule-shaped "Blast Sputnik" / "*Honni Soit le Spoutnik*" (McLuhan 1969a, 85; 1972, 85). In some instances, small references were erased altogether, as in "the city no longer exists, ex, exe, ex.cit." / "*la cité n'existe plus, ex, exe*" (McLuhan 1969a, 12; 1972, 12) without the abbreviation *ex cit.* (example cited). Only occasionally did McLuhan's Joycean wordplay force Paré's hand into homophony and guesswork: "rear end look? Ear begin look? / *Rire* end look" (McLuhan 1969a, 97) / "*Coup d'oeil en arrière? D'oreille en avant / En humour?*" (1972, 97).

Robert's work on logos would become identifiable if not well known throughout the 1970s in Montreal and the rest of the province, as they were highly visible and touched many walks of life; these included visual identities for the Montreal police, milk producers, annual reports for a variety of companies, publisher announcements and book covers, theatre posters, alcohol bottle labels, etc. His impact would be limited in *Counterblast* due to the lack of latitude for genuine invention. However, the fact that he did reinvent word-objects when required marks the French translation as more experimental than the Spanish translation *Contraexplosión* (McLuhan 1971), in which the BUM assemblage remained untranslated in English (39). McLuhan's (1969a, 22)

joke early in the book about how chairs "serve human ends," that is, rear ends, and the use of *"visées"* (*"fines"*), captures nicely the designer's aims. While the French to Spanish translation of *"chaises"* (*"las sillas"*) works despite the inversion of the *cul*, in which the "u" is turned upside down like a backwards "n" upon which the balancing "c" sits, with the "l" stretching downward as a leg, Robert added a hint of breast and arm for good measure by repeating the letters inside the design (thus, "cul" is reassembled in French into a semi-reclined position, but retains in Spanish its original rigid alignment in English). The "brilliant graphic imagination" of Isabel Carballo was praised by the Spanish translator (McLuhan 1971, 146), even though none of her inventions strayed far from the originals.

While the French retained the English title *Counterblast*, the Spanish translator explained that the choice of *Contraexplosión* was intended to approach the use of the term in the book as a counter-environment, and downplay the strong colloquial "code word" for smoking cannabis ("blast") as much as possible. Yet, the problem with "explosion" is that it doesn't sit well with the passage from the age of explosion to implosion, heralded by McLuhan.

Between Lineal and Non-Lineal in *Le musée non linéaire*

In terms of timing, only three years passed before the French translation of *Counterblast* appeared. It would take *Museum Communication* almost 40 years to appear in French under a new title—a much improved title to be sure. The first task in this section is to look at the translation itself and note where the translators pointed out errors and oddities in the original, but also how they reframed the work. In their translators' introduction, Bernard Deloche, François Mairesse, and collaborator Suzanne Nash pointed out that neither McLuhan nor Parker held favourable views of museums, and Parker especially was openly hostile to them, despite spending a formative part of his career in one. This combination of ferocity and precision of critique was voiced in a context in which the audience of museum professionals was largely still attached to the very traditions (visual, linear, and narrative frameworks) their invited guests fulminated against. The fact that the third guest, Barzun, vindicated the resistance of the invited guests

Regaining the Multi-Sensorial Museum in Translation 189

was noted in the previous chapter. The book itself was rechristened in translation as *Le musée non linéaire* because the text demonstrated the non-linearity of the process of its creation, a recording and transcription that yielded a *patchwork* without a storyline (McLuhan and Parker 2008, 16–17). This corresponded directly to how Parker understood his formation in art history—"I did it [art history] by little snippets... after a number of years, it began to coalesce into some kind of pattern" (McLuhan and Parker 1969, 42; 2008, 111–12)—through a non-linear method of training, cobbled together into a pattern, which he translated into his museum displays. This volume is not a historical artifact from a period when the traditional museum was under attack, as it sits comfortably within more contemporary innovations driven by the possibilities of interactivity brought about by technological change that many museums had embraced, but which they had been, after all, attempting to deal with (i.e., through computerization) since the late 1960s. The "cultural redistributions" (McLuhan and Parker 2008, 29) noted by the translators are in some respects beyond those proffered by McLuhan and Parker, as these came much more recently as part of a greater openness to non-Western cultures, and result from a critique of the preservation of Western values and exoticism; Parker was acutely aware of Western ethnocentrism and the unexamined tendency to treat Western values as superior to all others. Insofar as lineal and literate museum curators were educated and shaped by their training, which taught them that the museum is a book, the event of the seminar was nonetheless still turned into a book, and the translation itself strived for linearity in building explanatory footnotes for a French readership and providing citations missing in the original, as well as excavating wordplay. There are footnotes, in addition, containing a number of minor corrections of passing references made by Parker and McLuhan both to books and phrases, for instance, Parker's misnaming of the author and title of *On Human Time* (McLuhan and Parker 1969, 42; 2008, 111, note 94). Henri is actually Georges Poulet, whose book *Studies in Human Time* played an important role for McLuhan in *The Gutenberg Galaxy* (1962) by providing temporal insight into the "new time sense of typographic man" (241). Some original errors persist, for instance, Parker's reference to the countercultural neighbourhood only

blocks from the ROM as "Yorkdale Village" (Yorkville) (McLuhan and Parker 1969, 39; 2008, 105), which looks like a transcription error.

Although the terms in Parker's diagram of his multimedia installation, an orientation space for the Dutch Gallery, are not translated, the installation of six slide projectors, one 16mm projector, and screens, as well as two strobe lights and dressed mannikins is augmented with a footnote explaining that Parker's inspiration for the light show was the Electric Circus discothèque (McLuhan and Parker 2008, 105, note 92). The footnote adds a superfluous reference to Andy Warhol's role in founding the Exploding Plastic Inevitable, which predated the Circus on the same site, but neither version (English or French) contains a discussion of the role of psychedelic light artists in the evolution of the discothèques of the period, specifically Earl Reiback and Tony Martin (Masters and Houston 1968, 86 and 150), although examples of venues— Elcock explores the short-lived club Ruffin Cooper's Cerebrum in New York, in which guests removed their clothes and donned white togas, and created their own light shows and performances (see Elcock 2023, 152ff)—and artists are too numerous to pursue for our purposes; the artistic model of consecutive rooms, each delivering unique sensory experiences that *Mind Excursion* explored, was pioneered by USCO at the Riverside Museum in May 1966 (see Elcock 2023, 144–45).

Parker's signature rejection of storyline—"linear exhibits"—and narration through artifacts referred in passing to a wide range of phenomena such as, somewhat vaguely, "contemporary literature" with a "dropped story line" (McLuhan and Parker 1969, 42). The French translation of storyline as "*la trame narrative*" (McLuhan and Parker 2008, 110, note 93) is explained with respect to non-narrative novels in the *nouveau roman* tradition, specifically by Michel Butor in France, but also by Joyce and Beckett. Whether the term "framework" suffices to capture the abandonment of plot in the new novel, without a mention of Alain Robbe-Grillet, is probably beside the point, as the key reference is to McLuhan's conceptualization of the multi-sensorial intensely involving acoustic space reawakened by electronic media. However, De Kerckhove put Robbe-Grillet to good use in inserting a de-specializing quote about love, poetry, life, politics, and even revolution as so many games in the section on "Conscience" in *Du cliché à archétype*,

in between the existing quotes from Eliot and Mike Nichols' 1967 film *The Graduate* (McLuhan 1973, 71; McLuhan and Watson 1970, 66).

Parker's mention that he worked in "Metropolitan Television education" (McLuhan and Parker 1969, 42), rendered as "*le service 'Education' de la* Metropolitan Television" (McLuhan and Parker 2008, 111), required but did not receive some attention. He was referring to curriculum-based instructional programming delivered though the Metropolitan Educational Association (META) in Toronto. Broadcasting began in 1970 on the ultra-high frequency (UHF) analog Channel 19 and evolved into the public broadcaster TV Ontario (TVO/TFO). His own experience inside an educational system that continued to subjugate television to the book was offered in support of his own multi-screen-focused intervention in the form of a short orientation centre for visitors, contributing to a new form of education, he believed.

It was only a matter of time before Parker turned to his trusted epigram. Turning the conversation toward wit, in contrasting the designer with the curator, Parker admonished museum presentation style for settling on "good taste" in exposition as the fulfillment of its mission. The translation of the select epigram is "*le bon gout est le premier refuge de la bêtise*" (McLuhan and Parker 2008, 130). The inclusion of "stupid" is not as cruel as it may first appear, as it suggests a philosophical stupidity. Parker insisted that museums were traditionally in the service of the stultified who found refuge in the good taste exhibited therein. This sounds like nothing more than an insult, yet Parker was clearly haunted by it, and this haunting was a philosophical problem for him. It was Gilles Deleuze (1994, 151) who regained stupidity as a proper philosophical concern that can neither be reduced to mere error nor animal attribute. It cannot be pinned on others, for one owns it, it is one's own. So, Parker could not separate himself from this situation even though he certainly tried to, and his repeated returns to it signal an inability to get around or beyond it, and certainly he failed to extricate himself from it; he had to find a way to accommodate it. Indeed, all those who wish to communicate must grapple with it. The encounter with stupidity is at the heart of the conjunction of the museum and its capacities to communicate. If art occurs at the

interface of the artifact and audience, as Parker (2025, 166) insisted, then this encounter is haunted by the easy recourse to comfort, and to an aesthetic refuge in the undemanding, despite every effort to provoke reflection by the designer.

The Place of Parker and McLuhan in the New Museology

This second section looks at some of the deployments of the translators' introduction in the French secondary literature, and the questions that the translation raised about how to situate Parker and McLuhan in new museological terms. Laura de Caro (2015) cited *Le musée non linéaire* as a precursor to the contemporary museological interest in visitor experience as embodied, active, and productive. Her purpose was "to test the malleability of the [museum] medium" (57), and this required surmounting the transmission model of communication delivery, which required moving information unidirectionally to visitors from museal source repositories, and replacing it with a communicative making that was constructive, multi-directional, and multi-sensorial. It is almost *de rigueur* in museum studies to offer a critique of transmission, exposing its authoritarian connotations and announcing the break with some kind of processual, reciprocal alternative following a turn to cultural mediation in the secondary literature (Lemay-Perrault and Paquin 2017). Marshall and Eric McLuhan (1988) announced precisely this shift in the posthumously published *Laws of Media*, where matching was replaced by making (86). Although it appears, as I have argued elsewhere (Genosko 2010, 12), that making, presented as an alternative to the transmission model of communication, is often nothing more than "making do" or simply coping with new situations, the emphasis on interaction requires attention to the ways in which objects are embedded in matrices of virtual-mediatic networks, spatial-sensory-architectural potentialities, shifting organizational boundaries and organigrams, and the setting of parameters for active-participatory opportunities of engagement. Flexibilizing museums, as Parker would have it, would ready them for physical and psychical transformations and encourage community engagement (Parker would not have been satisfied with behind-the-scenes tours, to

be sure, unless they were useful in gathering data from visitors, which museums now do, even though the effects remain understudied; see Wilkinson 2019).

McLuhan's critique of communication as a form of transportation came in the form of the substitution of information for messages in which more than mere passage would occur: transformation took place in movement, and in terms of reorganized sensory interplays. Information in this respect sped up, and with an implosion of hitherto separate components, not toward an absorption of energy that was annihilating, but in establishing a new proximity (i.e., between sender and receiver). Instead of catastrophe, there was intimacy, beyond simply matching in the standard engineering model (where the transmitter changes a message into a signal, and the receiver converts the signal back into a message). Parker picked up this train of thought in *The Culture Box* and contrasted the microcosmic forces of making with the macrocosmic forces of matching (2025, 97). For him, it was the work of the artist to marshall these forces in an "inward turn," that is, a kind of "introspective involvement" in the situation of simultaneous communication and electric implosion (the pulling out of space/time differences). What had to be made was not given, even for inversion. What was made in being recognized, then, were emerging patterns, not previously carved pathways; hence, the dominance of the non-linear over the linear and the iconic over the illustrative.

De Caro (2015) wrote: "Together with Harley Parker, [McLuhan] spoke to an audience of museum directors about the 'modular' quality of museums. The museum was presented as a flexible medium" (57). Neither Parker nor McLuhan preferred to use this term "modular"; however, it was used elsewhere by McLuhan as a repetitive and resonant "module" or unit applicable to a variety of things, including high-rise buildings, mini-skirts, and youth culture figures like The Beatles, the Electric Circus, and Jefferson Airplane. The crossover becomes explicit in the case of the "space module" that either docks with or detaches from other components. De Caro (2015, 57) cited the translators' introduction by Deloche and Mairesse on this point about the museum as a flexible medium. Her quote is only partially retranslated into English. The full quote begins here: "*il est modulable et—à*

la différence du baseball qui, selon eux, demeure un jeu figé—on peut, comme l'expliquent les auteurs, en changer les règles; d'autre part, il est de par sa nature propre un moyen d'accès à la perception sensible et intuitive des choses" (McLuhan and Parker 2008, 14–15). What was meant here by "modular" was not the typical English sense of adding and subtracting component parts, but simply "flexible": "it [the museum] is flexible, unlike baseball, which, according to them, remains a finished game—[De Caro's translation begins here; see 2015, 57] *we can, as the authors explain, change its [the museum's] rules; and that is, it is by its very nature a means of access to the sensory and intuitive perception of things"* (author's translation). The contrast between the museum and baseball recapitulated in the seminar the difference between flexible and fixed. These statements partially quoted by De Caro are, however, attributable to one of the participants, Everett Ellin from the Guggenheim Museum, who took up McLuhan's suggestive contrast, which was based on why baseball is ill-adapted to television, and focused it on the museum. Ellin said: "The museum differs from baseball in that our ground rules are far more flexible, and there is no reason why we can't program our own environment to shape it to the expectations and the attitudes of the people who come to us…Baseball cannot change its rules and make itself multi-level without losing its identity. But I think museums can begin to think non-linearly" (as quoted in McLuhan and Parker 1969, 19; see also McLuhan and Parker 2008, 69). Thus, the proverbial mould can yield a new cast without losing its identity. The "rules" can change; syntax and grammar can evolve. It only requires a new ecology, one more like television, according to De Caro (2015, 59; also see McLuhan and Parker 2008, 48), following McLuhan, which is the potential for a non-linear museum to create an environment akin to other low-definition, highly involving, cool media of the electronic age. This would entail a new approach to artifacts, education, organization, visitor services, etc. The focus would be on the "exercise of perception," as Parker tried to initiate in his liminoid orientation experiments, and the nexus of attention would be the artifact-visitor encounter as that between different sensory systems and "biases." In a manner reminiscent of Parker's reflections on Indigenous and Inuit exhibits, De Caro (2015, 62) flagged here how a "colonial encounter" with artifacts

by museum visitors could result in a sensory clash. In turning to multi-sensory interpretation of exhibits as providing the promise of a respectful encounter with cultural difference, De Caro acknowledges the counterproductive lure of facile sensory marketing, as it is a distinct possibility within a highly corporate institutional environment.

Could this approach to the artifact bear and carry lessons of the sort that McLuhan argued applied to the satellite in its capacity to change how human societies relate to the planet—as a programmable human-made environment? The shift triggered by the satellite would be that of the artifact-visitor transitional relationship in terms of inculcating a reflexive sensory awareness about cultural differences. Parker argued in *The Culture Box* (2025) for three linked principles: first, decentralization—bigger museums are not better museums. He maintained that small, satellite museums, still linked to large parent institutions, had the ability to reach not only wider but different audiences (not merely school children through enforced attendance). Indeed, he wrote: "In satellite museums, people could become actively involved in museum affairs with their neighbours" (2025, 177). The second idea was that the pursuit of prestige through bigness is demoralizing because the "human scale" is lost. Hence, Parker was anti-elitist, fulminated against philanthropic culture and its "preciosity," recoiled against the "portentous" atmosphere of prestige institutions (180), and agitated for public funding. The third idea was that "solemnity" must be extinguished, because it supports the assumption of an "unchanging aesthetic" (180). For Parker, "museums are strangely antithetical to the joys of living even though they are packed with artifacts which came into being as happy acts. They are too often of the grave—literally" (180). The approach here is not about the artifact, or even the satellite as such, but about the environments these create and the relationships within them. Simulated artifacts in immersive virtual environments (various 3D imaging technologies) might supersede or augment physical structures, yet the limits of involvement even here are not probed. Membership or ticketed entry is a limited relationship, even if the new environment displaces a previous environment with a new wrapper—the old glass cases, tight classification, rigorous labelling, and untouchable artifacts are put into storage. While the release

of creativity is the expected result, it is not obvious how much input a visitor may actually have while briefly dwelling in a flux-y acoustic space, and the degree to which visual and linear thinking may reassert themselves remains unpredictable. This was Gascia Ouzounian's (2007, 55) critique of the visual-acoustic space dichotomy as it applied to the Philips Pavilion in the Brussels World's Fair in 1958. Designed by Le Corbusier with a sound and light show by Edgar Varèse, acoustic space was evoked visually both by sound and by site, contradictorily "rendering acoustic space 'visual'" and exposing the unresolved tensions of the distinction.

Translators Deloche and Mairesse considered the "modulable" factor to be unusual for offering an exit from traditional practices, despite, as they insisted, Parker and McLuhan's (2008) pessimism: "given that the museum, like a cyst, seems to have concentrated in itself all of the defects of Western society" (15). As they pointed out, the end result was a text with a number of non-linear attributes, and the process partially validated the claims of Parker and McLuhan. Yet, it appears that few of the assembled were willing to forgo the mastery of their collections for the sake of "the lived experience of sensoriality" (McLuhan and Parker 2008, 17), if it meant, as Parker maintained, that "an invertebrate palaeontology exhibit must not be designed for the three paleontologists in the city, but for the general populace" (17; McLuhan and Parker 1969, 13). It was not exactly the general population at stake, but the children who were the immediate conduits for Parker's patterns (recalling the element of coercion he attached to this fact at the ROM), while the main countercultural quarry remained elusive. His efforts in the Hall of Fossils were, after all, designed to bring in those living in the now, with integral touch, heterogeneity of experience, some familiarity with near simultaneity, and a willingness to explore the sensory profiles on display, as well as fill in subjectively, Parker insisted, what was missing or diminished by addition. Parker (2025) utilized Wilhelm Ostwald's (1969) remarks on colour theory to develop the meaning of "total sensory response" as a process of constant re-orchestration: "Ostwald said it was as if one had a test tube full of colour; if one wished to add another colour it could only be done at the expense of the original ingredients. In the same

way, any stepping up of one sense can only be done at the expense of another. So, in a painting, if the tactile quality is stressed it will always be at the expense of the purely visual image" (102). The idea of sensory "bias" arises from the deficit-effect of addition—one thing at the expense of the previously existing thing, rather than more by means of "and," as in a constant accretion.

Senses Working Overtime

Recent work on the sensoria of museums not only brings into contemporary focus Parker's much earlier reflections, but also revisits some of the same problems he encountered in dealing with Indigenous displays. A good example is Marie-Josée Blanchard and David Howes' (2014) study of the exhibit *C'est notre histoire: Premières Nations et Inuit du XXIst siècle* in the Musée de la civilisation à Québec. Reflecting on the historical phenomenon of colonizing objects by the Western gaze, and reinforcing the dominant role of vision in the museum and the aesthetics of display, the authors note that a new trend has emerged with regard to how institutional credibility requires consultation with members of the cultures exhibited, complicating both the question of preservation and of representation. Through the organization La Boîte Rouge VIF, a full-service organization working on the development and design of media to assist museums and other partners in the communication of Indigenous cultural values, the sensorial worlds of the Indigenous nations of Quebec were integrated into the exhibition. Blanchard and Howes (2014) construct their analysis around the hunt and the significance of spiritual communion with animals, the processing of all parts of animals, sharing, and consumption. These processes are richly ritualistic, tactile, olfactory, and auditory. The challenge is, then, how to recreate this sensory complexity and make it accessible, and the testimonials were clear on this point: they not only wanted Indigenous visitors to "se sentir chez soi" ("feel at home") in the museum, but they also wanted non-Indigenous visitors to be able to "sentir qu'ils entrent chez nous" ("feel that they are entering our home"), the home of Indigenous Peoples (Blanchard and Howes 2014, 259). Parker's (1972b) voice rings through this approach and is true to its problematic. Recall his concerns on precisely this point:

> Perhaps it is possible to empathically encounter the sense life of Indigenous peoples. They certainly didn't walk the way we do with our concrete battered, shoe-squeezed feet. Their sense of smell was very acute; as there was little noxious to smell, they had no need to hold their nose. Besides, one's nose, for a hunter, was very important. Their eyes, too, undimmed by artificial lights, and trained to catch the slightest movement, were acute and their whole world was filled with a multitude of things we would never see...I am not suggesting...that we should return to the pre-contact world. (54)

The sensorial encounter with Indigeneity was Parker's attempt to make non-Indigenous museum visitors feel that they were in the world, or better, "entering the home," of Indigenous people. In the Musée de la civilisation à Québec, this was done in a number of ways, by mixing circular exhibit design with curved screens (sound and vision), providing touch screens with selectable videos made by Indigenous artists and scholars, making skins and furs available for visitors to handle and smell, together with including hunting tools indexed to specific animals, as well as finished products like clothing, snowshoes, and a contemporary artistic installation. This level of coordination allowed for the olfactory experience of tanning, which lingered on the fingers and permitted a degree of discernment about which skins were the least and most odiferous. For the non-Indigenous visitor, this permitted, despite obvious limits with regard to the experience of hunting and butchering, "intimate and holistic contact" (Blanchard and Howes 2014, 262). The artwork was an interactive wigwam with warm stones, cedar smells, and low light that communicated the "value of intersensoriality according to First Nations" (Blanchard and Howes 2014, 263). Moving well beyond Parker, Blanchard and Howes reveal that some Indigenous visitors would have preferred much more extensive use of Indigenous languages, a greater role for humour, recognition of the interior world of spirits, dreams, and visions, understood not didactically but by means of gallery ambience, and perhaps an opportunity for visitors to repair damaged canvas or carry a travel bag and collect items in it as they passed through the exhibit. These

recommendations are acknowledged by the authors as "unquestionably legitimate [as they] would have permitted a completely different experience of the space" (Blanchard and Howes 2014, 265). The conclusion drawn about *C'est notre histoire* describes it as an uneasy "reconciliation" between museal and cultural sensoria; yet, as difficult as it seems, the goal of designing to deliver a "taste" of other cultures has the laudatory transformative goal of "overcoming cultural biases of the visitor imagination in order to better account for the environment and context around the exhibited object" (Blanchard and Howes 2014, 265). Whether a "taste" can ever make Indigenous visitors "feel at home" in the place of the other (or feel they are in their own home) remains an aspirational outcome.

Although *Museum Communication* played no explicit role in Blanchard and Howes' study, it is worthwhile revisiting one of Parker's passing ideas about how to "reconcile" sensoria in the museum. With reference to Inuit space, McLuhan and Parker (1969, 5) noted the usable parallel between acoustic space in terms of the igloo and geodesic dome, but further delineated the problem of how to communicate to museum directors about using sensation to generate data about visitors. Parker said: "I don't want to convince them by argument, but I would suggest that I put forward the idea of having a console in a gallery which would allow a person to manipulate the light, high, low, warm, cool, and to choose sounds in relation to things. There would be feedback on that, and then we would have some data which would be very convincing" (5). Visitor-controlled ambience, then, approximates the immersive experience hoped for by Indigenous visitors to *C'est notre histoire*, and the idea of using it to establish the terms of the interface between cultural representations and visitors in a way that communicates beyond overt messaging. Parker added an important consideration about the territoriality of academic specialists and internecine fighting among curators as obstacles to research into the multiple sensoria, not to mention the need for the designer to convince the director about committing budgets to such research. Parker got into the game early when it came to calling the curator into question. In the era when having museums without curators seems not only possible but perhaps even desirable from an undisciplined perspective, the potential role of

museographer—"a specialist in exhibition production and management"—looms large (Drouguet 2016, 29), and goes some ways toward Parker's valorization of the figure of the designer-communicator; it also promotes the sharing of experience between professionals and "active citizen partners" (Giroux 2016, 123), culminating in the declaration that since we are all more than visitors, "we're all curators," and we can all build the collection, and each tell the story of our lives (Worcman 2016).

In an overview of museology in Canada, Line Ouellet's reflections appeared on the heels of the French translation of *Le musée non linéaire*, and appeal directly to its insights. Ouellet drew attention to the translators' claims about the originality of museums as flexible sites of access to the sensoria of visitors. Ouellet (2008) claimed, in the spirit of Parker, that "the vision of the museum as a means of communication has gained ground in Canada" (521). This was most evident in science and anthropology museums, thought Ouellet, but what would Parker say about this claim? Parker (1970d) was not moved by the OSC, for instance, criticizing the hulking building itself as "monolithic, heavy, bearing no relationship to the implications inherent in modern technological advances," and critiquing its exhibit designs, which made no effort to "explain the effects of technology upon the community" (7). The Science Centre's slick advertising and sterile middle-class values were eviscerated by Parker. While Ouellet was aware of how caustic Parker's criticisms of the ROM were, his comments on the Science Centre would have provided a measure of balance about the inclusiveness of communication at issue. Parker (1970d) was critical of the substitution of verbiage for genuine efforts to democratize, that is, with wide-ranging and ongoing discussions, and on this issue he was explicit: "The function of a museum should be in large part to provide housing and background for a vast communal dialogue" (7). Parker (1970d) imagined a mutual stimulation of institution and community in the sharing of percepts and affects rather than concepts: "We have a tremendous tendency today to believe that education...results from overlaying the student mind with concepts, totally ignoring the fact that percepts (the involvement of the mind in the total field of sensory perception) are important to any ability to digest what are in

many cases extremely abstract ideas" (7). Without developing this distinction philosophically, Parker did not allow for the possibility that within the pedagogical function of existing science museums, there did not seem to be room for thinking through percepts. For him, the OSC was mired in a mechanical world view and could accede to nothing greater than push-button devices, so that there was no room for deep, transformative involvement. Within the contexts of science and technology museums, participation tends toward new pedagogical conceptions that engage "science in action, on errors and controversies, on the role of politics and ethics" (Gauvin 2015, 40)—in short, on the stakes of knowledge in the 21st century that are explored in spaces like *art-science labs* for creation and invention. The emphasis is not on transmitting existing knowledge, but on catalyzing experimentation and innovation (Gauvin 2015, 40). This kind of catalysis would have interested Parker.

Parker's writings throughout the 1960s, especially *Museum Communication,* which was recirculated and revalorized by the translation as *La musée non linéaire,* played the role of precursors for the new museological revision of the museum, with the role of the sensorium serving as a key precedent in the pathway toward the emergence of post-transmission models of museum communication. Already in 1964 Parker had stated that "the re-stimulation of the sense life of audiences must become central to museum interpretation" (1964a, 109), emphasizing cultural appropriateness rather than mere backfilling of "solemn" spaces, fostering empathetic and self-reflexive understanding, and dissipating incorrect assumptions. It is perhaps easier, as noted above, for the movement for museal democratization to accept that "we're all curators," or as Parker (1964a, 112) put it, "we are all lay[persons] in most areas" (rather than straightforwardly accept the proposal that "we are all exhibit designers"). It was, as Parker believed, the constructive collaboration between curator and designer, with architectural and organizational flexibility as hallmarks of advancement, that would open the door for the process of institutional decolonization that was years in the making, and that is still underway.

Conclusion

WHILE MANY OF PARKER'S IDEAS about the museum fit comfortably into the new museology as it developed in French contexts, there was one idea in particular that required a leap of logic. Although his reorientation gallery—a liminoid space adjacent to a museum and its galleries—did not gain traction in the field due to the obscurity of the publication of the excerpt from *The Culture Box*, and the book's unpublished status (and of course, there can be no guarantee of its influence now, with its appearance at such a late date), in addition to the very late translation of *Museum Communication*, the commitment to a reflexive grasp of sensory and participatory experience became widely accepted. The hurdle for museology was the abandonment of "storyline." There were two kinds of compensatory responses.

The first was provided by translators Deloche and Mairesse in justifying non-linearity and repositioning it as a *model* in its own right. They wrote: "the rejection of the story line advocated by McLuhan and Parker does not result in foundering in the throes of an uncontrolled disorder" (McLuhan and Parker 2008, 18). The reason, they continued, was that "the discontinuity generated by the rejection of the 'story line' is by itself a method of organizational behavior, insofar as it supposes in return the construction of models of reconnaissance or, more

precisely, models of 'recognition'" (18). Thus, non-linearity was first separated from disorder. It was then situated as a model of "recognition," substituting for pattern recognition, or sensitivity to patterns, as the authors explained in a footnote (18, note 19), without losing the sense of the process itself as an object of study. In order to illustrate that lineal consecution and a fixed point of view were deemed to be inadequate to learning, especially if their effects remained unacknowledged, Deloche and Mairesse quoted Parker's personal reflection about his own process of learning art history (quoted in Chapter 6), and his use of pattern recognition as a response to information overload in his design of the Hall of Fossils: "the museum must deal in pattern recognition," Parker stated (McLuhan and Parker 1969, 13). Pattern recognition was how one coped with information overload, in Parker's and McLuhan's estimation, but it was also a strategy of making over matching, and it presupposed simultaneity, instantaneity, and the "co-exist[ence] in a state of active interplay" of all factors of life (McLuhan and Fiore 1967, 63).

The second response from Deloche and Mairesse was that non-linear modelling of learning through recognition was flexible and constructivist in terms of what it permitted museum visitors to contribute. And it is here that the proverbial hippie returned. In a non-linear museum, such youth felt at home to exercise their own brands of pattern recognition. It was through the emphasis on "other methods of learning, other perceptive processes, [and] other behavioral attitudes" (Deloche and Mairesse, in McLuhan and Parker 2008, 19) that the social and cultural stakes of a new museum could be glimpsed. Parker's contribution to the importance of recognizing patterns included bringing visitors to a reflexive awareness of their place in the heterogeneity of the encounter between their sensory worlds and those evoked by exhibits, but not by means of "facsimiles," he insisted, as "the restimulation of the sensory life of audiences...does not...mean merely creating a facsimile of the original situation complete with touch and smell" (2025, 34). This was a recipe for revulsion, Parker (2025) thought, especially given the "antiseptically-oriented Western man" (34). Instead, he called for subtle techniques that would "disorient" and "disturb" bodily balances, not as novelties, but as

focused effects eliciting involvement by means of the "imaginative completion by the use of mnemonic recapitulations of sensory experiences not involved in the original experience" (2025, 34). This entailed, for example, introducing non-period music into a period room (36), as a kind of sonic wedge that would open a space for a rich encounter with the sensibilities of a different world. Such an approach suggests indirect media effects that are not, however—and this is a significant diversion—specifically linked to content, therefore diverging from typical effects models, but rather act as a tool in "inducing an empathic stance" (36), and thus influence how audiences appreciate artifacts and understand that different mentalities and sensibilities are at issue. Form carries the effects or impacts. The designer could not "compose music," Parker (2025, 36) claimed, to be played on instruments by contemporary visitors; the idea was to heighten awareness and sensitivity to the presentation. The designer-communicator, for Parker, seeks to expose the "sensory state of the creator, and the environment in which they are displayed" by either a "co-relative" sensory mix, or an abrasive "counter-environment" (2025, 37). What is provoked, it seems, is an engaged, sympathetic, and reflective, one wants to say almost Socratic, kind of enlarged self-knowledge within and about the sensorium. Change is indeed a goal, but the kind of change in "sensory orchestration" and all of one's "life patterns" (37–38). Parker wanted the museum experience to really rearrange awareness, and thus influence how one lived. As Parker (2025) put it, "all we are trying to sell to the public is increased perception" (80).

By rejecting replication, Parker advocated for evocation, degrees of similitude, and loose, indirect, inadequate, unhurried measures. In *The Culture Box* (2025), Parker used the term "objective co-relative" as a variation on T.S. Eliot's (1934) concept of an "objective correlative," which Eliot developed in his essay on "Hamlet" (141). However, Parker introduced two nuances: artifacts have the power to signify the sensory states of their creators and users, and when used in a display that utilizes this knowledge, also have the capacity to move the visitor's focus so as to encourage reflection upon it. This is indirect (since the designer does not reproduce an original situation) and not, as Eliot (1934) suggested, a scenario in which an arrangement of "objects,

a situation, a chain of events...shall be the formula of that *particular* emotion" (145). The emotion is, Eliot underlined, "immediately evoked"—hence a complete adequacy between external and internal states. For Parker, the process was not literary; and, the technique he preferred requires a degree of disorientation and imaginative completion. In short, a certain inadequacy and insouciance with regard to immediate results are required.

It is still easy to get it wrong when it comes to Indigenous artifacts. In his curatorial work, one finds Carpenter's (2011) criticisms of Western institutions such as galleries that discourage touch, libraries that promote silence, and the errors of exhibition display when they violate principles of Inuit sensory organization. The visual inspection from a favoured single point of view of ivory carvings, for example, violates the work's lack of a base upon which to stand, and thus disrespects the carver's sensory field of reference. This was perhaps exemplified for Carpenter (2011, 34) in archaeological samples of pendants meant to be worn upside down, or masks hung upside down, with this principle of inversion symbolically indicating death and invoking it as a protective measure in some instances. How, then, to present these in an exhibit? Certainly, placing them right side up in a well-arranged, orderly manner would only deviate from how they were intended to be viewed. Certainly, paying greater attention to sensory profiles would help designers to avoid such errors, and it is from the expert testimonies of Indigenous interpreters that these lessons can be made to stick.

Designing less didactic and narrative-driven exhibits and shifting from the "literate mould" of museum curation, to use McLuhan's term (1969a, 4), or the museum as book, as Parker preferred, to a reciprocal model based on sensory retraining, multimedia explication, and some measure of visitor control over ambience implies that in the museum communication must be meta-discursive. That is, what is called the storyline of an exhibit includes a reflection on itself, so that the production of an exhibit emerges from a specific set of institutional practices and commitments. The stance of the institution forms part of the construction of discourses in the encounter between visitors and exhibits, the discourses about artifacts in catalogues, about visitors themselves, about the adventure of collecting (often stripped from its colonial

and imperial prerogatives). As Patrick Fraysse (2017) has put it, "they [museums] now also produce a meta-discourse (auto-centered) that reveals their work behind the scenes, their own scientific and cultural positions, and even their own history of encouraging visitors to consult the contents placed at their disposal" (213). Parker's responses to the museum's immobility and immutability put him on a track toward this kind of self-recognition, and he brought the preparatory into focus in his orientation centre model. Yet one of the ironies of the rejection of storyline is that it involves re-integrating discursive production and making it, in addition to the museum's reflexive discursivity, one of the most fertile aspects of the new museology and its commentaries, declarations, definitions, and manifestos—an incessant questioning of the museum's meaning, existence, aspirations, publics, professions, etc., that the museum itself can utilize. Yet this can also fail, as Linda Hutcheon (1995, 6) argued in the case of the *Into the Heart of Africa* exhibit at the ROM in 1989–1990, which, despite the culture-text approach to presentation, rich in reflexive and ironic postmodern discursive strategies, failed to achieve a decolonial, deconstructive critique staged from the inside. "Metatexts" can falter and fall flat, Hutcheon said of the exhibit; they are hard to realize successfully because audiences can identify the absence of an "answering African voice."

Parker was an epigrammatic man restlessly stirring in the shadow of McLuhan's diagnosis of the effects of typographic culture, and he struggled to get beyond his own history in print cultural methods. If museum communication turns out to be meta-communication, then a higher-level reflection is required, one that will need to genuinely integrate more participants, deploy pertinent, critical social categories, and fully deconstruct print-centred environments of display. Most importantly, the French reception of Parker within new museological thought brings his contributions back into focus as a valued precursor, throwing his work a lifeline that pulls it into the present and the future of the museum. But is it too late? What this suggests in principle is that in rebuilding the Hall of Invertebrate Fossils it would be incumbent upon the ROM to account for its own legacy of design experimentation and to meta-discursively integrate Parker's masterpiece into its current

Conclusion 207

plans, by refusing to hide behind corporate sponsorship and exclusive curatorial prerogatives. Despite Parker's belief that the designer-communicator was on an equal if not higher ground than the curator in museums, the reassertion of curatorial authority at the ROM and elsewhere continues unabated. The renewed invertebrate palaeontology exhibit at the ROM is again newsworthy. Fifty-four years after the Hall of Fossils designed by Parker, the Dawn of Life gallery invited visitors in 2021 to view through its high-tech windows the creatures of deep geological time (Semeniuk 2021). This renewal makes one thing perfectly clear: the legacy of Parker's 1967 masterpiece has been erased by the reassertion of curatorial authority. The mantra of a post-museology in which the curator is a socially progressive-activist mobilizing communities, building capacities, and drawing expertise from among visitors, in a world in which we are all curators now, has evaporated at the ROM. Only academic specialists can build the collection and tell their stories. Everyone else has to listen to them.

More than 50 years have passed since the Hall of Fossils created a stir at the ROM and beyond its walls. Would a meta-discursive citation of Parker's legacy in a rebuilt Hall of Fossils simply devolve into postmodern pastiche? If so, this would have pleased Parker immensely. After all, citing the past as a tribute, with or without added nuances like humour, satisfied Parker's sense of the elevated role of unslavish replication (imitation combined with borrowed styles) in his gallery designs, one of the decentring strategies he deployed in characterizing the features of the medium of museum presentation. A good example of Parker's penchant for knowing quotation may be appreciated in the ROM's 50th anniversary show *Search and Research* in 1962. Parker brought a humorous touch to the archly postmodern design before the letter in murals that meta-reflexively mixed ancient icons containing their modern representations, as well as a materialist approach to exploration that linked the adapted tools of the trade, for instance, archaeologists utilizing dentistry equipment, to the artifacts themselves: "the spectator may be amused to see a dentist's drill used painlessly for once by palaeontologists to take delicate fossils from rocks. One clever mural designed by Parker suggests the continuity

of humanistic interest through the ages: a figure from a Greek vase holding a Daumier lithograph of a Greek myth" (McCarthy 1962, 7).

The orality of the epigram was perfectly suited to Parker's style of delivery, honed in public statements delivered in full flight, as decisive as it was divisive. Timing may not be everything, but it enhances the effects of delivery. McLuhan's (1962) recovery of the medieval manuscript culture of reading and writing in *The Gutenberg Galaxy* helps us to grasp the significance of what was on the tip of the epigrammatic man's tongue: a scholastic technique consisting of disjointed aphorisms slowly marginalized by print culture, reframed as impertinent (103). Print introduced confusion about authority into the aphorism, shifting away from the oral performance into the silent stasis of set type, which drove a wedge between Parker's attempt to keep alive oral tradition and insert his epigram into articles and books, as epigraph and demonstration. The tension between the audile-tactile and the visual deployments of the epigram was unresolvable. Repetition of the one one-liner inched toward the incantatory and even suggested magical properties, or at least its audile-tactile potency, but transferred onto an art gallery wall, or set on a printed page, the epigram sat still and backgrounded any surviving "sensuous complexity" (McLuhan 1962, 125). Studied in translation, the epigram as epigraph displayed a diversity greater than itself, in appearance and in words. Commenting on *Counterblast*, Rex Veeder (2011) observed: "Harley Parker performs McLuhan's idea of the auditory through visual manipulations and the oral dimension of language is suggested in the shifts in typeface and point as well as juxtaposition of words that appear to be leaping from the page with standard type" (n.p.) The epigram carried with it this suggestion of audile-tactility as it reanimated what had been consigned a background role, while having visual method look backwards, yet the fact that it was authored suspended the overall effect by Parker's taking ownership of it. If his name functioned like a "label of authenticity" (McLuhan 1962, 131), perhaps in the end Parker, advancing the hypothesis of a gallery without labels, tripped himself up by reducing tension, and diminishing perception, with which he so carefully imbued the page. The only label he could not forgo was his own name.

Conclusion 209

Parker remained acutely sensitive to the lingering values of print culture in both the museum and in contemporary arts. In one of his occasional reviews of exhibitions, for instance, Parker (1963b) argued that painter Greg Curnoe's use of typography and stencils in his paintings reproduced the "aridity" of print culture and released none of the audile-tactile potentialities of letters when they were manipulated: "the paintings do not display an unusual insight into the organization of images derived from audile-tactile awareness (iconography). Therefore, the vantage point of the phonetic alphabet gives no brave sweep over a new world but only stresses the general aridity of the view" (88). What would such a non-arid approach look like? An answer to this question can be found in what Parker accomplished with distorted, stretched, and manipulated typefaces that, for him, "translate the printed word back into a resounding icon" adequate to the shift away from the word to the post-literacy of tactual apprehension.

The difficulties that Parker encountered in searching for an audience segment—countercultural hippies who would best respond, he deduced, to the kind of design elements he favoured in practice and theory, namely, the multi-sensorial, immediate, iconic, electrically inclusive, post-visual—must have left him with a vague sense of accomplishment. Perhaps his recourse to hypotheticals can be explained by this difficulty; of course, there were practical considerations such as institutional politics, especially when it came to experimental galleries. In shifting his attention from artifacts to audiences, Parker (2025) wanted it both ways: to change audiences by making them increasingly "truly sentient" (42), even though he really didn't know them, except through his deductions of the attributes they possessed in theory. These finely perceptive persons, "imaginative and well-informed" (43), for whom the museum provided a "proper education," for Parker, were the only "products" (39) worth worrying about.

The goal of *The Culture Box* (2025) was to elaborate upon the general goal of "probing the possibilities of the museum idea in this century" (41). A probe in the context of reading the museum as a medium required a cutting epigrammatic wit that could slice through typographically induced smugness; speculation about audiences that one both could and could not quite reach; investigations of persons

210 *Conclusion*

challenged by their loss of one or more senses; a critique of "good taste"; and a solid grasp of how objects are organized according to size, colour, order, period of origin, purpose, etc., so that one could question habitual assumptions and break the rules: "quite often it happens that in the very areas which are so much taken for granted, the artist finds rich stores at hand for the reorientation of human sensibilities" (51).

How are we to understand the openings and restrictions of Parker's variation on McLuhan's medium theory in its application to the museum? Museum exhibition design requires the elucidation and analysis of the specificities of the media in the plural to be put into play by the designer-communicator, in constructive conversation with the curator, with the proviso that one medium is not enough. Parker approached inter-media mostly through the necessity for interdisciplinarity as a sign of institutional cooperation, and by means of the dismantling of visual space, the museum as book, and linearity in general, which had unfortunately become almost "instinctual," that is, "unconscious."

Parker's variations may be understood in three categories. The first is memory. In calling on "memory image" as figure against the sensory ground of exhibits, he invoked a "re-knowing" visitor whose recollection ran parallel to overt content in the "orchestration of senses" (2025, 31). The "memory image" for him was a residue of inter-sensory experience that supplanted content, and he looped memory through an account of *déjà vu* as attunement to familiar sensory arrangements; he then considered the memory of space as influenced by kinesthetic exhibits as opposed to visual codings (54), which tended toward retentions that were larger and more expansive than the actual exhibits. For Parker, memory (and imagination) also provided sensory filler, and they were activated to contribute anything that may have been missing in an exhibit. In introducing memory and imagination in this way, Parker warned against too literal an interpretation of sensory design because it trapped one in oversimplified matching.

The second category concerns content. Parker did not eschew content, if by this we mean the overt material-cultural meanings of artifacts, including original cultural significations and perhaps re-significations, issues of provenance, expert discourses, etc. While his criticisms of

Conclusion 211

printed labels as lineal and descriptive were pointed, this did not entail the abandonment of all description, as long as what remained could be delivered orally (via recordings or projections), or in modified print styles, with audience comments included, for better and for worse. However, in his agitating for better audience research, one might have expected that when the opportunity presented itself, in his explori-mental gallery at the Museum of the City of New York, where small groups were ushered through the room in a controlled fashion, and the experience was put on the agenda of the seminar, some systematic accounting, either qualitative or quantitative, would be attempted. Yet the absence of this shows the degree to which any content analysis occupied a marginal place in the pursuit of media effects. The theoret-ical position of the museum audience as ground that required greater scrutiny, if the institution was to become a "motivator" (educator, socializer, mobilizer) (Parker 2025, 183), meant that it must be studied since it was the source of such motivation as figure.

Third, as I have maintained, Parker's attention to the institutional context of display, which followed from his concern with how certain content was acquired and handled, expanded the range of medium theory by critically observing the imperial, colonial practices and the institutional elitism of museums. His observations about prestigious bigness, against his dream of a community-integrated smallness of sat-ellite orientation centres, brought the necessity of democratization into focus, even though Parker's grasp of segments of the commu-nity was deduced from medium theory, hence his abiding interest in countercultural youth and their promising sensory profiles: "The fact that the young people of today, because they have been conditioned by the staccato displacement of spaces by means of our various media and particularly by television, do not require transition, is something to know if one is designing for this particular age group" (Parker 2025, 53). In short, in this theoretically deduced audience segment, orienta-tion was not necessary, at least in theory, with a few provisos to be sure (e.g., the "bookish" among them).

If the traditional museum was a figure against a ground of con-stant change, technologically driving sensory remixing toward the audile-tactile, and of life itself in a grand struggle against inertia, then

the more the institution remained separate from its ground, the more monstrous it would become. Here we see the kind of argument that Parker makes throughout *The Culture Box*. Coupled with his discussions of hypothetical galleries and deduction of preferred audience segments, not to mention luddism (2025, 178) directed against computers, conjecturality won the day; it is ironic that computers would play a significant role in inter-institutional museal relations courtesy of one of Parker's strongest supporters at the New York seminar, the well-informed McLuhanite Ellin and the computer museum network that he promoted. Ellin (1969) thought the networking of collections could enhance orientation itself: "the museum's computer could be programmed to direct the operation of an orientation gallery where the visitor's prospective encounter with the institution's bewildering assortment of material might be individually styled. One could then choose an itinerary designed to his unique requirements, or rely instead on a random visit dictated by his own tastes and responses" (29). Here it is obvious that new information technologies may be used in support of Parker's hypothetical constructions. Parker remained, however, unapologetic about not providing "absolute answers," and comfortable with advancing hypothetical exhibits, sketching out approaches, and occasionally drawing upon his own experiences as a gallery designer. He was content to draw evidence from poets—Yeats, Eliot, and Blake. The final word in *The Culture Box* (2025) goes to a Walt Kelley comic strip character, the Pogo possum, from whom Parker borrowed on behalf of his favourite deduced audience members, who, in an act of defiance, "refuse to...'put stay'" (195) within the walls of even a successfully designed museum.

Notes

Introduction

1. Parker received the H.L. Rous Scholarship, named after the fine art printer and founder of the Toronto Typothetae, in his first and second years as a student at OCA (see OCA 1935–1936 and 1936–1937). Accessed with the assistance of Scott Hillis, archivist at Dorothy H. Hoover Library, OCADU.

1 | Typography and Beyond

1. Pamphlets, cards and short catalogues of Parker's exhibitions were made available through the assistance of Larry Pfaff, deputy librarian at the Edward P. Taylor Research Library and Archives, Art Gallery of Ontario.

2. Correspondence obtained with the assistance of P.J. MacDougall, college librarian, Massey College.

3. These were noted by Tushingham in his catalogue essay, but the discharged loan forms are in ROM Archives, RG 97, Box 5, "Up North" loans.

4. All references to the Greenbrier presentation refer to a letter from Parker and the attached mimeographed paper, an untitled and unpublished manuscript of seven typewritten pages (Fonds Marshall McLuhan, 1964–1969, Parker to Wm. S. Campbell, June 18, 1964).

5. I am grateful for reference archivist Sophie Tellier's assistance.

6. Tagline on the March 18, 1967 cover of the *Toronto Telegram Weekend Magazine*, which featured a colour photograph of Parker and McLuhan in front of an electro-mechanical squid in one of the displays in the Hall of Fossils.

7. I am grateful for the assistance of Marnee Gamble, special media archivist for the Robert Lansdale photographic collection in the University of Toronto Archives.

2 | The Making of an Epigrammatic Man

1. The materials relating to the Interact seminar and the Sound of Vision conference at RIT in 1973 were made available to me courtesy of archivist Elizabeth Call. Both are part of the Kern Program collection (RITArc.0044).

3 | Uncanny Selves and Family Resemblances

1. Quotations and details from Margaret and Eric Parker in the chapter are from personal communications with the author from 2021-2022.
2. I am grateful for the assistance of OCADU archivist Madeleine Bognar, who provided me with a handwritten staff list from 1903-1970, as well as the 1959 Course of Study Prospectus, available in the Course Description Box at the University Archives.

4 | The Hall of Fossils at the Royal Ontario Museum

1. I am grateful for the reflections on the 1960s of the Parker family, provided by Margaret and Eric Parker by email in response to my questions in March, April, and May 2021. Both sections on the Parker family in this chapter are based on our correspondence.
2. For clarity, Parker is referring to a period in which there were three directors of the ROM: Theodore A. Heinrich in the early 1960s; William E. Swinton in the mid-1960s; and Peter Swann in the late 1960s.
3. The archival catalogues and correspondence mentioned in this section were sourced from the ROM Archives (RG 107, Boxes 2, 3, and 7). From 1959-1964, Parker worked primarily on mounting special and/or travelling exhibitions. Accessed with the assistance of ROM archivist Judith Pudden.

References

"A citizen profile: Harley Parker, fronting for McLuhan." (1970, September). *Toronto Citizen*, np.

Alpers, S. (1991). The museum as a way of seeing. In I. Karp and S.D. Levine (Eds.), *Exhibiting cultures: The poetics and politics of museum display* (pp. 25–32). Smithsonian Institution Press.

Anshen, R.N. (n.d.). *Correspondence*. Ruth Nanda Anshen Papers, Columbia University Rare Book and Manuscript Library: Sub-Series II.2, Alphabetical Files (Uncatalogued), McLuhan, Box 21.

Anshen, R.N. (1938–1986). *Correspondence*. Ruth Nanda Anshen Papers, Columbia University Rare Book and Manuscript Library: Series 1, Catalogued Correspondence, McLuhan, Box 4.

Assembly of First Nations and Canadian Museums Association. (1992). *Turning the page: Forging new partnerships between museums and First Peoples*.

Attridge, D. (2018). What do we mean by experimental art? *Angles: New Perspectives on the Anglophone World, 6*. https://doi.org/10.4000/angles.962

Bacon, B. (1967). *Picnic in space*. Film. University Production.

Baker, S., Istvandity, L., and Nowak, R. (2019). *Curating pop: Exhibiting popular music in the museum*. Bloomsbury.

Barber, J. (1973, August 7). Are we building hostile society "to make profit?" *Rochester Times-Union*, 18.

Barzun, J. (1959). *The care and feeding of the mind*. Vinyl record. Distinguished Teachers Series, directed by Arthur L. Klein. Westminster Recording, Spoken Arts.

Bayer, H. (1957). Preface. In E. Carboni, *Exhibitions and displays* (pp. 5–11). Silvana Editoriale d'Arte.

Bissell, C. (1968). *President's report for 1967*. University of Toronto Press.

Bissell, C. (1971). *President's report for 1970*. University of Toronto Press.

Bissell, C. (1972). *President's report for 1971*. University of Toronto Press.

Blanchard, M.-J., and Howes, D. (2014). "Feeling at home" in the museum: Attempting to effect a fusion of sensoria in museums of ethnology. *Anthropologie et société, 38*(3), 253–70.

Bolton, S. (2009). Museums taken to task: Representing First Peoples at the McCord Museum of Canadian History. In A.M. Timpson (Ed.), *First Nations, first thoughts: The impact of Indigenous thought in Canada* (pp. 145–69). UBC Press.

Brett, K.B. (1967). *From modesty to mod: Dress and underdress in Canada, 1780–1967*. Royal Ontario Museum/University of Toronto Press.

Brodey, W. (1964). Sound and space. *Journal American Institute of Architects, 42*(7), 58–60.

Buxton, W.J. (2018, June 19). *The Ford Foundation and communication studies: The University of Toronto program (1953–1955)*. Research report. Rockefeller Archive Center. https://rockarch.issuelab.org/resource/the-ford-foundation-and-communication-studies-the-university-of-toronto-program-1953-1955.html

Caillois, R. (1984). Mimicry and legendary psychasthenia (J. Shepley, Trans.). *October, 31*, 16–32.

Calderon, M.J. (1990). Museums and communication. *Philippine Quarterly of Culture and Society, 18*(2), 137–40.

Cameron, D. (1968). A viewpoint: The museum as a communication system and implications for museum education. *Curator, 11*(1), 33–40.

Candlin, F. (2008). Museums, modernity and the class politics of touching objects. In H.J. Chatterjee (Ed.), *Touch in museums: Policy and practice in object handling* (pp. 9–20). Berg.

Carboni, E. (1957). *Exhibitions and displays*. Silvana Editoriale d'Arte.

Carl Dair Fonds. (1964–1966). Unpublished correspondence with M. McLuhan and H. Parker. Massey College, Series 3, Box 7, Item 29.

Carpenter, E. (2011). *Upside down/Arctic realities*. The Menil Collection.

Carpenter, E, and McLuhan, M. (1960). Acoustic space. In E. Carpenter and M. McLuhan (Eds.), *Explorations of communication: An anthology* (pp. 65–70). Boston Beacon Press.

Carpenter, E., Varley, F., and Flaherty, R. (1959). *Eskimo*. University of Toronto Press.

Castel, M. (2019). *La muséologie olfactive* [Doctoral thesis]. Paris: Sorbonne. HAL theses. https://tel.archives-ouvertes.fr/tel-02329881

Cavell, R. (2002.) *McLuhan in space: A cultural geography*. University of Toronto Press.

Communication Design Team, ROM (CDT). (1976). *Communicating with the museum visitor: Guidelines and planning*. The Royal Ontario Museum.

Cooper & Beatty Ltd. (1954). Flexitype, photo-typography. Brochure.

Cranny-Francis, A. (2005). *Multimedia: Texts and contexts*. Sage.

Cross, L. (1999). *Reunion*: John Cage, Marcel Duchamp, electronic music, and chess. *Leonardo, 9*, 35–42.

Cruchley, B. (1968, January 12). Headline freak out at U of T. *The Toronto Telegram*, np.

Darroch, M. (2017–18). "Arts once more united": Bridging disciplines through creative media research, Toronto, 1953–55. *Intermédialités/Intermediality* 30–31 (Fall/Spring), 1–31.

Davis, T.A. (1991). Our cultural heroes. In *Harley Parker*. Burnaby Art Gallery. Exhibition catalogue.

Debord, G. (Director) (1952). *Howls for Sade*. Films Lettristes. B/w, 64 mins.

De Borhegyi, S.F. (1963). Visual communication in the science museum. *Curator, 6*(1), 45–57.

De Caro, L. (2015). Moulding the museum medium: Explorations on embodied and multisensory experience in contemporary museum environments. ICOFOM Study Series 43b. *Nouvelles tendances de la muséologie*, 55–70.

Deleuze, G. (1994). *Difference and repetition* (P. Patton, Trans.). The Athlone Press.

Dempsey, L. (1970, March 25). Science Centre called outdated. *Toronto Daily Star*, np.

Derrida, J. (1993). *Memoirs of the blind: The self-portrait and other ruins* (P-A. Brault and M. Naas, Trans.). University of Chicago Press.

Dewdney, C. (2008, July 5). Crystal blurs ROM's natural wonder. *The Toronto Star*, np.

Dexter, G. (1968, March 7). The electrosonic climax was riotously funny. *Toronto Daily Star*, 23.

Dipede, C. (2015). From typographer to graphic designer: Typography exhibitions and the formation of a graphic design profession in Canada in the 1950s and 1960s. *RACAR: Revue d'art Canadienne / Canadian Art Review, 40*(2), 130–45.

Dommergues, P. (1967, October 18). La civilization de la mosaïque—Le message de Marshall McLuhan. *Le Monde*, np.

Dotzler, B.J. (2014). "Cambridge was a shock": Comparing media from a literary critic's point of view. In C. Birkle, A. Krewani, and M. Kuester (Eds.), *McLuhan's global village today: Transatlantic perspectives* (pp. 85–92). Routledge.

Drouguet, N. (2016). The curator's malaise with the "undisciplined" museum: Exhibition making in the *musée de société. THEMA: La revue des Musées de la civilization, 4*, 23–34.

Duval, P. (1962, June 16). Use life, color, drama to tell museum story. *The Toronto Telegram*, np.

Elcock, C. (2023). *Psychedelic New York: A history of LSD in the city*. McGill-Queen's University Press.

Elder, B. (2015). Myth and the cinematic effect in Harley Parker and Marshall McLuhan. *Amodern, 5*. https://amodern.net/article/myth

Eliot, T.S. (1934). Hamlet. In *Selected essays* (pp. 141–46). Faber and Faber.

Ellin, E. (1969). Museums and the computer: An appraisal of new potentials. *Computers and the Humanities, 4*(1), 25–30.

Ernst, W. (2016). *Chronopoetics: The temporal being and operativity of technological media* (A. Enns, Trans.). Rowman & Littlefield International.

Ferguson, M. (1991). Marshall McLuhan revisited: 1960s zeitgeist victim or pioneer postmodernist? *Media, Culture & Society, 13*(1), 71–90.

Fleming, A.R. (1956). The development of printing as an art. In *The art of fine printing and its influence upon the Bible in print: Being an exhibition held from September 11 to October 13 at the Royal Ontario Museum* (pp. 11–19). Royal Ontario Museum of Archaeology.

Fleming, M. (2011). Allan Fleming: The man who branded a nation." *Eye, 79*(20). http://www.eyemagazine.com/feature/article/allan-fleming-the-man-who-branded-a-nation

Fonds Marshall McLuhan. (1964–1969). Unpublished correspondence. Library and Archives of Canada, MG31 D156/33-45-6.

Foucault, M. (1986). Of other spaces. *Diacritics, 16*(Spring), 22–27.

Fraysse, P. (2017). Du dispositif muséal au complexe expographie autocentré. In François Mairesse (dir.), *Définir le musée du XXIe siècle* (pp. 201–13). ICOM International Committee for Museology (ICOFOM).

Freud, S. (2001). The uncanny. In *The standard edition of the complete psychological works of Sigmund Freud* (Vol. XVII, 1917–1919, pp. 217–52). (J. Strachey, Trans., with A. Freud). The Hogarth Press.

"From the ivory to control tower." (1963, March 9). *St. Catharines Standard*, np.

Fulford, R. (1959a). Allan R. Fleming. *Canadian Art, 16*(4), 266–73.

Fulford, R. (1959b, February 14). Art "yahoos" laugh in ignorance. *Toronto Daily Star*, np.

Fulford, R. (2005). All ignorance is motivated. In G. Genosko (Ed.), *Marshall McLuhan: Critical evaluations in cultural theory* (Vol. 1, Fashion and fortune, pp. 307–16). Routledge.

Garric, D. (1967). Le prophète de l'information. *Science et vie, 599*(August), 24–29, 142, 144, 147.

Gauvin, J.-F. (2015). Les musées de sciences, la "présence" des objets et les défis pédagogiques de l'habitus. *Education et francophonie: ACELF, 43*(1), 29–44.

Genosko, G. (1999). *McLuhan and Baudrillard: The masters of implosion.* Routledge.

Genosko, G. (2010). Coping with the McLuhans: The passively active receiver in communication theory and cultural studies. In P. Grosswiler (Ed.), *Transforming McLuhan: Cultural, critical and postmodern perspectives* (pp. 3–16). Peter Lang.

Genosko, G. (ed). (2015). Harley Parker [Special issue]. *Amodern, 5.* https://amodern.net/issues/amodern-5-harley-parker/

Genosko, G. (2017). The designscapes of Harley Parker: Print and built environments. *Imaginations: Journal of Cross-Cultural Image Studies, 8*(3), 153–64.

Genosko, G. (2023a). The first live performances on the Moog synthesizer and Intersystems' Electrosonic Concert at the Art Gallery of Ontario in 1968. In A. Lauder and M. Hayward (Eds.), *Computer art in Canada* (pp. 85–106). McGill-Queen's University Press.

Genosko, G. (2023b, June 7). When a lost manuscript turns up. *University Affairs*. https://www.universityaffairs.ca/opinion/in-my-opinion/when-a-lost-manuscript-turns-up/

Genosko, G. (2024). When a lost book manuscript turns up: The discovery of Harley Parker's *The Culture Box: Museums Are Today*. *Canadian Journal of Communication*, *49*(2), 314–34.

Genosko, G., and Marcellus, K. (2019). *Back issues: Periodicals and the formation of critical and cultural theory in Canada*. Critical perspectives on theory, culture & politics series. Rowman & Littlefield International.

Ghiselin, B. (1954). *The creative process: A symposium*. University of California Press.

Giroux, É. (2016). The public in museums: Visitors or citizen partners? *THEMA: La revue des Musées de la civilisation, 4*, 95–125.

Gopnik, B. (2020). *Warhol*. HarperCollins.

Gordon, W.T. (1977). *Marshall McLuhan: Escape into understanding, a biography*. Basic Books.

Greenberg, C. (1999). *Homemade aesthetics: Observations on art and taste*. Oxford University Press.

Grescoe, P. (1967, January 21). The McLuhan of the museum. *Toronto Telegram, 5*.

Griffiths, A. (2008). *Shivers down your spine: Cinema, museums, and the immersive view*. Columbia University Press.

Gurian, E.H. (1991). Noodling around with exhibition opportunities. In I. Karp and S.E. Lavine (Eds.), *Exhibiting cultures: The poetics and politics of museum display* (pp. 176–90). Smithsonian Institution Press.

Hall, J. (2014). *The self-portrait: A cultural history*. Thames & Hudson.

Harding, D.W. (1969, January 2). Trompe l'oeil. *The New York Review*, np.

Hayden, M. (2015). How the mind excursion came to be. In *Intersystems* (pp. 21–34). Booklet of vinyl reissue package. Alga Marghen.

Hooper-Greenhill, E. (2000). *Museums and the interpretation of visual culture*. Routledge.

Houédard, D.S. (1965). Between poetry and painting: Chronology. In *Between poetry and painting (Oct. 22–Nov. 17, 1965)* (pp. 85–99). Jasia Reichardt, Curator. London: Institute of Contemporary Arts (ICA).

Howes, D. (2022). *The sensory studies manifesto: Tracking the sensorial revolution in the arts and human sciences*. University of Toronto Press.

Hutcheon, L. (1995). The post always rings twice: The postmodern and the postcolonial. *Material History Review, 41*(Spring), 4–23.

International Council on Museums (ICOM) and Mouvement international pour une nouvelle muséologie (MINOM). (2010). Declaration of Quebec: Basic principles of a new museology / Déclaration de Québec: principles de base d'une nouvelle muséologie. *Cadernos de Sociomuseolgia, 38*, 23–25.

Intersystems. (1967). *Peachy*. Vinyl record. Allied/Pentagon ALS 142.

Jay, M. (1993). *Downcast eyes: The denigration of vision in twentieth-century thought*. University of California Press.

Jenkins, D. (1973, June 25). Don't "kill" the kids, pleads Harley. *Melbourne Herald*, np.

Keiran, S. (2007). Still spoken, gritty, scary. Sweet and sublime. *ARTiculate* (Spring/ Summer), 12–13.

Kessler, J. (1968, November 17). McLuhan nonbook nonenlightening. *Los Angeles Times*, D52.

Kirshenblatt-Gimblett, B. (1991). Objects of ethnography. In I. Karp and S.D. Levine (Eds.), *Exhibiting cultures: The poetics and politics of museum display* (pp. 386–443). Smithsonian Institution Press.

Kjaer, S.H. (2016). The performative museum: Designing a total experience. In J. Frykman and M. Frykman Porzanovic (Eds.), *Sensitive objects: Affect and material cultures* (pp. 237–55). Kriterium.

Knez, E., and Wright, G. (1970). The museum as a communication system: An assessment of Cameron's viewpoint. *Curator, 13*(3), 204–12.

Kroker, A. (1984). Processed world: Technology and culture in the thought of Marshall McLuhan. *Philosophy of the Social Sciences, 14*(4), 433–59.

Lauder, A. (2011). Harley Parker: Design for a "new ordering." *Hunter and Cook, 9*(Summer), 53–57.

Lauder, A. (2015). "A clash of spaces": Harley Parker's reconceptualization of the museum as a communication system. *Amodern, 5*. http://amodern.net/article/a-clash-of-spaces/

Lauder, A. (2022). *Out of school: Information art and the Toronto School of Communication.* McGill-Queen's University Press.

Lazzarato, M. (2019). *Videophilosophy: The perception of time in post-Fordism* (J. Hetrick, Trans.). Columbia University Press.

Lee, D. (1957). Lineal and nonlineal codifications of reality. *Explorations, 7*, 30–45.

Lee, J.M. (1967, February 26). McLuhan's views shape museum. *The New York Times*, 32.

Leighton, A. (1959). *My name is legion: Foundations for a theory of man in relation to culture.* Basic Books.

Lemay-Perreault, R., and Paquin, M. (2017). Le concept de transmission est-il révolu en milieu museal? In François Mairesse (dir.), *Définir le musée du XXIe siècle: Matériaux pour une discussion* (pp. 234–37). ICOM International Committee for Museology (ICOFOM).

Lemon, R.R.H. (1965). *Fossils in Ontario.* University of Toronto Press and ROM Series.

Lemon, R.R.H. (1967). The hall of science—New directions. *Curator, 10*(4), 279–83.

Levi, C. (2006). Sex, drugs, rock & roll, and the university college lit: The University of Toronto festivals, 1965–69. *Historical Studies in Education, 18*(2), 163–90.

Lowengard, S. (2015). Explaining color in two 1963 publications. In V. Malloy (Ed.), *Intersecting colors: Josef Albers and his contemporaries* (pp. 29–44). The Amherst College Press.

Lupton, E. (2020). *Herbert Bayer: Inspiration and process in design.* Princeton Architectural Press.

Lupton, E., and Lipps, A. (2018). *The senses: Design beyond vision.* Cooper Hewitt, Smithsonian Design Museum, and Princeton University Press.

Lusseyran, J. (1964). *And there was light.* Heineman.

MacDonald, G.F. (1987). The future of museums in the global village. *Museum International, 39*(3), 209-16.

MacDonald, G.F. (1991). A ten-year perspective on the museum for the global village. *McLuhan Studies,* 1, 171-76.

MacDonald, G.F. (1992). Change and challenge: Museums in the information society. In I. Karp, C.M. Kreamer, and S.D. Lavine (Eds.), *Museums and communication: The politics of public culture* (pp. 158-81). Smithsonian Institution Press.

MacDonald, G.F., and Alsford, S. (1989). Museums as bridges to the global village. In B. Alden Cox, J. Chevalier, and V. Blundell (Eds.), *A different drummer: Readings in anthropology with a Canadian perspective* (pp. 41-48). McGill-Queen's University Press.

Machado, I. (2011). Sensus communis: Understanding the acoustic space in its resonant and sensory environment. *E-compós, 14*(3), 1-17.

MacKenzie, J. (1967, December 30). Will Toronto's new electronic Tower of Babel fall on deafened ears? *The Globe and Mail,* 20.

Mair, S. (1965, September 4). Smile when you call it "museum." *Maclean's Magazine,* 20-23, 35-36.

Marantz, K.A. (1970). Review of *Exploration of the ways, means, and values of museum communication with the viewing public: A seminar. Studies in Art Education, 11*(2), 57.

Marchand, P. (1989). *Marshall McLuhan: The medium and the messenger.* Random House.

Marchessault, J. (2005). *Marshall McLuhan: Cosmic media.* Sage.

Marchessault, J. (2007). Multi-screens and future cinema: The labyrinth project at Expo 67. In J. Marchessault and S. Lord (Eds.), *Fluid screens, expanded cinema* (pp. 29-51). University of Toronto Press.

Marcotte, G. (1974, June 15). Marshall McLuhan et l'énergie du banal. *Le Devoir,* np.

Masters, R.E.L., and Houston, J. (1968). *Psychedelic art.* Grove Press.

Mauss, M. (1966). *The gift: The form and function of exchange in archaic societies* (I. Cunnison, Trans.). Cohen & West.

Mayrand, P. (1985). The new museology proclaimed. *Museum International, 37*(4), 200-201.

McCarthy, P. (1959, February 14). Parker's mask display something of thriller. *The Toronto Globe & Mail,* np.

McCarthy, P. (1962, March 31). Searching the past for fifty fruitful years. *The Globe and Mail Magazine,* 6-7.

McLuhan, M. (1945). The analogical mirrors. In *Gerard Manley Hopkins by the Kenyon critics* (pp. 15-27). New Directions.

McLuhan, M. (1959). Printing and social change. In C.L. Helbert (Ed.), *Printing progress: A mid-century report* (pp. 89-112). The International Association of Printing House Craftsmen.

McLuhan, M. (1962). *The Gutenberg galaxy: The making of typographic man*. University of Toronto Press.

McLuhan, M. (1963). Humpty Dumpty, automation, and TV. *Varsity Graduate, 10*(4), 25–28.

McLuhan, M. (1964). *Understanding media*. McGraw-Hill.

McLuhan, M. (1966). Electronics & the psychic drop-out. *This Magazine is About Schools, 1*(1), 37–42.

McLuhan, M. (1967). Television in a new light. In S.T. Donner (Ed.), *The meaning of commercial television: The Texas-Stanford seminar, 1966* (pp. 87–107). University of Texas Press.

McLuhan, M. (1969a). *Counterblast*. McClelland and Stewart.

McLuhan, M. (1969b). Distant early warning deck. *The Dew-Line Newsletter,* 2.1(July).

McLuhan, M. (1970). *Culture is our business*. Ballantine Books.

McLuhan, M. (1971). *Contraexplosión* (I. Gelstein, Trans.). Editorial Paidos.

McLuhan, M. (1972). *Counterblast* (J. Paré, Trans.). Hurtubise.

McLuhan, M. (1978, April). All the stage is a world in which there is no audience. *The Innis Herald,* 24.

McLuhan, M. (1987). *Letters of Marshall McLuhan* (M. Molinaro, C. McLuhan, and W. Toye, Eds.). Oxford University Press.

McLuhan, M., and Fiore, Q. (1967). *The medium is the massage: An inventory of effects*. Bantam.

McLuhan, M., and McLuhan, E. (1988). *Laws of media*. University of Toronto Press.

McLuhan, M., and Nevitt, B. (1972). *Take today: The executive as dropout*. Longman.

McLuhan, M., and Parker, H. (1968). *Through the vanishing point: Space in poetry and painting*. Harper & Row.

McLuhan, M., and Parker, H. (1978). The state of the art on art criticism: Marshall McLuhan and Harley Parker in conversation. *The Innis Herald, 11*(5), 7–18.

McLuhan, M., and Parker, H., with Barzun, J. (1969). *Museum communication: A seminar*. Museum of the City of New York.

McLuhan, M., and Parker, H., with Barzun, J. (2008). *Le musée non linéaire: Exploration des méthodes, moyens et valeurs de la communication avec le public par le musée*. (B. Deloche, F. Mairesse, and S. Nash, Trans.). Aléas.

McLuhan, M., and Watson, W. (1970). *From cliché to archetype*. The Viking Press.

McLuhan, M., with Watson, W. (1973). *Du cliché à l'archétype: La foire du sense, accompagné du dictionnaire des idées reçues de Gustave Flaubert* (D. de Kerckhove, Trans.). Hurtubise/Mame.

Meyrowitz, J. (1994). Medium theory. In D. Crowley and D. Mitchell (Eds.), *Communication theory today* (pp. 50–77). Polity Press.

Miles, R.S. (1986). Lessons in "human biology": Testing a theory of exhibition design. *The International Journal of Museum Management and Curatorship, 5,* 227–40.

Miles, R.S. (1989). *The design of educational exhibits*. Routledge.

Moore, G. (1968). Displays for the sightless. *Curator, 11*(4), 292–96.

Nagel, A. (2012). *Medieval modern: Art out of time*. Thames & Hudson.

National Gallery of Canada. (1967/1968). *Intersystems and lajeunie*. Exhibition catalogue.

Nichols, M. (Director). (1967). *The graduate*. Film. Embassy Pictures.

Nietzsche, F. (2001). *The gay science, with a prelude in German rhymes and appendix of songs* (B. Williams, Ed., J. Nauchoff, Trans.). Cambridge University Press.

Ontario College of Art (OCA). (1935-1936). *Prospectus of the Ontario College of Art*. Grange Park, Toronto. https://archive.org/details/ontario_college_art_design?and%5B%5D=prospectus&sort=date

Ontario College of Art (OCA). (1936-1937). *Prospectus of the Ontario College of Art*. Grange Park, Toronto.

Ontario College of Art (OCA). (1959). Course description for foundation year English. In *Ontario College of Art, Courses of Study*. Catalogue.

Ostwald, W. (1969). *The colour primer*. Van Nostrand Reinhold.

Ouellet, L. (2008). La muséographie au Canada: Une pratique réputée, une formation en devinir. *Perspective, 3*, 513-26.

Ouzounian, G. (2007). Visualizing acoustic space. *Circuit: Musiques contemporaines, 17*(3), 45-56.

Panara, R. (1973). Untitled presentation. In *Sound of Vision Proceedings* (pp. 23-25). Rochester Institute of Technology (RIT).

Papanek, V. (1967). A bridge in time. In M. McLuhan, *Verbi-voco-visual explorations* (pp. 1-10). Something Else Press.

Papanek, V. (1972). *Design for the real world*. Thames and Hudson.

Paré, J. (1968, November 15). Qui est McLuhan? *L'enseignement, 5*, 9-10, 11-12.

Parker, B. (1968). Application for non-teaching staff at the board of education in the city of Toronto. *Intersystems* 1967-68. File in Communications Box 3: C-08-05, Archives of the Art Gallery of Ontario.

Parker, B. (1994). *Stella! Black & white*. With J. Mills-Cockell and M. Hayden. Private release on cassette tape, with booklet.

Parker, B. (2011). *Laughter at my window*. Trafford Publishing.

Parker, H. (1956). Color as symbol. *Explorations, 6*, 55-57.

Parker, H. (1963a). The museum as a communication system. *Curator, 6*(4), 350-60.

Parker, H. (1963b). Greg Curnoe's paintings: Moos Gallery, Toronto (Sept. 12-Oct. 2). *Alphabet, 7*(December), 87-89.

Parker, H. (1964a). The museum, can we get with it? *ROM Meeting Place* [unnumbered series] (*Varsity Graduate), 11*(2), 109-12.

Parker, H. (1964b). The horse that is known by touch alone. *Scope, 3*(10), 4-11.

Parker, H. (1964c). Changing perceptions from the pictorial to the iconic. *Explorations* (*Varsity Graduate), 2*(3), 50-53.

Parker, H. (1965a). From the iconic to the pictorial and back. *British Columbia Library Quarterly* (April), 10-16.

Parker, H. (1965b). The visual unseen. *Explorations* [unnumbered series] (*Varsity Graduate), 12*(1), 57-64.

Parker, H. (1967a). Notes on perception. *Harvard Art Review, 2*(Winter), 25–26.

Parker, H. (1967b). New hall of fossil invertebrates Royal Ontario Museum. *Curator, X*(4), 284–96.

Parker, H. (1967c, July 1). The pill could make monogamy obsolete. *Toronto Telegram*, np.

Parker, H. (1968). The waning of the visual. *Arts International, 12*(5), 27–29.

Parker, H. (1970a). The horse that is known by touch alone. *Explorations, 29*(Winter), 96–104.

Parker, H. (1970b). The student-employer interface. *The Decisive Years, 8*, 4–7.

Parker, H. (1970c). The social implications of satellite technology. In A.M. Linden (Ed.), *Living in the seventies* (pp. 8–12). Peter Martin Associates.

Parker, H. (1970d, April 30). Science Centre: Monolithic nonsense? *The Globe & Mail*, 7.

Parker, H. (1972a, June 17). In paralogic's subtle shifts. *The Globe & Mail*, 29.

Parker, H. (1972b). The museum as a perception kit. *Explorations*, January 1972, 54–59.

Parker, H. (1973a, January 6). How to swallow now in one electronic gulp: Review of F.D. Wilhelmsen and J. Brett, *Telepolitics. The Globe and Mail*, 29.

Parker, H. (1973b, October). Introductory remarks. In *Sound of Vision Proceedings* (pp. 3–4). Rochester Institute of Technology (RIT). Kern Program collection, RIT Arc.0044.

Parker, H. (1973c). Presentation notes for Interface seminar, April 17, 1973. Rochester Institute of Technology (RIT). Kern Program collection, ARC.f3.10.

Parker, H. (1973d). RIT office memo to members of the Communications Conference Committee, April 25, 1973. Kern Collection, Sound of Vision Arrangements, 1 page.

Parker, H. (1976). Harley Parker: Artist's statement. *Bau-Xi Gallery*. Toronto (Sept. 14–Oct. 2). Pamphlet.

Parker, H. (2025). *The culture box: Museums as media* (G. Genosko, Ed.). University of Alberta Press.

Parker, H., Shanks, L., Cantor, E., McCormick, T., and Williams, T. (1975). Panel discussion: Does it have to be printed? *Design Quarterly, 94/95*, 42–43.

Peters, J.D. (2011). McLuhan's grammatical theology. *Canadian Journal of Communication, 36*(2), 227–42.

Petrov, J. (2019). *Fashion, history, museums: Inventing the display of dress*. Bloomsbury.

"Politicians walking backwards to future": A McLuhanite speaks. (1967, August 3). *Toronto Daily Star*.

Popper, F. (1968). *Origins and development of kinetic art*. Studio Vista.

Poulet, G. (1955). The course of human time. (E. Coleman, Trans.). *CrossCurrents, 5*(1), 51–75.

Poulet, G. (1956). *Studies in human time*. The Johns Hopkins University Press.

Read, H. (1959). *The meaning of art: From cliché to archetype*. Penguin.

Reid, D. (1970). Notes on the Toronto painting scene, 1959–69. In W. Townsend (Ed.), *Canadian art today* (pp. 33–35). Studio International/W. & J. Mackay.

Reid, D. (2015). Intersystems, 1967–69: Radically rethinking art. In *Intersystems* (pp. 93–99). Arga Marghen. Booklet.

Royal Ontario Museum (ROM) Archives. (1957-1958). Unpublished correspondence. RG 107. File labelled "Up North," in reference to "Up North: The Discovery and Mapping of the Canadian Arctic, 1511-1944," exhibit of April 1958.

Royal Ontario Museum (ROM) Archives. (1959-1964). Unpublished correspondence and catalogues concerning Harley Parker's early years. RG 107. Boxes 2, 3, and 7.

Schmidt, K. (2014). Radio voices: Reflections on McLuhan's tribal drum. In C. Birkle, A. Krewani, and M. Kuester (Eds.), *McLuhan's global village today: Transatlantic perspectives* (pp. 117-29). Pickering & Chatto.

Schwartz, B.N. (1968). Content, value & direction. In R.E.L. Masters and J. Houston, *Psychedelic art* (pp. 129-61). Grove Press.

Schwartz, T. (1973). *The responsive chord*. Doubleday.

Schwartz, T. (1981). *Media: The second god*. Random House.

Semeniuk, I. (2021, December 2). ROM gallery showcases the weird, wonderful first drafts of animal life on earth. *The Globe & Mail*, A8.

Sfintes, A.-I. (2012). Rethinking liminality: Built form as threshold-space. In *Proceedings of the International Conference on Architectural Research: (Re)writing History* (pp. 1-9). Ion Mincu Publishing House.

Sfintes, A.-I. (2019). Architecture and anthropology: Working in-between concepts. *IOP Conference Series: Materials Science and Engineering, 471*(2), 072017, 1-12.

Sparshott, F.E. (1969). The Gutenberg nebula. *The Journal of Aesthetic Education, 3*(3), 135-55.

Staines, D. (2014). Herbert Marshall McLuhan: Before *The mechanical bride*. In C. Birkle, A. Krewani, and M. Kuester (Eds.), *McLuhan's global village* (pp. 75-84). Pickering & Chatto.

Storring, N. (2015). Intersystems: Number one, peachy, free psychedelic poster inside. In *Intersystems* (pp. 77-91). Alga Marghen. Booklet.

Swann, P.C. (1967). *Annual report: 17 (July 1966-June 1967)*. Royal Ontario Museum.

Swann, P.C. (1968). *Annual report: 18 (July 1967-June 1968)*. Royal Ontario Museum.

Swinton, W.E. (1966). *Annual report: 16 (July 1965-June 30, 1966)*. Royal Ontario Museum.

Texier, J.C. (1968). Un nouveau imposteur: Marshall McLuhan. *COMBA* (August), np.

Theall, D. (1971). *Understanding McLuhan: The medium is the rear view mirror*. McGill-Queen's University Press.

Theall, D. (2001). *The virtual Marshall McLuhan*. McGill-Queen's University Press.

Towns, A. (2019). The (black) elephant in the room: McLuhan and the racial. *Canadian Journal of Communication, 44*(4), 545-54.

Veeder, R. (2011). Re-reading Marshall McLuhan: Hectic zen, rhetoric, and composition. *Enculturation, 12*(December). http://enculturation.net/hectic-zen

Velasco, C., Woods, A.T., Deroy, O., and Spence, C. (2015). Hedonic mediation of the crossmodal correspondence between taste and type shape. *Food Quality and Preference, 41*(April), 151-58.

Vergo, P. (1989). The reticent object. In P. Vergo (Ed.), *The new museology* (pp. 41-59). Reaktion Books.

Vi, T.C., Ablart, D., Gatti, E., Velasco, C., and Obrist, M. (2017). Not just seeing, but also feeling art: Mid-air haptic experiences integrated in a multisensory art museum. *International Journal of Human-Computer Studies, 108* (December), 1–14.

Whittle, C. (1997). *The museum as a communication system: A review and synthesis.* Research report. Education Resource Information Center.

Wilkinson, C. (2019). Understanding the effects of "behind-the-scenes" tours on visitor understanding of collections and research. *Curator, 62*(2), 105–15.

Wolfe, T. (1967). What if he is right? In G.E. Stearn (Ed.), *McLuhan hot & cool* (pp. 15–34). The Dial Press.

Wolfe, T. (1968, September 15). McLuhan: Through electric circuitry to god. Book Week, *Washington Post*, 4–5.

Worcman, K. (2016). We're all curators: Collaborative curatorship as a new museum experience. *THEMA: La revue des Musées de la civilisation, 4*, 125–36.

Yudhawasthi, C.M., Damayani, N.A., and Yusup, P. (2018). Museum as a communication system. In *Proceedings of the International Conference on Media and Communications Studies (ICOMA 2018)* (Vol. 260, pp. 1–6). Advances in social sciences, education and humanities research series. Atlantis Press.

Index

Page numbers in *italics* refer to illustrations.

Aboriginal peoples. *See* Indigenous peoples
abrasive juxtapositions, 121, 126, 163, 180, 205–06
 See also retraining sensory perception
academy. *See* universities and research centres
acoustics. *See* sound
Albers, Josef, 24, 26, 131–32, 143
alphabets. *See* writing systems
Anshen, Ruth Nanda
 editor of *Through the Vanishing Point*, 10, 25, 34–40, 74–76
 Parker's painting *Flying Children*, 38, 75–76, 133
architecture
 about, 68–69
 blindness and visitor experience, 68–69
 domes, 114, 119

flexibility in, 163
hypothetical subarctic gallery, 114, 119, 124, 178, 200, 210, 213
liminoid, as concept, 170, 177
process vs. product, 9
total sensory involvement, 114, 119
The Art of Fine Printing and Its Influence Upon the Bible exhibition (ROM, 1956), 28–29
artifacts and objects
 abrasive juxtapositions, 126
 artifacts as artworks, 122
 colonial legacies, 6, 121–22, 212
 orientation galleries, 8, 178–79
 sense ratios of culture, 4–5, 121
 sensory states of makers' world, 119–20, 163, 178–79, 181, 205–06
 See also collection and preservation of artifacts; exhibition design
Assembly of First Nations (AFN), 123–24
audience
 about, 111–12, 150, 159–63
 accessibility concerns, 159–61

229

adults, 138–39

children, 111–12, 135, 138–39, 150, 153, 161

déjà vu experiences, 163, 211

elitism, 6, 17, 196, 212

feedback from, 5, 113, 114–15, 121, 150–51, 155–56, 163

museum fatigue, 172

orientation galleries, 111–12, 144–45, 167–69, 182

Parker's ideal audience, 150–51, 210

research needed on, 150–51, 162–63, 174, 212

retraining sensory perception, 6–7, 121

sense ratios, 111–12, 115, 121, 155, 162–63

visitor-controlled ambience, 200

visual bias, 149–50, 159–63, 169–70, 198

youth, 111–12, 135–38, 150, 161–62, 177–78, 210

See also community involvement; youth

auditory. *See* deafness; sound

Babel: Society as Madness and Myth (U of T, 1968), 98

Bacon, Bruce, 11

See also *Picnic in Space* (film, 1967)

Barzun, Jacques, 180, 183–84, 189–90

Bat Cave (ROM), 13

Bauhaus influences, 24, 173, 176

Bau-Xi Gallery, 24, 88

Bayefsky, Aba, 109

Bayer, Herbert, 173, 175, 176

Bayle, François, 41

Beckett Gallery, Hamilton, 24

Bergson, Henri, 57, 58–59

Black, Mary, 167

Black Mountain College, 24

Blakeney, William, 106–07

Blanchard, Marie-Josée, 198–200

blindness

about, 64–70, 159–60

accessibility concerns, 159–61

Derrida on, 69

iconic mode, 65

inverse sensory biases, 70

Leighton epigram, 65–69

Papanek's designs for, 110

sensory compensations, 66, 70

sensory profiles, 71–73

Sound of Vision conference (1973), 70–74, 160–61, 216n1

suddenness, 64–66, 68–69

tribalism trope, 71–74

See also vision and visuality

body and senses. *See* sensorium

Bolton, Stephanie, 123–24

Bomac Ltd., 27

books. *See* writing systems

bow and arrow, 116

Brett, Katharine B., 140–42

British Museum (Natural History), exhibition (1977), 156

Brodey, Warren, 68–69

Brooke, Rupert, 75

Brussels World's Fair (1958), 197

Burnaby Art Gallery, ix, 19, 85, 88–89

Cage, John, 103

Caillois, Roger, 93

Calder, Alexander, 173

Calderon, Mary Jane, 156

Cameron, Donald F., 154–56

Campbell, William S., 45, 46

Canadian Museum of Civilization (CMC), 113–14, 123

Canadian Museums Association (CMA), task force (1992), 123–24

Carballo, Isabel, 189

Carboni, Erberto, 172–73

card deck, *Dew-Line Newsletter*
(McLuhan, 1969), 2, 9–10, 66
Carleton University, Ottawa, 24
Carpendale, Monica, 19, 89
Carpenter, Edmund, 3, 25, 33, 113, 168–
69, 206
Cash, Leora, 104
Castel, Mathilde, 125–26
Cavell, Richard, 52–53
C & B (Cooper & Beatty), 26–27, 28, 29, 31,
89
Centre for Culture and Technology (U of
T)
about, 105
Coach House seminars, 39, 43, 44
Parker as associate (1967–1975), 1–2,
24–25, 42–43, 44, 87, 105
Parker as McLuhan's substitute, 11,
43–44
research on sensory profiles, 44–45,
105, 140
C'est notre histoire exhibition (Musée de
la civilisation à Québec), 198–200
Chesterton, G.K., 63–64
chiaroscuro, 135
children
about, 161
as audience, 111–12, 135, 138–39, 150,
153, 161
television's impacts on, 44–45, 65,
105
total sensory involvement, 138–39
cinema. *See* film
class. *See* social class
CMA (Canadian Museums Association),
task force (1992), 123–24
CMC (Canadian Museum of
Civilization), 113–14, 123
Coach House, Toronto, 39, 43, 44
collection and preservation of artifacts
consultation with cultural members,
198

Indigenous involvement, 114, 120,
123–24, 200
midden metaphor, 9
preservation as obstacle to creativity,
183–84
colour theory
about, 143–44, 197–98
Albers's influences on Parker, 26, 143
colour as symbol, 26
Parker's studies, 24
retraining sensory perception, 20,
143–44
total sensory response, 197–98
Columbia University, 47
Communicating with the Museum Visitor
report (CDT) (ROM, 1976), 157–
61
communication theory
about, 154–57, 193, 202
concepts and percepts, 168, 184
conscious awareness of perception,
8, 181–83
feedback, 155, 163
intervals, 68–69, 87
museum as communication system,
154–55
non-linear model, 155
retraining of sensory perception,
167–70
ROM report (CDT, 1976), 157–61
Schwartz's resonance theory, 167–69
sensory states of makers' world,
116–20, 163, 178–79, 181
transformation model, 20, 157
transmission model, 20, 154–57, 193,
202
See also McLuhan, Marshall, medium
theory
community involvement
about, 5, 17, 162–63, 212
accessibility, 159–60, 162–63

consultation with cultural members, 198

democratization, 7, 17, 201–02, 212

designers as problem-solvers, 109–10

elitism, 6, 17, 196, 212

feedback from spectators, 5, 114–15, 121, 155, 163, 182

flexible engagement, 193–95

Indigenous peoples, 114, 120, 123–24

new museology, 17–18, 80

Parker's legacy, 198–200, 212

satellite museums, 196, 212

computers, 34, 54, 156, 190, 213

See also technologies

conservation. *See* collection and preservation of artifacts

Contraexplosión (McLuhan; Gelstein, trans. Spanish, 1971), 188–89

cool and hot media, 11, 37, 104–05

Cooper & Beatty (C & B), 26–27, 28, 29, 31, 89

costume exhibits (ROM), 140–42

Couchiching Conference (1967), 2

Counterblast (McLuhan, 1969)

about, 10, 64, 103, 107

acoustic space, 64

artifacts in new environments, 181

counterculture, 107

design credits, 103

French and Spanish translations, 185, 187–89

good taste epigram, 64, 74

Parker's graphic design, 171

phototype, 46

reception, 16

translations, 185, 187–89

typography, 64, 188–89, 209

Counterblast (McLuhan; Paré, trans. French, 1972), 185, 187–89

counterculture

about, 12–13, 100–01, 105–8, 136–37

audience, 136, 210

drugless artistic efforts, 101, 107–08

Electric Circus nightclub, 16, 101, 171–72, 191, 194

Hall of Fossils, 13, 100, 105–06, 136

Intersystems, 12–13, 98–101, 105–06

kinetic art, 13, 98–101, 105

Parker-McLuhan collaborations, 101, 107–08

Parker's life in Yorkville (1960s), 136–37

Perception '67, 13, 98, 107

psychedelic drugs, 99, 100–101, 107–08, 136

reception of works, 107–08

See also Intersystems (multimedia performance); youth

counter-environments, 121, 126, 163, 180, 205

See also disorientation of spectators

Cross, Lowell, 103

Cruise, J.E., 157

Cubist movement, 115, 116, 135

Culkin, John, 50–51

The Culture Box (Parker, 2025)

about, ix, 4–6, 19–21, 162–63, 210–13

editorial work, ix, 19–20

found manuscript, ix, 4, 18–19

Harper & Row as intended publisher, 10, 35–36

McLuhan's influences, 20–21

Parker's announcement of, 10

Parker's legacy, 210–13

The Culture Box, medium theory

about, 4–6, 20–21, 143–45, 162–63, 210–13

blindness and sensorium, 68–70

Carboni's influence, 172–73

cave art, 177

colour theory analogy, 143–44, 197–98

community involvement, 80, 109

conscious awareness of perception,
181–83
critiques of, 5–6
cultural assumptions of audience, 122
déjà vu experiences, 163, 211
designer as community problem-
solver, 109
disorientation of spectator, 177
display cases, 126, 143
T.S. Eliot's objective correlative,
205–06
feedback from spectators, 5, 155, 163
grammar of presentation, 172–74
iconic vs. illustrative space, 135, 176
intervals, 68–69, 87, 168
labels and explanations, 150
making/matching messages, 157, 194
newseum overview, 8–9
orientation galleries, 111–12, 144–45,
167–69, 176
preservation as obstacle to creativity,
183–84
Regency Room modifications, 177
retraining sensory perception, 101,
143–45
satellite museums, 196, 212
sensory states of makers' world, 4–5,
163, 178–79, 181, 205–06
simultaneity of perception, 180
thought experiments, 14
visual bias, 68–69, 157, 178, 198
See also newseum; Parker, Harley,
medium and design theory
curators
about, 208
collaboration with designers, 4, 80–
85, 136–38, 140, 150, 200–02, 208,
211
as communicators, 84
vs. designers, 4, 208
feedback from spectators, 5, 114–15,
121, 155

as social progressivist activist, 82–83,
208
specialists vs. generalists, 4, 149–51,
200–01, 208
Curnoe, Greg, 210

Da Vinci, Leonardo, 67
Dair, Carl, 27, 30, 36, 109
Davis, Todd A., 85, 89
Dawn of Life gallery (ROM, 2021), 208
De Caro, Laura, 193–96
De Kerckhove, Derrick, 41, 187, 191–92
deafness
accessibility concerns, 160–61
inverse sensory biases, 70
sensory profiles, 71–73
sign language as ideographic, 73
Sound of Vision conference (1973),
70–74, 160–61, 216n1
tribalism trope, 71–74
See also sound
Debord, Guy, 56
Deck, Barry, 46
déjà vu experiences, 163, 211
Deleuze, Gilles, 192
Deloche, Bernard, 17, 125, 189, 194–95,
197, 203–04
democratization of museums, 7, 17, 201–
02, 212
See also community involvement
Derrida, Jacques, 69
design, exhibition. *See* exhibition design
design, typography. *See* typography
designers
about, 4, 83–84, 159
authority of, 159
collaboration with curators, 4, 80–85,
136–38, 140, 150, 200–02, 211
community involvement, 20, 109–10
designer-communicators, 4, 20,
83–84, 208, 211

Index 233

feedback from spectators, 5, 114–15, 121, 155

good taste epigram, 83–84

as problem-solvers, 109–10

retraining sensory perception, 6–7, 121

specialists vs. generalists, 4, 149–51, 200–01, 208

Dew-Line Newsletter (McLuhan, 1969), 2, 9–10, 66

digital media. *See* technologies

dioramas

abstract dioramas, 130, 135

Hall of Fossils, 82, 102, 125, 130, 135

multi-sensory spaces, 125

pictorial-based design, 177

disabilities, 73, 110

See also blindness; deafness

disadvantaged people, 71–74

disorientation of spectators

about, 175–76, 206

abrasive juxtapositions, 121, 126, 163, 180, 205–06

T.S. Eliot's objective correlative, 205–06

removal of cap of invisibility, 175–76

retraining sensory perception, 6–7, 121

reverse perspective, 175–76

See also retraining sensory perception

display cases

glass cases, 114, 125–26, 138, 143, 149

sensory states of makers' world, 116–18, 163

as space dividers, 138

See also exhibition design

drugs, psychedelic. *See* counterculture

Du Cliché à l'archétype (McLuhan and Watson; de Kerckhove, trans. French, 1973), 187, 191–92

Duchamp, Marcel, 103

Dudas, Frank, 3

Dutch Gallery experiment, Museum of City of New York (1967)

about, 7–8, 15–16, 165–72, *166*, 178–84, 212–13

artifacts, 8, 178–79

audience control, 16, 167, 181–82, 212

critical reception, 8, 180, 183–84

diagram of exhibition, 165–67, *166*, 191

multimedia design, 8, 15, 165–69, *166*, 180–81

museum fatigue, 172

as orientation gallery, 7–8, 144–45, 167–69

as redesigned existing gallery, 167

as research, 212

seminar overview, 7–8, 15–16, 165–67, 183–84

See also *Museum Communication: A Seminar* (McLuhan and Parker, with Barzun, 1969); orientation galleries

ear. *See* deafness; sound

Easterbrook, Tom, 109

Eaton's, 23–24, 31, 89

education

educational television, 192

functions of, 201–02

portable media and access, 54

visual bias, 178, 192

See also children

education, higher. *See* universities and research centres

Elcock, Chris, 13, 112, 191

Elder, Bruce, 51–53

Electric Circus nightclub, 16, 101, 171–72, 191

Eliot, T.S., 205–06, 213

elitism, 6, 17, 196, 212

Ellin, Everett, 180, 195, 213

epigrams

about, 11–12, 209

dislocation and sharpening of awareness, 11–12

labels and explanations, 150

orality of, 209

"to the blind all things are sudden," 65–69

epigrams, good taste as "refuge of the witless"

about, 63–64, 74–79, 83–85, 209

in Burnaby gallery catalogue, 85

in *Counterblast*, 64, 74, 185

as critique of museums, 192–93

list of five variations, 78

in *Museum Communication*, 83, 192

orality of, 209

Parker as epigrammatic man, 11–12, 207, 209

Parker/McLuhan collaborations, 63–64, 75–76

stupidity, as concept, 192–93

in *Through the Vanishing Point*, 75–76, 78

translations, 182, 192, 209

typography, 74, 85

"witless" and snobbism, 74, 76–77, 78, 84–85

Etheredge, Gilbert, 30

exhibition design

about, 4–5, 120–21, 211–13

advertising influences, 174

community consultations, 198–200

designer-communicators, 4, 20, 83–84, 208, 211

designer-curator collaboration, 4, 80–85, 136–38, 140, 150, 200–02, 211

display cases, 114, 125–26, 138, 143, 149

everyday materials, 120–21

feedback from spectators, 5, 114–15, 121, 150–51, 155, 163, 182

good taste as compromise, 174

hypothetical subarctic gallery, 117–24, 178, 200, 210, 213

Indigenous involvement, 114, 120, 123–24

museographers, 201

non-linear narratives, 114, 179

Parker's experiments, 7–8, 15–16, 111, 150–51

Parker's legacy, 17–18, 198–200, 206–09, 211–13

reverse perspective, 175–76

sensory states of makers' world, 116–20, 163, 178–79, 181

shift from storyline to reciprocal model, 206–07

of single object, 119

storylines, 159, 191

traditional museums, 122

visitor-controlled ambience, 200

exhibition design, Hall of Fossils. *See* Hall of Fossils, exhibition design

exhibition design, labels. *See* labels and explanations

exhibition design, organizational methods. *See* organizational methods; story

exhibition design, orientation galleries, 7–8, 15–16, 167–69

See also Dutch Gallery experiment, Museum of City of New York (1967); orientation galleries

exhibition design, theory. See *The Culture Box*, medium theory; newseum; Parker, Harley, medium and design theory; sensory states of makers' world

Explorations (journal, 1953–1959)

about, 25–29

cover designs, 26

crediting issues, 26–27

Flexitype (phototype), 26–29, 33, 46

Fluxus version, 33
group members, 16, 25, 26, 33, 109, 113, 115
as insert in *Varsity Graduate* (1964–1972), 14, 26
Parker as designer, 9, 25, 26, 33
Explorations, articles and issues
"The Horse That Is Known by Touch Alone," 26, 64–66
"The Museum as a Perception Kit," 143–44, 162, 181
"Verbi-Voco-Visual" issue, 26
Expo 67, Montreal, 3, 16, 31, 47, 171, 179–80, 186
eye. *See* blindness; vision and visuality

fashion exhibits (ROM), 140–42
Ferguson, Marjorie, 56
Ferlinghetti, Lawrence, 41
film
about, 53
hot and cool media, 11, 37
Labyrinth (Expo 67), 16, 171–72, 179–80
media as content of other media, 5
multi-screen experience, 171–72
television/film relationship, 52–54, 58–59
See also *Picnic in Space* (film, 1967)
First Peoples. *See* Indigenous peoples
Fleming, Allan, 27–29, 31–32, 109
Fleming, Martha (Allan's daughter), 28–29, 31–32
Flexitype, 26–29, 33, 103–04
See also typography
Fluxus and Flux kits, 10, 33
Fordham University, 1, 3, 25, 81, 108, 165
Foucault, Michel, 59
Fraysse, Patrick, 207
Freedom Forum, Newseum, 8
Freifeld, Eric, 109

French translations. See *Counterblast* (McLuhan; Paré, trans. French, 1972); *Du Cliché à l'archétype* (McLuhan and Watson; de Kerckhove, trans. French, 1973); *Le musée non linéaire* (McLuhan and Parker; Deloche, Mairesse, and Nash, trans. French, 2008)
Freud, Sigmund, 106–07
From Cliché to Archetype (McLuhan and Watson, 1970), 187
From Modesty to Mod exhibition (ROM, 1967), 140–42, 144
Fulford, Robert, 26, 29, 31, 148
Fuller, Buckminster, 6, 48, 99

Gallery Moos, Toronto, 24
Genosko, Gary, 18–19, 185
gift economy, 118
glass cases. *See* display cases
good taste epigram. *See* epigrams, good taste as "refuge of the witless"
Gordon, W. Terrence, 108
Greenberg, Clement, 83–84
Greenbrier Management Conference (1964), 34, 43–45, 50, 215n4
Gresco, Paul, 78–79
Gutenberg bible exhibition (ROM, 1956), 28–29
The Gutenberg Galaxy (McLuhan, 1962)
on Barzun, 183
French translation of *From Cliché*, 186–87, 191–92
French translation of *Gutenberg Galaxy*, 186
manuscript culture, 209
Parker as epigrammatic vs. typographic man, 12
Poulet's influence, 190
reception in Quebec, 186–87
rewritten as *From Cliché to Archetype* (with Watson, 1970), 187

tension with older attitudes, 115, 183
tribalism trope, 71-74, 116, 120-21

Hagan, Fred, 108
Hall, James, 90, 92
Hall of Fossils (ROM)
 about, 13-15, 81-83, 207-08
 audience, *130*, 135-40, 150-51, 153, 210
 Bat Cave, 13
 construction and redesigns (1967-1984), 13, 113, 125, *146*, *147*, 148
 Dawn of Life gallery (2021), 208
 good taste epigram, 78-79
 inadequate recognition of Parker, 113-14
 Karsh's photo of McLuhan, 19, 132-34, *133*
 Lemon as curator, 80-82, 137-38
 McLuhan's influence, 125, 126, 131-33, *133*, 138-39
 Parker's legacy, 13, 207-08
 Parker's views on, 14-15, 138-40, 142, 152, 197
 reception, 113, 125, 131
 ROM report (CDT, 1976), 152-53
 security concerns, 153, 158
 "two Torontos," 125-26, 131
Hall of Fossils, exhibition design
 about, 81-82, 124-36, *127*, *128*, *129*, *130*, *133*
 architecture, 102, *127*, *128*, *129*
 counterculture, 13, 100, 105-06
 deep time, 82, 130-31, 208
 designer-curator collaboration, 4, 80-83, 136-38, 140, 150, 200-02, 211
 dioramas, 82, 102, 125, 130, 135, 152
 display cases, 125
 exit strategy, 82, 130-31
 iconic mode, 135

invertebrate palaeontology, 124-26, 136
 kinetic art, 13, 100
 labels and explanations, 134
 lighting, 101, 131, 138
 multi-sensory space, 125, *127*, *128*, *129*, 131, 138
 non-linearity, 81-82, 131
 organizational methods, 81-82
 retraining sensory perception, 13, 105
 smells, 101-02, 124, 125
 sounds, 101-02, 126-27, 131, 135
 technologies, 13, 81-83, 100, 126, *128*, 130-31, *133*, 134-35, 153
 total sensory involvement, 113-14, 125, 135
 touch, 125, 130, 138
hallucinogens, 99, 100-01, 107-08, 136
 See also counterculture
Harding, D.W., 40
Hayden, Michael, 98-99, 101-02, 104
Head Machine (Hayden, Mills-Cockell, and B. Parker), 98
hearing. *See* deafness; sound
Heinrich, Theodore A., 147, 216n2
higher education. *See* universities and research centres
hippie, as term, 112
Hopkins, Gerard M., 75
hot and cool media, 11, 37
Houde, Robert, 71
Houédard, Dom Sylvester, 36-37
Houston, Jean, 100-01
Howes, David, 17-18, 21, 198-200
Huang, Paul, 88
Human Biology exhibition (British Museum, Natural History, 1977), 156
Hurst, Arthur, 105
Hutcheon, Linda, 207
hypothetical news gallery. *See* newseum

Index 237

hypothetical subarctic gallery, 117–24, 178, 200, 210, 213

iconic mode
 about, 43, 64, 135
 blindness, 65
 hallucinogenic drugs, 136
 vs. illustrative, 135, 176–77
 intervals, 64
 McLuhan's acoustic space as, 64, 76, 120, 191
 in painting, 135
 shift from visual/illustrative bias to iconic/tactile, 43, 45, 65, 210
 timelessness, 43, 64
 total sensory involvement, 43, 64, 135
 See also total sensory involvement
illumination. *See* lighting
illustrative art
 vs. iconic, 135, 176–77
 orientation spaces, 176–77
 shift from visual/illustrative bias to iconic/tactile, 43, 45, 65, 210
Impact posters exhibition (ROM, 1960), *175*, 175–76
Indigenous peoples
 about, 114, 120–22, 206
 caribou example, 119
 CMC museum design, 123
 collection and preservation of objects, 114, 120, 123–24, 200
 colonial legacies, 6, 121–22, 212
 community involvement, 114, 120, 123, 198
 consultations, 198–200
 decolonization of museums, 114
 exhibition design, 114, 120–22, 206
 hypothetical subarctic gallery, 117–24, 178, 200, 210, 213
 marriage customs example, 118–19
 Parker's legacy, 198–200

sensory states of maker's world, 117–20, 206
stereotypes, 159
Taiga, as term, 117
task force on museums (AFN and CMA, 1992), 123–24
total sensory involvement, 198–200
traditional museums, 121–24
See also Inuit
Inkster, Douglas, 70–71
The Innis Herald, 41, 92
intake spaces. *See* orientation galleries
interdisciplinary research. *See* universities and research centres
International Council of Museums (ICOM/MINOM), 17, 82–83
Intersystems (multimedia performance)
 about, 12–13, 89–90, 98–106
 counterculture, 12–13, 98–101, 105–06
 kinetic art, 98–101
 members (Hayden, B. Parker, Mills-Cockell, and Zander), 98–99, 104, 106
 Mind Excursion, 13, 90, 98–102, 107
 Parker father-son relationship, 97–106
 sensory reordering, 105–06
 time period (1967–1969, 2021), 99, 106
Intersystems, works
 Canadian Artists '68, 100
 Direction '67, 99
 Duplex, 99, 101–03
 Free Psychedelic Poster Inside, 99
 Intersystems #IV (2021), 106–07
 Mind Excursion, 13, 90, 98–102, 107, 191
 Mind Power, 99
 Peachy, 12–13
 Perception '67, 98
 Stella! Black & White (1994), 104–05

intervals, 68–69, 87, 168

Into the Heart of Africa exhibition (ROM, 1989–1990), 207

Inuit
 acoustic space, 168–69, 200
 Carpenter's studies, 32–33, 168–69
 hypothetical subarctic galleries, 117–24, 178, 200, 210, 213
 interdisciplinary approaches, 32–33
 Up North exhibition (ROM, 1958), 32–33

invertebrate palaeontology, 124–26
 See also Hall of Fossils (ROM)

involvement, community. *See* community involvement

involvement, total. *See* total sensory involvement

Jacobs, Jane, 3, 31
Joyce, James, 34, 116, 188, 191

Karsh, Yousuf, 19, 93, 95, 132–34, *133*
Kelly, Robert, 114, 123
Kenyon, Robert, 145, 147
kinaesthesia and kinetic space, 124, 138, 168–69
kinetic art, 13, 98–101, 105
Klein, Roger H., 36, 38
Knez, Eugene, 154–55
Kroker, Arthur and Marilouise, 10, 20
Kuypers, Jan, 3

labels and explanations
 about, 18, 150, 211–12
 epigrams, 209
 exhibitions without labels, 161
 feedback from spectators, 5, 114–15, 121, 150–51, 155, 163, 182
 Hall of Fossils, *133*, 134
 hypothetical galleries, 161
 Latin names, 134
 oral delivery, 103, 212

ROM report (CDT, 1976), 159
 storylines, 159
 typography, 161

Labyrinth (Expo 67), 16, 171–72, 179–80
Lansdale, Robert, 43
Lauder, Adam, 8–9, 19, 89–90, 105, 115–16
Lee, Dorothy, 16, 115
Leighton, Alex, 65–69
Lemon, R.R.H., 80–82, 138
Lewis, Wyndham, 3, 64, 85, 103

lighting
 about, 117
 Dutch Gallery experiment, 165–69
 Electric Circus nightclub, 101, 171–72, 191
 experimental lighting, 83
 Hall of Fossils, 101, 131, 138
 Indigenous exhibition design, 198–99
 of labels and explanations, 150
 overcoming visual bias, 170–72
 retraining sensory perception, 168–70
 sensory states of maker's world, 117
 traditional museums, 149
 visitor-controlled ambience, 200

liminality
 liminoid as concept, 170, 177
 retraining sensory perception, 158, 169–70, 177, 195, 203

linearity
 about, 5, 16–18
 assumptions, 16–17
 Barzun's preference for, 183–84
 chronologies, 81, 131, 144, 177
 hypothetical subarctic gallery, 117–18, 124, 178, 200, 210, 213
 Lee's linguistic anthropology, 16, 115
 non-linear narratives, 114, 179, 183
 overcoming visual bias, 169–72, 174, 177–78

storylines, 17, 177, 191
vs. total sensory involvement, 121
visual bias, 18, 69, 149, 169–70, 198
writing systems, 5
See also vision and visuality; writing
systems
literary arts
Eliot's objective correlative, 205–06
non-narrative works, 191
poetry and paintings in Through the
Vanishing Point, 30, 36, 39, 41
See also epigrams
local society. See community
involvement
logical and paralogical, 87
LSD, 99, 100–01, 107–08
See also counterculture
Lusseyran, Jacques, 66–67

MacDonald, George F., 113–14, 123
MacDonald, J.W.G., 109
Mair, Shirley, 138, 178
Mairesse, François, 17, 125, 189, 194–95,
197, 203–04
Marantz, Kenneth A., 59–60
Marchand, Philip, 39–40, 63–64
Marchessault, Janine, 34, 73–74
marginalized people, sensory profiles,
71–73
Markowitz, Jane, 98
Martin, Anthony, 101
Marvell, Andrew, 30–31
Masks exhibition (ROM, 1959), 145, 147–
48
Masters, Robert E.L., 100–01
Mauss, Marcel, 118
Mayrand, Pierre, 82–83
McCord Museum, Montreal, 123–24
McLuhan, Corinne (Marshall's wife), 40,
99
McLuhan, Eric (Marshall's son), 9–10, 35
McLuhan, Marshall

as celebrity, 59–60
education, 63
health, 25, 88
Karsh's photo, 19, 132–34, 133
life in New York City (1967–1968), 1,
3, 25, 81, 108, 165
personal qualities, 11, 33, 60–61, 74,
76–77
See also Centre for Culture and
Technology (U of T)
McLuhan, Marshall, medium theory
about, 13–14, 18, 154–57, 211–13
acoustic space, 55, 64, 76, 120, 191,
197
artifacts, 178–79
conscious awareness of perception,
181–83
cool and hot media, 11, 37, 104–05
critiques of, 5–6, 45, 183–84
film/television relationship, 52–54
hot and cool media, 11, 37
Leighton epigram on blindness, 65–
69
making/matching messages, 157, 194
media nesting, 5, 52
modular, as term, 194–95, 197
new museology, 17–18
Parker's application to museums, 4–9
Parker's variations on, 211–13
research on television impacts, 44–
45, 105, 140
retraining sensory perception, 149
sensory balances, 18
sensory states of makers' world,
178–79, 181
sensory turn, 20–21
time, 57–59
tribalism trope, 71–74, 116, 120–21
visual bias, 14, 46–47, 69, 149
McLuhan, Marshall, Parker as substitute.
See Parker, Harley, McLuhan's
substitute (1964–1969)

240 Index

McLuhan, Marshall, Parker's collaborations

about, 3–4, 23, 25, 60–61

co-authors of *Through the Vanishing Point*, 10, 34–42

counterculture, 101, 107–08

cronyism and fronting, 60–61

first meeting, 23

at Fordham University (1967–1968), 1, 3, 25, 81, 108, 165

good taste epigram, 63–64, 74–76

letters to/from, 87–88, 135

McLuhan Centre, 1–2, 24–25, 42, 44, 87, 105

personal relationship, 33, 35, 39, 47–48, 60–61, 135

See also *Explorations* (journal, 1953–1959); *Le musée non linéaire* (McLuhan and Parker; Deloche, Mairesse, and Nash, trans. French, 2008); *Museum Communication: A Seminar* (McLuhan and Parker, with Barzun, 1969); *Picnic in Space* (film, 1967); *Through the Vanishing Point* (McLuhan and Parker, 1968)

McLuhan, Marshall, works

Culture Is Our Business, 66

Laws of Media (with Eric McLuhan), 157

"Printing and Social Change," 31

Take Today (with Nevitt), 67–68

See also *Counterblast* (McLuhan, 1969); *Explorations* (journal, 1953–1959); *The Gutenberg Galaxy* (McLuhan, 1962); *Museum Communication: A Seminar* (McLuhan and Parker, with Barzun, 1969); *Through the Vanishing Point* (McLuhan and Parker, 1968); *Understanding Media* (McLuhan, 1964)

McLuhan, Marshall, works: translations and reinventions

about, 185–89

From Cliché to Archetype (with Watson, 1970), as rewriting of *Gutenberg Galaxy*, 187

Counterblast in French and Spanish, 185, 186–89

Du Cliché à l'archétype (with Watson; de Kerckhove, trans. French, 1973), 186–87, 191–92

Gutenberg Galaxy (Paré, trans. French, 1967), 186

See also *Le musée non linéaire* (McLuhan and Parker; Deloche, Mairesse, and Nash, trans. French, 2008)

medium theory. *See* communication theory; *The Culture Box*, medium theory; McLuhan, Marshall, medium theory; new museology; Parker, Harley, medium and design theory

memory, 211

midden metaphor, 9

Migwans, Dolorès Contré, 124

Miles, Roger, 156

Miller, Jonathan, 66

Mills-Cockell, John, 98–99, 102, 104, 106

Mind Excursion (Intersystems, 1967), 13, 90, 98–102, 107, 191

Mindel, Eugene, 70–71

Miyake, Taizo, 180–81

modular, as term, 194–95, 197

Mondrian, Piet, 56

Moore, George, 160

Mouvement international pour une nouvelle muséologie (ICOM/MINOM), 17, 82–83

movies. *See* film

Index 241

The Multi-Media Orientation Gallery. See Dutch Gallery experiment, Museum of City of New York (1967)

Musée de la civilisation à Québec, 198–200

Le musée non linéaire (McLuhan and Parker; Deloche, Mairesse, and Nash, trans. French, 2008)
about, viii, 16–17, 185–86, 189–93, 201–02
cultural climate, 190
editorial work, 190–92
flexibility of museums, 193–95, 201
good taste epigram, 185, 192
inserted quote (Robbe-Grillet), 191–92
Nash as collaborator, 189
non-linearity, 195
Parker's designs, 185
Parker's legacy, 17–18, 193–202, 207–08
publication (2008), 16–17, 185–86
reception, viii, 16, 17–18, 185–86, 189–90
storylines, 203–04
title, 16–17, 190
translation issues, 190–92
translators (Deloche and Mairesse), 17, 125, 189, 194, 197, 203–04
See also *Museum Communication: A Seminar* (McLuhan and Parker, with Barzun, 1969)

museographers, 201

"The Museum as a Communication System" (Parker, 1963), 114–24, 136, 154, 178

"The Museum as a Perception Kit" (Parker, 1972), 143–44, 162, 181

Museum Communication: A Seminar (McLuhan and Parker, with Barzun, 1969)
about, viii, 7–8, 15–16, 165–84
artifacts, 178–79
Barzun's critiques, 180, 183–84
critical reception, 8, 17, 59–60, 180, 183–84
Dutch Gallery experiment, 7–8, 15–16, 165–69, *166*
Electric Circus example, 16, 101, 171–72, 191
good taste epigram, 83
Labyrinth (Expo 67) example, 16, 171–72, 179–80
multimedia design, 8, 15, 165–69, *166*, 174, 180–81
newseum overview, 8, 169–70
participants, 15–16
seminar overview, 7–8, 15–16, 165–67, 183–84
See also Dutch Gallery experiment, Museum of City of New York (1967); orientation galleries

Museum Communication: A Seminar (McLuhan and Parker, with Barzun, 1969), French translation. See *Le musée non linéaire* (McLuhan and Parker; Deloche, Mairesse, and Nash, trans. French, 2008)

Museum of Natural History, New York, 172

Museum of the City of New York, Dutch Gallery. *See* Dutch Gallery experiment, Museum of City of New York (1967)

Museum of the City of New York, seminar (1967). See *Museum Communication: A Seminar* (McLuhan and Parker, with Barzun, 1969)

museums
colonial legacies, 6, 121–22, 212

242 Index

as communication systems, 7–9,
154–55
data as content vs. structure, 115–16
empathic insights, 205
as flexible medium, 163, 193–95, 201
international council (ICOM/
MINOM), 17, 82–83
new museology overview, 17–18
Parker's critiques, 162–63, 189–90,
192–93
as perception kit, 162
purposes, 122
retraining sensory perception, 6–7,
121
sensory museology, 17–18
sensory states of makers' world,
116–20, 163, 178–79, 181
specialists vs. generalists, 4, 149–51,
200–01, 208
as unique medium, 156
See also museums, traditional; new
museology; newseum
museums, audience. *See* audience;
disorientation of spectators;
retraining sensory perception
museums, curators and designers. *See*
curators; designers
museums, exhibition design. *See*
exhibition design; Hall of Fossils,
exhibition design; orientation
galleries
museums, Royal Ontario Museum. *See*
Hall of Fossils (ROM); Parker,
Harley, career at Royal Ontario
Museum; Royal Ontario Museum
(ROM); Royal Ontario Museum,
exhibitions and galleries
museums, traditional
about, 17–18, 115–16, 196–97, 212–13
colonial legacies, 6, 121–22, 212
critiques of, 162–63, 189–90, 192–93,
201

data as content vs. structure, 115–16
elitism, 6, 17, 196, 212
exhibition design, 122
glass cases, 114, 124, 125–26, 143
good taste epigram, 78–79
lack of public involvement, 17
linearity, 18, 115
as rear-view mirror, 82
sense ratios, 121
storylines, 115, 159, 191
transmission communications
model, 20, 154–57, 193, 202
visual bias, 18, 69, 149
music
Electric Circus nightclub, 101, 171–72,
191
intervals, 68, 87
non-period music in period room,
205
Parker on paintings as music, 87
sensory states of makers' world,
178–79, 181
synthesizers, 12, 99, 106
works for *Through the Vanishing
Point*, 41
See also Intersystems (multimedia
performance); sound

Nagel, Alexander, 112, 131–35
narrative. *See* labels and explanations;
story
Nash, Suzanne, 189
Nevitt, Barrington, 67–68
New Amsterdam Gallery. *See* Dutch
Gallery experiment, Museum of
City of New York (1967)
new museology
about, 17–18, 79–83, 206–07
community involvement, 80–83, 208
computerization, 34, 54, 190, 213
critiques of, 207
curator as activist, 82–83

Index 243

curator-designer collaboration, 80–81

influence of translations, 17–18, 193, 202–03, 206–07

international council (ICOM/MINOM), 17, 82–83

Parker's legacy, 17–18, 79–83, 185–86, 206–08, 211–13

sensory museology, 17–18, 138, 159

shift from storyline to reciprocal model, 206–07

newseum

about, 8–9, 169–70

adjacent to main museum, 9, 170

colour theory analogy, 143–44

everyday objects, 14

exhibition stages, 9

existing Newseum (Washington, DC), 8

liminality, 169–70

news stories as content, 169–70

"nowseum," 20

process vs. product, 9

Newseum (Washington, DC), 8

Nietzsche, Friedrich, 84–85

The Non-Linear Museum. See *Le musée non linéaire* (McLuhan and Parker; Deloche, Mairesse, and Nash, trans. French, 2008)

objects. *See* artifacts and objects; collection and preservation of artifacts

odours. *See* smell

Ogilvie, Will, 109

Ong, Walter J., 3, 18

Ontario College of Art (OCA), 23–24, 28, 89, 96, 108–09

Ontario Institute for Studies in Education, 48

Ontario Science Centre (OSC), 2–3, 161, 180–81, 201–02

orality

Blake Parker's spoken word performances, 101, 103, 106–07

of electronic communication, 6, 121

of epigram, 209

of explanations and labels, 212

phonetic alphabets, 73, 210

of typography, 33–34, 45, 209

of voice recordings, 107

See also story

organizational methods

chronologies, 81, 131, 144, 177

Hall of Fossils, 81–82

hypothetical subarctic gallery, 117–18, 124, 178, 200, 210, 213

non-linearity, 114, 122, 131, 179

sensory states of maker's world, 116–20, 178–79

storyline, 203–04

Western sequential organization, 121–22

See also story

orientation galleries

about, 7–8, 15–16, 167–84, 207, 212–13

artifacts, 178–79, 181

attendance control, 182

awareness of cultural difference, 195–96

coexistence of senses, 179–81

connection to main museum, 169–70, 182–83

conscious awareness of perception, 8, 181–83

disorientation of spectators, 175–76, 180

Dutch Gallery as experimental model, 7–8, 15–16

existing centers, 172

feedback from visitors, 182

intensification of involvement, 170–72

lighting, 170–71, 181

liminality, 169–70

liminoid, 170, 177, 195

models of reference, 170–77

multimedia design, 8, 167–69, 174, 180–81, 183

museum fatigue, 172

orientation space, 176–77

overcoming visual bias, 169–72, 174, 177–78

Parker's legacy, 212–13

retraining sensory perception, 167–69, 181

satellite museums, 196, 212

sensory states of makers' world, 15, 178–79, 181, 195

sound, 170–71, 177, 181

youth audiences, 177–83

See also Dutch Gallery experiment, Museum of City of New York (1967); *Museum Communication: A Seminar* (McLuhan and Parker, with Barzun, 1969); retraining sensory perception

OSC (Ontario Science Centre), 2–3, 161, 180–81, 201–02

Ostwald, Wilhelm, 197–98

Ouellet, Line, 201

Ouzounian, Gascia, 197

Packard, Vance, 99

Paik, Nam June, 10

paintings

iconic mode, 135

as music, 87

typography in, 210

See also Parker, Harley, works: paintings, watercolours, and typography; Parker, Harley, works: portraits and photos

Panara, Robert, 70–71, 73

Papanek, Victor, 27, 33, 109–10

Paré, Jean, 185, 186–88

Parker, Blake (Harley's son)

about, 12, 89–90

Burnaby Art Gallery collections, 19

counterculture, 12–13, 98–101

death (2007, age 64), 19

father-son relationship, 12, 89–90, 97–106

found manuscript of *Culture Box*, ix, 4, 19

Intersystems overview, 12, 89–90

kinetic art, 98–101

life in rural BC, 87

life in Toronto, 136–37

Monica Carpendale as partner, 19, 89

Penny Knapp as partner, 137

poetry, 99, 101, 104, 105, 106–07

reception, 103

sensory reordering, 105–06

spoken word performer, 101, 103, 106–07

uncanny effects in works, 106–07

See also Intersystems (multimedia performance)

Parker, Blake, works

about, 104–05

Head Machine (1967), 98

poetry, posthumous publication (2011), 104

Stella! (1994), 104–05

See also Intersystems (multimedia performance)

Parker, Eric (Harley's son)

author's communications with, 18–19, 216n1

father's self-portraits, 88–89, 96

found manuscript of *Culture Box*, ix, 4, 18–19

life in India, 110

life in Toronto, 110, 136–37

in New York City, 108

Parker, Harley

about, *x*, 1–9, 23–24

birth and death (1915, 1992), 1, 124

creative agitator, 2, 6, 77, 145

education at OCA, 23–24, 89, 215n1

health, 88, 108

life in New York City (1967–1968), 1, 3, 25, 81, 108, 165

life in rural BC (1968–1992), 87

life in Toronto, 108–10, 136–37

marriage to Mary, 108–10

wartime service, 24, 28

Parker, Harley, career

about, 1–2, 6, 9–11, 17–18, 23–24

Albers' influences, 24, 26, 131–32, 143

awards, honours, and grants, 2, 24, 148, 215n1

book cover designs, 33, 103

book reviewer, 2, 6, 48

C&B typography, 26–27, 28, 29, 31–32, 89

counterculture, 12–13, 100, 107–08

Eaton's, typography design, 23–24, 31, 89

as epigrammatic man, 11–12

Expo 67 consultant, 3, 31, 47

his legacy, 17–18, 193–202, 206–09, 211–13

inadequate recognition of, 17–18, 113–14, 155–56

international lecture circuit, 6

McLuhan Centre (1967–1975), 1–2, 24–25, 42, 44, 87, 105

as McLuhan's substitute overview, 42–51

member of professional societies, 2

OCA instructor, 24, 28, 96, 108–09

as a precursor to sensory turn, 9, 17–18, 20–21

as typographic man, 9–12

See also epigrams, good taste as "refuge of the witless"

Parker, Harley, career at Royal Ontario Museum

about, 1, 24–25, 29, 152–53, 162

colonial legacies, 122

curator-designer collaboration, 4, 80–85, 136–38, 140, 150, 200–02, 211

Expo 67 consultants, 47

General Display Chief (1957–1968), 29, 112–13, 132, 145, 147, 162

Impact exhibition (1960), 175, 175–176

interdisciplinary approaches, 32–33, 151

lectures, 152

Masks exhibition (1959), 145, 147–48

Ming Tomb and Armor Court, 145, 147

From Modesty to Mod exhibition (1967), 140–42, 144

Parker's reflections on, 14–15

press coverage, 147–49

Search and Research exhibition (1962), 148, 208–09

Up North exhibition (1958), 32

See also Hall of Fossils (ROM)

Parker, Harley, McLuhan collaborations

about, 3–4, 23, 25, 60–61

co-authors of *Through the Vanishing Point*, 10, 34–42

counterculture, 101, 107–08

cronyism and fronting, 60–61

first meeting, 23

at Fordham University (1967–1968), 1, 3, 25, 81, 108, 165

good taste epigram, 63–64, 74–76

letters to/from, 87–88, 135

personal relationship, 33, 35, 39, 47–48, 60–61, 135

See also *Explorations* (journal, 1953–1959); *Picnic in Space* (film, 1967); *Through the Vanishing Point* (McLuhan and Parker, 1968)

246 *Index*

Parker, Harley, McLuhan's substitute (1964-1969)
about, 3, 10–11, 25, 42–51, 59–61
Babel: Society as Madness and Myth (1968), 98
correspondence, 42
cronyism and fronting, 59–61
events, 42, 47–48, 51
Expo 67 consultant, 3, 31, 47
Greenbrier talk (1964), 34, 43–45, 50, 215n4
iconic theme, 42–43, 45
Kern Chair, RIT (1973), 51
personal relationship, 47–50, 60–61
research on television impacts, 44–45, 105, 140
role of substitute, 48–50
typography, 45–47
Understanding Media, 10–11, 44
untitled typescript (1964), 42–43, 45
Parker, Harley, medium and design theory
about, 111–12, 117–24, 162–63, 206–07
Bauhaus influences, 24, 173, 176
conscious awareness of perception, 8, 181–83
counterculture, 12–13, 100, 105–08
data as content vs. structure, 115–16
designer-curator collaboration, 4, 126, 136–38, 140, 150, 200–02, 211
feedback from spectators, 5, 114–15, 121, 150–51, 155, 182
grammar of presentation, 172–74
his legacy, 17–18, 193–202, 206–09, 211–13
his reflections on, 14–15
hypothetical galleries, 14–15, 117–24, 178, 210
iconic mode, 135
ideal audience, 150–51, 210, 212
Leighton epigram on blindness, 65–69
orientation galleries, 111–12, 118–19, 144–45, 167–69
overcoming visual bias, 169–72, 174, 177–78, 198
research on television impacts, 44–45, 105, 140
retraining sensory perception, 6–7, 100, 105–06, 111–12, 121, 206
sense ratios, 71–73, 101, 111–12, 115, 121, 154, 163
sensory states of makers' world, 116–20, 163, 178–79, 181
shift from storyline to reciprocal model, 206–07
specialists vs. generalists, 4, 149–51, 200–01, 208
subarctic hypothetical gallery, 117–24, 178, 200, 210, 213
thought experiments, 111, 150–51
total sensory involvement, 113–14, 119, 135, 154–57, 162–63
tribalism trope, 71–74, 116, 120–21
variations on McLuhan's theory, 211–13
visual bias, 149, 169–70, 198
See also *The Culture Box*, medium theory; *Museum Communication: A Seminar* (McLuhan and Parker, with Barzun, 1969)
Parker, Harley, works: articles, books, and lectures
"Arts as Communication" lecture series, 152
"A Citizen Profile," 23, 152
"Colour as Symbol," 26
"The Horse That Is Known by Touch Alone" (1964, 1970), 26, 64–66
lectures, 152
"The Museum as a Communication System" (1963), 113–16, 118–22, 136, 154, 159

Index 247

"The Museum as a Perception Kit" (1972), 143–44, 162, 181

"Notes on Perception," 77

Two Blind Guys (with Mindel), 71

See also *The Culture Box* (Parker, 2025); *Le musée non linéaire* (McLuhan and Parker; Deloche, Mairesse, and Nash, trans. French, 2008); *Museum Communication: A Seminar* (McLuhan and Parker, with Barzun, 1969)

Parker, Harley, works: exhibition design. *See* Dutch Gallery experiment, Museum of City of New York (1967); Hall of Fossils, exhibition design; Parker, Harley, career at Royal Ontario Museum

Parker, Harley, works: paintings, watercolours, and typography

about, 88–89

Design for a Mural (pencil drawing), 89

DEW-Line Newsletter card deck, 2, 9–10, 66

Flying Children, 38, 75–76, 133

good taste epigram, 85

musical connections, 87

shows, 24, 85, 88–89

watercolours, 24, 88–89, 90, 96–97

See also typography

Parker, Harley, works: portraits and photos

about, *x*, 12–13, 88–97

Karsh's photo (1968), 19, 93, *95*, 132

photo in Hall of Fossils (1967), *129*

portrait in ROM office (1960), *x*

Self-Portrait (1945), 97

Self-Portrait (1947), 90–92, *91*

Self-Portrait (1948), 96–97

Self-Portrait (1985), 93, *94*, 96, 106

Self-Portraits (1950–1953), 88, 90–92, 96

symbolic disappearance, 12, 90, 96–97

time span (1945–1985), 12–13, 88, 97

uncanny effects, 106–07

unfinished works, *94*, 96

Parker, Margaret (Harley's daughter)

author's communications with, 19, 216n1

collection of Harley's artworks, 88–89

found manuscript of *Culture Box*, ix, 4, 19

Harley's self-portraits, 88–89, 96

Harley's stories on blindness, 71

Harley's view of watercolours, 96

life in Toronto, 108, 136–37

Parker, Mary (Harley's wife), 108–10, 136–37

Parr, A.E., 20

participation. *See* community involvement

Pauling, Linus, 67–68

Peachy (Intersystems), 12–13

Perception '67 installation (U of T), 13, 98, 107

perceptual retraining. *See* retraining sensory perception

Petrov, Julia, 140–41

photography

Karsh's portraits, 19, 93, *95*, 132–34, *133*

photomural in Hall of Fossils, 125

photos of Parker, *x*, 19, *44*, 93, *95*, *129*, 132, *147*, 215n6

photo-typography (Flexitype), 26–29, 33, 45–46, 103–04

Picnic in Space (film, 1967)

about, 11, 25, 51–58

acoustic space, 55, 64

Bacon as director, 11

248 Index

film/television relationship, 52–54, 56, 58–59

flashlight and lightbulb, 55, 56

hot and cool media, 11, 37

hybridization of media, 25, 54, 58–59

improvised dialogue, 55–56

literal metaphors, 52

media nesting, 52

montage, 51, 52, 54

non-narrative style, 51, 53, 55–57

reception, 51–53, 55

release (1973), 54

soundtrack, 56

time as flow and accumulation, 57–59

Understanding Media, 51–54, 58–60

women in film, 55, 56

pictorial. *See* illustrative art

Pitman's alphabet, 46–47

poetry

Beat poets, 104, 105

Blake Parker's synthedelic performances, 12

imagist poetry, 73

"kinkon" poetry, 36

typography, 36

in *Vanishing Point*, 38, 75

See also Intersystems (multimedia performance)

Pogo comic strip, 213

Pollock, Jackson, 41, 67

Popper, Frank, 100

Port Credit, Ontario, 137

portraits of Parker. *See* Parker, Harley, works: portraits and photos

poster exhibition (ROM, 1960), 175, 175–76

Poulet, Georges, 56–57, 190

Pound, Ezra, 3, 73

Pratt Institute, 47

preservation. *See* collection and preservation of artifacts

Prince Arthur Gallery, Toronto, 24

print. *See* labels and explanations; linearity; writing systems

psychedelic culture, 12–13, 100–01, 105–08, 136–37

See also counterculture

public as audience. *See* audience; community involvement; youth

Quebec

Expo 67, Montreal, 3, 16, 31, 47, 171, 179–80, 186

Indigenous consultations, 198–200

Musée de la civilisation à Québec, 198–200

reception of translations of McLuhan's works, 186–87

Robert as graphic designer, 188–89

Regency Room, Canadiana Gallery (ROM), 177

Reichardt, Jasia, 36

Reid, Dennis, 102

Rembrandt, 92–93

Remington, Roger, 51

research. *See* universities and research centres

retraining sensory perception

about, 6–7, 121, 154, 163, 167–69, 181, 205–06

abrasive juxtapositions, 121, 126, 163, 180, 205–06

colour theory analogy, 143–44, 197–98

conscious awareness of habits, 8, 167–70, 181–83

counterculture, 100–01

design for youth, 177–78

Dutch Gallery experiment, 167–70

empathic insights, 205

gradualist approach, 144–45

intensification of involvement, 170–72

Index 249

liminality, 158, 169–70, 177, 195, 203

models of reference, 170–77

new sense ratios, 121, 149, 154, 163, 167–70

orientation galleries, 111–12, 144–45, 167–70, 181

overcoming visual bias, 169–72, 174, 177–78

Parker's ideal audience, 210, 212

purpose of, 121, 154

sensory blackout, 143–44

sound, 170

See also disorientation of spectators; Dutch Gallery experiment, Museum of City of New York (1967); orientation galleries

RIT. *See* Rochester Institute of Technology (RIT)

Riverside Museum, 191

Robbe-Grillet, Alain, 191–92

Robert, Gilles, 188–89

Rochester Institute of Technology (RIT)

disability studies, 70, 110

Parker as Kern Chair (1973), ix, 1, 51, 110

Sound of Vision conference (1973), 51, 70–72, 160–61, 216n1

Rowan, Julian, 3

Royal Ontario Museum (ROM)

about, 82, 111, 124, 157–61

access for visually impaired, 159–60

audience, 139–40, 142, 150–51, 161–62

budgets, 148

communications guidelines, 157–61

community involvement, 80

designer-curator relationships, 4, 81–82, 126, 136–38

Fleming's association, 28–30

interdisciplinary approaches, 32–33, 151–52

McLuhan's lectures, 29–30

as multi-sensory museum, 125, *127*, *128*, *129*, 131, 138, 159–60

Parker's hypothetical subarctic gallery, 117–24, 178

Parker's legacy, 207–08

Parker's views on, 152–53, 201

press coverage, 147–49

ROM report (CDT, 1976), 157–61

security concerns, 153, 158

specialists vs. generalists, 4, 149–52, 208

as traditional museum, 82, 111

See also Parker, Harley, career at Royal Ontario Museum

Royal Ontario Museum, exhibitions and galleries

Bat Cave, 13

Dawn of Life gallery (2021), 208

Eskimo Gallery, 124

Gutenberg exhibition (1956), 28–29

Into the Heart of Africa (1989-1990), 207

Impact posters exhibition (1960), *175*, 175–76

maps, 32–33

From Modesty to Mod textiles (1967), 140–42, 144

Regency Room modifications, 177

Search and Research (1962), 148, 208–09

Typography, 29–30, 31–32

See also Hall of Fossils (ROM)

Schaefer, Carl, 109

Schmidt, Kerstin, 55

scholarly research. *See* universities and research centres

school children. *See* children

Schwartz, Tony, 15, 165, 167–69

science and technology museums

audience involvement, 161

functions of, 201–02

midden metaphor, 9

Ontario Science Centre (OSC), 2–3, 161, 180–81, 201–02

Science North, Ontario, 181

Scott, David H., 157–58

Search and Research exhibition (ROM, 1962), 148, 208–09

Segal, David, 38–39

self-portraits of Parker. *See* Parker, Harley, works: portraits and photos

seminar. See *Museum Communication: A Seminar* (McLuhan and Parker, with Barzun, 1969)

seminar, French translation. See *Le musée non linéaire* (McLuhan and Parker; Deloche, Mairesse, and Nash, trans. French, 2008)

sensorium
 about, 8
 cross-modal correspondences, 34
 intervals, 68–69
 new museology, 17–18
 sensory bias, 198
 sensory turn in research, 17–18, 20–21
 total sensory involvement, 135
 See also kinaesthesia and kinetic space; smell; sound; tactility; taste; total sensory involvement; vision and visuality

sensory states of makers' world
 about, 4–5, 116–20, 163, 178–79, 181, 198–200
 T.S. Eliot's objective correlative, 205–06
 hypothetical subarctic gallery, 116–20, 124, 178, 200, 210, 213
 Indigenous sensory states, 206
 lighting as example, 117
 music as example, 178–79, 181, 205
 orientation galleries, 15, 178–79, 181
 Parker's legacy, 198–200, 207–08

sensory biases, 178–79

Shakespeare, William, 92–93

Silver, Stuart, 157

simultaneity of perception. *See* total sensory involvement

smell
 about, 18
 audile/tactile/olfactory media, 159
 coexistence of senses, 179
 Dutch Gallery experiment, 165
 Hall of Fossils, 101–02, 124
 Indigenous exhibition design, 198–200
 involvement of audience, 124
 Mind Excursion (Intersystems), 101
 new museology, 17–18
 retraining sensory perception, 143–44

Snyder, Don, 100

social class
 elitism, 6, 17, 196, 212
 sensory profiles of marginalized people, 71–73

society, local. *See* community involvement

sound
 acoustic space, 55, 64, 76, 120, 168–69, 178, 191, 197
 coexistence of senses, 179
 Dutch Gallery experiment, 165–69
 Electric Circus nightclub, 101, 171–72, 191
 experimental typography, 33–34
 Hall of Fossils, 101–02, 126–27, 131
 history of museums, 134
 intervals, 168–69
 label replacements, 103
 liminality, 170
 orientation galleries, 170–71, 177, 181
 overcoming visual bias, 170–72
 recordings, 103, 107, 118, 134, 200

retraining sensory perception, 143–44, 170

Schwartz's resonance theory, 167–69

visitor-controlled sounds, 200

youth audience, 177–78

See also deafness; music; orality

Sound of Vision conference (RIT, 1973), 51, 70–72, 160–61, 216n1

space

abrasive juxtapositions, 121

acoustic space, 55, 64, 76, 120, 168–69, 178, 191, 197

domes, 119

feedback from spectators, 5, 114–15, 121, 155

retraining of sensory perception, 167–70

sensory states of makers' world, 178–79, 181

temperature, 124, 168–69

See also kinaesthesia and kinetic space

Spanish translations. See *Contraexplosión* (McLuhan; Gelstein, trans. Spanish, 1971)

Sparshott, Francis, 40–41

specialists. *See* universities and research centres

spectator intake. *See* orientation galleries

spectators. *See* audience

speech. *See* orality

Stensholt, Hakon Meyer, 34

Stern, Rudi, 100

story

French translation of *storyline*, 191

Indigenous history, 121–22

news stories in newseum, 169–70

non-linear narratives, 114, 179, 183

sequential organization, 121–22

shift from storyline to reciprocal model, 206–07

storylines, 115, 159, 179–81, 191, 203

See also orality

stupidity, as concept, 192

subarctic hypothetical gallery, 117–24, 178, 200, 210, 213

Subotnik, Morton, 56

substitute for McLuhan. *See* Parker, Harley, McLuhan's substitute (1964–1969)

suddenness, 64–66, 68–69

Swann, Peter, 81, 140–42, 152–53, 157, 216n2

Swinton, William, 138, 152, 216n2

tactility

about, 64–66, 76, 161

coexistence of senses, 179, 198

collections for handling, 160–61

demotion of touch, 18

Dutch Gallery experiment, 165

experimental typography, 34

"The Horse That Is Known by Touch Alone," 26, 64–66

iconic mode, 43, 64–66, 135

Indigenous exhibition design, 198–200

intervals, 64, 67, 68–69, 87

Inuit space, 168–69

kinetic/aural/tactile, 73, 126, 131, 136, 139

Leighton epigram on blindness, 65–69

in paintings, 76, 198, 210

print culture and audile-tactility, 209–10

sensory bias, 198

temperature, 124, 168–69

visual impairment, 64–69, 73, 159–61

Taiga, as term, 117

Take Today (McLuhan and Nevitt), 67–68

Task Force on Museums and First Peoples (AFN and CMA, 1992), 123–24

taste
coexistence of senses, 179
experimental typography, 34
new museology, 17–18
technologies
computers, 34, 54, 156, 190, 213
Dutch Gallery experiment, 165–69
Hall of Fossils, 13, 81–83, 100, 126, *128*, 130–31, *133*, 134
Parker's views, 34, 120–21, 161
private consumption, 54
recordings, 103, 107, 118, 134, 169, 200
See also film; television
teenagers. *See* youth
television
Bayer's theories, 173
film/television relationship, 52–54, 58–59
iconic mode, 65
media as content of other media, 5
research on impacts, 44–45, 105, 140
See also *Picnic in Space* (film, 1967)
textile exhibits, 140–42
texts. *See* labels and explanations; writing systems
The Multi-Media Orientation Gallery. *See* Dutch Gallery experiment, Museum of City of New York (1967)
Theall, Donald, 74, 76
theory, communication. *See* communication theory
theory, design. *See* colour theory; Parker, Harley, medium and design theory
theory, medium. See *The Culture Box*, medium theory; McLuhan, Marshall, medium theory; Parker, Harley, medium and design theory
Thompson, Brian, 99

Thompson, George, 9–10
Through the Vanishing Point (McLuhan and Parker, 1968)
about, 10, 25, 34–42
Anshen as editor, 10, 25, 34–40, 74–76
Dair's involvement, 30, 36, 37, 109
double-spread format, 30, 37
good taste section, 74–76, 78
Innis Herald conversation (1978), 41, 92
late additions, 37–38
Leighton epigram on blindness, 65–69
Parker's painting *Flying Children*, 38, 75–76, 133
poetry and paintings, 30, 36, 39, 41
publication processes, 34–35, 39–40
reception, 40–41
title, 35, 38
typography, 36, 37
World Perspectives series, 30, 34–35, 36–37
time and timelessness
about, 57–59
all-at-onceness, 6, 64
chronologies, 81, 131, 144, 177
continuous/discontinuous time, 57
deep time in Hall of Fossils, 130–31
hallucinogenic drugs, 136
media hybridization, 58
in *Picnic in Space* (film), 57–59
retraining of sensory perception, 167–70
timelessness, 58–59, 64, 135
Western sequential organization, 121–22
Toronto
Ontario College of Art (OCA), 23–24, 28, 89, 96, 108–09
Spadina protests, 2–3, 31
Yorkville counterculture, 136–37, 139, 161–62

Index 253

See also Royal Ontario Museum (ROM); University of Toronto (U of T)

total sensory involvement
 about, 113–14, 135
 all-at-onceness, 6, 64
 colour theory analogy, 143–44, 197–98
 communication systems, 154
 déjà vu, 163, 211
 domes and simultaneous sound, 119
 hypothetical subarctic gallery, 119, 124, 178, 200, 210, 213
 iconic mode, 43, 64, 135
 McLuhan's acoustic space as, 64, 76, 120, 191, 197
 memory image, 211
 ROM report (CDT, 1976), 160–61
 sensory states of makers' world, 163, 178–79, 181
 subjective completion by spectator, 211
 tactility, 65
 See also iconic mode

touch. *See* tactility

traditional museums. *See* museums, traditional

translations. *See* McLuhan, Marshall, works: translations and reinventions

tribalism trope, 71–74, 116, 120–21

Tudor, David, 103

Tushingham, A.D., 25, 32, 215n3

typography
 about, 29, 33–34, 45–47
 academic use of commercial technologies, 27, 29, 103–04
 book cover design, 33
 in *Counterblast*, 64, 188–89, 209
 epigrams, 74, 150
 experimental typography, 33–34, 36–37, 46, 103, 210

in *Explorations*, 26–27, 46
 ideograms, 46
 labels and explanations, 150
 McLuhan's influence, 27, 33–34, 37
 orality of, 33–34, 45, 209
 in paintings, 210
 Parker's influence, 33–34, 45–46, 103–04
 photo-typography (Flexitype), 26–29, 33, 45–46, 103–04
 Pitman alphabet, 46–47
 ROM exhibitions, 29–30, 31
 sensory dimensions, 33–34, 210
 shift from visual/illustrative bias to iconic/tactile, 45–46, 64, 210
 in translations, 188–89

Typography exhibits (ROM), 29–30, 31–32

UC. *See* University of Toronto, University College (UC)

uncanny in Freudian theory, 106–07

Understanding Media (McLuhan, 1964)
 blindness, 65–66, 68–69, 71
 book covers, 33
 celebrity status, 10–11, 42, 59–60
 film/television relationship, 52–54, 58–59
 influence of, 25
 language and consciousness, 58–59
 making/matching messages, 157, 194
 media nesting, 52
 Parker as McLuhan's substitute, 10–11, 44
 in *Picnic in Space* (film), 51–54, 58–60
 suddenness, 65–66
 television's effects, 44–45, 65
 timelessness, 58–59
 transformation model, 20, 157

unitary awareness. *See* total sensory involvement

universities and research centres
 about, 149–51

254 *Index*

audience research needed, 150–51,
162–63, 174, 212
feedback from spectators, 5, 114–15,
121, 150–51, 155, 182
interdisciplinary research, 32–33, 151
research on television impacts, 44–
45, 105, 140
sensory turn, 17–18, 20–21
specialists vs. generalists, 4, 149–51,
200–01, 208
visual bias, 149, 178
See also Centre for Culture and
Technology (U of T); technologies
University of Toronto (U of T)
relationship to ROM, 149
Varsity Graduate (magazine), 14, 26
See also Centre for Culture and
Technology (U of T)
University of Toronto, University College
(UC)
Babel: Society as Madness and Myth
(1968), 98
Mind Excursion installation (1967),
13, 98–102, 107, 191
Perception '67 installation, 13, 98, 107
University of Toronto Press (UTP), 27, 31
University-at-Large, Inc., 52, 54
USCO (US Company), 13, 100, 191

Vanishing Point. See *Through the
Vanishing Point* (McLuhan and
Parker, 1968)
Varley, Fred, 32–33
Veeder, Rex, 209
vision and visuality
about, 18
conscious awareness of perception,
8, 181–83
cross-modal correspondences, 34
historical dominance of, 18
ideographs, 73
linearity, 18

multi-sensory Cubism, 135
new museology, 17–18
overcoming visual bias, 169–72, 174,
177–78
sensory states of makers' world,
116–18, 178–79, 181
Sound of Vision conference, RIT
(1973), 51, 70–72, 160–61, 216n1
visual bias, 18, 34, 69, 149, 169–70,
198
See also blindness; linearity
visitor intake spaces. *See* orientation
galleries
visitors. *See* audience

Wallach Orientation Center, 172
Warhol, Andy, 50, 56, 191
watercolours, Parker's, 24, 88–89, 90,
96–97
Watson, Wilfred, 187
Whittle, Christopher, 155–56
Williams, Carl, 109
Winlaw, British Columbia, 87
Wolfe, Tom, 40, 113
Woodsworth House, Ontario, 24
Wright, Gilbert, 154–55
writing systems
book cover designs, 33, 103
linearity, 5
media as content of other media, 5
phonetic alphabets, 73, 210
Pitman alphabet, 46–47
visual bias, 14, 45, 149, 169–70, 178
See also labels and explanations;
linearity; literary arts;
typography; vision and visuality

youth
about, 111–12, 136, 177–78, 212
as audience, 136–39, 142, 161–62,
177–78, 210, 212
discotheques, 171–72

"nowness" involvement, 112, 139
orientation galleries, 177–83
sense ratios, 111–12, 136, 212
visual bias, 149, 169–70, 178
Yorkville counterculture, 136–37, 139,
 161–62
See also counterculture

Zakia, Richard, 71
Zander, Dik, 99, 106